I, Claudia

I, Claudia

THE LIFE of
CLAUDIA LAUPER BUSHMAN
in HER OWN WORDS

Greg Kofford Books
Salt Lake City, 2024

Copyright © 2024 Claudia Lauper Bushman.
Cover design copyright © 2024 Greg Kofford Books, Inc.
Cover design by Loyd Isao Ericson.

Published in the USA.

All rights reserved. No part of this volume may be reproduced in any form without written permission from the publisher, Greg Kofford Books. The views expressed herein are the responsibility of the author and do not necessarily represent the position of Greg Kofford Books.

ISBN: 978-1-58958-812-7 (paperback)
Also available in ebook.

Greg Kofford Books
P. O. Box 1362
Draper, UT 84020
www.gregkofford.com
facebook.com/gkbooks
twitter.com/gkbooks

Library of Congress Control Number: 2024942549

Contents

Foreword, by Richard Bushman, vii

Introduction, by Caroline Kline, ix

Part One: Growing Up

1. In the Beginning, 3
2. Childhood, 10
3. My World—The Neighborhood, 26
4. Sunset Ward, 37
5. Things My Mother Never Taught me, 44
6. School Days, 55
7. Off to College, 65
8. Wellesley and Brattle Street, 73
9. Courtship, 85

Part Two: Marriage

10. At Home and Abroad, 101
11. Eastward, 117
12. Belmont, 1970–1977, 133
13. Belmont Last Days, 154
14. A Bishop in the House, 165
15. Newark, 181
16. A High Time in The First State, 198

Part Three: New York

17. My Life as a Scholar, 207
18. Four Projects, 227
19. The Little Pink House, 247
20. The Claremont Idyll, 258
21. Wellesley Revisited, 264
22. Family, 269
23. The End of the Line, 281

Part Four: Essays

24. How to Live a Life, 291
25. The Bushman Plates: A Tale of Lust and Material Culture, 300
26. Obituary, 308

Index, 311

Foreword

I have known Claudia for over seventy years since we met in her boyfriend's Harvard college room in January 1953. I have seen her in every possible situation, attended her in childbirth, watched her teach and lecture, and observed her managing her projects, disciplining our children, even overseeing a parade she had organized in the Delaware state capitol. I know Claudia better than her parents, her sisters, and our children do. All this, and I still do not understand her powers.

Why did this so-so college student go on to get a master's degree when she had three children, begin a PhD program with five children, and finish her schooling with six? Why, over the years, has she published ten books, one on a mid-nineteenth-century Lowell mill girl, another on a Virginia farmer on the eve of the Civil War, as well as the oft-reprinted *Mormon Sisters* and the much-used *Contemporary Mormonism*?

How do we account for her power over her suitors? There were multiple proposals, all of which she turned down save one (thanks be). Why do New York millionaires she happened to sit next to at a dinner tell her their fears and frustrated ambitions? How was she able to produce a show of over 2,500 untrained Mormon kids at Radio City Music Hall with the largest cast ever to appear on that stage? How did she work her way through the many-layered New York City bureaucracy to gain approval for the erection of a Joseph Smith statue not far from Wall Street on the 200th anniversary of his birth? What about the commemoration of the Ship Brooklyn voyage with the departure of costumed Mormons on a real sailing ship from a dock in New York harbor?

Whence the maxims she lives by? *If you keep up, you will never get ahead. You can be happy even when you are miserable. If I didn't quit, I could never go on.* Why do strong hearts tremble when she repeats her insistent refrain (*A record must be kept!*) and asks if they are keeping journals.

Her high school friends presciently voted her the classmate most likely to succeed, but she would have preferred to have been chosen the best dressed or the best hair. She insists she is essentially a lazy bum who much prefers to lie down in the afternoon and read novels. And she does read novels: the complete works of Anthony Trollope, James Joyce's *Ulysses*, and Jane Austen over and over. After hearing her comments and the passages

she reads to me, I form opinions of the books as if I had read them myself. She reads for two. And yet from the bed where she lies reading come these degrees, these books, these enormous projects.

Perhaps an off-hand observation tells us something. When seeking approval to erect the Joseph Smith statue, Claudia dealt a lot with the New York City architect. After months of fruitless struggle, he said to her: "You are going to get approval, you know." She replied: "How can you say that? I am getting nowhere." "Yes," said he, "but you don't give up."

That may be it. Once a project or course of action takes hold, she is relentless. She thinks of her plans as revelations, like the ones her mother, also a project person, received. She sees in one swoop all that could be done and exactly how to do it, and then she is on her way.

She complains about writing, but it comes naturally to her. The wit and the well-turned phrase are her native speech. She is often surprised that people laugh when she gives talks. She does not mean to be funny. It just comes out that way. Partly they laugh out of surprise. She is so daring, so bold, and yet so real. Once, when speculating about how to celebrate the ratification of the US Constitution in Delaware, the "First State," she proposed that school kids and state legislators participate in a great ladybug launch. The ladybug was the state insect. Thinking of it as a sky-blue proposal, Claudia did it for fun. To her surprise, the state PTA leaders came up afterward and said they thought it would work. One morning in 1987, two hundred years after ratification, legislators and school kids liberated a million lady bugs to fly into the Delaware skies or crawl into the Delaware grass, an event none are likely to forget.

There are many gifts. Claudia can remember the names of her friends in first grade. She has thousands of song lyrics in her head. She says if Rogers and Hammerstein had written the Bible, she would remember every word. She harps on the handicap of being left-handed. She can't remember left and right or north and south. But she can recite word for word the Lawton creed that she learned in grammar school.

One of Claudia's maxims is that every meeting can be improved by dancing and singing. If she is asked to speak, the audience must be prepared to stand up and do "The Lauper Shuffle" in the aisles and between the chairs. People laugh, they are embarrassed, but they stand up and dance. If I am unable to explain Claudia, you can try for yourself as you follow her, dancing and singing, through her life story.

<div style="text-align: right">Richard Bushman</div>

Introduction

Women's stories matter. And they must be recorded.

Claudia Bushman deeply impressed this on me throughout the three years I took classes from her at Claremont Graduate University. While we delved into Mormon women's history, we also worked to document contemporary Latter-day Saint women's lives. During this time, Claudia founded the Claremont Mormon Women's Oral History Project, teaching us students not only how to conduct oral histories, but also why such a project was so essential.

"We have to get such stories down. If we want to live forever in the minds and annals of the earth, if we want other women to be represented into the future, we have to leave a record," Claudia writes in the introduction to *Mormon Women Have Their Say: Essays from the Claremont Oral History Collection*.

These oral histories we collected—and still collect—as part of this project are generally stories of everyday Mormon women's lives, in which details of families, church service, and employment coexist alongside reflections on personal triumphs, disappointments, and lessons learned. As Claudia taught us, women's life stories don't have to be extraordinary to be recorded and preserved. What matters is that they are honest and reflective. What matters is that they illuminate women's lived experiences in all their complexity, experiences that are typically not as well documented as men's within this androcentric faith tradition. As Claudia has often said, she thinks these oral histories are "pure gold," records that will live into the future and provide untold insight and wisdom for coming generations.

Claudia has left just such a record—and more—for us in *I, Claudia*, her frank, thoughtful, and illuminating account of her vibrant life. Woven throughout her rich memories of growing up in San Francisco, pursuing higher education, motherhood, and numerous ambitious projects are her reflections on her own strengths, failures, joys, and disappointments.

She does not shy away from the difficult episodes of her life, nor does she shy away from her many successes. She particularly struggled during the years her husband served in church leadership, thereby leaving Claudia to manage the children herself on Sundays. She writes, "I was generally

a very bad sport about all of this. I resented having to get my children ready all by myself and transport them into church on the bus, walking the last few blocks. . . . I was a depressed young mother, and I spent a great deal of energy furiously seething." How relatable! How human! Her book shows how she ultimately channels these feelings into carrying out large-scale projects, ranging from founding the Mormon feminist newspaper *Exponent II* to spearheading a years-long LDS effort to build better relationships with residents in Harlem. Despite the various limitations she navigates within—be it familial, church, or other—again and again Claudia makes things happen. Claudia might have been something of a half-hearted student during her college years, but we can see her brilliance brimming over as she sets her mind to realize big-vision ideas.

Threaded throughout Claudia's story is her pithy wit and wisdom, accompanied by perspective from the vantage point of a life well lived. I find myself moved by this book because it is so Claudia. Open. Real. Brave. She practices here what she has preached to so many of us. *Put words to paper. Don't sanitize your history. Reflect on how you make meaning in your life.* This is advice for the ages. *I, Claudia* stands as a model to us all of a woman unapologetically claiming her story and her place in history, telling the world that she loved, she learned, and she mattered.

Throughout the years I have known her, Claudia has signed off her emails to me with the phrase, "Carry on!" I see agency, resilience, and forward motion in that phrase. What a perfect encapsulation of the indomitable Claudia Bushman.

<div style="text-align: right;">

Caroline Kline
Director of the Claremont Mormon Women's Oral History Project
Research Assistant Professor, Claremont Graduate University

</div>

―Part One―

Growing Up

–1–

In the Beginning

Where did I come from? I liked to think that I was a lost princess, left on a doorstep. But I eventually learned that I am a product of Northern Europe and the British Isles. Three grandparents emigrated and one grandfather was born of new immigrants in the United States. My family came because of European unrest, rigid class structure, financial concerns, and the hope of free or cheap land. That's all true. But most of all, I am a product of conversion to and the gathering of The Church of Jesus Christ of Latter-day Saints, often called the Mormon Church. I am almost a third-generation American. I am almost a fifth-generation Mormon.

My Mormon credentials, while they do not date back to Palmyra, Kirtland, nor Nauvoo, are more than respectable on my mother's side. One great-great-grandfather, who later left the Church, crossed the plains with John Taylor in 1852, involved in the enterprise to refine sugar. He and one great-grandmother who pulled a handcart across the plains in 1864 with her three surviving children are legitimate pioneers who came before the completion of the transcontinental railroad in 1869. Later, my mother's Gordon parents, grandparents, and their children were part of one of the Church's last organized migrations to Canada in 1899. More recently, three generations from both sides of the family participated in the informal move of Mormons to Southern California in the early twentieth century. All four branches of the family had joined The Church of Jesus Christ of Latter-day Saints well before the end of the nineteenth century, giving us a century plus of Mormon life extending five generations, of which I am the third generation.

My grandparents came from four different countries: Switzerland, Denmark, Scotland, and England. My paternal grandfather, Emile Lauper, whose last name—it is said—is a Swiss version of the French Le Pere, was a vintner, a poor peasant boy who joined the Church and came to America with his sister Alice. They settled in Lehi, a small Utah town. My paternal grandmother, Emma Wissing, was born into the Church in Denmark. Her parents were both members of their small Danish congregation. Emma, a teenage girl, came to America with her young mother. They also settled in Lehi, Utah.

My great-grandmother saw my grandfather working in a grape arbor, and assuming that he owned the land, thought he would be a good match for her daughter. Emile turned out to be a hired hand and much older than Emma, but they married. Emma's marriage and her mother's American marriage occurred about the same time, and they raised parallel families of children.

Emile and Emma became homesteaders on a dry farm in Utah. The family hauled in every cup of water that they ever used. Grampa, raising a crop and a few animals on his desert acreage, eventually managed to prove up his claim. Ten children were born to them. Little Elsie died as an infant, but the other nine grew to maturity. My father Serge, the eldest, was followed by Ivan, John, Felix, Alyce, Marcel, Viola, Dennis, and Ralph. The family lived in a tiny house; the big boys slept in a nearby tent.

A homesteader with a large family on a dry farm in dry Utah, particularly one whose English was not too sure, would have had difficulties. In bad times the children had only popcorn for their school lunches. My father remembered his mother refusing to take food from better-off neighbors. He pointed out that they really needed the help. His mother, too proud to accept charity, drove the women off with her broom.

Grandfather Emile was a very tough, strong man who could lift one-hundred-pound bags of grain with each outstretched hand. He would say, "Dot is nutting." His children were fiercely loyal to him and they learned to work early. Young Ivan cultivated a whole acre of sugar beets in a single day to prove a bet. The boys grew strong, and their father hired them out to neighbors for cash when they were very young.

My father, Serge, finished the sixth grade and went off to a nearby town to go on with his education. But lonely, boarding with strangers, and knowing that he was needed elsewhere, he dropped out and went home. Two of his brothers, Felix and John, were killed in accidents in their late teens. Soon after her last child, Ralph, was born, my grandmother had what was called "a nervous breakdown," and neighbors took in little Ralph. When Ralph was two, his mother was well enough that he was brought home. His two older sisters, Viola and Alyce, retired their mother to an easy chair, never to do another thing. From the time she was about fifty until her death at seventy-seven in 1958, she sat there, in black dresses and black, old-lady, laced-up shoes, her long white hair braided and wrapped around her head. My father said that she had been a fun-loving mother, and my sisters remembered her joking with her sons and playing with the grandchildren. In my memories she is always serene,

sad, and beautiful, tears sometimes running down her cheeks—a strong woman worn out by a hard life.

When the homestead claim was proved up, my grandfather traded it as a down payment on a spruce little farm some miles away. Here was a charming and comfortable house. The barn was stocked with attractive animals. An irrigation system was being installed to bring water to the dry acres. But the irrigation water brought the alkalai to the surface and killed the young plants, and the farm was too low to drain. My father, seeing no hope for the place, left for California to find his fortune there. He set off on Christmas Day, 1921, at age 20 with his brother Ivan, a year younger. Serge was a clear-eyed, hard-working young man who ever after had no one to rely on but himself. My mother, who had some tensions with her in-laws, told me that after his departure, his family regarded him as having abandoned them, even though he sent them money, brought them all to California, and helped them the rest of his life. His father died in California at age 67 in 1936, still landless.

When some of my uncles, who all became successful California businessmen, revisited the old homestead many years later, they asked whether anyone remembered their father. They were told, "Oh, yes. That's the man who fed his animals, but not his children." My insulted uncles, who had their share of frontier pride, left the town in high dudgeon. The strong, healthy children were certainly fed most of the time, but the comment suggests the marginal position the family occupied in the community. The family has since turned out five generations of good and productive citizens from five branches of the family. Those are the Laupers.

My maternal grandmother, Margaret Elizabeth Schutt Gordon, born in England, came to British Columbia at age 10 with her sister and parents, lay missionaries with the Anglican Church Missionary Society, to teach the Christianized Indians. Margaret spent about eight years in the progressive Canadian village of Metlakahtla. She taught indigenous people and translated Christian materials into native dialects. She traveled to Victoria to attend school. When she was eighteen, then living on the shores of Lake Huron in Ontario in another native settlement, she converted to The Church of Jesus Christ of Latter-day Saints, influenced by printed materials sent by a cousin in Utah who was already a third-generation Mormon. Young Margaret, her mother, and her sister wanted to gather with the Saints. The father, Henry Schutt, agreed to move to Salt Lake City and there Margaret and her father taught school. Then Henry decided to try farming and moved the family to another primi-

tive settlement, the tiny, barren, muddy, one-street town of Meadowville, Utah, near the Idaho border. Margaret later noted that she had never seen anything so desolate. She taught school in the larger nearby Lake Town, becoming a fearless horsewoman on her daily commutes. In Meadowville, she met my maternal grandfather, James Frater Gordon, born in Utah after his family had come from Scotland. His mother had brought his four older siblings to the United States on a ship and, with the surviving three, walked across the great western plains pulling a handcart. His father came a year later, driving a team of oxen. James was born in Salt Lake before the family settled in Meadowville.

James, a very competent rancher and farmer, rode the range, working on big projects. He could also tap dance and play the violin for the local dances. Within a couple of years, he had cut out the competition and proposed to the more sophisticated and talented Pansy, as Margaret was called. They married in the Logan Temple of The Church of Jesus Christ of Latter-day Saints in 1893. James built them a tidy new home. Margaret furnished it and assembled a trousseau with her school money. But after their two sons were born, Margaret and James felt the limits of their small town. They drove wagons north to help colonize Canada by working on a huge irrigation project for cash and land.

The Gordons began to farm in Stirling, Alberta. Repeated weather disasters put the family into debt. They moved with their sons to a nice house in the sugar-refining town of Raymond, Alberta, but had no funds to furnish and decorate it. James became a surveyor of western Canada, leaving his home for months at a time. Two daughters, Hortense and Jean Vernon (my mother), both musically talented, were born to them in Canada. The oldest son, Kenneth, quit school after not making the basketball team. He refused to go back. The second son, Henry Fairfax, was accused of a minor theft and expelled. He was later exonerated, but in the meantime, he had joined the marines and spent several years in the Philippine Islands. After twelve years of failed hopes, the Gordons retreated to Salt Lake City. Things were no better there. Eventually, the parents followed Hortense and her husband westward to Southern California. James contracted diabetes and was hospitalized. He died in 1940. Pansy, who had found meaning in her life by studying and teaching genealogy in Salt Lake, continued to do that work. Her daughters supported and cared for her until her death at age 100 in 1966.

These four people, from four different countries, were gathered up in the Mormon gospel net. Emma was born into it. James was born after his

parents emigrated to Utah. Margaret and Emile were genuine emigrating converts. They had been intrigued by missionary preaching or the Book of Mormon that the missionaries claimed was the story of Jesus Christ and his people in America, translated by Joseph Smith with the help of an angel. Or they were so dissatisfied with their lives that they were willing to risk their lot in the West. Having made that commitment, they gathered to Utah to live with the Latter-day Saints. They gave up families, friends, and nationalities. They began life anew. All remained loyal to their new faith. None ever returned to their native homes. They met, by twos, in Utah. Without their conversion to this new church, they would never have met at all.

My parents, Serge Lauper and Jean Gordon, met in Los Angeles, indirectly through the Church. My mother knew my father's brother, Ivan, who mentioned that he had a brother on a church mission in Florida who would soon be back in Los Angeles. Mother was then working at the May Company in the fabric department. One day in the store she saw a young man who looked like Ivan demonstrating vacuum cleaners. She watched him for a while, then said, "You sound just like a Mormon Elder," before stepping away. Serge was unsuccessful at finding her in the store. She said that he had not tried hard enough. The two met at church and began to date. They considered marriage, and he carried a wedding ring in his pocket for six months, but as she said, she was twenty-three, "stubborn and short-tempered," and he was twenty-six, "stubborn and short-tempered," and they were frequently on the outs.

After more than a year, Serge, who had gotten a promising job with the Charles R. Hadley Company, was about to leave for Oregon to work as a traveling salesman. My mother invited him to dinner the night before he left. At dinner, Jean's mother asked if they planned to marry before Serge left. They had had no such intention, but they looked at each other and nodded, and then tried to plan a last-minute wedding.

It was general conference time in Salt Lake City and all the church officials were out of town. Serge and Jean finally found a church official available many miles away and were married about ten at night. The counselor's wife sang "O Promise Me," a song my father hated ever after. My mother wept through the ceremony and said she felt rather silly. Serge's siblings, with whom he had been living, had been told never to mention the name of Jean Gordon again. They were more than surprised to see her emerge from Serge's bedroom the next morning and to be introduced as his wife. Serge left town that morning, and Jean did not join him for four months.

When she finally went north to meet him, he seemed like a stranger. But, as she said, "before long we were having a very happy time. He had a nice little new dark red Ford and immediately taught me to drive it. He was so good to me. We had all of our disagreements before our marriage and got along beautifully after."

They traveled the Oregon territory together for some time and then, because my Grandmother Gordon needed some financial help to attend a genealogical training session in Salt Lake, my mother settled in Portland and got a job in a department store. When they were ready to settle down, Serge asked for a new territory, and they moved to Oakland, California. My father became the bishop of a Mormon congregation. My mother became active in church musical circles, singing solos and organizing and conducting choral groups. Their first child, a daughter named Georgia Kathryn, was born in Oakland. Mother noted that she had never been one to hold other peoples' babies and wondered whether she would like the particular baby she expected, but when she first saw her little Georgia, "it was as if I had stepped out into a beautiful meadow after spending my life in a small dark closet. I wept with joy. I was quite overcome with the perfection of this exquisite child, and then quite suddenly I knew why I was born. It was to be a mother." It was an apt sentiment. She was a wonderful mother.

Serge and Jean Lauper, at the time of their marriage in 1929.

That's a good story, almost better than being a princess left on the steps. And while my forebears came from four different countries, they came from a relatively small and cohesive area, Northern Europe and the British Isles. They were quite a bit alike, fair-complected and blue-eyed. Their Mormonness, grafted onto their old identities, made them a similar lot. I married someone with a like background, English and German. I felt that I had a good strong handle on who I was and where I came from.

In the Beginning

But fate has strange surprises for us. One came for me several years ago. With this long family and church interest in genealogy, I was chairing a genealogical program in New York City. Because I was working with a group in Harlem, it was an African American genealogical event. I had engaged a Black geneticist, Dr. Rick Kittles, a medical researcher at Ohio State University, to speak to the group. Kittles, a pioneer in collecting and reading DNA evidence, wanted a Harlem DNA sample. He brought his team of technicians and set up a lab in our church building. His people took DNA samples from most of the four hundred people present at the event. I enthusiastically joined in on this testing opportunity, and along with the others, swabbed the inside of my cheek for about thirty seconds. The materials were gathered, and several months later we all received results in the mail. I worked at deciphering the report, the graphs, and the model. When I finally had it all figured out, there was the startling conclusion: according to the report, I was ten percent, more or less, sub-Saharan African! This was a result of which I had never ever even dreamed.

Ten percent could be almost half a grandparent, about a full great grandparent, or pieces of several ancestors further back. What could this mean? Strange misalliances: someone's mixed background? But where, when, by whom? Family members said that it was an obvious error. My sister, the only other family member to have DNA testing, assured me that there was no such finding on her DNA report. But the researchers were careful with their evidence. They were scientists, after all. There must be something to it. The accepted error range was twenty percent which could certainly diminish or even eliminate the African strain. But whence could have come this genealogical line? I thought I knew a lot about my ancestors, but maybe I was wrong. Ancestors stretch far back in time. I do have this curly hair.

–2–
Childhood

My husband, Richard, says that he remembers walking for the first time. He was only a year old and his family, overjoyed at the achievement, made much of the incident. I don't remember anything that early. My first vivid memory is of standing on the landing of the wide wooden stairway in the Oakland, California, house, where my father's mother, Emma Wissing Lauper, and her five unmarried children lived. I was three years old. There was a heavily carved newel post with indentations that felt comforting to my cheek and fingers, and I stood there, fitting myself into the carvings.

This house was generally a very happy place to be. My older sister Georgia and I liked to visit there. On this big landing, a window looked out at a tree where nesting robins raised their little birdies. We played with the big tortoise that lived under the stove. We explored our aunts' sewing box, spilling out the pins and picking them up with a big magnet. We sorted the buttons in the button jar. Our merry uncles and aunts teased and played with us on frequent visits.

But on this different day, I was sad, forlorn, standing alone on the landing. What had happened? Something so primal and threatening, something so life changing, something that so disrupted the pleasant world I lived in, that I remembered this moment above all others. What had happened? My little sister had been born.

All that large household was too busy to play with me. They were at the hospital or somewhere else, and I was abandoned. Of course, I was happy to have another sister. But I also understood that life as I knew it would never return. I had lost my position as the pampered baby. Little blond Dixie Pauline with her sassy ways became the "sunshine" of our family. My privileged days were over.

My father had been a traveling salesman and my mother had traveled the cities and towns of Oregon with him. But when they realized that they would become parents, he asked for a settled territory and they moved to Oakland, California. We three little girls were born there. When he was transferred to San Francisco, we lived in a rented house. I have four memories of life there.

Childhood

In the first, I was asleep in my crib in the bedroom when a strange man quietly entered. I could vaguely see him by the glow of my night light. He stood silently and looked at me for a while, and then departed. This was the only time I ever saw my maternal grandfather, James Frater Gordon. And I didn't know who that visitor was until years later when I described the scene to my mother and asked who that visitor had been. My grandfather, who died soon after, was a ghost in my young life.

Then there was the giraffe under the bed. The double bed in my room was usually empty. That night I woke in the dark of my crib, and by the pale light from the window, I could see the giraffe under the bed. He was lying on his side. There was his long, spotted neck along the foot of the bed, his little horns close to me, with his large body spread flat and his long legs sticking out on the side. I knew that it was unlikely for a giraffe to be in my bedroom, particularly under the bed, so I looked very carefully. Could that actually be a giraffe? Yes, it was a giraffe. So I called my mother. She came in, listened to my story, and turned on the lights. The giraffe had disappeared, gone away while we had been talking. When the lights were turned off, he was still gone. But he had been there before.

I spent a lot of time in that crib. My mother wrote a poem about it when I was two. She had nicknamed me Toddy after a rough and tumble little boy in *Helen's Babies*, a favorite book of hers.

"Soliloquy"
(Written November 1936 to Toddy)

You know, it seems a funny thing—
When Mother puts me down to nap
And tucks me in so nice and smooth
And leaves me quietly alone,
I get right up and throw my quilt
Upon the floor, and shake my bed—
And make some wet marks on the pane,
And watch the clouds and birds fly by.
And after while I put my head
Down at the foot, it's fun, you know,
And wonder what there'll be for lunch—
Then presently I wake right up,
And I'm tucked in so smooth and nice,
My head is in the proper place—
It seems a funny thing to me!

—Jean Gordon Lauper

Some Lauper women, left to right, Emma (Grandmother), Jean (Mother), Claudia with characteristic squint and Georgia (daughters).

Childhood

Another memory from that house is of a dress and coat my mother made for me. She was a marvelous seamstress, imaginative and skillful. She sewed us many outfits, and I think I wore this one to see the Disney movie *Snow White and the Seven Dwarfs*. The dress was of pink taffeta with puffed sleeves and a full skirt, the fabric printed with tiny wooden dolls in dresses of various colors. Some dolls wore purple, and my mother had matched the color with a lavender coat lined with the pink printed taffeta: an ensemble fit for a princess! And there were purple buttons with indentations fitting my little fingers. I've never had an outfit I liked better.

Then there was the bad experience in that rented house. We scribbled on the walls with crayons. My mother, dismayed at the discovery, scrubbed the offensive marks off, and tried to fill in the design with watercolors. I remember the loud fury of the landlord when he visited his property and discovered our desecration. His anger was matched by my father's, and he passed it on to us. We were properly cowed. But that terrible experience led directly to a new house for our family, one my father had built for us, a few blocks away. Bad things often turn out well.

What else can be said of that little girl's early years? She regularly ate the icing off her mother's beautifully decorated cakes. Once, her exasperated mother sent her to her room, an unusual punishment. Her father coaxed the mother to let her out, saying that the little girl wouldn't do it again. "Well, I don't know whether I will or not," the little girl said, and she did it many other times.

Another time she refused an ice cream cone because it "not got nuts." She had wanted pistachio. She was proud of a pair of shoes with fringed flaps in front like golf shoes. The shoes made a satisfactory slap with each step. She had a favorite blanket with a shabby, frayed satin binding. She called this her "fisker blanket" and rubbed her face with it. She was heard to mutter, "Just like Daddy's fiskers." This is the little girl who poetically pointed out "the little pansies" kneeling by the fence.

She loved cats but did not treat them well. She remains ashamed of her treatment of Dodo and Goody, the family's two kittens. When she was six, doing away with back yard snails with a little spray can of poison, she sprayed Goody to rid her of fleas. Goody licked off the poisonous spray and was soon lying all but dead in the garden. Mother quickly took her to the vet who fixed her up.

Another time the little girl put the kittens under a big packing box and forgot them. The children hunted for the kittens for a couple of days in vain before the little girl remembered to look under the box on the

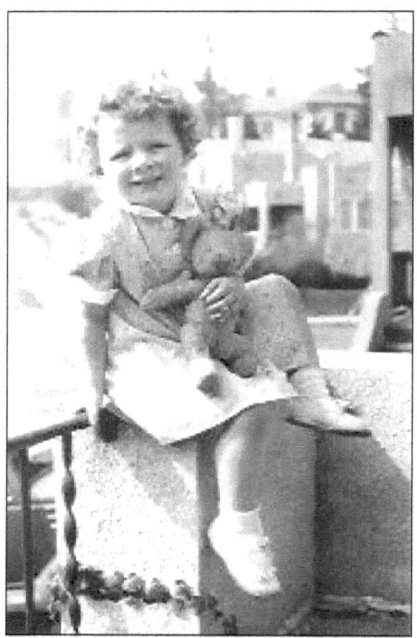

Claudia, about 3, squinting again.

lawn. The kittens survived, but many other little creatures—toads, frogs, fish, turtles, and lizards—died under her hand, ignored or mistreated. She is so sorry.

What kind of a person was foretold from these scrappy memories of herself and of others who knew her? She liked modest sensuous pleasures. Her busy parents were fond of her, but they had other things to do. She took particular pleasure in beautiful clothes and little animals. She lived a secret and imaginative life.

I remember my family as middle class and upwardly mobile. My mother's mother's family had had some long-ago pretensions to gentility. My grandparents, however, were immigrants with the problems and marginal incomes that came with settling in a new country.

Their children rose above that. My father, Serge Lauper, was a particularly hard worker, and he refused to settle for life on the farm. He continued to hunt for opportunities until he found a secure salesman's job with which he earned a good income. While he was tight and unwilling to spend money casually, he provided a very safe and secure environment for his family. We never knew hunger or fear with our strong provider. My sisters and I, children of the Great Depression, had a pleasant and secure childhood. My father was the person in his family where the buck stopped. He had no help from others. Although he did well financially, and particularly so with his limited education, he was pained to see money spent and wasted in any way.

Along with his difficult job as a salesman, always selling himself, always cheerful and hearty when he did not feel that way, my father had heavy responsibilities in the Church. When I was born, he was the bishop, the leader of our Latter-day Saint congregation. He always held a position that was the equivalent of another working job. He was wise, measured, able, and much respected as a church worker. He was a somewhat stern and distant father, easily understood from his responsibilities. I tried to

stay out of his way when he was in a black mood, which happened more often than when he was a sunny daddy. I deeply regretted raising his anger, which I did on several occasions. He would tell me to go find a stick of a certain length and circumference so that he could beat me as I deserved. What a sorry thing to have to do. When I came back with the stick, he sometimes forgot to carry through. Sometimes he didn't.

One time at church when I was an infant, mother had handed me to a friend to hold while she led the singing. My father came upon the group and congratulated the woman on having such a good-looking baby—me! The woman immediately announced that Dad was working so hard that he hadn't even recognized his own child. He was working too hard. He did work too hard. He carried many burdens. I'm not sure that he ever paid much attention to us when we were young or for that matter, when we were older.

My mother compensated a great deal. She was a wonderful person full of fun with many, many talents. She enjoyed a joke, was interested in people, and loved to set out on an impromptu adventure. She felt my father's wrath more than we did, but she had learned not to provoke it or even notice it. She never fought with him.

We four girls were a bunch of little curly-headed smarties. Georgia wore glasses. I had a lumpy little potato face. Paulie had blond hair. Bonnie, who came much later, was everyone's little dolly. We were not a gorgeous bunch, but we generally looked pretty good due to the beautiful clothes that our mother crafted for us. We girls did squabble more than we should have.

From the time I was three or four, we lived in a comfortable three-bedroom house in San Francisco's Sunset District. After the angry incident with our landlord, my father vowed that we would soon have our own house. And the house, where our family lived for fifty years, soon began to take shape. We married from that house. My mother suffered a fatal stroke there. My father succumbed to congestive heart failure there. We lived and died in that house.

We had almost no furniture until the house was paid for. We had an empty dining room and a living room with an old blue sofa and a worn upright piano. The original price for the house was $7,000 at 4% interest. My thrifty dad doubled and tripled the monthly payments, retiring the mortgage in nine years instead of twenty-five. He paid about $10,000, including principle and all interest. Then my mother, with her great taste and skill, painted, sewed, decorated, and bought furniture until the house

Georgia and Claudia Lauper, c. 1936.

looked like a magazine spread, a place we were all proud of.

My sister Paulie and I shared the back bedroom, which looked out the western windows toward the Pacific Ocean. We could see the distant water, twenty-four blocks away, merging into the horizon. I remember going downtown with my mother to choose basic decor. We chose some pretty wallpaper with sailing boats. We chose a white ceiling light fixture with three gold stars for the sky. For the floor we chose a by-the-yard linoleum, blue mottled with white, like the waves breaking just beyond the shore. A white stripe inlaid a foot from the wall edge gave the room a military smartness. I spent a lot of time on the bed doing my homework. I never had a desk until I went to college. Once when I was ten or eleven, I thought the bed was too close to the wall. I pushed against the back window with my foot, eventually pushing my foot right through the window glass. I still have the scar on my ankle.

Another time, lying on my parents' bed, I wondered what would happen if I poured nail polish remover on the light bulb in the lamp at the bedside. The bulb exploded, depositing a blob of molten glass on one of my knuckles. I still have that scar, too.

My parents despaired of my reckless experiments. On one memorable day when I was young, I opened a new box of my mother's face powder to sniff that good smell, dumping it all on a dark rug. I filled my little pail with some gravel and poured it into the toilet to see what would happen. This was the same day I got my neck stuck in a picket fence. I also ran so hard into the piano bench where the wood edge was just the height of my lip that blood was plentiful.

To better steer my imaginative behavior, I was given a chemistry set with little test tubes and containers of chemicals. Most experiments required more items than were available in my little set, but I did the ones I could do over and over, thinking that I might someday be a chemist. I also imagined being a farmer's wife and living in sweet-smelling clover with

gentle animals, or being a naturalist, inspired by my frequent trips to the natural history museum. I loved birds, insects, reptiles, and amphibians and still do.

My mother encouraged us to do cultural and artistic things. She coached us in little church presentations, took us to concerts and to museums. She said that a woman in Salt Lake had given her many musical opportunities in her youth, bringing her such pleasure, that she could hardly keep herself from conceiving new projects for people in the Church or at school. She got very little encouragement from anybody: she was a complete self-starter.

She was not the only one engaged in enlarging our cultural life. We had regular instruction in speech, drama, and dancing at church. Our LDS education helped prepare us for life. I think that everything I ever needed to know I learned at church, and I still call on the things I learned there.

Several days before my oldest sister, Georgia, was born in 1931, my grandmother, my mother's mother, Margaret Schutt Gordon, came to visit. On that Sunday, my mother, well along toward delivery, stayed home to rest while my father and grandmother went off to church. When they came home, my mother asked if anything interesting had happened. My grandmother noted that the ward had a new bishop. When my mother asked who the new bishop was, my grandmother hooked her thumb toward my father and said, "Him." So it was that my father became a bishop in Oakland. After we moved to San Francisco, he became the bishop of another congregation. He was only released from that responsibility to go into the stake presidency, the group overseeing the bishops, then to become the stake president, supervising multiple congregations, and then to become patriarch, to give prophetic blessings, and then to become a temple sealer, to bind families together through temple rituals—all of them positions of honor and responsibility.

My father was first asked to be bishop at the last minute without any nice little visit at home with his wife. He had no time to think about the call, but he would have taken on the responsibility anyway. He was not a pious person, but largely through the teachings of his pious mother and the example of his mission president Charles A. Callis, he was devoted to the Church and willing to take on any responsibility that the leaders required of him. He had been a young man in California when he received a surprise call to go on a two-year mission for the Church, to be sent out to proselytize for The Church of Jesus Christ of Latter-day Saints. He had been sending money home to his mother and she had turned it all over to the Church as

his tithing, although the recommended donation was ten percent. He did not want to go on a mission, but he realized that nothing he could ever do for his mother would be valued if he did not serve. His perceptive mission president saw his talents, maturity, and resentment, and he used those traits to inspire my father toward devoted church work. My father served an honorable mission and was ever after strongly devoted to the Church.

I was a lucky person for having grown up Mormon in a secular world. I have long thought that people who live simultaneously in two different cultures have a perspective that the one-world people lack. They can judge one world by another. They can escape from one to another. They can take their experiences and strengths from one place and apply them to another place. I am thankful for my Mormon identity.

I grew up in San Francisco, just across the Bay from Oakland where I was born. Yes, we lived right in the city, as I am frequently asked. This was the city of light, Baghdad by the Bay, a beacon of civilization on the west coast, a city of unquestioned culture, charm, and beauty. This city was ethnic and diverse, with large groups of Italians, Chinese, Japanese, Russians, African Americans, and even gays, even then. Catholic by majority, the city featured representatives of every other religion imaginable, even some early new-age types. There was certainly room for an invisible little band of Mormons.

My family lived in the greater world. My father sold office supplies, primarily custom business forms, in a business where he was the only Mormon. My mother, active in neighborhood, cultural, and school circles, was the only Mormon among many acquaintances. My sisters and I were generally the only Mormons in our school classes. We did all the things our school friends did. Yet all six of us lived primarily in a Mormon world.

My father was always my ecclesiastical leader. Mormonism offers no equivalent positions for women, but in my family's case, my mother had a great deal of secondary power while my father was the bishop. He ran the administrative aspects of our Sunset Ward congregation, and she, under his protection, was a strong and imaginative cultural leader. She operated on a budget of diluted power and charm, enlisting local members in her projects. Together they made our little congregation a model Mormon ward in the alien Catholic city of San Francisco. Our congregation, mostly lower middle-class working people, contained a polyglot group of professional people from Utah, some immigrants direct from Europe, Asia, and the Pacific Islands, graduate students and their families, military service people from Treasure Island, and some converts. The ones we knew were

Childhood

devoted Mormons because anyone disaffected could easily disappear into the greater city. We had a good group of disparate but congenial people.

Our San Francisco congregation first met in a Masonic Hall. Our family arrived early to meetings to tidy up and to hang a little felt banner which said "Sunset Ward" on the podium, our symbol of identity and authority. The banner showed the setting of a stylized sun, a gold semi-circle sewed to a dark blue background with gold pie-shaped rays emanating from it. The sun was setting somewhere, never disappearing.

While attending church in that little rented hall, I first spoke to a congregation, reciting four-lined verses prior to sacrament services. These Sacrament Gems were often taken from hymn texts. One, I remember, went like this.

> I come to Thee all penitent.
> I feel Thy love for me.
> O Savior, in this Sacrament,
> I do remember Thee.

I remember my early performance in a Christmas program. My mother had taught me a Christmas lullaby, and I sang it to my rubber dolly wrapped up in a dish towel. I knew all the words and sang clearly, without fear or nervousness. I was an honored member of that community, even though I was very young. We all took turns being up in front. I rocked my dolly and sang,

> O, hush thee my baby, a story I'll tell.
> How little Lord Jesus on earth came to dwell.
> How in a far country, way over the sea,
> Was born a wee baby, a dear one like thee.

I was like Mary, the mother of Jesus.

My sisters and I presented hundreds of talks and were involved in many musical presentations, all of which we were happy to do. All of these were rewarded with kindness and compliments from our brothers and sisters in the congregation. We were wrapped in the warm ward cocoon. We learned to speak in public with the continued practice of Sacrament Gems, short talks, and the occasional longer, more serious talk in our evening sacrament meeting. We sang in choruses and operettas and did lots of trios and quartets, as well as led the music and accompanied the singing in church meetings. We had leading roles in a long succession of plays. Because I took elocution lessons, I also did dramatic readings and

recited poetry. We had a remarkable Mormon upbringing for living in a city where LDS membership was so small.

As volunteers, we felt the pleasure of participation, of being part of things. Fellow members warmly congratulated us on our little bits. We have always been comfortable speaking and performing in public and organizing things. How grateful I am for having been a little Mormon.

We attended church at the Masonic Hall for several years, taking the streetcar or driving our old gray Ford. During this time of the Great Depression under which the nation staggered, my father was told to build a new chapel for our congregation. Important people wanted an impressive flagship chapel in that important city, and the land was purchased.

My father didn't know anything about building a chapel. He had been a poor farm boy and then a salesman. Our faithful congregation was not well off. My father was impatient, easily frustrated, and quick to anger. Building the chapel was a terrible burden.

He asked Claude T. Lindsay, a building contractor, to be the first counselor in his bishopric. Lindsay knew the things my father did not. His major work was building the characteristic San Francisco townhouses that march over the hills on the west side of the city. He was the one who had suggested that my father have a house built and had noted an available lot just two and a half blocks from the place where the new church would rise. He made the lot and the house he would build on it available on attractive terms, and when I was four, the Lauper family moved into that new house.

Several years later, just a few short blocks from my house, our beautiful Sunset Ward chapel rose. I spent my early formative years active in all the goings on in that handsome building. My sisters and I had the dual identity of being members of a strange, tiny, once-outlawed sect, even as we were also, through the connection with our parents, the undisputed first daughters of the Sunset Ward realm. We had a great upbringing, even as we took it for granted.

I think it is significant that our family had only daughters—four of them. If there had been boys, we might have felt some differences. As it was, we girls and our mother formed a comfortable unit, occasionally visited by our father who was very busy first with business and second with the Church. He worked hard and we tried not to bother him and to be good when he came around. He had many responsibilities and was easily angered.

Childhood

On one memorable occasion, our mother had persuaded him to take three of us, then three, six, and nine, to an amusement park on a Sunday afternoon. He grudgingly agreed to take us. We visited our favorite rides and booths. He allowed my sisters to go on one last ride. I stayed with him. They were slow to return, and as he saw the hour grow later, he grew increasingly angry. Not concerned—angry. Finally, he and I got into the car and drove to the church, leaving them, wherever they were, behind. My mother, ready to lead the music for the sacrament meeting, asked him where the girls were. He said that they had refused to return and that he had to get back to start the meeting. She handed him the baton and walked out to find the girls.

This was a more innocent time, and the distance from the park to the church was only twenty-six short blocks and four long ones. My nine-year-old sister could probably have found her way home. My mother, driving up and down the streets, eventually found two tired little girls trudging home after they figured out that they had been left behind. All was well. But it was a powerful lesson to me to see that some things were more important than others for my father, and that little girls were not high on the list.

When I was still pre-adolescent, I remember hearing that the programs for boys were changing. There was official church concern that too many boys were leaving the Church. We certainly saw many in our ward lured away by city enticements. The Church beefed up the boys' scout and priesthood programs. I asked what was to be done for the girls and was told that the girls were so good that they didn't need anything else. That was probably true. We loved the Church and all the activities and enjoyed the things we did there. Because we were mostly female in our family, I was not then aware of the secondary nature of women in the Church.

I attended hundreds, maybe thousands, of Sunday and weekday services. I certainly sat in on and participated in hundreds of lessons suitable for my age group. I have very little memory of any. I do remember the Primary, the children's organization, where we were encouraged to bring a penny for each of our years to drop into a bank during our birthday weeks. The bank was a model of the Primary Children's Hospital. The pennies of the Primary children supported the treatment of children with polio, then a common and dreaded disease, and the combination of the good work and the singing and marching of our local birthday children have kept that memory alive for years. We sang, as children dropped their pennies into the bank, the familiar "Give Said the Little Stream" and the lively

> Five pennies make a nickel, two nickels make a dime.
> Ten dimes will make a dollar, let's make it shine!
> It's for the crippled children, who cannot walk or run.
> Who have to lie in bed all day and cannot join our fun.
> So, let us be unselfish and bring our pennies here
> To help the crippled children become stronger year by year.
> We'll march along and sing our song and pray that they may be
> A little better every day because of you and me.

I am sure that all former Primary children could join in a marching chorus of that stirring number.

We learned many things at church, many crafts and skills. The Church was and is an unparalleled school. We learned to organize events and to run meetings. We participated in Big Events. We worked at ward dinners and ward fairs. We had hayrides. As a teenager, I organized young people and collected the funds for weeks away at Yosemite National Park. I put together a cruise of the San Francisco Harbor. I've now run lots of Big Events, and my Mormon experience has been invaluable. We had many years of modest instruction in parliamentary procedure. We learned to stick to an agenda and to close on time. We can take church manuals and translate them into entertaining lessons to keep a class going for an hour. We developed skills in dancing, drama, speech, and music. I think of Primary pageants with casts of two hundred young people, singing, dancing, wearing crepe paper costumes. I think of duets, trios, and choruses where we honed our abilities to sing in parts. I think of the weekly record dances we had after our Mutual Improvement Association lessons where everybody learned to dance. I think of the exhibition dances we performed during our regular formal dances. I think of many three-act plays where we trod the boards, reciting memorized lines and projecting our voices. No other young people I knew at school had the cultural opportunities that we did.

Along with opportunity, I learned disillusion. I was shocked—shocked—to learn that all my brothers and sisters in the gospel were not completely obedient to all teachings. I took the teachings seriously, which meant, as a simple example, that I closed my eyes during prayers. In those old days, we sat in class groups during the opening exercises of Sunday School, and I was shocked—shocked—to hear the boys and girls in one of my classes laughing and talking during the opening prayer. They poked each other and snickered, and I was eventually persuaded to open my

screwed-up eyes. I considered them coarse and childish. But I soon found that others pushed back against the rules.

One day I discovered that even my Sunday School teacher, whom I was sitting next to, was reviewing her lesson during the opening prayer. Now how did I discover that? So, I decided to check during the sacrament prayers to see if she continued her reviewing. She did. I was very sad to see that even people in authority broke rules. As I, unfortunately, did myself.

I also was strongly impressed that we were to take the sacrament bread and water with our right hands. That was difficult for me as I was left-handed. I had to think hard on every occasion which hand was the correct one to use. I decided that the requirement to use the right hand exemplified the left-phobic tradition of the Judeo-Christians, an unfortunate reflection of an unfortunate prejudice. For a while, I used my left hand to show equality for the left-leaning. Surely a loving God would not punish His children for their differences; He had created them, after all. Either this was a plainly prejudicial imposition of the middle management, or left-handedness was somehow eternal, in which case it also should not be punished.

I began babysitting early. My first regular job was, at the age of nine, to tend the three young daughters of a church family *in their car* while the parents were in an evening service at church. When I was about ten, I was tending the young daughter of the teacher of the Primary class at church. The parents intended to be very late and suggested that I sleep over. I was not asleep when they returned, but I pretended to be as the man of the family—a military officer—entered and engaged in the only sexually abusive act of my young life, whispering my name and running his hands over me under my pajamas. I rolled over and away as soon as I could, still feigning sleep. I continued to babysit for the family, always staying up rather than sleeping over. When I finally told my family of the experience as a middle-aged woman, they were, of course, surprised and alarmed. It was certainly a modest attack, but I had been completely unable to speak of it, although I have thought of it almost every day ever since.

As I approached my teen years, I sometimes found going to church twice each Sunday, and on many other days, a burden. I wanted to stay home sick. I wanted to hang out in the ladies' room during class. I wanted to get dressed up and then take off with one boyfriend or another for a ride to the beach or the park, and I sometimes did. But I usually did go. My mother, I later realized, provided bribes. After church, we often headed four blocks south to Irving Street to an ice cream store for a hand-packed

Serge and Jean Lauper, c. 1955.

quart of Heavenly Hash or Green Goddess ice cream. Or we would go to an Italian delicatessen where we chose half loaves of sourdough bread spread with cheese, butter, and herbs. A nearby high-class bakery had pastries filled with raspberry, apple, prune, custard, and almond paste fillings. And we also visited See's Candies for a box or a little bag of our favorite pieces of chocolate. A visit to one of these places provided a happy after-church occasion for our family. My mother also often whipped up a batch of fudge.

Another church treat was visiting other LDS churches and congregations. Off we went in our beautiful clothes, our mother chic in handsome dresses and hats. We would file in with small smiles and sit in the congregation, and our father would give an excellent address. He was much admired by the Saints for his probity and wisdom, and we basked in his authority.

Readers may notice with dismay little reference to the scriptures or the restored Gospel. We heard the lessons of the Church and accepted them, but we did little serious gospel study. We grew up before seminary classes were organized. We might look up scriptural references for a talk, but we did no gospel study. We did not doubt the Church's teachings, having nothing to compare them with or question them by. The only criticism I remember is when a young friend asked how so few people could be right and all the others wrong. A good question.

I lived my early life encapsulated in Mormonism. It was the foundation, the walls of my world. I also lived in an alternate universe, in city life and at school, and I lived there by those outside rules, while maintaining adherence to the Mormon markers of the Word of Wisdom—refraining from alcohol, tobacco, coffee and tea—and not swearing. I valued my tradition.

My father, though often gruff, once said later in his life, that the most important things that occurred in his life were the births and growth of his daughters "into wonderful wives and mothers, as well as loving daugh-

ters." He said that the highlight of his life was when Bonnie, the youngest of the four Lauper girls, was sealed—that is, married—in the Oakland Temple to Glade Goodliffe, and all the daughters and their husbands were in the temple at the same time. "It was the pinnacle of my life and the most marvelous of all occasions that they all could be there." Whenever he had the chance, he was proud to introduce his sons-in-law to others.

Many of the riches of my early Mormon experience have been sliced away in the name of unity and simplicity. The new globalism of Mormonism has required many changes. I still value the community of Saints and the opportunity to help build the kingdom. The Church is a good thing, an arena for personal activity. It is always interesting. There are so many opportunities to do things. The Saints are wonderful people. The rich culture of the Church continues. I'm glad to be part of a still thriving community. But I prefer the active church of my youth.

–3–
My World—the Neighborhood

San Francisco's Sunset District was my primary place. Originally a sandy wasteland, it was one of the last of the city's developed areas. Sunset is a largely residential district of narrow two-story, wood-frame houses with decorative stucco facades. Construction began during the 1920s, gained momentum through the 30s and 40s, and filled the district during the 50s.

In the tidy, gridded Sunset District, houses march up and down the navigable hills, roughly enclosed by Golden Gate Park on the north, by the Pacific Ocean shore on the west, by the zoo and Sigmund Stern Grove on the south, and land too hilly to be gridded on the east. This neighborhood, where I lived from early memory until I went to college, and where my family lived on for many more years, combines named and numbered streets for easy location. The short, numbered avenues run north to south from one to forty-eight, except that Arguello is the first, followed by 2nd Avenue, and that 13th Avenue is chastely named Funston. My real neighborhood began with 19th Avenue, a major thoroughfare and a California highway running from the airport all the way to the Golden Gate Bridge and across to Marin County. We could hike up to 19th and catch the bus that took us to the bridge and then walk across it.

The longer east-to-west streets are named alphabetically for Spanish explorers and significant early Californians that are largely forgotten today. This alphabet starts in the north "across the Park" in the Richmond District, with Anza, Balboa, and Cabrillo, but after crossing the park south, begins out of order with Lincoln Way, another major street, which takes a traveler straight west along the park to the wide sand strip known as Ocean Beach and the setting sun. From Lincoln Way south, we pick up Irving, Judah, Kirkham, Lawton, Moraga, Noriega, Ortega, Pacheco, Quintera, Rivera, Santiago, and Taraval, which pretty much ended my neighborhood but was followed by Ulloa, Vicente, Wawona, and even Yorba Streets, the group ending at Sloat Boulevard.

I lived at 1731 24th Avenue, just half of the avenues to the beach. The 1700 number placed the house between Moraga and Noriega Streets. Our house had three bedrooms, a bath and a half, with a living room, dining room, large kitchen, study, and interior patio open to the skies. The lots

My World—the Neighborhood

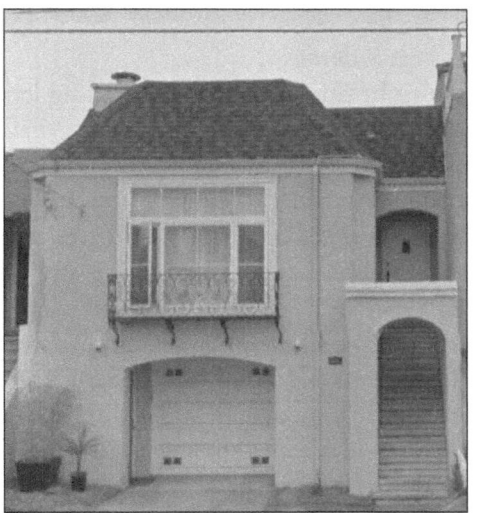

1731 24th Avenue.

were just 25 by 125 feet, but the houses, immediately adjacent to each other, were freestanding. People who took the trouble to look could see narrow cracks of light between them. The fronts of these houses were all different, each vaguely evoking some architectural style, being slightly Mediterranean or Southwestern or modern, painted white or pastel colors. Ours, I thought, was vaguely French with long formal windows on the front, a metal balcony painted white—mostly decorative, although we spent a lot of time there—with a blue roof extending up at an angle and suggesting a Mansard style.

These long, thin houses had no windows on the sides, but the rooms had windows bordering open patios or air shafts or skylights. Covered stairways mounted to the main living quarters on one side of each house, most of which sat firmly over garages, with cement driveways flanked by the modest landscaping of tidy lawn squares, hedges, decorative fences, geraniums and hydrangeas—perennials in that mild, moist climate. These were practical city houses, spacious, private, and surprisingly light and airy.

At the top of those fourteen steep, black- and white-flecked steps, the front door opened on a small front hall with a coat closet and a niche for doorbell chimes. To the left was a spacious, even elegant, living room running the width of the house. In one far corner was a fireplace with a stucco breast, and the dining room opened to the right of that through a large decorative arch. If not turning left into the living room, a person could go from the front hall directly ahead through my father's study, a green, book-lined room with a large desk and several chairs. This study was a status symbol in our not-very-intellectual neighborhood. All those books! Beyond the study, a visitor entered a hallway leading to the bedrooms, but before doing that, the kitchen, again going the width of the house, took off to the left. There my mother created her wonderful meals. These four front rooms surrounded the small open-aired and cement-floored patio providing interior windows and French doors to our dining room. There

was running water in the patio, and we kept some plants there. My frogs and lizards also lived there until their early demises.

The hallway continued down the right side of the house, turning left and heading straight to the bathroom. Two bedrooms opened off the hall to the right before reaching the bathroom. A third bedroom, added to the basic plan and built on stilts, could be reached through either of the other bedrooms. I spent my early years in that back bedroom. Later, my two younger sisters took over the back bedroom, and I moved forward to room with my oldest sister, Georgia.

My mother painted three walls of our pretty room green and papered the other with an ivy and lattice pattern. I pasted small bird stickers onto the ivy branches. The small birds did not immediately stand out, and I enjoyed rediscovering them each day. My bed was next to a window a story above the ground, but a fence between us and our neighbors provided a platform from which our adventurous cat, Gypsy Rondo, would leap up and climb to my windowsill. Many pet cats ran free in those days. In the late night or early morning, Gypsy would yowl out her loud demand to raise the window so she could come home. I would let her in and usher her to the basement stairs. She could not stay upstairs. My father hated cats.

The stairway to the downstairs was off the hallway, just past my father's study. Downstairs there was plenty of room for a cat to hide from my father. Two cars could park inside. Our washing machine was there, fed by the laundry chute from my parents' closet which dumped the dirty clothes into a big box. We had a rough playroom with small furniture and a blackboard. My father had a work bench and saved lots of things that might one day prove useful. There was a bathroom near the wash tubs, big wooden boxes to play with, lots of canned and bottled food for future use, boxes of apples and oranges to help ourselves to, and one memorable time, after visiting a ship with a friend whose father was the captain, a stalk of bananas four feet long which my father nailed up by the stairs. We had many good times there, but also bad ones, as we were required to "clean the basement" every holiday.

My mother rejoiced that our house provided both privacy and light, and good sound insulation, too, as the closely adjacent houses had no common walls. Wooden fences of various kinds, mostly about five feet tall, divided the backyards from each other. When each house was built, there was some arrangement of cement squares laid out in the backyard to contrast with the dirt squares. In our yard we had cement under the back bedroom and a cement walk in a U-shape that divided the lawn. We

had two relatively good-sized squares of lawn in the middle and back and shrubs and flowers on all the sides. During World War II, my father dug up the lawn squares and planted a "Victory Garden" of vegetables. We did harvest a few things, mostly Swiss chard. My father also hung a swing for us on the wood edge below the third bedroom.

These would have been pleasant enough play spaces, but for the heavy, cold fogs that rolled in from the ocean. Muffled foghorns steadily played their mournful two notes. No one ate meals outside as it was just too cold and wet, especially in the summer. Often the clothes did not dry on the line. If ever a place benefited from electric dryers—appliances we did not have until the 60s—it was Sunset District. My sister Georgia memorialized San Francisco in this prize-winning grade-school lyric displayed in our school's lobby.

> On seven hills our city lies
> With dark blue bays and foggy skies
> The hills strapped down with streets of grey
> Too cold to let the children play.

Yet, in that damp backyard, on the cement under the back bedroom, my father created a playhouse for me—a little wooden house with a single room, maybe six by eight feet, with a peaked roof, glass window, and wooden floor. The inside walls were finished with pine boards. I painted the pine knots different colors and called it the Polka Dot House. Our visiting Aunt Jane painted a dot design on the blue front door, and I added a wooden woodpecker for a door knocker.

It was a miracle that Dad ever built that house. I had been genuinely thrilled by a little shack a friend's father had thrown together for her out on the sand dunes near the beach, and I had talked about it with enthusiasm, but I would never have asked for such a thing myself. It would require much effort and expensive materials. The window itself cost $25. Dad built the house during World War II when the products he sold were rationed and he had more spare time than he liked. I loved my little house, and I can still hardly believe that he built it.

As previously stated, our house sat on a rectangular block in a gridded neighborhood. This block between Moraga and Noriega Streets, between 24th and 25th Avenues, was my longtime home. In this conservative, white-collar, middle-class neighborhood, the men mostly went to some business, the women mostly stayed home. In pre–World War II America, the minorities were still ghettoized in other parts of town. No Black or Asian children

lived in our neighborhood. There were some Jews and Italians, and some fairly new immigrants. Sunset was primarily a white district.

I had two male friends my age. Dickie Skidmore, whose skiing family often wore casts, and Bobby Sloane, whose father, a handsome dark-haired bartender, avoided maraschino cherries because he considered them poisonous. Bobby's mother, a fabulously beautiful blond, looked like a movie star. Alice Joyce Duerner and her large family lived across the street. They were members of the Church of the Nazarene which allowed the children no movies and no dancing. We played softball and kick-the-can with the Duerners in the street between our houses on dusky evenings. My best girlfriends, Myra Greenberg and Ruthie Pugh, lived around the corner and we three were in school together for many years.

My father's sisters Viola Johnson and Alice Brown and their families moved into the neighborhood on 37th and 44th Avenues. The six cousins there were younger than we were.

Small shopping districts, which grew up along some of the streets, gave some richness and variety to the long lines of houses. Just up 24th Avenue on Noriega Street could be found a mailbox, Seabright Grocery Store where we used to beg for severed chicken feet to scare people, Mr. Becker's Drug Store at the corner of Noriega and 25th where we would try to read the comic books and movie magazines without buying them, a hardware store, a bakery, and a dime store across the street where we frequently bought sewing findings for mother's projects. They also had oilcloth, cheap toys, thumb tacks, bobby pins, binder paper, and all manner of other items. There was some movement in these stores, and a large, more sophisticated grocery store—the Super X—was installed on the corner of 25th Avenue while Seabright became a martial arts studio. Other businesses that came and went included a bank, a real estate office, a beauty salon, and a service station. That one block of shops met many needs. For years before the service station was built, we had an empty lot on a corner of Noriega and 24th. Here was a touch of wildness, a place to empty the cat's litter box and fill it anew, a place with tough sea grass and other native plants growing wild in the sand with occasional bright spots of Indian paintbrush, lupin, and California poppies. We dug happily in the dirt, coming across toads, lizards, and interesting insects.

Another small group of stores grew up on Lawton Street between 25th and 26th. There could be found another grocery, a drug store, a beauty parlor, a fountain where we got our Cherry Cokes after school, and across the street, Mr. Mercer's shop which featured penny candy. Over him was

a Japanese man who ran a cleaning and tailoring establishment. He disappeared shortly into the war when the Japanese were interned.

A more serious shopping center could be found on Irving Street from 19th Avenue to 24th. Our handsome public library, an original Carnegie model, was at 19th Avenue, along with the Jefferson Elementary School, the Colonial Restaurant—an old hang out—a post office, the imposing Bank of America where we had our accounts, choice candy, ice cream, bakery, and gift shops. I don't remember any clothing stores. Farther east on Irving Street was the Irving Theater, our closest movie house. Here we saw cartoons, serials, newsreels, and double features, coming in at any time and often staying to see the films through a second time. A quarter bought respite from the real world at the Saturday matinee. Irving Street was definitely in reach, although we generally drove to get there.

A block above Irving on Judah Street we could catch the N, our major streetcar. The N ran from the Ferry Building downtown to our beach at 48th Street, from one edge of San Francisco to the other, passing through a long tunnel, going by the San Francisco mint, passing near San Francisco's old Spanish Mission Delores, and stopping downtown on Market Street where we shopped at big stores and visited the elaborate movie palaces. Along the way we could get off at San Francisco's Civic Center, where we found the city hall and the grand memorial twins, the opera house and the veterans building. A ride cost a nickel.

The N also went west to Playland at the Beach with its waterfront novelty attractions. Favorites were the Fun House with its crazy mirrored maze where you really could get lost, the spinning platforms that flung off sitters onto the padded walls, and the three-story-high slide to climb up to for a smooth or a bumpy two-hundred-foot ride down. A larger-than-life mechanized fat lady called Laffing Sal was in a glass case at the front. The motto beneath her read, "Laugh and the world laughs with you. Cry and you get a red nose." Sal's raucous laughter echoed for several blocks. I only braved the huge roller coaster twice in my life. As my comrades screamed with delight, I muttered, "This is the end, the absolute end!" But I survived to ride the large ferris wheel and the little boat in "Laugh in the Dark," and go to the Crazy House where the floors were tilted and water ran uphill.

Just beyond Playland, the blue-gray waters of the Pacific Ocean provided a straight shot to Hawaii or Japan or almost anywhere else. How insistent and majestic those waters were, pierced with a few sharp rocks several hundred feet offshore, home to the barking sea lions. The beach

front belonged to the people, and a person could walk along the cold, wet sands for several miles without being in anyone's backyard. The tide came in and out, leaving a supply of driftwood, seaweed, shells, sand crabs, interesting rocks, and other debris. Sometimes the waves would rush in and, with a powerful undertow, snatch things and people and pull them back out. This once happened to me when I was young. I was just standing on the shore when a powerful wave pulled me off my feet and began to carry me out to sea. An unknown man reached out and grasped my ankle as I floated by. Maybe he saved my life.

An important annex to Playland and the beach was San Francisco's northwest corner, a high place where could be found the Cliff House, the Legion of Honor Museum, and Land's End. The first Cliff House, which was built during the Civil War and later succumbed to flames, was a famed resort frequented by US presidents and wealthy San Francisco families who rode to the beach in their carriages and raced them along the packed sand. In the 1880s, the Cliff House was sold to Adolph Sutro, a very rich man, later the mayor of San Francisco, who built a railroad to bring the general public out to the beach. Sutro rebuilt the Cliff House, which survived the 1906 earthquake, only for it to burn down again. The place went through several more metamorphoses between our visits when we dined on shrimp cocktails and surveyed the extensive gift shop.

Other Sutro enterprises in the vicinity included the scary Sutro Forest, full of moss-covered statues. With the gloomy fog blowing around, and the foghorn for sound, it would have made a great set for a horror movie. Then there was the Sutro Baths, a group of small swimming pools, and in the same complex, the Sutro Ice Rink. These were built on the side of a cliff, and we entered up on road level and descended many stairs down to the wreck of an old hotel, bath house, and pools, encountering museum rooms with mummies, stuffed birds, and other oddities, moldy and dusty and very creepy. The ice rink continued in business longer than the baths, but both are long gone.

Lands' End, a wild and rocky cliff, historically strewn with wrecked ships and given to landslides, was located at the opening of the Golden Gate to San Francisco Bay. Lands' End was between the Cliff House and another place we loved to frequent: The Legion of Honor, a museum built by the French to honor American soldiers who died in World War I. At Lands' End there were hiking trails down to the beach, if we were brave, and back into the woods, if we had dogs, and the best and grandest view of rugged California meeting the ocean. On many a happy occasion, we

watched the ships in convoy pass under the Golden Gate Bridge into the safe refuge of the Bay. Later, on that barren lookout, a memorial to the USS San Francisco, a cruiser that suffered multiple hits and fires at the battle of Guadalcanal in 1942 during World War II, was installed. The warship's bridge, showing its battle-scars, is there for all to see, along with the names of the more than one hundred men who lost their lives in the battle. It stands as a stirring reminder that not all the men come home. Our N streetcar took us to many significant places.

We also had a convenient bus, the 71 or Haight-Noriega, and its relative, the 16, which rode the same route express at rush hours. These buses ran from the beach at Noriega Street east to 22nd Avenue, turned north down to Lincoln Way and on to downtown. The corner where this bus turned was crucial to us girls during our working days. If we left the house punctually, we could catch the bus at its stop at Noriega and 25th. But we often ran late. Should we see the bus passing at the top of the street as we left the house, we knew that we could turn down to Moraga and run like the dickens to catch the bus at Moraga and 22nd Avenue—this after spending extra time trying to look beautiful for the day.

Our elementary school, the Lawton Grammar School, was located on Lawton Street between 30th and 31st Avenues. The school was a long, low, beige stucco block with lots of windows and a big play yard. The year before I entered school, a whole complex for kindergarten children was created at the southeast corner. There were two attractive, light classrooms and a special playground just for little children, walled and raised from the rest of the school yard with a brick floor. We were the first class to play there.

A few blocks beyond the school was another major thoroughfare, 36th Avenue, a handsome boulevard with a wide landscaped strip on each side, heading directly north into the Golden Gate Park. My Brownie and Girl Scout Troop's leader, May Sewall, whom we called Pippet (our leaders all had bird names), lived on 36th Avenue. We frequently used the narrow, landscaped "parks" on 36th for nature study.

We walked through or around a full block of a playground to and from school. The playground was the scene of the frequent replays of "Boys Chase the Girls" when our male class members tormented us, bursting from behind buildings or out of garbage cans, yelling and terrorizing our screaming selves. These events were really scary before we realized that they were actually compliments.

Our other notable school was Abraham Lincoln High School which was straight up the steep hill on 24th Avenue from our house, a nice red-

brick block located between Pacheco and Quintera Streets. From the school high on the hill, we could look north and see our brilliant orange Golden Gate Bridge, if it was not obscured by fog. If only the top towers emerged from the fog, the bridge was particularly handsome. And there were days, especially in September, when the air was clear and the view breathtaking. The view to the west was the restless blue-gray ocean, occasionally dotted by a tiny ship.

This western view was particularly good as a large, low, flat-topped, cement water reservoir along the western side of 24th Avenue provided a wide scope. The northern front of the reservoir, which went sharply downhill, was landscaped with walking paths, well-kept lawns, and shrubs. People walked dogs there, and I did some birdwatching. We rolled or ran down the steep hills. Once I ran, and, attempting to leap a little hedge at the path's edge, caught my toe and fell knees first onto the rocky path. I had to walk the four blocks home, the blood running down my shins and soaking my socks, feeling pretty sorry for myself. I still bear those scars.

But the fenced space behind the reservoir was infinitely more interesting to me because there was the swampy area full of frogs and fish that my friend David Frazier and I explored. The place seemed like an enchanted landscape, sand blown into patterned stripes, small oases of tall dune grasses, little pools and larger ones, stagnant, scum-covered, edged with cattails and bushes. The place seemed pristine and prehistoric. People did not go there. There were some industrial leavings from the construction of the reservoir, but the space was empty of beer cans, plastic bags, and other debris. David and I had to sneak in through a small opening cut in the fence. But once in, the swamp was ours and it extended forever. We knew that if we were lost or broke our legs there, we would never be found. David and I had this enchanted place all to ourselves.

Our neighborhood, bounded on the west by the Pacific Ocean, was bisected by the N streetcar line on Judah, the 19th Avenue highway, and the 36th Avenue parkway. There were plenty of other landmarks as well. To the north were two cultural institutions of major importance. Fleischaker Zoo sat right at the beach as far away as the alphabetical streets extended. That world class-zoo was then accompanied by an Olympic-sized swimming pool filled with salt water from the ocean and by a playground full of swings, slides, and sandboxes. We would come to see the animals when we were children and later in our teens, sneaked in at night to swing.

The other landmark was Sigmund Stern Grove. This thirty-acre estate, deep in a canyon, was donated to the city by Rosalie Meyer Stern in honor

My World—the Neighborhood

of her husband, a nephew of Levi Strauss. The WPA landscaped the area, laying out a large meadow with a stage. We took a winding path downhill from 19th Avenue through eucalyptus trees, examining snails, slugs, and poison oak along the way. Weekly cultural events—operas, symphony performances, ballet programs—have been held there during the summer on Sunday afternoons since 1938. Thousands of people attend these free presentations. A rich experience.

Our view to the east was marked by Twin Peaks, two large hills too steep to be built over.

The streets in that area departed from the grid to curves and squiggles. We drove over there, but our neighborhood ended on the east at 19th Avenue.

So far, I have left out the greatest treasure of our neighborhood, and the largest one. Golden Gate Park, with more than a thousand green acres created from a large waste of unpromising sand dunes, provided an endless variety of delights. The park, like New York's Central Park, was rectangular, long and narrow, but almost two hundred acres larger. In San Francisco the park runs from Stanyan Street to 48th Avenue and is about four long blocks wide. Once inside, a person could seldom see out through the tall trees and dense plantings. By 1879, more than 150,000 eucalyptus, pine, and cypress trees had been planted on the park's sandy acres.

Of course, the park has wide, green meadows bordered by trees and lakes. And there are playing fields with bleachers in multiples. But there are also playgrounds with merry-go-rounds, Stow Lake where boats can be rented to pilot around Strawberry Hill (which can also be climbed), Spreckels Lake where we could sail our model yachts if we but had them, horses to ride and paths to ride them on, families of gentle bison in fenced enclosures, a conservatory of flowers with a huge glass greenhouse fronted by flower pictures made from plants, more and more lakes with waterfalls spilling into each other, places to play polo and soccer, a garden of the plants named in Shakespeare's plays, an arboretum with fragrant plants for the blind, Kezar Stadium where our high school played football games, a music concourse with fountains, a stage for Sunday band concerts, and a whole platoon of trees positioned uniformly and trimmed to be completely flat on top, two large working windmills imported from Holland to pump water for the park (of which one survives), all of them wonderful attractions.

But my favorites, institutions of great richness and repute, stood in two clumps. The first clump held natural history buildings, an aquarium,

an African Hall with stuffed animals in large dioramas and another hall of stuffed birds and small animals, again arranged in their reconstructed native habitats. I spent endless time looking at those creatures close up, noting the exquisite arrangements of their feathers and hair, their quiet interaction with their fellow creatures and their surroundings. A plethora of reptiles and amphibians as well as fish lived in the aquarium, and there was information on all these exotic species.

Across the way were two more magnificent institutions, the Japanese Tea Garden with its steep horseshoe bridges—which the brave visitors still climb—its tea house, its rude and fearless squirrels, and its exquisitely tended moss lawns and beautiful ponds, and the De Young Museum with its rich collection of art works, many of which we came to know intimately from repeated visits. I was particularly taken by the El Greco painting of St. Frances, who was the patron saint of the city. I liked the paneled period rooms, the first ones I had ever seen, and a green sedan chair that had been used to carry important people in Russia. An enchanting pool and fountain in front had a bronze statue of Pan, the Piper.

All of this could be reached by a five-minute drive, a fifteen-minute bus or streetcar ride, much of it by a half hour walk. Was any child ever so privileged by her surroundings? Anyone who lived in reach of so many treasures, so many convenient places to go to once and again would have had a charmed childhood. I told my mother that it was all mine. It seemed to have been constructed and arranged solely for my satisfaction. I wonder if an alien creature landing on the high hill of 24th avenue, with this account in his little paw, would be able to find his way around my neighborhood.

–4–
Sunset Ward

I spent many hours in the Sunset Ward chapel of The Church of Jesus Christ of Latter-day Saints in San Francisco when I was growing up. It was a handsome building, unlike any other ever built in the Church. Firmly planted on a hillside corner in San Francisco's Sunset District, the three-story white stucco building with Spanish accents was the largest building in the neighborhood. The red-tile roof made a striking contrast to the smooth, white walls. A dominating square bell tower rose over the entrance. The round arch above the front door was echoed in the tower and in fan lights above the tall chapel windows.

This ambitious structure was built with the dreams of visionaries, the pennies of poor Saints, and the blood of my father who was then the bishop of the ward. The church was just three blocks from my girlhood home, and I can recall many childhood moments in those impressive rooms and secret places.

The large chapel with tall windows on both sides was bright and elegant. Our congregation was attractive and always dressed up for church. On Sundays, the chapel was full of flowers and beautiful women with pretty hats. On the pulpit, the four standard texts of the Church, the Bible, the Book of Mormon, the Doctrine and Covenants, and the Pearl of Great Price, were set in special inlaid boxes. When giving talks, my sisters and I loved to impress the congregation by referring to a scriptural verse, pulling out one of these volumes, leafing through to places we had marked in advance, and reading them aloud. Behind the pulpit was a large picture of Christ in Gethsemane on which we could focus our attention during the sacrament while the organ played contemplative reveries. For the many conferences that took place there, we had additional seating by mechanically raising the back wall that separated the chapel from the recreation room, or cultural hall. As it rose, the wall would groan out the "Lost Chord"—or a reasonable facsimile thereof.

The cultural hall, with its beautiful hardwood floor, was the site of many formal dances. Unsullied by basketball hoops, which were forbidden during my father's tenure, the room had a large, velvet-curtained stage where we enjoyed many plays and the annual summer musicals my mother produced. Our cultural hall even boasted a projection booth so

we could watch films on a screen pulled down from on high. The booth was an enclosed room set high above the varnished floor, reachable only by a steel ladder attached to the wall. Going up there was like climbing to the high diving board and was absolutely forbidden. Still, we did it from time to time.

The chapel and recreation hall were on the second level of this tall building and stood two stories high themselves. The offices of the mighty were even higher. The bishop's office was on a landing above the chapel; the stake president's office was up another narrow staircase beyond that, just below the bell-less belfry. That spacious office with its plush carpeting and imposing desk seemed near the angels indeed. But the real wonder of the uppermost office, in the early 40s when TV was still in the future, was a console radio with remote tuning.

As impressive as anything was the ladies' room, which, besides the requisite plumbing fixtures, had a dressing room right out of an art deco nightclub. Little stools allowed twenty ladies to sit before a counter and mirror that wrapped around two walls to see to their makeup. An immense full-length mirror maybe six by ten feet, dominated another wall. No excuse for a showing slip coming out of that room. I can recall dozens of scenes of pretty young girls in taffeta and net ball gowns, pinning on fragrant corsages from florist boxes with their waxy green paper strewn around.

Another wonder was the women's center, the Relief Society room. The clever ladies of the congregation had procured fifty or so wooden and upholstered armchairs of different styles and reupholstered them in harmonious new fabrics. Castoff wooden tables had been refinished. Handsome standing lamps made the room, which could seat fifty or so ladies, look like a very large, genteel living room. The Relief Society also had a practical room with a big loom to make rag carpets. There were quilts on frames, barrels of dried apples and pears, items reminiscent of the pioneer past.

The blue-tiled baptismal font was in a dark room with no windows. An electric light shining through a stained-glass window brought the room to life and revealed the image of a crowned nymph with streaming hair standing on a sphere, her arms outstretched and yearning. This exotic font was seldom used, but we loved to look at it.

What good times we had! Every Tuesday evening after the teenagers met in their Mutual Improvement Association classes, we danced to records like "Take the A Train" and "String of Pearls." "Let's Take the Long Way Home" was always the last dance. Lots of young servicemen and

working people lived near, and my constant hope that someone new and exciting would turn up was often realized. Everyone danced, stirred up occasionally with mixers.

On Sundays my mother would often say, "Now girls, we have a particularly good dinner today. You may each invite home a guest." We always brought boys home, and after dinner and dishes, we spent the afternoon in Golden Gate Park or at some cultural event.

In the early days, our family often spent Saturday afternoons cleaning up the chapel because ward money was too tight to pay someone to clean. My sisters and I grimly vacuumed and swept as required. We counted the change of the tithing money for deposits. Stuffing the tithing envelopes with accounting slips was another of our regular chores. And as a serious departure from tradition, my sisters and I prepared the sacrament bread and water for both morning and evening meetings. Our ward was short of priesthood-holding boys who were supposed to do the job, and we were available. We got to be very efficient at setting the table with linens and plates of bread, putting out the prayer cards, and filling the tiny glass cups that fit into the trays. Enough priesthood people of various ages could still be recruited to bless and pass the bread and water, but my sisters and I also cleaned up afterwards. Sometimes we took the leftover bread to feed the ducks in the park. Sometimes we ate it ourselves to become more holy.

Some ambitious aspects of the plans were never realized. No bells for the tower and no elevator, but many imaginative features were completed, and even some extras.

The building was dedicated on June 15, 1941, during stake conference. Brother Rudger Clawson, one of the Church's Twelve Apostles, prayed in his dedicatory talk that faith would be renewed and saddened hearts would be blessed. He hoped that the building would be a haven for those who were discouraged.

After many years away from home, in about 1984, I came to California for some forgotten reason. I was visiting and staying with Dad, who wanted to talk. He was concerned about the church building. Those young, ignorant bureaucrats of the Church Building Committee wanted to update the Sunset Ward building in ways he considered desecration. I was sympathetic. I did not want the building changed, but I had heard it all before. It was all he had talked about for months. I was jet lagged and could hardly stay awake. But despite my dimness, I had a sudden inspiration. I stopped him mid-sentence, got out my little computer, set it up, and said, "Okay, Dad, start again at the beginning." He talked slow and I

typed fast, and I had several good pages written before we gave up for the night. I read it over and edited the pages that night. He read them the next morning, and we had the beginning of a priceless account of the building.

We continued the process until he had nothing left to say about the building. I worked that into an article I wrote for *Dialogue*, telling the building's story, its renovation, and its rejuvenation. It is probably the most successful and long-lived article I have ever written. Copies of it continue to resurface as people who attend church in that building discover it and copy it for their friends.

But long before that in my visits, we had moved from Sunset Ward to his life. Whenever I was in town, I took down his history and his memories and edited them. He wrote me letters and told me stories that I incorporated. He called me on the phone. Gradually, the material I had fell into chapters. He looked things over at every stage. Finally, I told him, it was time to publish. I took a file to Kinko's print shop and ordered copies for family members and sent them out. A couple of days later, I received from him a long list of errata. I thought we had been careful, and he had approved it at every stage, but there were mistakes. I planned a second edition. I fixed all the errors, encouraged a few more memories which I wrote up, and ordered more of the books—a lot of them this time—so he could give them out to anyone he wanted to have one. Much of what is in the book is well known by this generation, but we now have a written account of the world as he saw and experienced it. The account is a narrative of his life, in his words and in his voice, but cleaned up and edited to read very well. Many people have read it. When he died all of the speakers carried and quoted from his book of *Remembrances*.

I have done a lot of historical projects. Many begin that way when there is a coincidence that brings together the topic and the chance to work on it. I have long been very, very grateful that I got out my computer that day and began to record my dad's life. It was easy work. It brought us closer together than we had ever been. He thought that it was remarkable that I could do a project like that. I said that I had learned to do such things in the education that he had paid for.

On June 14, 1981, all former members of the Sunset Ward were invited to come to a fortieth anniversary commemorative service. Elder David B. Haight, a member of the Council of the Twelve Apostles and a one-time member of the stake, presided over the reunion services.

The commemoration was timely. Soon after, the Sunset Ward felt the influence of the Church Building Committee, which had been created in

response to the frustrations of inexperienced bishops constructing chapels on their own. Bishop Lauper's early wish had been granted, and the Church Building Committee planned to bring the building up to date.

An architect surveyed the existing building, compared available space with mandated changes, and drew up new plans. For one year the ward met elsewhere, while at a cost of approximately $1,330,000 a new Sunset Ward meetinghouse was created within the existing shell. On March 26, 1988, the renovated Sunset Ward was rededicated by Stake President Jeremiah I. Alip.

The building looks the same on the outside. Zoning restrictions forbid extensive exterior modifications on buildings with no parking space. Handsome new windows with black frames have been installed, but the openings are the same size. The overgrown landscaping has been pulled out and fresh new shrubs and lawn have been planted. The white stucco has been painted a warm beige color.

Although a plaster beehive and seagull still grace an outside wall, the plaster likeness of Joseph Smith has been removed from the front of the building because "that sort of thing is not done anymore," according to the building superintendent. Instead, the front semi-sphere has been replaced by glass, which brings new light to the interior. The Joseph Smith sculpture is now in the collection of the Church History Museum in Salt Lake City.

The chapel itself used to be white with red-trimmed theater seats. Now the colors are California golds and greens, the colors of sunburnt hills and sand and pines. The first impression is heavy and quiet because of the beautiful dark oak paneling. The pulpit area is separated from the congregation by a short wall of this oak. Twelve people can sit on the stand with the organ on one side and the grand piano on the other, and at least fifty choir members can sit in the two rows behind them. The wall behind the stand curves both vertically and horizontally to accommodate the organ pipes and the air ducts. This wall is formed by narrow vertical oak laths, visually unifying the wall and giving a tambour effect. The chapel's red-trimmed seats are gone, and the dark oak pews are upholstered in pine green; a lighter green carpet covers the floor. The five tall windows and their arched fanlights above brighten the room through billowing, gauzy curtains. Six heavy octagonal chandeliers, each four feet tall, hang over the congregation, and three more grace the pulpit area. Four brass wall fixtures add more light to the room. The congregation reflects the rich cultural and racial makeup of the area.

Basketball standards have been added to the cultural hall, and the stage and projection booth have disappeared. Only a flimsy folding platform, which can be locked up in a closet, remains for programs. Green composition panels protect the plaster walls from errant basketballs. The kitchen is completely new, but city ordinances now forbid any cooking there.

Three items remain of the original building: the hardwood floor in the recreation hall, the chandelier in the foyer, and the pipe organ in the chapel, though some wanted it replaced with a new electronic model. Brother Semereau's large charcoal drawing of Christ in Gethsemane, which used to be in the front of the chapel for contemplation, now hangs in the lobby. The elevator that was too expensive during the original construction now allows the many senior citizens of the ward to ascend to the chapel without climbing steps.

The long hallways are lined with dark oak doorframes set in walls of caramel-colored textured plaster. The scout room and other large spaces have been sacrificed to make space for more classrooms.

The baptismal font has disappeared entirely, replaced by the library. The bathrooms, made accessible to the handicapped, are clean and new but have no dressing room for primping. A partial bathroom is located near the Relief Society room, which is now just a double classroom with a divider wall. The room has attractive plastic stacking chairs upholstered in dark green.

The general effect is lovely. It is as if we were seeing an old building when it was new and fresh, but more luxurious than it was originally. It smells like a new building. The Church Building Committee has taken this veteran and given it a new life.

The benefits of change, of course, do not come without costs. Once a local ward was completely responsible for creating a building. Now the ward has very little to say about it. Once the Saints had to sacrifice to have a place to worship, and their building reflected their local abilities and interests. Now we have beautiful buildings, managed through a general program, which rise and are reborn with little effort and sacrifice from us. Once we had to learn everything on the job. Now we have experts who know better than we do. Both stages have been played out in this one building. Sunset Ward illustrates a significant development in Church practice.

The decisions made reveal further changes. What does it say about the Church that this chapel building now has basketball standards but no stage? The cultural life of the ward with its three-act plays, musicals, and

variety shows is no more. I hate to see that go. And what about this rich, conservative chapel interior, devoid of Christian symbols? This could be the auditorium of a prosperous business: it says nothing about Christianity and nothing about The Church of Jesus Christ of Latter-day Saints. Have we moved from our tumultuous beginnings, past conventional Christian standards, to a new barren elegance? Why was Joseph Smith banished from the building despite local protest? I wish we could develop acceptable visual symbols that represent our faith and our history. Our temples, until recently, have been topped with angels sounding trumpets, but our chapels have no such imagery. Our stylized steeples are borrowed from other traditions and seem to be shrinking into half-hearted gestures. Something unique should identify our buildings.

We must congratulate the architect and the Church Building Committee for their loving restoration of the Sunset Ward and for fitting all the necessary components into the space provided. I was more impressed by the building's resurrection than I intended to be, even though I will always be nostalgic for the old building and the accomplishment that it represented.

–5–
Things My Mother Never Taught Me

My mother, Jean Vernon Gordon Lauper, was a remarkable and memorable person. She had notable and infectious enthusiasms, and she had many, many fans. She began her life very humbly in a small town in Alberta, Canada, with meager family resources. Her mother, a lively intellectual, was concerned about many things, but not homemaking. What my mother learned, she taught herself. Her mother bought her a used sewing machine when she was ten or eleven and told her to go ahead and sew. She was soon the family seamstress and cook. Mother admitted turning out some sorry things, but she eventually became adept. Later in life, a talented designer told her she should have been a milliner because of her imagination and skill with detail.

The family moved to Utah and then on to Los Angeles before she married. Eventually, Mother had a very good life which she filled with impressive accomplishments, primarily in the areas of music, textiles, and genealogy. She conceived big projects and carried them out. She entertained often and effortlessly. She invited us along in her many activities, she encouraged us in whatever we wanted to do, but she didn't teach us very much.

That is, she did very little formal teaching. She mostly gave her four daughters Georgia Gates, Paulie Hutchings, Bonnie Goodliffe, and me a vision of herself in action, the example from which we learned—or did not learn. The only really specific teaching moment I can remember is her response to an offhand question I posed while driving in the car. "How does Heavenly Father know when people are married so that he can send them babies?" This question, ignored at the time, led to a later encounter. Mother, uncharacteristically uneasy, sat me down with a book called *Being Born*. I had always been interested in nature and knew about animals. As mother began a halting explanation of the birds and bees, I said, impatiently, "Yes, yes, I know all about that, but what has it got to do with people?" The final answer was a real shock.

More characteristic was the time when I was six or seven and she told me to make a cheesecake. A cheesecake! I did not know what a cheesecake

was, and I'd certainly never eaten one. She pointed out the recipe and where some of the ingredients were. She was not well and was lying down. I puzzled out the instructions, making many trips to the bedroom for clarification. Where was this? What did this mean? She grew impatient with my queries. I was sorry to keep asking, but I really did not know the answers. I finally made a cheesecake. Mother expected us to do whatever was required.

My sister Paulie had the same experience. She recalled that Mother, with her great skills and wisdom, seldom explained things. She would say, "You're so clever, you can do this already." Paulie, completely in the dark, would try to figure it out. She feared she would be unable to accomplish the task, but when she asked for help, Mother was not pleased.

Soon after Paulie began kindergarten, she was left at school to walk home by herself. We lived on the far edge of the school district and would certainly be bused today. Paulie got home, but she was pretty upset. Mother said, "Well, you made it, didn't you? Don't complain." That sort of set the tone.

Paulie had to figure out how to do the washing. She was told to cook dinner. And she did figure things out. While feeling somewhat neglected, she learned early that she could tackle almost anything and figure it out. We learned a great deal from our mother, but she was seldom specifically teaching us. Mother would probably be surprised to hear these comments. No one had ever taught her anything, and she certainly figured it out.

Mother never taught us that this is a world of trouble without pleasures. She thoroughly enjoyed many things and made a point of entertaining herself. She improved the shining moments by escaping. She went off to shop, out of the house, away from this or that. She made a virtue out of avoidance, and in doing so, had experiences that others did not. She was much better acquainted with the riches of San Francisco that any of our friends or neighbors. I later codified this position for myself as: *If I didn't quit, I could never go on.*

More than many others, she made a virtue of necessity. When she didn't have food on hand to pack school lunches for us—our school had no cafeteria—she would pick us up at school and take us out for lunch. I remember several times she took us to the beach. We got hot chicken or beef turnovers from a little place there and ate them sitting on the sea wall, swinging our legs, watching the roaring waves of the Pacific Ocean. Then she would take us back to school. No other mothers did such imaginative things.

She would leave the house and set off for concerts, plays, and drives in the country to enrich herself. She would say, "Girls, I see in the paper that the fleet is coming in. Let's go!" And we were off for an adventure. She would say such things as, "Look! The sun's out! Let's go to the park and feed the ducks." Or we would visit the arboretum or the Japanese tea garden. With visitors, we were off to Muir Woods to see the redwood trees or the museums. Our family was better at visiting places of interest than my friends' families. We were more cultured.

Another thing Mother never taught us was to work. Thank heaven. I don't like the punitive talks that tell us to teach our children to work, to equate love with being helpful. My father tried to teach us to work. Still these many years later, my sisters recall that if it's Memorial Day or the Fourth of July or Labor Day, we should be downstairs cleaning the basement.

Mother never taught us that work was virtue and duty, that anything worth doing was worth doing well, that all tasks were of equal importance. We certainly worked, but in spurts, doing what was needed for specific purposes. Was company expected? Would Dad be upset if we didn't manage certain chores? Was something beyond respectable? Work was for a purpose and not for itself alone. I learned that some things were more important than others and that not all work deserved prime attention. From her example, I learned to pace myself, to compromise, to pick and choose, to store energy for the big push, and to rest up afterwards. From this came my most useful mantra: *If you keep up, you'll never get ahead.*

Mother had reasons for her selective labor. Her health was poor, her energy limited. She spent a lot of time on the bed resting, reading, listening to the radio, or preparing for some coming demanding activity. She had many inspirations but noted that "just because you think it up doesn't mean you have to do it." She picked the most promising and irresistible, and rose to those occasions. She taught us to plan. In one of her frequent sayings, "Who lies in bed must run all day," she pointed out that we might not have time to do desirable things if we were slow to do necessities. From her I learned to do the things I absolutely have to do first, then to do what I want to do, and finally to do what I ought to do. That works well.

Mother never taught us to eat wisely. My mother's mother, my Grandmother Gordon was a terrible cook. Her children thought the lumps in their daily mush were treats. My mother was a glorious cook, and she easily and regularly put charming and delicious meals on the table. We ate a diet characteristic of our time and place. My father liked things

simple, so we had many baked potatoes and his favorite bread and milk with raisins. But he didn't like cooked tomatoes or onions, so there was no Italian cuisine. We lived by the ocean but never had any fish but canned tuna. We ate little red meat, and then usually as ground beef, stew, or pot roast. We occasionally had ham. We never had chicken and ate turkey only on Thanksgiving. My mother thought those birds looked too much as if they had once been alive, and indeed in our day, they were hung at the butcher shop with their heads and feet looking gruesome. Mother preferred meat that came in chunks or slabs or little bits, a prejudice I share.

Mother's special food interest—and ours—was for desserts. She made exquisite layer cakes from scratch, slathered with luscious frosting and decorated in ingenious ways. I remember the beautiful spring cakes with small animals cavorting on green-tinted coconut for grass and with little nests of jellybeans and mirrors for ponds. She made fabulous themed cakes for our birthday parties before anyone else considered doing such a thing. Our pleasant evenings were spent at the kitchen table sewing and doing homework, listening to the radio while mother whipped up a cake or some brownies. Frequently, we jumped into the car to drive the few blocks to Irving Street for See's Candies. Our breakfasts featured Danish pastries, warmed in the oven with extra butter melted on them. Food underscored happy family events and relationships. Our food was wholesome and delicious, presented attractively, and featured many, many special treats.

But Mother almost never sat down at the table with us. She had skipped breakfast and lunch and snacked through dinner preparations. She was not hungry for dinner but later on, she ate things far worse than the good meals she had provided for us. She had a lifelong love-hate relationship with food. Heroic abstention was followed by binges. Happy family living meant heartily eating of lots of wonderful foods. My sisters and I had our own tension, eating all that good food while we were expected to be slim and pretty, in beautiful clothes with handsome young boyfriends.

One memorable summer, my mother decided to teach me to cook, and I made a pie every day. Mother's piecrusts were quite out of this world. Thanks to her real training—or at least her passing comments as I made the day's pie—mine are good, too. She told me to work in half the butter until it was fine as cornmeal for a tender crust and to work in the second half until it was the size of a pea for flakiness. And always I should roll out the dough with my little fingers raised to keep a light touch. She cautioned that rolling the dough twice would make it tough and that any

holes should be patched up rather than re-rolled. I can still make a creditable pie. But I never got to meats and vegetables.

Mother never taught me to iron a shirt. She just expected that I could, if necessary. I remember once when my mother-in-law-to-be was visiting, I asked, in all innocence, if she could show me how to iron a shirt. She led me through the routine, first the collar, then the yoke, then the cuffs and sleeves, and then around the body—a useful lesson. But when my mother came on this little domestic scene, she took serious umbrage. She thought I was ingratiating myself with this new mother figure and casting her (that is, my mother) in a bad light. But that was not true; I just had never learned to iron a shirt and expected that I would soon have to. Thanks to my mother-in-law, and a great deal of experience, I can iron a shirt very well. But my mother was right not to teach me this task. People who can iron shirts have to iron shirts.

Mother never taught us to resolve conflicts. Communication was not a strong suit in our home. Mother was the peacemaker in our family by means of retreat. Our father was a man of quick anger. We understood that our mother had also been that way. By the time we children knew them, Mother had completely withdrawn from that style. She seldom got angry at us, and she advised us to stay out of our father's way when he was angry. Most outbursts in our house were of the sisters against each other; Mother did not participate. She might require that we sing "Angry words, oh, let them never from the tongue unbridled slip," or "Let us oft speak kind words to each other," which we did through clenched teeth. She reserved her disdain and fury for people outside the family, for people whose help she needed for her projects who did not grasp her vision of what could, should, and must be done. From this I learned the pragmatic value of controlled public behavior. I have never been sorry to be able to put on a public face.

Mother did not teach us a lot of things. Which does not mean that we did not learn things from her example. She was certainly our prime model, and we are all better for it.

She had many talents that she plied with precision and passion.

Music was first. Mother, who conducted choruses and choirs her whole adult life, took her groups to sing at the World's Fair and at city-wide concerts. She conceived productions at which she served as producer, director, musical conductor, public relations person, and deep pockets. Working with a limited pool of talent, she made something good out of little. People of small ability were pulled into her performances, and they trod the boards

because they were all that was available. She brought them along, and they were grateful. When we were young, she frequently told my sisters and me to go into the living room and sing; she would do the dishes.

She had come from a musical family. Her father played the violin, accompanied by her mother on the piano. Her sister Hortense and brother Fairfax played piano duets and won contests at the yearly fair. One afternoon when she was very young and her mother had been rehearsing a vocal solo of "The Rosary" with a young visitor, my mother got out her father's violin and with some effort, sawed out an alto harmony to the melody. Her thrilled parents got her a violin and started her on lessons.

When her family moved from Canada to Salt Lake, life was dreary and depressing. Mother's life improved when she met Stella Bradford, who with her husband, William Clive Bradford, taught community music classes in directing and voice. My mother's sister Hortense became the Bradford's accompanist, and Jean went along, taking voice lessons, drawn into their world of music.

Mother could not play the piano well, having been trained as a violinist, but she was often at the piano poking out vocal parts for her various choruses and choirs. She conducted ladies' choruses from the time before I was born, and it was from her that I learned the importance of being positive and warm rather than critical and of not talking too much during rehearsal. She was a genius at bringing people together, and the members of her groups always loved her. She conducted concerts every season or year with talented local artists. Programs, flowers, diva gowns, parties, gifts, and photographs accessorized those performances. She would prepare the group to do, say, three groups of three songs. She would have the visiting artist or artists do one or two additional groups. The performances were elegant and accomplished, very much enjoyed by the musicians and the audience.

She did church choirs for years. She spent hours on the phone calling potential, recalcitrant, and faithful singers, urging them on and encouraging their participation. She was always charming at rehearsals, but on the way home, she would speak bitterly about those who had let her down.

She was drafted to conduct a city-wide PTA chorus of Mothersingers, which she did for eleven years. There she had none of the difficulties she found with the Church administration. Her volunteer singers were devoted to her. One choral member asked Mother if her family appreciated how wonderful she was. Mother was forced to admit that no, they did not. She was right, of course. While we did know that she was remarkable, we

did not sufficiently appreciate her qualities. She had artistic sensibilities, temperament, and knowledge and was able to convey them to groups in a way that brought combined enjoyment and accomplishment to them while she entertained them and taught them about music. Her talents were complex and complete, and while she used them on a narrow local scene, her achievements were impressive.

During my teen years, my mother produced a musical play with the young people in our church congregation every summer. This was entirely her own idea, and she handled all aspects of the production: choosing, casting, recruiting talent, planning and painting sets, rehearsing, making costumes, props, lights, programs, and conducting the final production.

My sisters and I were the great beneficiaries of this vocal and dramatic training. Georgia and Bonnie accompanied, improving their pianist skills. We all watched as our mother moved her single-minded vision forward. We four girls have all been able to do large projects from watching her take on these big responsibilities, time after time.

I regret that I resisted learning the things my mother would have liked to teach me or at least have me learn. I took piano lessons for two years. I liked the music. I liked my teacher. I enjoyed the lessons, but I hated to practice, and I hated to show up poorly prepared at my lessons. So, I deviled my mother to let me quit. She finally gave up on me, but only at my own urgent demand. My other sisters play well. Now my failure to be able to play the piano is my greatest sorrow. Still, my love of music, my participation in a long string of choruses, choirs, trios, musicals, and concerts, and my pleasure in attending musical events of almost every kind is thanks to my mother.

When I was in high school, Mother noted in the newspaper that the University of California Extension Chorus would be meeting for a new semester and was auditioning singers in San Francisco. Georgia was away at college by then. Mother suggested that she and I should go down and give it a try. The stern and sprightly conductor, Madi Bacon, put us each through a few paces and then conducted the group in some Bach. The next week, we found that Mother was on the accepted list but I was not. Mother refused to accept Madi's verdict. She did not want to go alone, and I loved the small taste of Bach I had had, so we both just kept coming, singing with the group for several years.

Madi Bacon did not like me. One time she detected a strident alto, and thinking to embarrass me, brought up a group in front of the chorus to sing, dismissing us one by one as our voices did not offend her. I knew

that Deirdre, one of her favorites, was the strident one, but she was an officer in the organization and knew well enough to tone it down during this little ordeal. I knew and loved the music, so I sang on lustily, the book hanging from my arm. Madi Bacon finally sent us all to our seats, somewhat disgruntled at the outcome. I remember this incident because Mother told the story several times, saying how proud she was of me.

I thoroughly enjoyed the experience of singing in this group that opened a new world to me. I never sang in a serious chorus in school, and I had only sung in my mother's choirs where we sang a repertoire of religious anthems, many very lovely. But in Bacon's chorus, we sang choral masterworks, the work of Brahms, Bach, Handel, and others. The first time I sang Bach, I couldn't believe it. I had never heard such complex and satisfying music before. Every part was independent and interesting. I could hardly get to sleep on rehearsal nights. I learned a great deal there, even though I was young and marginal.

In another area, my mother, who had been making doll dresses since she was four and selling them to neighbors for pins, was a wonder at the sewing machine. She had an unerring sense of style and decoration and was incredibly fast and accurate. She was inspired by fabric and loved to shop for it. She never felt challenged unless she was half a yard short or else had to cut around some imperfection. When she was a young woman working at the May Company, she made two dresses a day on the yardage floor. This was a McCall's dress pattern called the Forty-Five-Minute-Dress. Mother was always a speedy seamstress and never took more than thirty-five minutes, including cutting and finishing the dress. She really flew. This was a very simple dress, but still the sign said, "See our Miss Gordon cut, sew and finish a dress this afternoon." Before she was married, she was sent to St. Louis for special design training. She might have had a serious career.

After she married, she turned out thousands of dresses for us. She was always sewing, cutting fabric on the dining room table, constructing garments in the bedroom, pressing them at the kitchen ironing board. The evening before any holiday she was sewing hems and buttonholes and attaching snaps on pretty dresses for us to wear the next day. Before every vacation, we each got a new wardrobe. We began the school year with new outfits. All the machine work was done during the day in her bedroom and was completely cleaned up before our dad, who hated the detritus of sewing, came home.

Mother, the deftest seamstress ever seen, was scornful and sorrowful at my sewing efforts. Although there are few things that I enjoy so much today as handwork, I know that I had the great exemplar in my house for many years and did not really learn what I could have. Why did I take it all for granted?

I resisted my mother's efforts to get me involved in genealogy when it was the prime interest of her life. She took it on after the death of her genealogist mother, but then did so with zeal and fervor. She organized the family for reunions, began a family directory, collected money for distant research, and did much herself. I dismissed the endless search for yet another ancestor as mindless, needle-in-the-haystack labor, pointing out much better uses of time and energy. I had no interest in the distant forbears, and I was not about to scroll the endless Yorkshire parish and census records. Now I do a lot of historical projects and family history work and I enjoy them. But I did not take advantage of her skill or of her wish to see me involved. The sorry truth is that teaching requires both an agent and a recipient: teaching needs someone to receive on the other end. This is why the human race does not improve. Each new generation is too smart to learn from the one preceding. We don't get better. We just do things differently.

When I had wonderful, bright, creative children of my own, I thought that I would teach them everything I knew and valued—songs, nature, nonsense poetry, handwork—and they could go on from there to learn whatever else interested them. But I found them resistant. They didn't want to learn the things I knew. My daughters endured my sewing lessons with frowns and tears and escaped as soon as they could. All the children took music lessons, but only one still plays his instrument. Sometimes the children managed to learn enough that they went on to do wonderful things on their own. One of my greatest pleasures is to hear my four boys, who live far apart and seldom get together, sing their repertoire of quartets. I had always tried to get the children to sing together and perform. They reluctantly did. My oldest son, Brick, got the vision after he went to college. He saw that singing was a good thing and realized that he would never find a better group than his own brothers. Back home, he organized the long-lived doo wop group, Benny and the Pork Chops. Anyone who hears them is impressed. I have requested their arrangement of "Blue Skies" for my funeral. Many years later this son has completely morphed from being an investment banker to a full-time musical impresario. Another son has moved halfway in that direction. Mother would be pleased.

Things My Mother Never Taught Me

What I never learned from my mother is that I would become like her. I did not expect it. I was the different one in our family, the dour one, the left-handed one, the one who studied elocution instead of the piano, the one who mooned over birds. I was stunned when my sister Bonnie once said offhandedly that I was just like Mother, always doing projects. And I have come to see that I have pretty much grown into her image.

My mother went gray early, probably related to her thyroid difficulty. I am the only gray-headed one of her children. One sister now has red hair, another is blond, and one was brunette until she passed. But I am gray, now white, like my mother, by choice and in memory of her. I see her in the mirror if I cock my head a certain way.

When my mother died, my father was thankful that she had not suffered long. He was grateful that he was with her when the seizure came, and that her last days had been happy ones visiting my sister Bonnie and her much-loved children. He was grateful that she had gone first.

For several years I transcribed Mother's almost-daily diary, from 1930 when she was married until the day of her fatal stroke in 1977. These were short entries, maybe five or six lines a day in little five-year diaries. In those pages, I vicariously relived much of the past. I was sorry to see myself there as the haughty, aloof, bad-tempered, insensitive child. As I grow older in the diaries, I see her picture of me as a thoughtless daughter, a slovenly housewife, living a grim and joyless life in my rickety old Victorian mansion in Massachusetts, ignoring Father's Day, seldom writing. I exaggerate, but the clues are there. I see her coming to visit me and not having a good time. I see her preferring the well-ordered house of my sister Georgia, the efficiency and thoughtfulness of my sister Paulie, the exquisite and precocious children of my sister Bonnie. I should have done better.

Still, with all my failings, I am very much her daughter. When a new project suddenly comes to my mind, full blown in detail, with solutions to all problems, with the spurt of energy needed to bring it to fruition, I consider it my revelation from heaven. But I also know that I have just cashed in on a part of my mother's legacy. She taught me to make something of my life, to act on my good impulses. She taught me to rise above the things I have to do and reach for something else. I know that I can carry out ambitious plans because I saw her doing it. How happy she was with each new inspiration! When in the throes of one of those visions, she was charm itself, projecting her vision, bringing people into line through cajolery and compliments.

O, mother! If you were still around, I would be a better student. I would be a better daughter. I would be a better friend. Maybe I had better warn my children that I will soon be gone, and they had better take advantage of my great wisdom and experience. They will be sorry one day. One more generation will learn the lesson too late.

–6–
School Days

I thought I was an interesting child. My mother encouraged me in this thought, but I was humbled when I went off to kindergarten.

We had lots of programs in our school and in the first that I remember, I recited the following poem:

> A birdie with a yellow bill
> Hopped upon my window sill
> Cocked his shining eye and said,
> "Ain't you 'shamed, you sleepy head!"

I said this with a loud voice and considerable drama. I have a photograph of myself and two other girls on the front steps of our school, wearing the crepe paper costumes of the day. Mine was lavender, the edges hand-crimped to look like ruffles. The bonnet had a peak and a big bow. I remember thinking to myself that I must pose, and there I am, with long straight arms and a ghoulish smile, a stiff ramrod of a little squinting girl, my curly brown hair poking out awkwardly. Beside me were two pretty, graceful, demure little girls, Janet and Joan, who provided the image of what I always failed to be: a beautiful, sweet girl.

In kindergarten, little pieces of pasteboard with cartoon designs stamped on them were distributed for any good act. I tossed all those I received into the locker I shared with Elaine. At year's end, we counted up our pieces for prizes. I was shocked when Elaine claimed all those in our shared locker as hers. I complained about this to no avail. Socialization was painful, but I did eventually learn how to get along.

I was left-handed as well, which meant that I never learned to write. My first-grade teacher put our small group of deviant lefties in an outer dark corner where we remained awkward and ignorant. We could not write without smearing the ink. The standard punishment for talking too much in school was to write on paper or on the board one hundred times "I must be quiet," a painful and humiliating job for a left-hander.

These early school days took place against the drama of World War II, a frightening event in San Francisco. We had bomb drills, black outs, heavy drapes on our windows. We gave up our meat and butter to the soldiers, flattened tin cans for metal drives, donated clothing for refugees, wore dog tags so that our dead bodies could be identified, watched

as Japanese merchants closed their shops and disappeared. We saw our schools filled to overflowing as war workers and soldiers brought their families to our city. We learned how to put out incendiary bombs.

Our district was growing quickly anyway as houses were planted on the Pacific Ocean sand dunes. During the World War II mobilization, school construction was frozen. Our fairly new K–8 Lawton Grammar School was soon so crowded that half a dozen single room classrooms, or shacks, were brought into the schoolyard from army bases to hold overflow classes. Three new classrooms were built into the open recreational area of the main building. All spaces had classes of thirty-five to forty students.

I enjoyed classes in the shacks with their adventurous deprivation. They were bare-boned, very much like the one-roomed schoolhouses of yore. We felt like pioneers. The shacks, each completely separate and self-contained, had electric lights but were still quite dark. There was no plumbing. A little, blocked-off cloak room had storage closets and hooks for our coats. The shacks were heated with potbellied coal stoves that glowed bright red on cold San Francisco mornings. We hurried home during air raid drills or when enemy planes were suspected in the area, hoping to get there before the bombs fell. We sort of learned how to read and write and spell.

Three positive incidents remain from my earliest years in school. I ran one of my earliest projects. It happened that my mother had made me a cotton dress with a print of black and white checks with pink roses. The dress had a white yoke on which Mother had appliqued a garland of the pink roses cut from a scrap. I must have gotten the dress for Christmas because I also had a new baby doll with a piece of brown colored lamb's wool glued on for a wig. She looked sort of like me with curly brown hair. I called her Peasey for her full name, Sweet Pea. My blond sister Paulie had a similar doll with yellow fur for hair. I mentioned to my mother that I wished my new dolly had a dress like mine. And soon she did. Mother cut the doll's dress from fabric scraps with only small roses, and as the piece de resistance, the kind of thing at which Mother excelled, she cross-stitched a little rose garland in shades of pink and green on the dress's white yoke, the same as mine. The effect was enchanting. I took my dolly to school and persuaded the teacher and the class that we should have a doll contest. I organized the event, giving each student three little pieces of paper—red, blue, and yellow—with which to cast weighted votes. I set the date with the teacher and told all the girls to bring in their favorite dolls. I, of course, wore my black and white and pink dress that matched

Lauper family, 1945. Left to right: Claudia, Jean, Paulie, Georgia, Bonnie, Serge.

my little dolly, and I put her on the shelf with the others. The students filed past the shelf and placed their markers before their first, second, and third choices. I didn't win. But I had run an event, something I was to do many times in my life.

Another time I let my teacher know that I had a dramatic reading I could present about St. Valentine. The holiday had come, and the students were exchanging valentines. I was taking dramatics lessons at this time and had memorized a number of such pieces. I presented my history of St. Valentine's Day with great confidence. The teacher was surprised and impressed. She sent me around the school to give the reading in several classes. That was a small triumph.

But the biggest triumph, the one that made the most difference, was when my classmate Carole Baskin told me matter-of-factly that I was the smartest girl in the class. I was surprised, amazed, and thrilled at this observation and asked her to repeat it from time to time, which she always did, true to her early inspiration. I felt that I had been anointed and after that acted with more confidence. Was I a good student? Not particularly. I did learn to read well and "with expression." But my papers were always messy because I wrote in the upside-down-left-handed style and smeared up all the pencil and ink. But someone thought that I was smart.

I had a great fondness for Lawton School, for Principal Miss Mennie, for our several strange teachers, and our non-rhyming school song:

> Hail, hail to thee
> For our dear Lawton School, let's cheer.
> Let hearts and voices ring with praise and loud acclaim.
> We pledge ourselves to this dear school we love so well.
> With loyal hearts and colors high
> It's Lawton School forever, ever more.

Miss Mennie was very much into building citizenship by repeating patriotic creeds. We not only pledged our allegiance to the American flag each morning in school, we also recited the American Creed by William Tyler Page, which goes like this:

> I believe in the United States of America as a government of the people, by the people, for the people; whose just powers are derived from the consent of the governed; a democracy in a republic; a sovereign Nation of many sovereign States; a perfect union, one and inseparable; established upon those principles of freedom, equality, justice, and humanity for which American patriots sacrificed their lives and fortunes.
>
> I therefore believe it is my duty to my country to love it, to support its Constitution, to obey its laws, to respect its flag, and to defend it against all enemies.

Those patriotic cadences still bring thrills in my old age as they did to my young patriotic heart.

We also recited the Lawton Creed, which has less pretense to stirring literature but more real appeal as a set of goals. I think it is touching how the multiple lists of virtues try to encompass all good things:

> To be cooperative, courteous, sincere, and kind in our relations one with another. To have self-control at all times. To possess a love of the beautiful and increasing eagerness for knowledge and a seeking after truth. And a desire for accuracy, quality, and skill in that which we do. In these ways we hope to develop ourselves as capable, cooperative, and worthy citizens of our school, city, state, and nation.

Many, many years later, I still hope to be a worthy citizen of Lawton School.

As we grew older, we moved out of the shacks and into the main building where we had better classrooms. We learned literature and history and mathematics. At the end of our seventh grade, we also learned that we would be bused to another school for the eighth grade. So it was that we walked to Lawton to board a bus that took us to Presidio Junior High School on the other side of Golden Gate Park. This was a great adventure

School Days

Claudia, c. 1950.

for us, going to various classes in different rooms with different teachers, much more adult than those at our grammar school. We were freer. That school had a dress code for important events when all the girls wore white middy blouses and navy blue pleated skirts. We Lawton people never heard of this requirement and never got the outfits. So, my one picture from the school yearbook is in a student council picture where all but one of the class representatives are wearing white middy blouses— I wore a blue angora sweater. We had been K–7 in a K–8 school, but over there, we were the middle class of a 7–9 junior high. We stayed just a year. Then we became the small ninth-grade class at Lincoln High School, waiting for students from other junior high schools who joined us in the tenth grade.

> High on a hilltop, 'mid sand and sea.
> Abraham Lincoln, we will honor thee forever
> Thy sons and daughters, however long the trail,
> Always will remember thee. Hail! Hail! Hail!

Lincoln High School itself was not very impressive. Construction of the school was halted by the war. We had a single block of classrooms on an unfinished campus. We had a yard full of worn and primitive shacks, as in grammar school, for overflow. There was a modest cafeteria in the basement of the block, but the small library was a classroom, as was the girls' gym. We mostly played games outside, but if the weather was bad, then it was exercises in the "gym." There was no boys' gym either, no football stadium, no indoor basketball court, no auditorium, no little theater. We had our football rallies outdoors behind our building on graduated cement steps.

But deprivation led to opportunity. We played our football games at Kezar Stadium in Golden Gate Park where the San Francisco Forty-Niners used to play. We had our graduation in San Francisco's extremely grand World War I Memorial Opera House.

Besides this, the school was located "high on a hilltop, 'mid sand and sea,'" a fabulous place, straight up the high hill from my house. From the hilltop we daily saw a thrilling panorama of the Pacific Ocean, the Golden Gate Bridge, the San Francisco Bay, and the towers of the city proper—at least when gray fog did not obscure the scene. Sometimes the view was illuminated through sparkling sunshine. Sometimes we saw the fog rolling in, the orange bridge towers slowly disappearing in the swirling, damp clouds. Frequently there was both shadow and sunshine. Just being there was a gift.

By high school I felt experienced, smart, and even wise. In our small freshman class, I was a class officer. I had all As on my report card. When the tenth grade came, however, we Lawton types were superseded by the "good" kids who came from Aptos Junior High.

At the beginning of tenth grade, I experienced a clarifying and life-changing event. I was invited to a party with a group from Aptos Junior High School. I was the only one of the old Lawton kids there. It was not much of a party. We rode around in cars with dates, and when the group had nothing else to do, we drove to the St. Francis Yacht Club to which some parents belonged. These were kids who thought a lot of themselves, who felt entitled, who exuded superiority as much as a tenth-grader could. I felt privileged to be there. I was also nervous because I thought they might behave in ways I was not supposed to behave.

There was nothing to do at the yacht club, so some of us sat down at a big round table. We began to take turns tossing a pair of dice. One young man got an alcoholic drink from the bar and raised the ante by saying that the low man on each toss of the dice would have to take a drink. I didn't drink. I had never had a drink. I did not want to take a drink, but I didn't want to make a big thing out of it either. My aim was to arouse as little attention as possible. I took my turns and threw the dice. My chances were one in eight; not too bad, I thought. On the fifth round, I was the low man. Now I had to face it. I did not want to make a fuss. I raised the glass to my lips but did not open my mouth. That is to say, I did not inhale. I put the glass down and the game proceeded. I felt smart and relieved that I appeared to be one of the kids without actually acting against my religious teachings.

Three years later, as we were about to graduate, one of the girls at that early party, then a good friend, asked me why I had taken that drink at that yacht club party. She had thought of it many times and wondered what I had been thinking. Why had I done it? I thought that I had escaped the embarrassment of revealing my puritanical standards. Instead,

Claudia in high school.

my failure to live up to them was thought about and disapproved of. That was a memorable lesson about being true to myself.

I enjoyed Lincoln High School. I was a school song leader, one of a group of four who waved pom-poms at rallies and games while the students sang school songs. We were not allowed to raise our feet from the ground as that was considered unladylike. Just as well, I could never do splits or cartwheels anyway. I was one of the forty links in the honor society. I did star in the term play; I did produce the school variety show; I did speak at graduation; I was voted most likely to succeed. There wasn't a lot of competition.

I had several interesting boyfriends during high school. There was Ted, the tenor, whom I met at the music summer school I attended with Georgia. He was very cute, sang well, lived nearby, went to Lincoln High School, and was one year older than me. I thought that he was the best-looking boy I had ever seen. I liked him a lot. At first anyway. On our first date we took the bus downtown to the Fox Theater to see a movie. He wore his brown suit. We briefly went steady. Another memorable boyfriend was Arnold, a young man of Armenian descent who came from a family successful in wholesaling produce. We went out some. He was very smart but never acted like it. He thought I was the only one in our class who had any idea of what life was about, who had any vision of the future. I went to my senior prom with Kirk, who wore braces on his teeth and drove a big old Packard car. He called me his Moll and had a special hat for me to wear in the car.

Then there was Alan, a too-experienced older young man who turned up as a friend of someone at church. His widowed mother supported her two sons, and he was working his way through the University of California

at Berkeley. He worked a semester and went to school a semester, gradually getting a degree, caught temporarily in the warm net of young Mormon life. We became friends and went out a lot. He taught me many useful things—too many actually. He encouraged my smarty side, but easily put me down. He joined the Church and was called on a mission. He went to the Mission Training Center and was about to be sent out to the field when his draft board drafted him into the army to fight in the Korean Conflict instead. He went into basic training instead of on a mission.

Because he was smart and he tested well, Alan was sent to Monterey, California, to the Army Language Training Center to study German. He did well in the course and was assigned to Germany to work in the office there. At this point he proposed to me and asked me to come to Germany with him. I was sixteen.

My mother was, of course, horrified. She thought that Alan was okay to go out with but nobody to marry. He was a fierce-looking guy, short and broad, a little bandy-legged, a Black Irishman with a hairy back and a decided manner. He was certainly not the tall, clean-cut, wholesome, blond kind of a guy I generally favored. My parents' opposition pushed me rebelliously toward this life-changing event.

At this point my father called me into his office and we had one of the two very influential father-daughter talks of my life. He noted that I was young. That stopping my education would be a serious step. He said they had nothing against Alan, but they were not sure I was ready to be a wife. All quite true. But, he said, if this was what I really, really wanted, they would support me in my choice. But I had to be very sure that this was what I really, really wanted. I was weeping copiously by then, and I decided that this was not what I really, really wanted. Alan went off to Germany without me.

Many years later, in 2002, I got a notice that my old classmates would be gathering in the spring of 2003. A few stalwarts were organizing events. I was far distant from Lincoln High School by then, across the continent. I hadn't kept up with many high school friends, although if I were to do it again, I would try harder. I was perfectly glad to move on when I finished high school.

Over the years, there have been occasional reconnections. Like the phone call I got when I lived in Delaware suggesting a reunion of the Point Lobos Ladies' Choral Society. This was a short-lived group created to perform in the school variety show. I had directed both the group and the show, "Caught in the Act," some fifty years before. We wore purple

robes and sang several songs. I wrote the words to our "hymn" sung to the tune of "God of Our Fathers Whose Almighty Hand."

> Hail! Hail! Point Lobos, praise to thee we bring.
> 'Neath thy bright flag, in harmony we sing.
> In thy blest world, pray may we ever be
> Point Lobos Ladies' Choral Society.

"Good grief!" said I. "Who am I talking to?" The caller turned out to be Sally Marquis, then Cairns, late of the Point Lobos group. She lived in nearby Maryland. We got together several times.

Then there was the time a woman I met in Pittsburgh, a member of the Church, who asked whether I remembered Jerry Messner. I certainly did. He was a bright, dramatic, articulate, baby-faced classmate whose friendship I very much enjoyed. She had worked with him at a junior college in California. He gave her his card with a message for me should she ever meet me. I was thrilled to reconnect. I wrote to him, exchanged half a dozen letters, and had a good long visit before his sudden and unexpected death.

Then there was a Wellesley reunion when I discovered that the husband of a classmate had gone to Lincoln. He and I spent a happy couple of hours at the reunion reconstructing the school fight song, the hymn, and some of the yells. So, I had some evidence that somewhere out there the school and some of her alumni still did exist.

In fact, my sisters and I were contacted by the Abraham Lincoln Alumni Association, which publishes an occasional newspaper called *The Lincoln Log*. The editor wanted to do a piece on us because four sisters had attended Lincoln. We all wrote pieces which were published in the *Log*.

I decided to go to my class reunion and reconnect. I arrived during an opening reception and recognized most of the well-dressed and well-coiffed sixty-eight classmates present. Audrey Dulberg came up to me and exclaimed, "At last, someone who didn't go on a diet or to the beauty parlor before coming here!" That was some cold water. I thought I looked pretty good for my age and experience.

I moved around and spoke to various old acquaintances, people I had not seen in fifty years but of whom I still had indelible memories. Joan Cox said that Rod Lundquist was looking for me, that I had saved his life long ago. When I ran into Rod, he described an incident of which I had no memory. I gradually pulled it back. We were both taking English A, the college prep English class. The teacher, in preparing us for college, gave us repeated spelling tests of hard, college-type, tricky words we could

easily look up if we needed to use them. I thought that this was pretty poor pedagogy.

Rod sat behind me in alphabetical order. I had known him since kindergarten. He was also left-handed, and we had suffered many indignities together. He was even worse at writing and spelling than I was. After a grueling spelling test in the English A class, we were told to pass our papers forward to be corrected. I got his. The teacher spelled out the words and I noted the errors, but I did not mark them. Then I asked Rod for his pen, saying that I was only going to fix the easy ones, and I corrected several errors. No one would believe it if he got a perfect paper. He got a C on the exam and passed the course.

I gradually remembered this incident as Rod reminded me. I do not regret helping him. He had been a very interesting and articulate kid, and at the time of the reunion, he was teaching in a community college—a worthy job. He could teach even if he could not spell. I did cheat, but I did not cheat for myself. I didn't regret it. I had looser morals then and did not regret helping a fellow leftie. Reliving that incident was the most memorable event at my high school reunion.

I had some good encounters with various old girl- and boyfriends. I saw the old school had blossomed and matured with every amenity for sports, drama, and scholarship. It had gone through a difficult period when tough kids from other areas were bused in. My mother reported that police sirens could be heard every day. But as the neighborhood had increasingly become home to an Asian population, the school had become calm and peaceful, and students were winning valuable scholarships and prizes. I am sure that they are better students than we were.

–7–
Off to College

San Francisco had reasonable schools. Our teachers were sufficiently prepared to teach, and they took us through the paces. Still, the atmosphere was not exactly conducive to learning. Academic achievement was not very important, far less so than many other school activities. According to our code, it was acceptable to be smart and do well in school if the feat could be accomplished effortlessly, and particularly if one were also beautiful, popular, and well-dressed. But pity the poor little person whose love for learning overwhelmed all other values. That story-book style held little interest for us. And I never actually knew such a person. Although our minds were mostly elsewhere, we went to school as expected, somewhat enjoyed it, dutifully did our homework, took our examinations, and got our report cards. They were usually good enough.

This attitude continued through high school when we were partly tracked for the first time. There were manual arts classes, secretarial classes, and college prep classes. We chose things that seemed interesting. I don't remember anyone saying that we should have four years of language, science, English, history, and math classes if we wanted to go to college. I did plan on college but took only two years of Spanish, three years of science, two years of history, and two years of math, filling my program with such frivolous courses as a semester of conversational Mandarin, two full years of dramatics, and the innocuous Senior Goals. I took two free periods my senior year to produce and organize the variety show. I certainly don't regret the two years of typing, the economics class, or the driver's education course, but I hardly maximized the academic opportunities at Lincoln High School.

As in grammar school, I did well enough. I took care not to get an all-A report card after my freshman year. I certainly did not want to be defined as a "greasy grind." I did not let my schoolwork interfere with my social life or my activities. I failed by half a grade to become a lifetime member of the California Scholarship Federation, which required a certain grade point average. And I regretted that I had not managed that simple achievement. I was surprised to be elected "most likely to succeed" on the list of senior superlatives. I was pleased to have been singled out, but I thought that the title was really an insult. I would rather have been

Claudia, c. 1950.

chosen the best dancer or the person with the best hair.

As our senior year approached, people began to talk of their future plans. Our students were not very ambitious. Maybe half went to college to the most popular destinations: the two-year City College of San Francisco or maybe San Francisco State College. Some went to the excellent University of California at Berkeley across the bay. Few people went elsewhere. These public schools were inexpensive. Cal, as we called the Berkeley school, cost $35 a semester in our day. A person could live at home, commute, buy books, and get a fine education for very little. A very few handsome, excellent athletes who were also good students and some very smart girls might make it to Stanford, down the peninsula.

I was in a modest quandary. I was expected to attend Brigham Young University, the church school my older sister had attended, but I would have liked to go out-of-state with my best friend. My father, however, refused to pay out-of-state tuition. I explained all this to my guidance counselor on a routine visit. She said that I should certainly go to an excellent school and told me to apply to Cal and Stanford, handing me applications. Then, in an offhand manner, she handed me a sheet of paper that might be of interest, an announcement for a Seven College Scholarship.

Seven eastern women's colleges: Barnard, Bryn Mawr, Mount Holyoke, Radcliffe, Smith, Vassar, and Wellesley had set up regional scholarships after the war. Other eastern schools were also inviting in promising young people from the West and Midwest with scholarships to create a nationwide student body and to broaden their own reputations. Each of the seven women's colleges offered three regional scholarships a year, one each to a student from the western states. I looked over the explanatory sheet and thought I might as well apply, mostly because my grandmother

Off to College

Margaret Elizabeth Schutt Gordon had considered and almost attended Mount Holyoke, the oldest of the group.

I had to list three preferences on the application, so I got out the family atlas and plotted the locations of the schools. I was disappointed to see Mount Holyoke so far inland. Having grown up within sight of an ocean, I could not imagine living away from one. I was willing to trade the Pacific for the Atlantic, but I needed some ocean. Barnard and Radcliffe were closer to shore in New York and Cambridge, but I had never heard of them. Bryn Mawr in Philadelphia was interesting, but unpronounceable, and certainly no one would want to go to a school named Smith! Vassar, I had heard of, but it was in a little town called Poughkeepsie. Surely that would not do. That left Wellesley. A friend of my mother's had graduated from that college and liked it very much, although she said she would never send her daughter there. Still, people in novels sent their daughters to Wellesley. I listed my choices as Wellesley, Vassar, and Mt. Holyoke and sent in the application. Somewhere along the line, I was summoned to the high Berkeley hills for an interview, and I had a pleasant visit with an elegant Wellesley graduate.

The application required taking the College Board examination long before everyone was taking such exams. I made an appointment and turned up on the required day with about two hundred other young people who sat for the exam that day, hoping for admission to some demanding college. I learned that not all the students in greater San Francisco were like those at Abraham Lincoln High School. I knew no one there, but my ruthless high school eye identified the "smart" people with excellent records, those undersized and oversized loners. But there was also a large contingent of a new kind of people—beautiful people, beautifully dressed—who were there with friends from prosperous homes "down the peninsula" or rare private schools. This supremely cool group was not behaving in a cool manner. They cared a lot about doing well. They feared that they might not be admitted to desirable schools. They referred to courses taken to improve their exam performance, but they were still unsure of themselves. I listened to their chatter, feeling more mature, if less prepared. I had nothing to lose. It was exhilarating to spend the whole morning taking a test.

My applications to Stanford and Cal bore fruit, and I determined to attend the former. Timing had a lot to do with it. The Stanford letter, dated March 28, 1952, said that the committee had been able to reach an early decision "because of your fine academic and personal record."

I, Claudia

Claudia, c. 1951.

That was a laugh. I must have done better than I expected on the College Boards. I was assigned a Stanford room and a roommate, and I had written to her. I might meet some of those big, handsome, blond California jocks that Stanford admitted and might not have too much competition from the unattractive female brains. The campus was very beautiful, not too far away, and in a sunny location. I was amused to be awarded a $150 scholarship to Cal which would be dispensed in four equal installments of $37.50. But that letter was not dated until June 9.

I don't remember thinking much about the Seven College application. I had not applied to any of the schools individually. The months passed. My big variety show, "Caught in the Act," had been successfully produced. I was working on my commencement speech. But one day I had letters from Mary E. Chase, Director of Admission, and Lucy Wilson, Chairman of the Faculty Committee on Scholarships at Wellesley College, dated May 15. I must have been on a waiting list, notified after someone else

Off to College

turned them down. Dean Chase invited me into the class of 1956, asking for a speedy acceptance. Dean Wilson told me I had been awarded "one of the Far West Pendleton Scholarships." Not the Seven College Scholarship, but a Wellesley award. I had said I would need $1,000 a year, and they offered that. I couldn't even think of asking for more. Dean Wilson said that the committees "were much impressed by your credentials and have confidence that you will bring honor to the College and your school." I was surprised, amazed, and pleased. My family looked the letters over, thunderstruck that anyone would offer me what looked like a very large sum of money to go to college—me, a person Wellesley knew nothing about and who hardly saw herself as a serious student. My father, a self-made man who had worked very hard for everything he had ever gotten, could hardly believe it.

That evening, my boyfriend Alan called. I said, "Guess what? I got a scholarship to Wellesley. Of course, I'm not going to go." His response changed my life. "Why not?" he said. "If I had a chance like that I would certainly go." After I hung up the phone, I told my family, "Alan thinks I should go to Wellesley." And we all considered it. Maybe I should.

I had only gotten out of California once and that was to Utah. My comprehension of the United States was extremely sketchy. San Francisco was a twentieth-century city. Almost nothing remained from before the earthquake and fire of 1906. Californians looked forward, not backward. The Civil War was as distant to me as the Crimean War. The Revolution was a costume party about the time of Columbus. What would I find in this strange new place? I knew no one there. But what an adventure! What an opportunity for something new! I was never afraid of new situations. I was more confident then than I am now. The simple gesture of my guidance counselor had brought me a Cinderella opportunity. Wellesley would broaden my vistas and redirect my life. Somebody somewhere had seen some promise in me.

An unexpected result was that my father bragged to his business associates about this unexpected honor, and several of them wrote me nice notes of congratulation. I pasted them in my scrapbook. My father made a point of saying that the Wellesley thing had been "arranged by her own initiative, without any real encouragement at all." He began to take me to lunch with some of his associates and customers. Wonder of wonders, my father was proud of me.

My allegiances switched. I withdrew from Stanford. I graduated. I got a good summer job and saved my money. Wellesley sent a reading list,

and I read a series of wonderful, important works on the bus to and from work. I went to a dance for eastern college kids and did not see any of the people who had sat the College Boards with me, but people much more likely to go to eastern schools than I had ever been. I chose a dormitory by its name, requesting a single in Severance Hall, a room of my own.

My mother made me a new wardrobe. We chose a light blue poodle cloth for a new winter coat. But that fabric was very popular that year. My mother, not wanting me to look like everyone else, made me another coat of a nubby black and gray tweed. She made some beautiful suits, skirts, blouses, plaid jumpers, and two extremely elegant party dresses, one of red silk—like crumpled poppy petals—and another princess style of beige silk. All these new clothes, along with my good supply of high school cashmere sweaters, meant that I was very well-dressed for a scholarship student.

Things were different then. As I climbed aboard the airplane for my first flight (a thirteen-hour trip to Boston) absolutely terra incognita, I wore a tailored gray wool dress and black heels with my new tweed coat. I also wore a black velvet hat and white gloves. Because sailing off on an airplane was an unusual thing to do then, I had been given a large purple orchid, which I wore, and a box of See's Candy, which I ate. Carefully watching the steps as I boarded the plane, I was so busy with my shoes that I did not turn to wave to my waiting family. This became the symbol for my fearless departure from home: "She never looked back."

The long day gradually passed. As we neared Boston, the pilot warned of bad weather. We reached Boston and circled a few times before officials announced that landing was impossible. The plane turned south to New York and landed at Idylwild Airport, now JFK, in Queens. Now what? I could certainly manage if things went smoothly, but here was a crisis. Could I get to Boston from New York? The airplane people gave us two options. We could wait in the airport for the first plane north or we could take a bus to Grand Central Station and take a train. I was soon on a bus for the city. I was not missing this.

New York City had special meaning for me. Growing up on the West Coast, I was always aware that I was not living in the *real* United States. We had a great city in San Francisco. I loved it and still do. But it was other. Our long, narrow townhouses were not like the houses we saw in our school readers, nice ranches or colonials with wide lawns where the dog could romp. We had impressive cultural institutions, but the paintings in our museums were not reproduced in art books. We had lots of good dra-

ma, but our live theater had touring companies, not the stars. We lived in damp fog, delicious in its way, but not the sunny skies of the *real* America.

For years my sisters and I had listened to the radio on Saturday mornings when we were supposed to be heading to our Young People's Symphony programs downtown at the opera house. We listened to fairytale dramas on "Let's Pretend" and then a more adult radio drama linking several human stories in "Grand Central Station, Crossroads of a Million Lives." We sometimes stayed home too long when we should have been on the streetcar. We loved the interlocking stories that took place in New York's great railway station. The introduction to the show talked about the train speeding through the underground tunnel that brought it to the city and ended with the sonorous voice of the conductor announcing the wonderful "Grand Central Station." And now I had the unexpected chance to go to this fabled place where millions of lives crossed daily. The power of the station's name coupled with the idea of arriving from everywhere to that final grand destination with its storied vaulted halls, its roaring rush of great trains, its connection with the great rascal Cornelius Vanderbilt, made it a special place to me, although I had never seen it and had never expected to.

By the time I arrived at Grand Central, it was 4:00 or 5:00 a.m. The sun was still down as we left the bus. Almost no one was there in that huge space. But I was in Real America at last. I walked up and down the stairs, looking over the scene from different vantage points. I could imagine throngs of people meeting their fates. My life was changing dramatically. Perhaps I would have an adventure. I was approached by a young man with a notebook.

It should be mentioned that the dawning day followed a historic 1952 night. Dwight D. Eisenhower, nominated as the Republican candidate for president, had chosen California Senator Richard M. Nixon as his running mate. Nixon was accused of some financial improprieties, and the talk was that Eisenhower wanted to replace him. Nixon, resisting the ouster, had given a speech to persuade the voters that he was a worthy candidate. He had said that his wife wore only a cloth coat—the family could not afford fur—and that although they had received a black and white dog named Checkers as a gift, they were not giving him back. The talk was a triumph for Nixon.

The young man with a notebook identified himself as a reporter from *The New York Times*! He wanted my impressions of Nixon's speech! Alas, I had nothing to say! I had been up in the air and on the road all night! I

asked him about the speech which he described in great detail. We had a warm and enlightening conversation. Grand Central Station and *The New York Times*! I was really living at last! Surely more significant events would be coming.

I boarded a train from Grand Central and rode north through the early autumn landscape, by then a seasoned traveler. When I alighted at the Back Bay Station, I met other Wellesley girls with their mothers, waiting for the commuter train to Wellesley. How thrilling it all seemed. But then I was hysterical from lack of sleep.

When our cab drew up at Severance Hall, my new home, I was enchanted. Surely Wellesley's campus is the most beautiful in the United States, if not the world. My little single room with its simple bed, desk, bookcase, chest of drawers and its concrete floor promised a hermit's life devoted to meditation and great thoughts. The single leaded casement window overlooked my own little slice of beauty, not an ocean or even Wellesley's Lake Waban, but the small Longfellow Pond by the shores of which the great poet had read his works to students. I closed the door, pulled my coat over me, and went off into a happy sleep. A couple of days later I walked to the village and bought a couple of yellow blankets and a green corded bedspread. I later added a black canvas sling chair with a metal frame. And that was it.

We registered for classes, bought books, had many meetings on the honor code and the library, had our meals in Severance's dining room. All was interesting and new, thrilling in the sense of being part of traditional activities.

My most lasting observation was how seriously everyone took this college business, both faculty and students. They really applied themselves to their books. They spent hours reading and writing their assignments. I was still inclined to flip things off in the high school mode. It took me a long time to learn how to apply myself, and many years after Wellesley, I still have lapses. But I also have the results of Wellesley's greatest gift to me, an appreciation of the life of the mind. How different these years would have been without it.

–8–
Wellesley and Brattle Street

I felt very privileged to have been plucked from the West Coast and placed on the East Coast. Going away to a demanding women's college in the 1950s had been nothing that I had ever thought about, and actually getting there was a result of accident, luck, a generous family, and my sense of adventure rather than my desire to be a learned person. The experience turned out to be all I'd hoped for and much more, but I was not the disadvantaged little girl from the West who came to the big city, worked hard, and triumphed. Far from a triumph, Wellesley was a sobering experience.

The college was more intense than I expected. I certainly worked harder than I wanted to. Other people were better prepared than I was. Sometimes I caught the vision and was absorbed in learning great things. Sometimes I did my work in a perfunctory way. I did not become a distinguished student. The beautiful campus, with a big lake set into acres of lawns, gardens, and trees, dotted with elegant, weathered stone and brick buildings of the Collegiate Gothic style, was distracting. Adventures off campus were even more distracting.

Maybe it was because of Church teachings that I did not really buy into my Wellesley education. Being at the college was a great adventure and opportunity, but I did not think of a career—nor did many girls of that time. I had thought of studying political science and joining the state department, but that was only a hazy notion, and I did not like my first and only political science class. I majored in English because I liked reading novels. Margaret Clapp, our acerbic president, hoped that we would not all graduate and disappear into suburbia, that we would instead pay back for our privileged educations by improving the world. Social work, teaching, and foreign medical missionary work were considered pretty good paybacks. But I was a good Mormon girl and saw my only future as a wife and mother.

Wellesley was farther from the ocean than I had thought—twelve miles—a cloistered ivory tower in the countryside. But staying on the campus all the time was claustrophobic. Many students stayed on campus month in and month out. But I got off each weekend for dates and to go to Cambridge for a long day at church.

When I began as a freshman at Wellesley College in 1952, I called the mission office and asked for directions to the ward building, then an aged, dark, Longfellow family house on Cambridge's Brattle Street. I was quite scornful that the missionaries were unable to provide clear and concise directions on how to get here. What were they there for, if not to help people get to church? I eventually discovered that the trip was very complex. It went like this: twelve minutes by bus to Wellesley Hills, fifty minutes by bus to Boston (Mechanics Station), ten minutes by subway to Park Street, ten more by subway to Harvard Square, and ten minutes by bus to where the man said I'd be able to find Brattle Street. I finally came in on the long-gone Mount Auburn Street streetcar and walked up through the then-scruffy Longfellow Park. It was a long and complicated journey.

That first day I was incensed and grumpy. When I finally met some of the other college students, my question was, "Why did the Church ever buy property in this slum?" Not a very nice thing to say when the Church had sacrificed so much to buy two spacious and significant houses on Cambridge's finest thoroughfare. But after beautiful San Francisco, I found Boston drab, frumpy, full of treasures, but too sure of itself to bother to show them off. Boston and Cambridge are much better looking now than they were then, but still it was insulting and jejune for a brash westerner to say such things.

Still, the snide comment was a great benefit to me in that year since a Harvard sophomore who had grown up in Cambridge and whose family lived in nearby Belmont took me on as an almost-lost cause. He decided to educate me about the glories of Boston and Cambridge. Once a week he took a bus to the family home, borrowed a car, and drove out to Wellesley to pick me up. Then on the twelve-mile ride back to town, he would lecture me about a magnificent site we were about to visit. "Today we are going to the Saugus Iron Works and this is important because. . . . We're going to see the Christian Science Mother Church and the mapparium. . . . The Cooper-Frost-Austin house is the oldest house in Cambridge, built in. . . ." He worked hard on his preparation and learned a few things himself. He also took me to Celtics and Red Sox games and explained the only sports strategy I've ever learned.

He was just a year older than me and had never had a girlfriend, but he knew a lot of things about which I was ignorant: Boston, collegiate culture, sports, and several other topics. He discovered that I had failed my driver's test and had no license and tirelessly drilled me in all driving aspects, demanding that I take the test over Christmas vacation. I did, and

thanks to him, I passed. He took me to many important places, and best of all, to many Harvard events. We went to three-day football weekends complete with games, dances, concerts, dinners, parties, and plays. I owe him a great debt. It's because of him that I can discourse knowingly about the Cooper-Frost-Austin House and the Saugus Iron Works. It's because of him that I know the Harvard songs and those of many other Ivy League institutions. It's because of him that I can drive. We had an extensive correspondence and sometimes talked all night on the telephone.

It was a romance, but an innocent one. We just had lots of good times together. He who felt he knew so much more than I did adopted a senior tone with me. He had had the best prep school education and therefore thought he was superior. He was certainly a snob. He did not credit my experience at all. He saw me as a blank slate. He was my Svengali. He was going to shape my mind. I felt more mature and worldly, so I didn't let him get away with too much. I knew plenty of things he didn't and frequently reversed the situation. For him I was a work in progress.

After a while, I began to take him to concerts and art museums and tell him why they were important. As a result of this activity of students teaching each other, we became very close and devoted friends, we both became better informed, and I became much more appreciative of Boston. I've been to lots of places in the vicinity, and I did come to appreciate Brattle Street. I also went out with lots of other people.

When I first came to church in Cambridge, we met only in the morning for Sunday School. The trip in took longer than the service. This difficulty was alleviated when I discovered that Clare and Rulon Robison, long-time pillars of the Church, brought the Wellesley girls to church.

Soon after my arrival, the ward instituted a sacrament meeting in the evening, so there were both morning and evening services. The Robisons still came in in the morning, but then they went home. I wanted to stay on for the evening meeting. This meant that I was soon lunching and museum-going with one male student or another because, for one thing, I frequently forgot to bring carfare and lunch money and had to charm someone into taking me to lunch and then persuade someone with a car to drive me home to Wellesley. That kind of attention is what girls expected in the old days. I was often not home until ten in the evening.

I loved coming to church with its variety of interesting people. I particularly liked teaching Junior Sunday School which I was soon asked to do. Wellesley was a paradise, but it was occupied only by girls ages 18 to 22 along with a few desiccated professors and administrators. I, who

had been very active in church (but also very casual about it), now spent entire Sundays going to church. At college I stopped doing schoolwork on Sunday. I became a better church person and a more serious scholar.

The church student group was small and tight. I learned right away about other students whom I had not yet seen. Chase Peterson was the senior member of LDS students in Boston, having been to prep school and Harvard College, and about to attend Harvard Medical School. He was widely admired, and I was informed one Sunday that he was in the infirmary with mumps. I joined a group that went to see him, eager to meet this heroic paragon. But there he was in flannel pajamas, suffering from a childhood illness. I was still impressed by his stylish nonchalance.

Richard Bushman, another important yet absent student, was away on a church mission to the New England states. The headquarters of the New England States Mission of The Church of Jesus Christ of Latter-day Saints was in another old house, next door to the old house where we had church. I guess that people in the Salt Lake missionary office thought he had learned the language and would be able to communicate with and convert the locals. He had told his Harvard friends that he would be going to some exotic clime to preach the gospel and was somewhat crestfallen to discover that he would only be moving next door. Missionaries were in short supply during the Korean War. Many young Church members were being sent to Korea as soldiers. Richard, from Oregon, was able to get a religious deferment.

I wrote a lot of letters home from college which are now in Special Collections at BYU,[1] and they make pretty good reading. Here I was at this elite institution, supposedly imbibing the wisdom of the ages. I listed the courses I was taking and reported on upcoming hour exams and papers due, mostly with dread. I quoted bits and pieces I picked up here and there, occasionally including schoolwork and the grades I was given. But real evidence of my schoolwork was in short supply. In my letters, I

1. My college letters were in the papers of my mother and grandmother. I contributed their papers to Special Collections at Brigham Young University in 1978, soon after my mother's death in 1977. My mother and grandmother were voluminous correspondents and I turned out to be one, too—too often adopting cute words such as 'twould, 'twill, 'twas, and m'old—often preferring to write home rather than writing a class paper or studying for a test. It must be admitted early on that I was writing for a specific audience that expected me to do well, to appreciate my opportunities, and to be happy and that I was probably not nearly as upbeat from day to day as I presented myself. Some of the background for this narrative also comes from journal entries I wrote in March of 1955.

talked to my parents about the beautiful campus. I described rowing crew on the lake and walking around it. I joined organizations that produced plays, discussed religion, and kept up with current events. I talked about auditioning for and being accepted into the best a capella singing group, the Wellesley Widows. We traveled New England to sing at colleges for big dances and house party weekends. Those who invited us provided lodgings and blind dates, and we had lots of adventures. We sang our four-part standards with the Yale Whiffenpoofs, the Princeton Tigertones, the Harvard Dunster Dunces, and many others at octet concerts and special events. It was a real plum for my extracurricular life.

I described places I visited and people I met, but mostly I talked about my tangled and exciting social life. An exception to this is the first paper I wrote for my English composition class. My teacher said that it was the best first theme in her two sections of English comp, but she still gave it only a B-. This was in the days before grade inflation when students earned honors and dean's list status with a B average.

Miss Dyer said of this paper and my future work that my biggest problem was that I "write too easily." She said that my papers were "beautifully readable" but not "technically good." At first, she was overcome by my fresh style, but she soon got over that. So much for natural talents. Of course, I did not write easily. I had never been a writer and had to extract every word from my mind with pincers. My training in high school and my aspirations in life had been modest. When I reported my grades in that English class to my parents, I said, "My English grades run thusly, don't faint. B-, D [that was the paper where I dismissed Plato's thought as simplistic and outdated], C, C+, B-, B-, B+." There was improvement, but I did not prevail. And yet I went on to become an English major. Here's the first paper with the professor's comments in brackets.

Why I Came to College

> I have some of the usual noble reasons for coming to college. I enjoy being exposed to intelligent people and doing some learning myself and I know that the associations will make me a better person, easier to live with and of greater use to society. However, on closer examination my reasons show up as dreadfully petty and selfish. Nevertheless, I am not ashamed of them. [The teacher wrote, "Excellent paragraph."]
>
> First, I have always had a strong, secret desire to become important. I admire well educated men with power, honestly gained, who have gone to college and emerged to climb to positions of importance in business and political fields. I understand that one good way to become a big shot is to start in a little world and become important there, then to gradually work into bigger worlds. We start this

[faulty reference] in our families and carry on with grade and high school. College is one more proving ground before stepping into the world, and campus politics and activities provide a fine opportunity for proving. [vague. Proving has a moral sound which just doesn't seem to fit in. Your very good thesis breaks down here. The point is not made. Get back to desire for own importance.]

Second, I have come to college to build the foundation of my future life. [cliché] Here I expect to make friends who, along with those I already have, will supplement my knowledge [how?] and share my good times. I expect to take a course, one which will prepare me for a job in the outside world which will be beneficial to the community and will satisfy my longing for importance. Here I hope to find my future husband, a nameless someone, at present, who should also be going to college now and may be doing so nearby. Whether I find him now or not and whether I fulfill my wishes or not, I shall soon discover. However, regardless of these things, I expect these four years to be among the most formative, informative and joyous [wrong word. Use satisfying] years of my life.

Before the limited success of that first paper, I had wondered if I should just go back home to San Francisco's City College. I wasn't prepared for this demanding school. I didn't have enough background. I had poor study habits and I didn't really catch the vision of how to succeed. I never really did. I felt intellectually poor. I was not one for deep thought and earnest endeavor.

In the social line, I was a very successful college student. At the first house meeting, with freshmen all over our Severance Hall living room, in came the person who was "sitting on bells"—our description for answering the phones, to say that there was a long-distance call from a boy for Claudia Lauper. Talk about social success! I went out to converse with Fred, a young man I had met at Yosemite Park during the past summer who attended a college some three hundred miles north. He was coming to Boston to spend a weekend with me. He did, and we had a pretty good time even though we were both so ignorant about Boston that we couldn't find anything we were looking for. Our continued relationship never went anywhere, but I was always grateful to him for making me look good that first week.

The freshman class was divided between all the many dormitories and settled in little knots in each of the halls. Our group of seven freshmen was one of several small freshmen groups scattered over Severance Hall. Our basic unit was two double rooms and three single ones. All of us were far from home. Developing an off-campus social life was no cinch for girls located twelve miles from Cambridge. Three of the girls in our group were already attached to the men they would marry. One still went out with boys she knew from home at local colleges. Two had little social life at all. I, with my church connection, had the best opportunities.

Wellesley and Brattle Street

The nearby colleges had a series of "mixers" each year to help students become acquainted with each other. Busloads of people were brought from one campus to another for these ritual events. I went to some of them. You danced with someone for a while, and if he liked you, he'd take your telephone number. Then you danced with someone else. Or horrors, you remained unasked on the peripheries. I was dancing with one of the Harvard students at a Wellesley mixer when another young man cut in. He was tall, dark, and attractive with curly hair. He was also an excellent dancer. When I had to leave early, he brought me home. He took my telephone number and said he'd call.

Later one of the girls in my dorm, in discussing the mixer, said, "That was a Negro that you were dancing with, wasn't it?" That possibility had not occurred to me, but dancing with a "Negro" at that time and place would have been a potent social statement. Was he, in fact, as described? And, if so, should I go out with him? This possibility became a cause célèbre in my dormitory. The girls discussed it at length, I wrote my parents for advice, the house mother said that tolerance was one thing, but. . . . Still, we had had a great time together, so I decided that if he asked, I would accept.

I wasn't home the first time he called. I was busy the next two times he asked me out. I doubted that he would call again. But he did. And by this time, my whole dorm favored the date. So, when he called, we went to a dance and had a wonderful time. We had such a good time that as he left, I broke my solemn vow and kissed him goodnight, a much more demonstrative action than I planned. After that, I could not go out with him again and so, despite repeated invitations, I didn't. His race was never determined.

It was an innocent time, for most of the people I knew anyway—much more innocent than my high school life had been. For all our festive lives, we were quite restrained. I noted in a letter to my family that I was surprised that the students were so sober. We went to parties where no one drank and only one girl smoked. "Very few girls on our [Wellesley] corridor, have ever had a drink, and only two have ever been drunk." I was surprised by so many abstainers.

Many of my relations with young men developed into literary correspondence. We went out on the weekends, but during the week we wrote letters. I was also writing to young men I knew at home and had a really thriving set of relationships. I filed these letters in shoeboxes by name and date. Many of the young men I went out with were very bright and articulate. They wrote well and persuasively, often fueled by unrelieved,

raging hormones. I loved these letters, which were full of news as well as devotion and flattery. Yet later, when I became engaged to my husband, I felt that I must destroy them. I burned all those wonderful letters in my San Francisco fireplace. What a sorrow! I have regretted it ever since. Very few escaped the flames. I had a platonic relationship with D. K., a west coast Harvard man with smoldering dark eyes. He himself has been gone for many years, but two of his letters have survived because I sent them home to my parents as objects of interest.

> Dear Toddy [as I was then known]
> Your handwriting reminds me of young rice stalks in a typhoon in old Kwangtun: beautiful. Coupled with the hurricane of your delivery it sweeps me right off my feet. As I flail in the upper atmosphere, of course, I get the momentary feeling that such women are dangerous, but I fancy that after all, with a sturdy whip and merciless torture, I could keep you safely in hand—at least long enough to make a getaway.
>
> I am amazed but not taken in by your evasions. Your feminine guile is obviously highly developed, through years of misleading innocent young males, but this only intrigues me. I long to study at the feet of such an awesomely fair and dangerous practitioner of the arts of the fair and dangerous sex, if only to learn about the techniques that promise to enslave and destroy me. Like a moth to a flame I am swept to the telephone.
>
> Not just yet, however. My exams don't end until Friday, and I'm having a hard time getting by.
>
> Hasta la vista

That one was pretty remarkable, but how about this much later one from him, urging a freer life. Who could resist? Apparently, I did.

> Dear Toddy,
> Scrap it. Scrap it without wasting another hour on it.
> Your morality doesn't fit the facts; it doesn't help you; and it doesn't help the world. You'd be a useful citizen if you turned your fight from teapot tempests over your own throbbing vitality to battles with real problems.
>
> Why not let loose your energies on a broad front unencumbered by worthless petty restrictions? Those rules of yours aren't keeping you celestially angelic! The real you is as sexy and devilish under a Mormon code as she could be. You're knuckling under before a lot of hooey, throwing away a chance to be really great just to be hypocritically goody-goody.
>
> Mormonism may be good enough for some people, but it isn't good enough for you. Scrap it.
>
> Your friend, D.
>
> P.S. Wine is good for you, tasty, harmless, and turns your poor man's meal into a banquet. Intelligent men at every age have drawn relaxation and regeneration from it.

> Kissing is great fun and is practiced in all societies for its entrancing pleasure: It has all the delights of light music. You should gaily cultivate the art.
> Sex has a thousand aspects, all innocent in the right hands. Much may be learned by the modest young lady, and the knowledge gained will serve as the cornerstone of a happy, sincere and fruitful marriage.

When one young man who wanted to become my correspondent sent me a letter, I responded that he would have to be more entertaining if he wished to continue the relationship. "His return," as I wrote to my parents, "was 28 pages long, entertaining and with 12 cents postage due."

The church situation was wonderful for me because there were a dozen or so really stellar young men gathered together who would have been standouts anywhere. And at that time, there were very few eligible girls. I was eligible enough, but not the good, sweet, beautiful girl generally favored. Still, I got quite a rush. I have one letter left from a handsome, well-off graduate student who was eager to marry me in Massachusetts while I doubted that he would have even noticed me in Utah. I liked him a lot. My family was enthusiastic. I might very well have married him if the timing had been different. But I was a just a freshman and had not been interested in marriage.

In the letter from him that I sent on to my parents, he acknowledged that I was not ready to marry him while wishing it were otherwise. He was going off to find a wife elsewhere. Here's one paragraph of the letter.

> I got a kick out of talking to E. yesterday morning. He asked me why I was going [away] next year—and I told him a big consideration was that I didn't look forward to a bachelor's status for three or four more years (might as well be honest about it). He said, "What's wrong with the girls here—you should be able to find one if anyone can" (which isn't true, of course). So I asked him to name the prospects, and he said, "Well, there's Claudia—and Claudia—and then, Claudia!" What made it so funny was that several other people have used those same words to describe the situation. I'd say that there was a chance of you getting spoiled from all the attention, but then it'd probably happen anywhere.

That same young man rated his girl friends on eight counts, as many young people used to do. He would score them on personality, disposition, religion, face, form, family, intelligence, and culture. I was told that he had given me a full score in all categories. But I don't think that it would have happened anywhere else. I was and am amazed at my social success. I did have pretty clothes (one young man asked if I didn't ever run out of new outfits), I was at Wellesley which was impressive, and my father was made stake president in the Church in San Francisco which

gave me points in the religious area, but I knew that I got attention I did not deserve.

I had a much more interesting social life than my new classmates. They knew a lot and worked hard, and they spent more time on campus than I did. There were people from well-known families. I was told that 80% of the Wellesley girls had been abroad and that over spring vacation they all flew down to Bermuda to cavort on the pink sands, destinations that I could not even consider. Yet for all that, I thought that there were more beautiful girls at Abraham Lincoln High School in San Francisco, perhaps because it was more important there. Many Wellesley girls seemed young, inexperienced, even naïve to me.

Having an available, undemanding boyfriend at church, as well as these others, was a great plus for me. My guide was generous and willing, and he took me to great places. When spring came along, I invited him to the big Wellesley weekend known as Carousel. My girlfriends in our dorm discussed the Carousel event and applied a point system to see which of my swains would get the coveted invitation. He got points by having a car, being able to get blind dates for my friends (which he did), being able to get along with me for three days, being handily located so I wouldn't have to pay for rooms, presenting no drinking problems, and several other reasons. He and I had a great time at Carousel and began to tote up the hours we spent together on these long weekends, sometimes staying up all night to increase our scores.

Later on, I told my faithful swain that I didn't think that there was any real future for us. He wrote a nice letter which said, "A history—a long one—of many happy times together deserves a better fate." He said that his "self-respect had been taking a beating ever since anger and pride working on sincere disappointment got out of hand." I think he really tried to do what he thought would make me happy. First, he had a long talk with his school friends about how we had broken up, so they were surprised to see me again at all. Then he went to a mixer where he was careful to be seen by many people, eight of whom reported the sighting to me. Then he fixed himself up with a blind date for a game and dance. When he next took me out, he reported that "he had done everything with a purpose and now his purpose had been accomplished."

Then there was my academic life, the real reason for it all, which continued to not improve. My final grades one semester, in classes that I liked, were a miserable C- in history, C+ in French, C+ in Bible, B- in English, and B- in art. I just could not get the hang of being a good student. I know

that this was a concern to my family. They must finally have sent me an ultimatum, for on March 10, 1954, I issued a grim defense. I felt forced to defend my grades, saying that I had chosen Wellesley for the varied opportunities offered outside of classes as well as the schoolwork. I said that I thought it more dangerous to be one-sided scholastically than to do fairly well all around. I said that my time was not badly spent. That I "got up at 5:30 went to bed at 10 and spent 7–11 hours daily on classes and schoolwork six days a week," and I guess I did sometimes. "I do not study on Friday or Saturday nights or Sundays, except for occasional study dates on the former two. I feel that any more time spent would bring diminishing returns." My parents thought that a "quick, intelligent, well read" person like me should be getting better grades or had better go to BYU, and that I was wasting my opportunities. I pointed out that I had many perfectly good credits. I finished up my two-page defense like this:

> I did not come to college to get a husband, my education is important to me. I do not knit, play bridge or work cross word puzzles; I feel that my extracurricular activities are constructive ones. Of course, I feel terrible to have disillusioned you. I hope my grades will come up this semester, but I don't see how I can work any harder.

How could they not feel as they did? And they were right. I should have done better. I should have had better grades. I should have been able to get As. I just didn't know how. I couldn't do it. And how could I say that I wasn't there for a husband when all I talked about was my social/love life? And while I defended myself with haughty superiority, I agreed with them. I had been given a great opportunity and I was squandering it. How could I not feel like a failure? I was certainly having good times, but I could not justify them.

The Latter-day Saint congregation was beginning to raise money to build a chapel. We were a poor little branch and I wondered how it could ever be done.

We had ward suppers. We made small individual donations. We did little projects. George Albert Smith Jr., our most established and successful member who taught at the Harvard Business School, wrote to his friends and to the former branch members and asked for contributions. We had to raise fifty percent of the cost of the building then–a great deal of money. I thought that there was no way we could ever raise enough, but suddenly we were ready to build.

The local establishment was not pleased that the upstart Mormons were building on the exclusive Brattle Street. They criticized plans for the

large, blocky building on that residential street. Some changes were made to the plans. Bill Cox, the cigar-chomping engineer and insurance man married to our Relief Society president, was a potent force in policing the construction. He came every night to see that any slipshod work was torn out and replaced the next day. Cox reconverted himself to the Church by this building construction and went on to become a potent branch president, bishop, and later Manti Temple president where he singlehandedly, according to my sources, prevented the "modernization" of that august building by making the rooms smaller and covering up the murals. He was one of the "Irascible Saints" common in Mormonism.

For spring vacation of my freshman year, I went to Washington, DC, with some college friends. I had never been there before. We saw many wonderful and fabled things, were thrilled by the flowering trees which were a month ahead of our Massachusetts blooms, and went to museums and significant restaurants. I climbed the Washington Monument in my high heels and still have scars on my heels to show for it. I left Washington to visit a girl in New York. She lived with one of my mother's friends who kept a large apartment and served as a sort of housemother for three or four students or working girls. She lived at 111th and Broadway and she and the girls really lived the enviable New York life.

With her instructions, I went off to see the nearby sites: Barnard College and Columbia University, Riverside Church, the Cathedral of St. John the Divine, Grant's tomb, and the Hudson River. These things were all near her apartment. More than forty years later I came to live in that very neighborhood myself. I know these famed places in a way that I never thought I would. So our lives turn and turn.

This had been a broadening spring vacation and we were soon moving toward the end of our freshman year. I was summoned in to speak to the scholarship committee. The committee members said that ordinarily my family was too well off to justify the $1,000 scholarship they were giving me, but that it was "an incentive to lure girls" from the west and due to my tremendous record at home and *at Wellesley* that they would do their best for me. They talked about how Cs were good grades there. I found this a confusing meeting, but I felt assured that my scholarship would be continued.

I returned to San Francisco for the summer and worked, saving my money for school. I had many good times at home, met new people. When I returned, several of my former beaux had moved on.

–9–

Courtship

People ask from time to time how Richard and I met. I have told the story in various ways for different occasions. Much of what follows comes from a brief journal I kept in an old brown binder in which I wrote back in 1955. That's sixty-nine years ago at this writing. I have cut, added, and edited to provide explanations and to protect the living and the dead. I mostly call the man I eventually married Dick Bushman in this account. He later, about 1992, became Richard Lyman Bushman.

Monday, March 1, 1955

After Richard Bushman had been at Harvard for two years, he was called on a Latter-day Saint mission to the New England States. At that time, the Church mission home in Cambridge was immediately adjacent to the chapel, both located in old houses built by the Longfellow family across the street from Henry Wadsworth's very grand house. Dick had thought he would be sent to some exotic foreign location. Instead, he moved next door, as it were. He was active in that small church group, well acquainted with the mission president, J. Howard Maughan, and the mission personnel. The president's wife always called him Dick, rather than Elder Bushman.

Fewer missionaries were then serving because eligible young men were being drafted during the Korean War. Dick got a mission deferment because he lived in Portland, Oregon, where prospective Latter-day Saint missionaries were few. Many Utah boys went off to war instead of off to proselytize. The New England Mission had only about fifty missionaries during his time, maybe a quarter of their usual complement, and Dick was frequently sent off by himself to supervise the distant elders in all the New England states and Canada's Maritime Provinces. President Maughan instructed him to stay away from the bad influence of his college friends.

Dick was serving in his second mission year when I arrived for college from San Francisco. He had begun college three years before me, and so after his two-year mission, he would be only a year ahead of me. I heard about him from young people at church as soon as I arrived. He was a fabled figure, spoken of with awe. The two most memorable stories were that in running for the student council as a Harvard freshman, he had

knocked at every classmate's door and asked for support. He was elected. Could I imagine such a driven person? The other story was that after the election, Dick refused to nominate another church friend for the presidency of the student council. He said he preferred to support the other candidate. I thought that Dick must be a hard man, one to avoid.

Our actual fateful meeting is a blur. A group of the LDS students gathered in a Harvard room, Lowell O-34, one Sunday evening. Elder Bushman arrived, alone. Why, we can never remember or determine. He must have had a reason; he was not one to break rules. He turned up at this forbidden gathering of old friends and we met. He says it was passionate love at first sight, although missionaries were strictly forbidden romance of any kind. I have suspected that he had heard about me, as I had heard about him, and that my church credentials and my Wellesley credentials suggested that I was a more serious student of religion and academics than I really was. The meeting was soon over. In 1955, I wrote this.

> During the first month of school back in 1952 I met a young elder named Richard Bushman. The group I was with had spoken more than highly of him and I was not disappointed when he talked to us. . . . He was both thoughtful and articulate. However, his reddish hair grew down over one eye in the manner of a romantic poet and my total impression was, "What a lovely boy; I wish he'd cut his hair."
>
> I saw him occasionally at church when he was in town but avoided him when I could. He was so intense. One Sunday when I couldn't get out of the way fast enough, he forced me to reveal plans for a political science major and then proceeded to pry out my views. I didn't have any and only blushed painfully and tried to get away, vowing not to get caught again.

Otherwise, I had a lively social life and was enjoying myself. I went out with several young men at school, plus a few at home. My mother felt I should go out with many people, and I did.

The next year Dick returned to Harvard as a junior, and our relationship began in deadly earnest. He was not very nice to me. He was stern in his invitations, as if this were an unpleasant duty that he had to perform. We usually had study dates at the old Wellesley Recreation Building. He seemed so much more mature and serious than I was that we could hardly manage to carry on a conversation. I knew he disapproved of me. I was always surprised when he called and asked me out, or in, that is, to the Rec Hall.

I, who had been used to going to every football game, every dance, and every concert, found my social life much straightened. Sometimes we walked on the Wellesley campus. Sometimes we attempted to try a

little dancing in the Rec Hall. Always our conversations were painful and awkward. After a while, each date would be followed by a letter in which he would bawl me out for something or lecture me on something else. I hardly knew what to think about this.

During Christmas vacation, I received some unexpected communication from him: a couple of letters and a book about a former Wellesley president, Alice Freeman Palmer. I was very surprised that he should be so nice to me. I read his letters to my father because they were so well-written, and my dad suggested, in the way of fathers with four daughters, that I should marry this man. I said that there wasn't a chance; he was the finest of young men but beyond my deserts. Mother gave me the usual lecture about how I could have anything in the world I wanted, but I was not convinced.

During the summer, I went out with several interesting young men and had a good time. Dick passed through San Francisco with his family on the way to Los Angeles. I looked forward to having him come, but when he didn't call when he said he would, I accepted another date for the evening. I agreed to see Dick the next day, but again he didn't call. I assumed he really didn't want to come, and I went out with someone else.

Back at school, he invited me to a concert several weeks in advance. That turned out to be the weekend of the Dartmouth game and surrounding events when another young man and I usually did a solid three days of the big football weekends. We both thought Dick wouldn't mind my breaking the concert date as he was a good casual friend to us both. But Dick insisted that the date go through. We had a nice time at the concert, although I could not be at all spontaneous. I was ladylike and dull all day. He made an obvious point of being nice to all the unhappy girls at church. I resented being classed with the lonely girls, people who needed help. But he was very nice that night.

The next week we planned to attend a lecture by Arnold Toynbee, but the crowds beat us there. I was having trouble defining my position. Dick must be doing more than just being nice to call me all the time and to take me to some nice things, but I was always miserable in his presence: tongue-tied, stilted, and stupid. Not even decent company. He was stern and silent. There was certainly no romance. He continued to ask my opinions on things I knew nothing about and treated them seriously. About then I decided that the whole thing must be a plot of the Cambridge church boys to play a trick on me. I determined to enjoy it as much as possible but not to be taken in. And it was flattering. I liked having Dick

around. I knew that he was much sought after. I hoped I would be none the worse for the experience of his company and that I could survive with some dignity when the game was over.

Then on the evening of November 18, Dick came out and suggested we take a walk. He brought a white carnation on a long stem. We walked and I played with my flower. Dick wore a long red scarf and carried an umbrella which he later broke. It had been raining. We wandered to the lake's edge and sat in a spoonholder on Tupelo Point.

The Wellesley campus is built on the shores of beautiful Lake Waban. A path running around the lake boasts four or five rustic little nests with benches for conversation and for viewing the lake. These are called spoonholders, and they exist to hold the spooners. On our walks around the campus, we often stopped to sit in one and talk a little. The campus legend is that after being walked around the lake three times, a couple would stop in a spoonholder and there would be a proposal of marriage. Richard did not know the part about walking around the lake, thinking we had only to visit the spoonholders. I had no idea of any serious intent for this walk.

On that fated evening, unseasonably warm, Richard sternly and seriously proposed marriage. I was completely surprised and undone. He said that he loved me and had for some time. I was astonished. I was not completely naive. I had already had a few proposals and could read the clues. But I never saw this one coming. Instead of leaping up in enthusiasm, as would be expected, I wondered if he was serious, saying that he did not know me at all. And he certainly did not. I liked frivolous things: nonsense poetry, Gilbert and Sullivan, Broadway musicals, birds, fashion, good times. He was serious, ambitious, driven. I could not believe that he wanted to marry anyone like me or that he would have suggested it if he had any understanding of what I was really like. Other girls were much prettier and more religious than I was. Why was he proposing to me? I was shocked, but also thrilled to be loved by such a man. I came home quite dazed but very happy. Marrying him was a new idea.

Of course, he tells a different story. His memory of the evening was that I had accepted him and that we were engaged. I thought we had moved into a new limbo. We continued our tortured relationship.

Occasionally we went to a movie. I remember once that we went to see an adaptation of John Steinbeck's *East of Eden*, another story of tortured relationships. After the movie I burst into tears and sobbed and sobbed. Richard did not know what was wrong with me and I certainly

Courtship

could not tell him. The tensions and frustrations of our relationship had burst through. I felt disoriented, living my life through some kind of fog.

The last night of November, the day before he left for an appointment at West Point and home for Christmas, Dick came out and we walked and danced, and he insisted that I stop in Utah on the way home. I was hesitant. My family, however, was in favor of the visit so I began negotiations for tickets. Still not certain I wanted to go (I would have to impress the Bushmans, wasn't really presentable, and was still not comfortable with Dick), I didn't try hard for tickets. Then I got sick and went into the infirmary a few days before leaving. Mother made reservations in San Francisco, Dick made them in Salt Lake City, and I decided against going. En route home in Chicago, I realized that I could change my flight and stop in Salt Lake. But I was $5 short of the needed funds. I got back on the original plane, feeling sorry for myself, though really glad I didn't have to go.

I had a very good time at home. I had dates with about a dozen men with whom I could talk very well. I visited friends and helped around the house. My sisters were good friends. My dad's business was going well, and I loved my family more than usual. I dreaded going back to my hated dry cell at Wellesley.

Then there came a letter from Dick inviting me to Salt Lake to celebrate the New Year. After a quick family conference, I dispatched a hasty and delighted consent. On New Year's Eve, I kissed my family goodbye and set off. Dick met the plane and seemed very happy to see me. I forgot to be apprehensive. When the clock struck the witching hour, he kissed me chastely on the forehead and we went to his beautiful house to meet the family: his successful, good-looking father; his lovely young mother with a charming smile; Cherry, a stately, serious blond around my age; and Bill, a tall, clean-cut, American-boy type. We went to the church dance and danced until two or so in the morning and then came back to a party at the house with some nice young people.

At the end of New Year's Day, the family and I dined at a nice restaurant, and after taking his family home, Dick and I took a long ride and ended up high on Capitol Hill. I was wretchedly unhappy and couldn't say anything. I could not speak. Dick was sweet and patient but was obviously disappointed in my reactions. We came home very late. I shivered all night, a chronic upset while in Salt Lake. I wanted to profess my devotions but just could not do it. It was a bad night.

Richard and Claudia, c. 1955.

The next day was Sunday; we went to church and visited friends and my relatives. I was very stiff. Dick seemed to have known them all of his life. At an equally stiff dinner that evening, I knew I was a failure. I wanted to be gone as soon as possible. That evening Dick spoke at a fireside gathering to an impressive group of young people who obviously thought he was the tops. I enjoyed the fireside and with effort chatted around afterwards. I'd be doing quite well until Dick came around and then I would have nothing to say.

Courtship

The next day, Dick drove me down to Provo to visit my sister Georgia. I said about ten words the whole way, thinking of how I would tell people that it had been a very nice weekend and that I had really enjoyed it, even though it had been painful. I spent three peaceful days with Georgia: it didn't matter there whether I impressed anybody or not.

I hated to come back to school for all sorts of reasons. I felt a vague dread all the way. But after a few days, when I had dispatched all my thank you notes and gotten back into my courses, I felt better again.

After that visit I wrote to my family, "As to Dick and me, I cannot say. We had a lovely time and I don't think anyone was too disgusted with me. Dick, I love dearly and respect profoundly and who knows, this bud of romance may be a full blown rose when next we meet. . . . There's nothing to tell—not really. I couldn't be happier though."

Dick had sent a telegram from Kansas City to greet me on my arrival. Light in tone, it contained tempered terms of endearment and I was pleased. Maybe I hadn't been such a flop after all. On the day he was due to arrive, I returned to my little cell and found a pink carnation with a rather tender card. I put the flower in a water glass and hoped that it might be a positive symbol. I had a date that evening and so missed his call, but I called him at midnight when I got home. We had a very gay chat about nothing much.

Next Sunday afternoon he came out to get me for church. He sat on the dirty rug in my dorm room and gave each layer of dust its due; I felt newly inadequate. But we went for a short ride and enjoyed the countryside, if not each other.

Turbulent as my romantic life was, I was also having a hard time on the academic side. Somehow, I felt compelled to challenge one of my English teachers. I didn't like what she was teaching me. I went into the final exam with a B grade but determined to say what I thought was right and correct, and whatever that may have been, I flunked the exam. When grades came out, I had an A, two Bs, a C+, and a D. I had failed my English exam. I had tried to be honest on an exam, and I had failed it. I cannot even remember the issue.

Later that evening we attended MIT's Miami Triad at Boston's Hotel Somerset where the Wellesley Widows were performing. I just wanted to go home. Dick saw that I was grim and subdued. He repeatedly asked what had happened. How could I tell him? He was graduating magna cum laude. He was phi beta kappa. He was the class orator. How could I admit to flunking an exam? He would not want anything to do with me.

I finally admitted the awful truth and was amazed at his response. Was that all? That was of no significance. He was quite relieved that it wasn't something serious. What could he have imagined?

Miss Jones, my Wellesley class dean, called me in to talk about my grades. She wondered why I had fallen down in just one course. The teacher had described it as an inexplicable total collapse, an utter failure. Dean Jones offered college help for any problems, maybe some tutoring. She said that such things were usually related to problems at home. I admitted some personal problems, and she arranged an appointment for me with the school psychiatrist. This doctor, on call for Wellesley students, spent an afternoon a month at the college.

Going to a psychiatrist was serious business. T. S. Eliot's play *The Dinner Party*, portraying Christ as a psychiatrist, was then being performed. Freud was at the height of his popularity. We considered these mind doctors to be superhuman in many ways.

I went to see Dr. Snyder. What I had to say was that a romantic situation had reached a difficult climax the night before the exam, exacerbating my antagonistic relationship with my professor. I expected the psychiatrist to dispense some moral judgment, to say that my action was stupid, childish, and wrong.

I knew his time was valuable at $25 an hour. So I told this nice-looking young man everything bothering me about my romance and the exam as fast as I could. I did not know what else to say. He listened. He made a few notes as I talked. I ran out of things to say and stopped.

He said that writing the exam in that way was an unconscious attempt to get back at the professor, that there were better ways to do it, and that he could not get excited about my grades. I don't remember anything else he said. I rose from the chair a new person. I left all my troubles on the floor of the room. I felt cleansed, renewed. I felt as if I could be myself again. I was calm and happy and ready to commit myself to marriage.

Back in my room, I wrote Dick a letter unconsciously full of Freudian imagery, frank and loving, and told him what I felt and hoped for. I mailed the letter. Then, though I instantly regretted that action and mentally devised schemes for retrieving it, the letter was delivered.

On Thursday, February 17, I lived in real terror but heard nothing. At four o'clock, I went to a Wellesley Widows rehearsal. We were singing to the Harvard freshmen that night. On returning from the rehearsal, I was told that Dick had been calling all afternoon and that there were flowers. I dashed down and got my flowers, a dozen yellow and white roses. The

Courtship

card said that I should give the flowers names, half boys and half girls. I was joyful and overcome.

I chatted gaily with the Widows and our drivers on the way to Cambridge. Dick was waiting inside the door of Harvard's Memorial Hall. He'd had his hair cut and it was still a little wet. He enclosed me in a most welcome arm and said he'd see me after the show.

Afterwards, he drove me home. We walked to Tupelo Point, the same place we had been about two months before, and looking out over the lake, pledged our love. Dick offered a prayer of thanks and for help in the future. We were officially engaged.

The next day was the big Wellesley weekend, Carousel. Dick came out and we walked around the lake identifying coniferous trees. We torchlight paraded and watched *An American in Paris*, the Scotch dancers, and the octet concert before going to the old Rec Hall and dancing.

Dick came out before lunch the next day bearing daffodils and a balloon. We wandered the campus, identifying trees, enjoying the unseasonably nice weather. As a special celebration we drove to Boston for a ritzy dinner at Lock-Obers. We finished our very posh meal with Baked Alaska which we called "Baked Elastics." We chatted easily about many little things. The next evening we went to see the London Festival Ballet's version of *Petruska*, *Swan Lake*, and *Prince Igor*. We ran into many acquaintances, and I felt very happy to have my very own nice, handsome man at my side.

I received lovely letters of welcome and congratulation from the Bushman family in Salt Lake with high hope for the future. Already in a delicate emotional state, I had to do some face working to keep back the tears. Then I got a special delivery letter from Mother, very gay and highly approving. This was only the second of my young men of whom she had ever approved. Well, it would be difficult for anyone to disapprove of Dick. I responded to the congratulatory letters I had received and counted my blessings.

The next day the Wellesley Widows went to a recording session. We worked for about five hours and finished what turned out to be a pretty good record. Dick picked me up for dinner and we dined at Winthrop, his Harvard House. We then went to his room to have a little "chit-chat." His roommate Charles was out for the evening and Dick produced a stack of congratulatory letters. He took a bath while I read the letters and looked through his journal, then we laid some broad plans for our future together. Trust was first mentioned: we are to be complete and total confidants and

tell all. We are to respect each other and not only not to make fun of our love or take it lightly but never to flirt or pay undue attention to anyone else. We are to be constantly alert of ways to help others and of manners in which to disseminate the gospel. We planned lots of nice things we'd do for our children: take them out, teach them languages, learn 'em the social graces, teach them in the ways of the Lord, and stimulate their precocious minds. And we would be civic leaders and good hosts and kind to all and many more good things. It was a pleasant evening with many shared confidences.

I had never really confided fully in anyone before this and it was hard to tell him things that I would never reveal before, especially as his standards were so high. I kept telling myself that this was what made a successful marriage, and thank goodness it was a gradual process. I had to remind myself that this was a man I loved and trusted, whose only desire in knowing all my thoughts and troubles was to make us closer in unity.

We went to dinner at Winthrop House. Then we two went to the room of Dick's tutor, Bob Feer, to pick up a corrected fellowship application for a Rhodes Scholarship. I peeled him an orange. Back in his room, Dick read the fifteen-page application aloud for my criticism. I knew it wasn't perfect, but I could not find anything wrong with it. Besides, I practically went to sleep while he read it—not because I wasn't interested but because I was sleepy and warm. Dick thought I was bored and put his head in his hands so dejectedly that I tried to comfort him. He made a few corrections and I set about typing the application. I was half finished when it was time to go to church.

March 2, 1955 [from my journal]
I wasted a good portion of the day. Got a sweet letter from Dick's brother; the burden of the letter being what have you got anyway to get this great guy. I wrote humbly back—I don't know. Also wrote to Dick's mother. I hope that they really think I'll be all right.

My Mother seems to be spreading the good word with a spatula. She suggests a picture and formal announcement pronto. She imagines the bridesmaids in pink chiffon, beautifully draped and suggests that we have a small combo to play for dancing. Mother says she doesn't think I realize just how much Dick thinks of me. No, mother, it's past my comprehension say I smugly. . . .

Dick got a letter from Daddy today. Seems to have been in the formal vein with requests to know how much that Wellesley will cost him next year. I'm so glad Dad finally wrote him. . . .

From my window I can see the seniors trotting off to Honors chapel. In a few minutes I too will go and next fall I shall be wearing a black robe. Who would have thought that I would ever spend this much time at Wellesley and

now look forward to a clean stretch until graduation. Claudia Lauper Bushman, Wellesley 1956. . . .

<div style="text-align: center;">March 8, 1955</div>

My mail brought a warm, affectionate letter from Mother B., a picture of Richard (rather frightening in its intensity) and a lovely lacy slip for my trousseau from the family B.

Later, Dick and I strolled along the Charles for a bit and talked of the difficulties of expression. I hope I eventually get so that I can <u>talk</u> to him. Sometimes it is really bad. I don't know whether it's because his proximity just upsets me or because he doesn't expect me to be brilliant and I try to fit into the pattern. Anyways he's got himself a pretty mute woman who just must seem dull.

And so we were engaged. I had my picture taken at Bachrach's and it ran, with our announcement, in *The New York Times*. We planned and executed our own engagement dinner at the home of some friends.

I continued to be shaky and rattled. I went about forgetting appointments and assignments and generally making a mess of things. After our engagement dinner, I went on both academic and social probation at Wellesley. The college required that we attend "calendar day" classes the two days before and after vacations. I slept through a class the morning after the dinner and so went on academic probation, which required that I attend all of my classes for two weeks and sign in to show that I had done it. I went on social probation for missing my curfew and forgetting to sign out twice during that period. For that I was required to be in at 10:00 p.m. for a week. I pulled myself together after that for a while.

Dick decided, to my family's chagrin, that he should spend the summer with us in San Francisco. He lived in the basement and my father was impressed when he very quickly got a job, worked hard, and helped around the house and the church.

In August we had a big pre-wedding reception in the Sunset Ward Cultural Hall and then set off across the desert to Salt Lake City to be married in the temple there. As we pulled away in Dick's black Ford, my mother turned to my father and murmured, "I wonder if she's good enough for him." My own mother.

We still had trouble talking to each other, and we had some rough patches in our early marriage. Eventually I discovered that he was very different from the man I imagined him to be, and since then we have both felt very fortunate in our marriage to each other.

Claudia and Richard at their wedding reception in San Francisco, 1955.

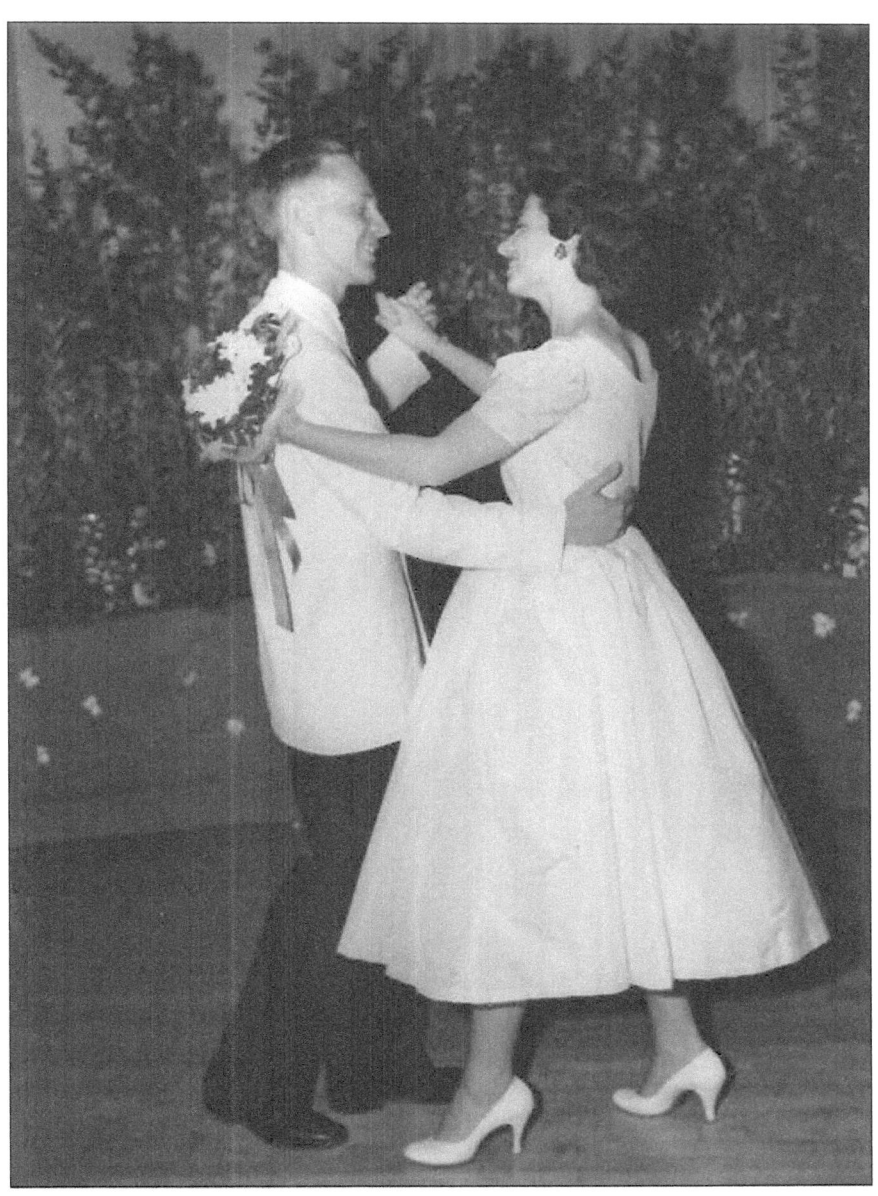
Claudia and Richard at their wedding reception in San Francisco, 1955.

—Part Two—
Marriage

–10–
At Home and Abroad

When I was married after my junior year of college, I became a student wife instead of a full-time student. We would be staying in Cambridge as Richard was beginning graduate school at Harvard, starting down a path that would take four or five years at best before he was employable. I began my senior year at Wellesley, a commuting student. The deans at Wellesley had discouraged our early marriage, revoking any further scholarship awards for me, saying that I would no longer be "contributing to the community." My family paid my tuition. I was grateful to them for that support and for the money. That gift was certainly more than they should have paid since my father had just begun a new business.

My parents would have been perfectly happy if I had stopped school, but I wanted to finish things up, even though I felt guilty about being a continuing burden. They had other children and demands. We probably should have waited until I graduated to be married, but marriage felt right for us at the time.

We were very happy. Our life was speedy and delightful. Dick (as he was called then) helped around our house, and he was always looking for ways to cut down the things I needed to do. I complained about how taxing my schoolwork was and the pressure. I still hadn't learned how to manage school. He said that if I could get Cs, that would be cause for rejoicing. Of course, he never got anything lower than an A-. I dutifully went to class, wrote papers, and took exams.

With the dignity of marriage and steadier habits, I should have improved as a student, but I didn't. I retired from the Wellesley Widows and other on-campus responsibilities. I did take on an assignment to speak at a morning worship service at the Wellesley College Chapel. I decided that since it was a church I might just as well talk about what I believed and preached some Mormon doctrines. Some people were quite surprised. That put me behind for a while, but I was glad that I did it. I did graduate, the first person on either side of my family to finish college.

Cambridge, Massachusetts, 1955–1958

We were now a married pair in the Cambridge Ward where we had been single students, joining the ranks of the young marrieds. I remember

Nora Cox, the Relief Society president, collecting my fifty-cents dues since I was now a member. Richard had been instructed to begin the program of the MIA, Mutual Improvement Association, throughout New England when he was on his mission. Now as young marrieds, we were called to supervise the New England Mission MIA, a church program for teenagers.

When we had become engaged, I was called to join him as the supervisor for the young women. Richard accepted for me, saying that the assignment would solve our entertainment problems. I noted that I had spent many Sunday afternoons reading the newspaper while he had been deep in his MIA business. And so I took on that church job which simplified future committee business.

Mutual Improvement Association, the forerunner of the Young Women's and Young Men's programs, was still in its infancy in the mission. I had grown up in this program and benefited greatly from its lessons, programs, and activities. Richard and I traveled around New England and visited the small branches of the church, encouraging meetings, activities, and reporting systems to bring along these young congregations. We organized mission-wide youth conferences in Cambridge, bringing in the kids from Maine and Vermont.

I was also asked to be chairman of our area's first overnight girls' camp—pretty remarkable since my lone camping experience was two weeks at Girl Scout camp which resulted in my being asked to leave the organization. But all these things are examples of the great opportunities we have in the Church. We are asked to do things that no one in another setting would ever ask us to do, and we learn how to do them. I have often said that everything I ever needed to know I learned at church.

We lived in a nice little one-bedroom apartment in a Harvard student housing complex. Our address was 25B Shaler Lane, a little alley off Mount Auburn Street, not far from the Charles River. Many young families with their babies and older children lived there. The women had a pleasant life, sitting on our stoops, playing outdoors, going on field trips to the grocery store and to church. Our husbands were off for school, mostly working on PhDs. It was a happy time.

My mother, who visited at my graduation, described the place differently.

> Their little place here is very shabby. The furniture, such as it is, beaten up and old. This little lane is about 25 feet across, filled with little children and tired looking young mothers. Whether you agree or not, you must give credit to these young people who struggle along in such humble places, while they

learn. Whose minds are hungry for knowledge, and whose aims are to impart it to others.

My mother was also clear-eyed about my commencement which she attended, concluding,

> Dick was taking an exam so he wasn't there, and if I had not been, Toddy would have been all alone in a huge crowd of parents and daughters. I felt so happy I was present.

Children

With school out of the way, I moved on. Of course, I had always planned to be a mother in Zion. What else would I do with my life? That goal wanted only reaching a certain age and finding an excellent husband, and the future would take care of itself. I certainly had no other plan. My mother hoped that we would not have children too soon. We were just graduate students with Richard's scholarship stipend as our only support. Going slow would have been a good idea.

My married sister Georgia sent me an extended description of the rhythm method of family planning which I looked at and disregarded. In the few discussions we had on the subject, my husband and I agreed that children were the result of marriage and the reason for marriage and that we should welcome whoever came our way.

I still prefer this traditional way. Who could ever find circumstances so salubrious as to make a conscious decision to take on the cares and responsibilities of a child from infancy to the age of self-sufficiency? Who, after having one, could choose to double those cares and responsibilities by having another? It seemed better to regard each new child as a gift, unsought and appreciated, rather than to wait until we could be responsible parents. Such views seem old fashioned today with serious costs and multiple careers at stake, a blithe indifference to reality, ignoring the many heartbreaking things that can and do happen.

But Mormons believe that children are blessings, that families are good things. Influential past leaders have urged members to "multiply and replenish the earth," to invite in as many children as they could produce. This belief has led to some very large families, but in practice, Mormons tend to have just one more child than the people next door.

Richard came from a family of three children. My family had four, which many of our acquaintances considered large. My mother came from a family of four, but my father was one of ten. Two of my sisters have four children and one has seven. Richard and I have six beautiful, bright,

Claudia and Clarissa, 1956.

and charming children. We were glad to welcome these little spirits as they broke through the floor of heaven.

Our plan served us well. We never had hard decisions about whether we were ready to welcome a child. We never suffered the anguish of being unable to conceive on schedule. We didn't worry that children would upset our plans and schedules. They were our plans and schedules. Richard became a father as he completed his first year of graduate school. I had read that the statistics for producing healthy babies began to turn against mothers at the age of thirty-six. So, married at age twenty-one, I had fifteen good years for bearing children. And along with other things, that's what I did. Our six children, who are both very much like us and each other and also very different, were born during that period. A list of their names, birth years, and places of birth provides an outline of our lives at that time.

- Clarissa Lucretia, 1956, Boston, Massachusetts
- Richard Lyman Bushman, Jr. (Brick), 1959, London, England
- Karl Edward Bushman, 1962, Provo, Utah
- Margaret Elizabeth Gordon Bushman, 1965, Providence, Rhode Island
- Serge James Lauper Bushman, 1966, Provo, Utah
- Martin Benjamin Bushman, 1971, Cambridge, Massachusetts

These birth dates show pretty good spacing, considering the lack of planning. There is only the quick advent of Serge in 1966 just fourteen months after Margaret in 1965. Their early years were tense times of managing the needs of two babies along with everything else. Ben was born five years after Serge. If Serge had been born two years later, things would have smoothed themselves out.

We planned to name all our daughters for literary heroines and all our sons for historical figures. That worked for our Clarissa, named for the virtuous letter-writer in Samuel Richardson's 1748 novel of that name. Clarissa was given no real middle name, but she took the initial L. of both of her parents, and she later unofficially expanded the L. to Lucretia. There is no question that Clarissa Lucretia has a certain heft.

So, it was with pleasure and without surprise that I announced to our parents that we would become parents about October 1, 1956. I hadn't seen a doctor, but I had the symptoms. Then began a time when I worked through fatigue and sickness, when I never felt well, when Mother Nature reminded me every minute that something important would soon happen, and that I needed to be constantly aware of it. My condition was impossible to forget.

Richard was solicitous and kind, though busy and distracted, and we moved inexorably toward my graduation and confinement. This event set my future course of combining school with motherhood. I later began my MA program with two children and finished with three; I began my doctoral work with five children and finished with six. Richard was lighthearted about the event, noting that my four years at Wellesley would enable me to fold diapers with a grace and charm unknown to those less educated.

I had always enjoyed the creative aspects of homemaking—sewing and decorating, cooking, and even hanging out the wash. I was very glad to be through with writing papers and being under constant pressure, but I missed the structure of going to school and preparing for classes. I missed the sense of getting ahead. At church, I became one of the student wives instead of being a student myself, and even there, I felt a loss of status. I worked for a while that first summer and then spent my time knitting and preparing for the grand event. Still, I was glad to be through with school. It was a wonderful experience, but I had no intention of ever returning to school. I was through with school. I mean, I was *through*.

A new chapel we sacrificed for financially, a handsome brick edifice that we were all proud of, was completed while we were in graduate school. I was in that LDS Cambridge Ward building for the dedication of that

long-hoped-for building in 1956. At the dedication, I sat behind and to the left of Church President David O. McKay who came out to speak. I was a member of the dedication choir. I well remember the date because I was very pregnant with Clarissa, wearing what I thought was a particularly pretty blue jersey maternity dress with a sleeveless overcoat that I had made. There had been some doubt that I would make it to the dedication at all because Clarissa was due on October 1, but she was not born until October 3. I was there to sing "How Lovely Is Thy Dwelling Place" from the Brahms *German Requiem* and the "Hosannah Anthem" that goes with "The Spirit of God Like A Fire is Burning."

I spent much of the rehearsal time making a christening dress by hand with white lace and embroidery—white on white—for my expected daughter. Many Bushman babies have worn it ever since. The birth of the building is closely allied to the birth of my first child. I became a mother here.

Having a baby did not interfere with other plans. I had no career goals, and I couldn't imagine that anyone would be willing to hire me to do anything. The couples in our church congregation were growing young families. Any sorrow about children was in not being able to conceive them. Our plan was to accept what the good Lord sent us, mostly ignoring the connection to physical actions we might ourselves undertake.

We were poor students when Clarissa was born, but Richard's good scholarship included a modest maternity insurance policy to participate in a program to train gynecological residents at the Boston Lying-In Hospital, a highly reputed teaching hospital. Expectant mothers were attended by several medical residents—rather than by a private doctor—and would be delivered by whichever resident was on duty when the baby came, perhaps someone completely unknown. The upside was that someone was always available.

My baby developed in a breech position, feet first. The baby was also inexplicably carried on one side rather than in the center. The doctors tried unsuccessfully to turn her around in utero and determined that I must have some division down the middle of my uterus. It was with this uncertainty that I went to the hospital to deliver my first child.

The labor room in Boston Lying-In was notorious, a large room of expectant mothers in the painful early and later stages of labor. The women, each on her own hard pallet, screamed, swore, cursed their husbands, and wept, making a lot of noise. It was a pretty good picture of hell. When I felt something strange, I asked a nurse to check me out. She looked and discovered that a foot of the baby had been "born." There was a horrified

gasp, a call for attendants, and I was rushed to the delivery room, there to be attended by a man I had never seen before. I was an apprehensive first mother, and thoroughly alarmed by all this. I told the doctor to put me out; I just did not want to be around for the climax. He took my hand and told me that I was a lot farther out than I thought. It was the last thing I remembered.

When I regained consciousness in my hospital bed, I was the mother of a daughter, seven pounds and twelve ounces. Because of the dangers of a breech birth, of which I fortunately had not been informed, she had been put in the nursery with the premature infants. I was woozy, but I got up and made my way to the nursery to see her. They didn't catch me until I was almost there, and then they felt I might as well keep going, so I finally got to see my precious little girl. She was twice the size of the other babies and looked very healthy indeed. She was a beautiful baby, a beautiful child, and a beautiful woman.

I was enchanted by our new daughter with her big, bright blue eyes and a good head of chestnut colored hair which might curl. Her little head was a lovely shape (because she came out backwards). She was a beautiful baby.

Richard brought us each a rose, a yellow one for Clarissa and a red one for me. He came twice a day to see us. We already had a tradition of writing letters to each other. After bringing me to the hospital he went home and wrote a letter from which the following musings are quoted.

> Our little Clarissa may be shy and thoughtful, both pleasant and pretty. Sensitive to help the needy, but not bold in invading their privacy. She will write, I think, unusual perceptive things, drawn from the world by a Jamesian sensitivity, and expressed with the concision of Emily Dickinson. She will not be talkative, but her resolves will be firm and her life active.

We had all the middle-class ambitions for our children. It was so much fun.

One evening Richard brought the news that Nathan Pusey, the president of Harvard University, was impressed with the report of the impact of religion on Harvard life that Richard had directed as a member of the student council. President Pusey provided funds to have the report published, and he spent a whole morning chapel service at Harvard praising the report. This was Richard's first publication.

Life with a baby was a big change: the end of my independent life. Now I always had somebody else to think of first and take care of. In those days before disposable diapers, I washed diapers for six children. Hanging diapers outside and folding them up in neat ways was a task at which I

had a great deal of practice. I eventually had my own washing machine and much later, a dryer.

Classes

I was glad to be a mother. It was what I had believed was my goal in life. I didn't get all sentimental or religious about it, but I was proud of my beautiful daughter, dressed her in pretty outfits sent by my in-laws or sewn up by myself. I liked to show her off. I realized that there was little respite from the job, but I frequently woke up my beautiful baby after I had put her down for the night just to play with her. I spent my time caring for the baby, cooking, doing housework, listening to the radio, and reading novels—women's traditional work. Clarissa was healthy and developed well. We took her to Dr. T. Berry Brazleton, a famous baby doctor, and I repeatedly read the works of the great and popular Dr. Benjamin Spock whose advice mostly worked for her. She had regular appointments for shots and attention at a well-baby clinic at the Mt. Auburn Hospital near our apartment, justified by our low income.

In our student housing development, I sat on the front stairs with my baby and watched other young wives, some also with babies, going off for classes themselves. Others had jobs, some perfunctory, some very interesting. I gradually found myself discontent with just keeping house. I wondered whether the Wellesley experience had ruined me for my chosen future. I didn't seem to be leading a real life, while Richard, deep in his books, was. I thought about doing some of the things other women were doing, but I believed strongly that a mother should leave her children only under the direst necessity.

Miss Clapp, our Wellesley President, had told us that we were not to disappear into suburbia but to continue our education and to make contributions to our society. I hadn't thought that her dictum applied to me. I was living the life that I had been brought up to live. But that germ grew in me. I thought I could do more. And for me, that ironically took the form of going back to school. At Wellesley I had warred with my conception of what the school wanted of me. Now that those days were over, I was hungry to get back into the classroom.

The next year I found a flyer for the Lowell Institute, a Boston philanthropy, which offered classes taught by local college professors to adults in the evenings. This program had been set up by a rich industrialist to educate mechanics and artisans to make them better citizens. The courses were to be offered for the price of a sack of wheat, each of which then cost

$5. I poured over this flyer with intense hunger. Each offering seemed exquisite and delectable. My husband thought that he could probably take care of the baby around dinnertime if he could go back to the library later in the evening. I finally settled on three courses: the English novel, the music of Bach, and French Impressionism taught at the Boston Museum of Fine Arts. I read the assignments during the day when the baby was sleeping, and three evenings a week I went off to class. I never had a better semester. I always had something interesting to think about, and I could go off purposefully to class. I felt that I was making progress. From then on, I tried to take some kind of course all the time, trying to give my life structure. I looked forward to the day when I might be able to afford a degree program.

A Year Abroad

When Clarissa was a year and a half old, Richard completed his course work and was researching what would become his dissertation and his book on Connecticut. We sublet our apartment and moved to Hartford, Connecticut, to a stuffy attic space in an old house. Richard spent his time researching at the state library while Clarissa and I carried on at home. We had sold our car while we were in Cambridge, and Richard took the bus to the library. I was on foot with Clarissa to go anywhere else during a humid, hot, difficult summer, preparatory to another move.

Richard had been awarded a Sheldon Traveling Fellowship from Harvard University. The purpose of these grants was to allow a young scholar the opportunity to experience the broadening aspects of extensive travel, making connections, becoming a person of parts. Winning that generous fellowship was a great honor, but by then there were three and a half of us to live on a grant for one. We planned to travel in Germany and France before settling in London where Richard would continue his research on colonial Connecticut at the British Library.

So that fall, with Clarissa getting close to being bathroom trained, we set sail on the last voyage of the oldest ship on the North Atlantic run. The motley crew neither spoke nor understood a single language. I have repressed the ship's name. We spent a very long time—two weeks—on the rough North Atlantic seas that early fall. I have never, never since wished to go on an ocean voyage.

Our constant fear was that Clarissa would somehow fall overboard. Richard made it a major philosophical problem for many years: if she should fall in, should he jump in after her? And if he did so, was there

I, Claudia

any chance that either of them would survive? More than fifty years after the voyage, he posed the question to our new grandson-in-law, Jack Woodhouse, a naval engineer. Jack did a little computing and determined that from the front of the ship, from the side, and from the back, the answer was the same. To go over the side was to die. We're glad she did not fall in, and now we fly when we travel.

There was very little to do on the ship but eat, and we had the same massive but unappealing menu about five times a day. I was also, as suggested above, pregnant with our second child. That had a lot to do with my miseries.

I did have an important clear-cut lesson from that voyage. We spent a lot of time in our tiny stateroom, making many trips to the ship's smelly "head" down the hall. I thought how much more I would enjoy the voyage if only we had a little bathroom of our own. Another academic family traveling on the voyage had the great luxury of a private bathroom. But they continually complained about how hard it was to manage their two young children without a bathtub. They had a toilet and a shower, but no tub. We all got to know a single man traveling first class. He had a tub, but he bemoaned that it was so small. No passengers, not even the most privileged, were content. We also got to know a couple like us with one small child and expecting another, traveling in an inside cabin. They were also miserable. "If only," they reflected, "we had a porthole. Then we could enjoy this trip." We, I realized, had a porthole which we were not appreciating sufficiently. I tried to spend more time looking at the rise and fall of the gray seas. It was useful to me to realize that people could feel deprived at any level.

We landed in Bremerhaven and traveled inland to Munich and Bad Godesberg. We visited Willard Bushman, Richard's brother, there on a Mormon mission. Richard bought a little tan Volkswagen, which, with his limited German, was a great achievement. From then on, we traveled by car, getting used to new rules and places of driving and parking. I really liked Germany—so clean, so well ordered, white lace curtains blowing over grim coal yards—although I felt that we rushed to every public restroom in the country, often too late. We visited beautiful castles and museums, saw charming towns and colorful shops. But I didn't feel well.

We traveled on to the less-appealing France, every day starting out again. We ran out of gas on the Champs Elysee. We went up in the Eiffel Tower, but I was too frightened to go very high. I wore down day by day to the extent that when we parked to go into the Notre Dame Cathedral, I

couldn't even get out of the car. We drove on north to Belgium, where we saw the king at a large fair, and then crossed the English Channel.

London, England, 1958–1959

We found a nice little flat at 16 Kings Avenue, NW10, in the then-unfashionable London suburb of Muswell Hill, hard by Crouch End, Hornsey, Alexandra Palace, and other colorful English places. We had a feisty landlady, Miss Hunt, and several comfortable rooms, and rest, finally rest.

Our flat was the ground floor of a three-story, semi-detached brownstone. Our landlady lived one floor up and on the third level was an old man, almost an invalid, whom we seldom saw and whom the landlady cared for. We entered our place through a front door that proceeded down a long hall to our "kitchen." The front room was our bedroom, but we had to go down the hall and back to get into it. It was the only bedroom, nicely furnished with a double bed, a big dark wood wardrobe, and lace curtains. I can't remember where Clarissa slept. Maybe with us.

The next room was a good-sized combined kitchen-bathroom as is sometimes found in rental flats set in basements. There was a big tub on one wall, a toilet set off in a small closet with a door, and a kitchen corner consisting of the flat's only basin with running water and a set of burners on which I cooked the dinner and boiled the wash. There was no oven and no refrigerator. Adjoining that space was our sitting room with a sofa where I spent most of my days listening to BBC radio on a set we rented, a round table with four chairs where we ate our meals and wrote our letters, a cupboard with a vent to the outside where we kept anything we wanted cool, and best of all, a small electric heater. That was our one livable room during the cold, damp English winter. At the back of the apartment we also had a very pretty salon decorated in pale green and white with graceful furniture and a nice rug. This drawing room had French doors to the outside garden. The garden was graced with a life-sized statue of a small, barefoot girl that Clarissa dubbed "No Shoes." This room and garden were very nice, but the salon was unheated and we seldom ventured into its icy atmosphere.

Richard was right off to the British Museum, reading old documents, taking notes, writing essays in an atmosphere as frigid and damp as our drawing room. I kept house, cared for Clarissa, and signed up with the National Health Scheme to have a baby in England. We could not afford a private delivery, and we were grateful that the health scheme provided care for all of England's permanent and temporary citizens. Doctors were

available for pre- and post-natal care, but midwives delivered the babies. When I expressed my doubts, I was told that midwives had more experience than doctors and did a better job. The midwives I came to know were sturdy and competent—think Juliet's nurse in Shakespeare's play. The doctors preferred to have babies delivered at home to minimize the possibility of infection, but they judged our flat too ill-equipped for a home delivery and signed me up at the Alexandra Maternity Home.

This maternity home, a former rich person's mansion, had been transformed into a hospital by building a dormitory addition on the back for the post-birth mothers. The front rooms had been reformatted for labor and delivery. It was all dark wood, nothing white or sanitary. The labor rooms were individual cubicles separated by curtains. The floors were of wooden slats, perhaps so the rooms could be hosed down. Each expectant mother, lying on a hard platform in her own cubicle, was free to howl or weep as she so wished. Each had a bell to ring should she need help. When I was settled in one of these, a woman in another cubicle from another country groaned and yelled and pushed the button steadily for minutes at a time. After a while, the midwife went into the cubicle and pushed the woman's bed away from the bell. Undaunted, the woman climbed down, pushed her bed back to the wall, climbed back up, and continued to ring the bell. It was all noisy and primitive.

When my time for delivery came, the midwife worked with the unborn child, manipulating it toward delivery. No doctor was present. We had no epidurals, no knockout shots; we had only a mask of oxygen and gas for deep breathing. The baby was born, and I recovered immediately, with no medical hangover. I felt terrific.

Our naming system of historical names for boys and literary names for girls fell apart early. Our second child, our first son, was named Richard Lyman Bushman, Jr. His father was a historical figure, after all. Our junior was born in 1959 and was assigned the nickname of Brick after a character on a BBC radio program I had listened to. Brick O'Halloran was a Teddy Boy, a British juvenile delinquent. I am still partial to Brick's nickname which suits his suave, witty, devil-may-care style. He uses Richard professionally and his wife prefers it.

My husband wrote the following account to my family.

> Claudia was smiling and radiant when I walked into the ward and happily stretched out her hand to me as soon as she saw me. She had brushed her hair and put on some lipstick and, to my surprise, still had color in her cheeks. She was simply beautiful. The baby arrived four hours after the first labor pains and

three from the time I left her lying on the hard delivery bed. . . . While I was there, they brought in our son. He is truly a handsome fellow. At first, Claudia, says, he was red-purple and a little unsightly, though everyone said at once that he was splendid. When I saw him, he had been bathed and had faded to a manly brick color. His eyes are blue as you might expect and his red hair is about a quarter of an inch long, though not so thick as to make him look pre-historic. He lay very quietly in my arms. Moving his head and arms, but not crying. We both agree that he is very distinguished. . . . I still feel happy whenever I think of our baby's fuzzy pink head and Claudia's glowing face.

Brick was a sweet baby, though not the beauty Clarissa was. He had a longer nose and a hairy face and frequently looked rather cross. But he had lovely big eyes and was very strong.

We had all brought diapers from home for our babies who were wrapped in our own receiving blankets. As there were no plastic pants, the babies were frequently soaked. The little blankets were hung on heat pipes to dry between times. I think the diapers did get washed. I don't know where or by whom. The mothers spent a couple of weeks in the home trying to get their nursing established, drinking a lot of tea but no milk. A physical therapist came in every day to lead exercises in our dormitory sleeping room. New mothers just brought their chins to their chests a few times, but soon they would be on the floor strengthening their muscles and helping with the chores of the little hospital. We new mothers had a collegial time talking together, sharing our problems. I thought that it was a healthier atmosphere than being alone at home during that early time of new adjustments.

> Brick continues a delightful baby [I wrote four days later]. Last night I was away for the moment while they brought him in, and they put him in my bed. He looked so sweet, boxing around, and searching for food, that I could hardly stand it. He has Dick's cowlick on the corner of his head. What a characteristic to carry from generation to generation. . . . He really has a very nice little frog-legged body, plump and firm."

After the birth, we visited our own pediatricians and were given tokens to buy milk, orange juice, cod liver oil, and rose hip syrup (for more vitamin C) at low prices. England wanted the best for her new generation. Soon we were all out and about, pushing our new babies in prams for our daily shopping expeditions.

London Life

We were very fortunate to join a Mormon congregation in London where we had immediate connections with friends and fellow Latter-day

Saints. We and the missionaries were the only Americans. Most members were working-class English converts. They were strong members, living modest lives in a city still recovering from World War II. Our branch president, a railroad worker, dressed respectably in excellent old woolen suits on his salary of fourteen pounds a week. Despite a limited education, he spoke fluent King's English, knew the scriptures, and gave excellent gospel disquisitions.

His wife, Winnie, and her sister Dorothy, each with a teenaged son, were much taken with our two beautiful little children and urged us to go out and let them babysit. Richard was very deep into his research, but I did manage a few wonderful days of liberation, taking the bus into London's center and finding my way around on the tube. I saw some significant places that way. Richard and I managed a handful of nights out and probably would have managed more had we not suffered a couple of serious setbacks.

Richard was devoted to his work. He went off each morning, even though he contracted colds, coughs, and sore throats. The low temperature of the British Museum worked against his recovery. He was young and strong and sure that he could beat any of these minor infections on his own, but he didn't get better. Every day he hauled himself out of bed and came back beaten and sick to fall back into it, sleeping heavily until it was time to rise again. He tried to go to the doctor, but the waiting line was long, and he just came home. One night he began to hallucinate. The bishop told me to call the ambulance. The uniformed men came and took him away. His body, unable to conquer the infection, had turned against itself.

He was taken to Whittington Hospital, an aged gray edifice we often passed on our way to church. The hospital was named for "Young Dick Whittington," the ancient hero of song and story, who rose to become "Lord Mayor of London-Town" in the fourteenth century. The hospital seemed to date from then. The inside was more like a gym than a hospital with many grim and grimy spaces. I finally reported his condition to our parents.

> Richard has rheumatic fever [and acute nephritis]. He is in the hospital and will probably be there for six or eight weeks. [He was there for ten.] Only two of his joints, an index finger, and a knee, are very swollen and painful and the results of the tests taken indicate that his heart has not been damaged. He doesn't look or feel very sick, although he is a little foggy because of the medication he gets constantly. . . . Richard is to have complete rest. A nurse feeds and washes him and he can't sit up or get out of bed. . . . He can't write yet because of his finger.

Richard's head soon cleared, but he felt lazy and tired all the time and retained a low fever. His unusual complications puzzled the doctors. They gave him penicillin and a sulpha drug.

Winnie and Dorothy would come over to care for the children and I would drive our little VW the short distance to the hospital to see Richard every early evening. He was in a ward with several people he came to know very well. None of them seemed to be very ill, but sometimes I would arrive to see the curtains drawn around a bed, and the curtained bed would proceed to the doorway and down the hall, bearing a patient no longer in need of care. Someone new would be in the space the next day.

Richard was very sick for a long time. His family, far away in Utah, was frantic. He gradually began to improve, moving into the culture of the sick where he forgot about the pressing concerns of eighteenth-century religious culture in the American colonies and began to think of his family and children and living a warm, good life. He got very tired of the bland white meals he was served—steamed fish, mashed potatoes, and turnips on a white plate, for instance. He requested that I provide him with thick hamburgers spread with bleu cheese, lots of catsup, mustard, and onions. He would wolf these down. He liked lots of flavor.

It had been an eventful winter with Brick's birth and Richard's illness, and I added another concern when I was driving home one evening. Being a left-handed person with a poor sense of direction, I had trouble driving on the wrong side of the road in England. Never having been able to tell left from right without figuring it out each time, I have to second- and third-guess myself. Going to the hospital one evening, I made a left-handed turn into the path of an oncoming vehicle and was hit broadside. Our new Volkswagen was badly smashed. No one was injured. I felt terrible about it. My carelessness, my stupidity, my fault, but mostly, as ever, it was the money. Repair would be expensive, and we had limited insurance. Here I was supposed to be an adult, managing the home front, and I had sabotaged it completely. We borrowed money and had the car repaired.

At this time I wrote a long, miserable letter to my family that concluded:

> I hope you will forgive this outburst but I have no one to really confide in here and what with Dick so sick, the children so sick (Clarissa is almost better now) me getting no sleep and this other awful thing hanging over my head I am almost at my wits end. [I said how in novels people really didn't kill themselves for love but for the need of money.] and that's the way I feel now. We have felt like children of providence for so long that we really deserve some hard knocks. Well,

I feel a little better now for letting down for awhile. I get so tired of being brave. But nothing *really* horrible has happened and we'll be back to normal soon.

Don't write back and sympathize or tell me to pull myself together, please. Send gossip and such.

Claudia

The children grew and developed with help from our friends. I reported these to my family. Clarissa became a hypochondriac. "She feels Brick's head and says, 'Just a little fever, take medicine, make you better. Blanket on, stay warm.'" Her many babies—six dolls—got the best of care. She pretended that her father was in his chair. She would sit on his lap and give him kisses. She was also sufficiently distressed that she did some acting up.

> I have always been rather proud of my mischievous childhood and now am pleased in a way that Clarissa has become such a little devil. In the last three days, among other things, she poured a bottle of Touch and Glo makeup into my underwear (it isn't very white anyway) bent my best earrings, wrote all over the wall with my stick cologne (the room smelled so good) and broke and ground into the rug five eggs. She has also stripped the blossoms off the rhododendron bushes, colored all over our photos, etc. etc. What an inventive mind, what insatiable curiosity, say I to myself. I know she is upset and needs extra attention and discipline. Still, she is a sweetie.

Brick became a real laugher. He liked to have us say "toot-toot" in a high tone or play pat-a-cake. Clarissa behaved well when we went out for a haircut. The lady told her how very good she was and what lovely hair she had. I was pleased, too.

After ten weeks, Richard, thin and pale, with a small limp and less endurance than usual, emerged from the hospital. He was old enough that the rheumatic fever did not injure his heart. He took over, and it seemed like old times. We made repeated reservations by ship and airplane to return to the United States, canceling them when we were not yet ready to go, and finally we flew away, stopping in Iceland, on our way to San Francisco. Both sets of parents greeted us in San Francisco, glad to see us and meet our little Brick.

–11–
Eastward

Back in the United States, Richard, still thin, steadily improved. We picked up the little VW shipped from England and drove it back across the country to Cambridge where he continued to work on his dissertation. His professors Oscar Handlin and Bernard Bailyn liked it, and Professor Handlin offered to publish it in his Harvard University Press series on history of liberty in America. Richard was offered a job at Brigham Young University in Provo, Utah, and accepted it. We set off across the country, westward this time. He turned in his dissertation by mail at the end of the summer. The department waived the requirement for a defense as we were so far away.

Provo, Utah, 1960–1963

We had an income at last. I think it was $6,000 a year, and we lived in a modest two-bedroom duplex apartment, 722 North 900 East, on a busy thoroughfare, within walking distance of the university. We bought our first oriental rug there. I guess we now have a half dozen or so of various sizes. After a year, we moved through the block to a three-bedroom rental house in time for Karl's birth.

After Clarissa, our literary heroine, and Brick, named for his father, all the children got family names. Our next child, our second boy, was named Karl Edward after Richard's German maternal great-grandfather, Edward Schoenfeld, and his brother-in-law, a noted Mormon educator, Karl G. Maeser, who had been president of Brigham Young University. We had survived our problems. Richard was well. He had a job and an income, and we had our precious Karl, a new type of Bushman kid. Clarissa and Brick were both very blond, slight, and graceful. Karl had brown hair and the elfin charm of a small woodland creature.

My clearest memory of the birth is of lying there in the delivery room and the nurse calling out the window to the approaching doctor, "Don't change! Come fast! She's about to deliver." The doctor barely made it in time for the delivery. It was getting easier to have children, and we were thrilled to welcome this cute little guy.

When Richard took his first job at Brigham Young University, I saw the chance to enter a degree program, something I had been unable to af-

ford as a student wife. BYU offered free tuition to spouses—a great boon. I looked over the offerings and decided to work toward a master's degree in American literature, taking two courses at a time. I left my two little children with a neighborhood grandmother or with my husband only during class. I did all my reading at home or at night in the library.

Another new faculty wife, also with two children, decided to sign up for graduate school at the same time, and we took the first course together. She worked very hard, and at the end of the semester, she had the highest grade in the class. I also had an A, several points below her. But she quit after that first semester. She said that combining schoolwork and family care was just too hard; it wasn't worth the effort. For me the situation was different. I had to go to school and was willing to compromise on both sides to do it. I had to have some life of the mind. I couldn't work, because then I would have to leave my children and would have a prior obligation to my employer. In a school situation, a missed class or late paper would hurt only me. I had to have some connection to the world outside my kitchen. When I didn't, I confronted the abyss and was marooned in a balloon, disconnected from other people and from ideas, never going or getting anywhere, repeating meaningless chores.

I was not a brilliant student working on that degree either. Some of my professors made it very clear that I should just stay home and leave school to the real students, the unmarried undergraduates. Pressed at home, I did not do as well as I might have. Still, I persevered. After three years of work, with three children, I defended my master's thesis, but not very well. I was grateful to complete the work and get the degree. Even in 1963, it was an incredible bargain. I had free tuition and it cost about $250 in cash, which included babysitting, books, and having my thesis typed. Most important, I had a degree!

Providence, Rhode Island, 1963–1965

After three years in Provo, we packed up our little tan Volkswagen (the one I wrecked in London) with clothes and equipment for two adults and three children, and set off for Providence, Rhode Island, where Richard had been awarded a two-year fellowship at Brown University to study and teach history and psychology, then a new field.

In Providence, we found half of a large duplex at 28 Dana Street with three floors of three big rooms each, running railroad-style front to back, as well as a cellar and an attic and a glassed-in front porch. We had more space than ever and filled it with second-hand furniture and home-made

items. Richard studied the first year, regularly commuting to Cambridge to attend the seminar of Erik Erickson, the great psycho-historian at Harvard. The second year, Richard taught a new course at Brown University on psychology and history titled Varieties of American Experience.

Clarissa was in the first grade by then, walking to school when she had previously been driven. She came home one day for lunch and announced that President Kennedy had been shot and killed.

Brick was attending nursery school at The First Baptist Church of America, the grand edifice in Providence honoring Roger Williams. Brick was small and had a crackling voice, always surprising and impressing others with his abilities. He took his English identity seriously and at his direction, I made him a little Cold Stream Guard uniform, a red jacket with navy pants with a red ribbon stripe down the side. I also made him a shako out of an oatmeal box covered with fake black fur. The hat was uncomfortable and did not get much wear, but the uniform was worn almost daily over regular clothes.

Clarissa taught Brick to read early. He decided that he wanted his own library card and went to the library to apply for one. He was told that he was too young and needed to be able to sign his own name. In his cracked voice, he said he could do that. He signed the form for the amazed librarian and from then on borrowed his own books. His nursery-school teacher recommended that he skip kindergarten and begin with the first grade, which he did.

Karl was also precocious. He learned letters and read words before he was three. He had an extensive vocabulary and was teaching himself to read. He would stand by us and point out letters by name on material we were reading. We would write a sample word on the back of each of his hands and he would spell the letters and say the word over and over. We couldn't really tell whether he made the connection to actual objects, but he could recognize and call off the written words. He could count to ten on his fingers, and one morning he surprised me by calling off the colors on a picture. He named all the primary and secondary colors and did it all by himself.

In Providence, I gave birth to our second daughter and fourth child, Margaret. I had a new doctor, of course, and I warned him that my babies came fast and that I expected him to do the same. But then, the baby was several days late. My mother, who had come to help, was greatly pained by this delay as she had obligations elsewhere. Even when I finally went to the hospital, the baby did not come. The doctor who had hurried over was also greatly pained by the delayed and long delivery. However, Margaret was

born and welcomed. She paired well with Karl. Both were imaginative, brown-haired, mischievous, and charming. She received most of the name of my maternal grandmother, Margaret Elizabeth Gordon Bushman. Four names seemed plenty for this pretty little girl, so we left off my grandmother's maiden name, Schutt, and her nickname Pansy.

My new master's degree made it possible for me to teach at a state school, Rhode Island College. I taught freshman composition to a group of kids, children of immigrants, who saw the school as a chance to get ahead in the world. We all worked hard, and I enjoyed it very much.

We had another car adventure there. We were headed to Cambridge for a church leadership meeting. It was an easy one-hour journey but a very icy day. Richard was a careful driver, but at one intersection with a traffic light, we were rear-ended by another car and our little VW was completely destroyed. Karl, who was sleeping in the far back section of the car, was sprayed with glass from the broken window. He was a little bloodied, but we were all okay. I was very much upset, not having wanted to venture out that day anyway, but Richard, of sterner stuff, noted that our problems were only financial. We soon had a new car, a red Ford Falcon station wagon, which was to carry us back to Provo.

Provo, Utah, 1965–1968

Back in Provo, I taught freshman English at BYU and enjoyed it very much. But when I told the chairman that I expected child number five, he told me that I would not be able to teach again. He would not say why. I felt stymied. I would have gone on for a doctorate in English, but none was offered. I considered getting a secondary teaching credential, but I was told that I would have to retake all the same courses I had already taken, recast for high school teaching. I was back to taking interesting single courses, but not making any progress. The demands of the family were great, but I could have borne it better with some sense of purpose. I felt lost, without any clear direction, though with four little children and lots of church work, I had plenty to do.

Serge, our fifth child, was born after our return to Utah from Providence. Only Karl and Serge were born in the same place, Provo, and they are not sequential. Serge was named for my father, Serge James Lauper Bushman. I seriously regretted foisting such a difficult name on a little pink baby, but Serge turned out to be as trendy as any of the names we chose, and he has proved well able to carry it. He weighed nine pounds, ten ounces, but was just twenty-one inches long, quite round and solid.

The nurses called him the football player. His head was nicely shaped and his skin unblemished. He had two cowlicks—one center front, the other on a back corner—and two big dimples. The children were curious and interested. Margaret, just a year old, was rather confused and concerned by this new creature and patted his head in the manner of a gentle assault. They developed a good relationship, but when Margaret was almost two, I wrote that she continued to be impossible. She was usually cheerful but so willful and destructive that she left me breathless. We were in a store one day, and she ran away or fought to be free every second. A man offered to carry out my small purchases, saying he could see I had my hands full. At home, Margaret bit (twice to blood on me), scratched, and squawked. Serge had to be taken to the eye doctor with a sore eye which turned out to have a big scratch on the eyeball. She may have managed to do that. I sometimes wondered how she could grow up.

Back in Provo, we bought our first house, one that we could feel happy to stay in forever. It was a couple of miles from the center of town, near the mouth of Provo Canyon, leading up into the mountains to Sundance and other ski resorts. Our house was in a development planned by Greg Austen, one familiarly referred to as an "Austen-tatious" house. We had four bedrooms, two bathrooms, a large eat-in kitchen, a very large living room with a stone fireplace, and floor to ceiling windows overlooking the mountains. There was also a full ground level unfinished basement. It was new, nice, and promising.

We thought that we were well settled in this nice place after much moving around in our earlier years. Richard had first come to Massachusetts in 1949. I came in 1952. We left together in 1960 and went to BYU for Richard's first job. After three years, we went back east again, this time to Providence, Rhode Island, for two years of a post-doctoral fellowship at Brown University. Then it was back to BYU for three more years, which made a total of eight years since we had left Cambridge.

Richard returned to teaching at BYU as an assistant professor in the history department and as associate director of the honors program. Harvard University Press had published his dissertation, and the book got a lot of attention. His study of Connecticut towns, a close look at the way theocracies moved toward a less religious style, fit right into a major trend in American history at that time, known as community history. He was invited to consider a job at UCLA. Then, in the great event of 1968, he won the Bancroft Prize for one of the best books in American history that year. That huge honor brought a prize of $4,000. The press sent me a

dozen roses. Bernard Bailyn, one of Richard's Harvard professors, was also one of three winners that year.

We were invited to New York City for the award ceremony which was to take place in the rotunda of Columbia University's beautiful Low Library. This was a dressy occasion and my problem, as a hick from the west, was what to wear. After wide consultation, I chose my sister Paulie's embroidered silk Chinese banker's coat over a slinky black dress. I had my hair done. Richard prepared a suitably erudite address. We stayed at the Algonquin Hotel.

The event was maybe the most sophisticated I had ever attended, with intellectuals speaking several languages, a long receiving line in which my hand was kissed several times, a trendy dinner with several courses, and then the impressive talks of the prize winners. We spent a couple days in the city after this introduction to academic high life, going to plays and shopping for ourselves and the children before going back to Utah. On our return, we were shocked to discover that Low Library, where Richard had so recently been feted, had been occupied by insurgents. The campus was in an uproar as students and some faculty were striking for the inclusion of Black citizens who lived on the fringes of the university and also protesting the war in Vietnam. Buildings were barricaded. Police were called. The president of the university, so impressive at this last recent event, was forced to resign. Columbia University, with many problems reflecting the discontent and uproar in the greater society, slid into a long decline. This was the first of a series of uprisings on college campuses.

Back to Boston

After three more years at BYU, Richard had earned a sabbatical, so we returned to Cambridge where he had a fellowship at the Charles Warren Center to do historical research for another year. BYU was paying half his salary, and Richard felt financially and spiritually obligated to return to Provo. That was our home. We had finally bought our house. But circumstances contrived to make it attractive to remain in Cambridge. Richard, the Bancroft winner, became a valuable commodity. He was approached by several universities. The aggressive history chairman at Boston University, Sidney Burrell, energetically recruited him. Richard was hesitant. He felt obligated both spiritually and financially to return to BYU. I favored the move because it would give me more options and opportunities. He eventually took the job, deciding to stay in the East. Boston University bought out his sabbatical from Brigham Young University, eliminating

any financial obligation. Richard was to assist in the organization of the new American Studies program.

Arlington, Massachusetts, 1968–1970

This time we stayed in Boston for nine years. I was glad. I had been able to finish up my master's degree in American literature, but I saw no opportunities at BYU. By then I was a mature wife and the mother of five children, but I still wanted to go back to school. Boston University, with reduced fees for faculty wives, made that hope a possibility.

We rented a wonderful house in Arlington, Massachusetts, immediately adjacent to Cambridge. It was a large Queen Anne cottage covered with brown shakes on an acre of wooded land in the center of a block, high on a hill, overlooking the children's school across the street. There were airy bedrooms, spacious public rooms, a big wrap-around porch with a view of Spy Pond under large trees. There was a large old carriage house, redone as a three-car garage with a big loft that made a very nice place to play. The house wasn't exactly up to date, but it was a very choice residence and we loved it. The children made friends with the neighbors. Richard set up shop at the Warren Center.

We had some adventures there, including the time, not long after we moved in, when we were awakened at dawn by a terrible crash. A very tall tree, maybe three feet across, at the foot of the property had fallen on the house. The tree was in full leaf but was apparently rotten inside. It fell from a great distance away, mostly crushing plant growth on the hillside, but the upper branches broke off a corner of the roof, snapped off the TV antenna, crashed through and destroyed our big porch, and broke through the gable and window near where Serge was sleeping. We were all up in a flash to survey the damage, marveling that no one was even slightly injured. We lived in the debris of that accident for a long time before a new porch was constructed.

Another thing that happened at that house was that I had a miscarriage. I was about three months along, not feeling well, not sure that I was ready for another baby. But when it happened, I wept and howled like a wild animal, scaring all the family. I realized how such an interruption in ongoing life frustrated and warred with the basic forces of nature. I felt weak and sad. I had a hard time readjusting to the summer. The event brought more of an emotional wrench than expected.

Meanwhile, the children grew and developed. Clarissa, who danced before she could walk, continued her devotion to dancing. She had studied

with Virginia Tanner in Utah and at the demanding Rhode Island School of Ballet when we were in Providence. She worked hard and made a great deal of progress, promoted to the pre-professional level at her school in Cambridge. She adored her toe dancing and often came home with bleeding toes. She was chosen to put on a demonstration for a visitor from the New York City Ballet and received a scholarship to pay for a third weekly lesson. I hated to see her spend three afternoons a week at dancing, but I was glad to see her willing to work so hard. She was later told that she could take as many lessons a week as she wished, which meant that she was dancing every day. She was also doing well on the piano, but she discontinued her lessons in high school. She managed her advanced classes at school with very little effort and gave up her study periods to sing with the glee club and be in the art club. She really did everything extremely well.

Brick began to play the violin in a school program at the total cost of $20 a year to rent the violin. His teacher, who taught all the Arlington school children, said that he was one of the seven of the eight hundred she taught who had real promise. She had him come early and stay later than the group for private attention. She arranged for him to have a new violin because he was such an apt pupil. He also broke the town record for the running broad jump—over eight feet! He represented the school in the town track meet. That summer, the children were not out of school until almost July. Brick went off to his swimming lesson at the Boys' Club and from there he went off to pick up his violin and schedule for summer lessons. He managed his various activities without conflict. He also took tennis lessons and had a new bike, for which he paid half himself.

Margaret was having difficulty hearing. The doctor said that her adenoids were blocking her eustachian tubes, which had filled with liquid, and that her allergy reaction, which showed up as eczema, intensified the problem. He prescribed an antihistamine to wring out and shrink the tissues. She learned to read lips pretty well. We felt so sorry for the little mouse. Medicine was a great help for her, and she was much better, but she eventually did have her adenoids taken out.

I sometimes took the children to the Harvard Museum with the glass flowers, mostly to look at birds, animals, and native costumes. The first time was dreadful. Serge began to weep in loud hysteria and could not be quieted. We finally got home. Some days later, when we went again, he announced every few minutes, "*I* don't cry." And from then on, he was fine. Everyone was growing up.

Richard was at the Warren Center at Harvard our first year in Arlington. The next year he began work at Boston University. I took the Graduate Record Exam and applied to the English department to study English literature. The head of the history department, who had hired Richard, pressured the English department to admit me to the program. I had the required preliminary degrees from good schools, but I did want to go part-time, and I was a middle-aged mother with five children, not anybody's idea of a serious graduate student. Mature women were not going back to school in those days. The chair was a bachelor who was not hesitant about telling me that I was an unsuitable candidate. As he said, "Oh, Mrs. Bushman. Why don't you just stay home with your children!" But this going back to school was what I wanted to do, and I was prepared to try to do it despite the scorn and disbelief of others.

Student unrest was growing in the United States. We were in San Francisco in 1964 when the students at The University of California at Berkeley occupied Sproul Hall. We had just missed the occupation of Low Library at Columbia in 1968. Martin Luther King was assassinated that year. Harvard Students for a Democratic Society occupied Harvard Hall in 1969 when we were there. The police, using tear gas and night sticks, arrested 133 and injured some others. Student issues were civil rights, free speech, and opposition to the war in Vietnam. National Guard soldiers shot and killed four student demonstrators at Kent State in Ohio in 1970. Students for a Democratic Society (SDS) students at Boston University met with faculty members to draft a resolution about how far the students could go. Although I was certainly no fan of that awful war, I was discouraged about the disruption, probably because I was already about forty. I saw civilization overrun with barbarians. I thought we were heading into the dark ages again.

I was accepted as a doctoral candidate in the English department at Boston University. I was allowed to go part-time—a big concession—and I guessed that I would be around the continued unrest, unless I was cut down by a stray bullet. BU continued to have bomb scares. Around that time there were, in one week, thirty-five or forty phoned threats that canceled classes and delayed classwork. The teachers began to hold classes anyway. They could continue to teach or not at their discretion and the students could stay or not at theirs.

Boston University required four languages for an English literature doctorate. I had studied the required Old English and French, but I still needed a classical language and another modern one. I was studying Latin in night school and finding it very hard, and I still had to begin German.

One day I was musing on the spectacle of a mother with five little children trying to learn enough Latin to pass the qualifying exam when Richard came home from an American Studies meeting. He reported that a discussion of how many and which languages to require for an American Studies doctorate had resulted in a decision to require just one. A light bulb exploded in my brain. The next semester, I became a student in the new program in American and New England Studies and restyled myself as a social historian. It promised to be a very good year.

It was a good time for me to begin work on a doctorate, even if I did have another baby along the way. This activity gave me something to think about while I did the dishes. It gave me something to escape to from my household labors. And school was painful enough that I was glad to escape it to make cookies and read to little people. Even scrubbing the floor was more welcome than writing papers. I also escaped the competition of LDS women for cleaner houses, more perfect children, and more good works. School worked very well as a device to insulate me from things I didn't want to do and also gave me the sense that I was making some kind of progress.

When I became a doctoral student, I decided to give up three things: fashion, creative housekeeping, and entertaining. I gave first attention to the children and to providing food, second to my studies, and third to laundry and house cleaning. I still had people for dinner and made Easter dresses for the little girls, but I tried to avoid guilt for not going all out. I always held church jobs and never turned any down. I usually took just two courses which met once weekly in the afternoon, requiring minimum time in class. Even so, the long process of becoming a doctor with a PhD took me more than ten years.

When asked what I wanted to study, I said that I wanted to do female studies, to use my own life as a measure against which to compare women's lives of the past. The everyday life of women, the work they did, the way they felt about their families, drew me powerfully. I was the first person I knew to stake out such a field. The new feminist movement had not yet broken on the scene. When it did, it seemed distant to me. I had strong admiration for the feminists of the nineteenth century, particularly Elizabeth Cady Stanton, but the twentieth-century movement and its leaders seemed crass and held less appeal for me. I was surprised that I did not relate to the new feminists as they emerged, maybe because I was already so deep into domesticity. The Women's Lib Movement never got to me, but I did like the past.

Along with this student unrest, this was also a time of family disruption at Boston University. High profile professors left their wives and children to move in with lively undergraduates. One of my fellow students asked me if I was concerned that my husband would succumb to such temptation. I was able to say that I did not fear that. My husband was even more devoted to his principles than he was to me. I felt that he would be able to resist any temptations in that direction, and I think he did.

Spouses could take courses for half of the usual cost, but Boston University was an expensive school, and a financial stretch even with tuition reduction and our new inflated salary. Sometimes I could not afford tuition for two classes and took only one. Sometimes, when I could come up with a good excuse, like my sixth child, I petitioned for a semester of leave to slow down the cost. As the years passed, I began to teach in the summertime and save the whole salary for the next year's tuition and nursery school for my youngest. I did most of my dissertation research in the three morning hours that he was at school.

I did feel pushed when I went back to school. I had to perform in many areas, and I always felt behind. But the things did get done. I never felt that I was doing my real best at anything, but I got through assignments and met deadlines. I wished that each semester was over. I felt that I did well to put meals on the table and occasionally run through a load of wash. Richard would never let me quit anything and just said I should be keeping a journal so I could remember how it was. He was understanding and undemanding.

The new American Studies program at Boston University focused on new directions. We read census lists, town directories, newspapers, and popular fiction instead of textbooks. We were discovering and recreating the world out of primary sources. My first class was a seminar in eighteenth century New England architecture given by one of the directors of the Society for the Preservation of New England Antiquities. We toured the countryside on field trips looking at structures that had survived for two hundred years. We studied construction techniques, traced the importation of styles from various places, and conducted original research. We learned to look at things as documents. This new emphasis on things was exciting to me, all this material culture outside the classroom.

For my first seminar paper I took on the Jason Russell house in Arlington, not far from the house we had rented there. I already knew it well as one of the survivors from pre-Revolution days. After the battles at Concord and Lexington, colonial patriots had gathered in that house

to fire on retreating British soldiers. The house itself had been built in 1740 and had been through many changes. I got access to the house, then open to the public as a patriotic monument, and spent many happy hours inspecting the construction and reconstructing the uses. We looked at things in altogether new ways.

The next semester I continued my study of women's work, both theoretical and practical. I decided to study the mill girls, a significant group of early female wage earners who ran the spinning machines and looms that replaced the textile work women had done by hand for centuries. I wrote my big seminar paper on them and discovered Harriet Hanson Robinson, the author of the best book on the topic, *Loom and Spindle*. Harriet, a plucky young girl, moved to Lowell, Massachusetts, an early mill town, after her widowed mother took on the management of a company boarding house.

Harriet herself went into the mills at age 10 because she wanted to earn money like the other little girls. The law required that working mill children attend school for three months a year, and young Harriet made the most of her schooling, even testing for a couple of years of high school along the way. She met and married William Stevens Robinson, a bright, young newspaper editor from a similarly impoverished old Yankee family. Harriet became my guide to real life in nineteenth-century Boston and environs. *Loom and Spindle*, a somewhat idealized view of the mill girls, drew me in, but it was the material in her journals, scrapbooks, and letters that she created and saved over her long life, stored at the Schlesinger Library at Radcliffe, that made her my friend, confidant, and basis of my dissertation.

Working on mills and mill girls, I moved on to pursue another of my interests: historical huswifery. I wanted to understand what women's work of the past had been like. I practiced several of the basic skills, not getting very good at any of them but understanding how they were done. One day I went off to the Merrimac Valley Textile Museum to collect information. I came home with a "great wheel," a big old-fashioned spinning wheel, to practice spinning on. I signed a pledge for $100 in case I destroyed the big wheel, but I was given it for two months free to practice on. Then I traded it for a flax wheel, the smaller size, and tried that. They gave me some "rovings," long strips of soft, clean wool to turn into thread. A wealthy mill owner had endowed the museum, an attractive and imaginative place. Ten people were employed there, but few scholars were then

Claudia practicing historical huswifery, c. 1980.

using their research facilities. That morning I had the combined attention of the director, curator, and manager of artifacts all to myself.

The New England textile mills were a big discovery to me. Having come from California, I had never heard of them and did not know how important they had been. By the time I got to graduate school, they were already all closed and urban renewal would soon take out those remaining brick factories, knock down the bell towers, and repurpose the boarding houses. The mills had been of great importance for women's work, but they were already history. I remember reading that in 1851, it took the year's wool from 3,500 sheep to run the mills in Lawrence, Massachusetts, for one day.

I became a spinner and did some weaving as well. I learned to make soap and cheese, having brought home a cow's stomach from an abattoir for the required rennet. I grew flax and retted (or rotted) it in my children's little wading pool. As I say, I never got to be very good at any of these things, but I did understand how they were done. One time a friend and I demonstrated the processing of flax for linen at a state fair. She borrowed a flax-break from a museum which we were using to crack off the crusty shell from the inner fiber. I provided my home-grown flax. A man with an Irish accent came by and picked up some of our product, rolling it between his fingers. He said, "This is the worst flax I've ever seen." That about sums up my skills at historical huswifery, but I can still talk process,

and I very much value what I learned. When I finally graduated with a PhD, my husband gave me a beautiful antique spinning wheel which I display prominently and never use.

Yes, it was awkward to go to school in a program where my husband was a professor. And I did once take a seminar on Boston in 1800 that he and David Hall, who later supervised my dissertation, co-taught. The class concentrated on the close reading of contemporary documents, a skill we all worked at in that program. We searched town directories and property valuations, reconstructing neighborhoods and social groups. I reported on the merchants who so enriched themselves with Chinese goods and traded with the northwest United States and West Indies. They didn't all make a killing; many lost their shirts. I learned a lot of things I was glad to know in graduate school. It was too much to do, but I am very glad that I did it. No one was ever that impressed with my abilities, but I kept on plugging, reading my assignments, writing my papers. I didn't ask for any favors besides being there.

Richard was, meanwhile, also heavily pressed with his work as a professor and scholar. He worked very hard, but he said he was very happy, that he enjoyed everything he had to do. I meanwhile groused and complained and thought that he was more fortunate than me. Which I now see was not so. I was very fortunate to have been able to do all the things I did and do. Some people thought that I was not worthy to be in graduate school, but I eventually came through, and I have been productive. I said at one time that I was becoming less hysterical and more philosophical. It didn't matter if my professors and fellow students considered me subpar.

Richard's reputation continued to grow. When we attended a meeting of the Connecticut History Society in Hartford, Connecticut, one day, Richard presented comments on two of the papers. He was quite a lion in that group. Professor Edmund Morgan of Yale, a man we all respected highly, introduced him as "the man who has done so much to illuminate Connecticut history." Not too bad.

Concord, Massachusetts, 1970

After we had been in the big, brown, rented house for two years, the owners decided to return home. We were sorry to leave as we would have been happy to stay there forever. We began to look at houses. We came down to a choice between buying something impressive and being house poor or buying something more modest and being relatively well off. At the time, I leaned to the latter. It would be so nice to feel rich, and with

our income we really ought to. But I always felt too poor to do some things I would have liked. We decided against the Newtons with their very competitive schools. We didn't want to go as far out as Concord, Lexington, or Wellesley. We thought seriously of Belmont, the next town, so popular and respectable that no houses stayed on sale long.

We looked and looked, and unable to commit, adopted a halfway measure: renting a house in Concord for the summer. We moved to a big, sturdy old house in the town, within walking distance of interesting stores. We were there for July and August, as if for a nice summer vacation.

We had five bedrooms on the second floor and four on the third. A gate in the back fence opened onto a shopping plaza so I could send the children to the store or to get a gumball when they needed a bribe. A train stopped about a block away so that Clarissa could get in and out of her dancing classes by herself. We could walk to a pleasant park where Margaret and Karl were enrolled in a playground program and Brick took tennis. We could drive quickly to Walden Pond to swim or to an organic farm where we picked our own vegetables and fed cows and horses. Richard went to Boston three times a week and otherwise worked at home. I ran people around and shopped. We were close to the public library, and everyone read and played the piano. Brick and Clarissa went on an "H. M. S. Pinafore" kick and sang and played simple versions all the time. It was an ideal summer.

Belmont, Massachusetts, 1970–1977

Richard was leaning toward a nice house in Belmont, but we had made no offer. He was away when the realtor called to say an offer had been made on it and asked if I had a counter-offer. I was not as enthused about that house as Richard was, and when he returned to town, that house had been sold. To this day he has not forgiven me for not buying it. Instead, we bought a big old Belmont house, among the first we looked at. It was in a good location but had suffered extensive water damage from a frozen and broken water pipe. The whole kitchen was awful, just washed out, ceiling, floor, everything. The house was undistinguished, but very spacious with a thirty-foot living room, four bedrooms on the second floor and two more on the third. The near neighbors became good friends. Six good Mormon families lived within easy walking distance. The house was close to the swimming pool/skating rink and the library and half a block from a bus line. The schools were excellent and convenient. I thought it would do us well as soon as we got the plumbing fixed,

installed a new water heater and furnace, mended the floors and ceilings, redid most walls, and landscaped the yard.

We painted, papered, and dealt with six rooms. This house was never an elegant one. We thought that it was a tract house of about 1894. It had no distinguished features, not even a fireplace, but it was very spacious and comfortable, and we came to like it well enough. The upstairs hallway was as large as any bedroom and was my study. One bedroom housed the washer, dryer, sewing machine and iron, TV, phonograph, and sofa.

Brick was a great help in doing the work and though we had not planned to do his room in the first group, his wish that we would was so strong that we did. One wall was papered with a Revolutionary War design, and we painted the other walls blue. Brick and Karl had bunk beds with red spreads and had a blue rug with white fringe. Brick was very pleased and said it looked just like rooms in magazines. He later moved into an unfinished attic area where he created a cozy den under the eaves, sharing space with visiting bats. For the time being, we ignored the dining room and the bombed-out kitchen. After extensive renovations, much labor and money, Richard, who had always regretted buying that house, noted that it was no longer substandard; it had graduated to ordinary.

–12–
Belmont, 1970–1977

As always, we were very much involved in church life. Mormonism has both a very active church life, one I have always highly valued with lots of activities, and no paid clergy. I had spent my youth deeply involved in this church life, and so it was only fair that I should be involved in running programs for the next generation, which I was happy to do. However, assignments multiplied and overlapped. I liked to think that I was a good teacher and administrator. But I also complained a lot.

I was called to be the president of our congregational MIA, the Mutual Improvement Association for teens, a weekly program of lessons and activities with a number of larger dramatic, social, and cultural events. That was something I could do and enjoyed. In the meantime, I was teaching the monthly Cultural Refinement lesson in the Relief Society, the women's organization, and also running a Church-sponsored Cub Scout troop for a group of young boys. Richard was the bishop of a separate congregation of young single adults. We were, in effect, attending different churches. I did a fair amount of entertaining and speaking for that group as well as my own. And I did have the children, the household, and my graduate schoolwork. I noted at the time that I felt persecuted by the Church.

The MIA was the most demanding of my church responsibilities. I took over at the beginning of the school year and things went surprisingly well. I had two willing but inexperienced counselors, one who was an able mother of five married to a non-member who had never allowed her to have a church job before. The other was a flashy single woman, a middle-aged convert in advertising who put on the best social events anyone remembered. Our congregation was short of leaders, but we soon had ten good women to teach classes and run events for our fifteen teenage girls. Some boys wanted to write the roadshow for the annual dramatic competition. We encouraged them to do it. Things were going well.

A month later I noted that the rehearsals for the roadshow were going very badly, as usual. At the dress rehearsal, the stage was full of rummage for the bazaar and three of the leads were absent. Kids kept deciding that they did not have time to be in the show. The date for the performance was changed. The costumes cost too much. The lead singer sang off key. However, there were many positive aspects. Some shy new kids liked be-

ing in it. Some international kids were integrated into warm relationships. Our music director, a twenty-year-old mother with a jobless husband, living in a motel in New Hampshire because the family had been evicted from their apartment, came by train to our rehearsals. She found her only escape and purpose in the roadshow. My Clarissa blossomed as the best singer and dancer, coming home from rehearsals high as a kite. It was demanding, but good things were going on.

What I liked was wide participation in cultural affairs where our young people put on their own speech and music festival. No adult intervened or spoke throughout the meeting, though the teachers did sing with the chorus. The standard was not super high, but the kids did things that were hard for them, and they were proud of themselves. The guitars were not in tune, and they played more and more softly as we sang louder and louder. Still, none of those kids had played guitars at all two months before. Adults had rehearsed the one difficult choral number, but a young girl led the performance. At the end, after the chorus sang two verses of "The Spirit of God," the congregation joined in while the chorus sang a descant. It went better than I could have hoped. I was thrilled.

I still complained. I got tired of doing good. When a girl called and asked me to contribute to a bake sale, I sprang as a coiled serpent and refused to do another thing. I'm sure she was surprised and shocked. I was furious at having to do so much, but I could not resign nor complain because I needed the help of so many other people to do my own jobs.

After some time, the bishop released me as the leader of the MIA. I still had the Cub Scouts and was immediately called to teach the monthly Spiritual Living class in Relief Society and lead the music in the Sunday School. And I was to stay with the MIA to put on the large annual music festival. I noted that for the last two weeks I had had at least one church meeting a day, with three on Thursday, two on Friday, and multiple that spanned all afternoon on Saturday. I was churched out. I felt sorry that I had taken on so much responsibility. I felt bad that I was unable to do everything as cheerfully and willingly as Richard would have liked. I didn't want to do anything at all

Richard continued to move into more responsible ecclesiastical positions. From being a congregational leader as bishop and branch president, he moved into diocesan leadership as a counselor in the stake presidency. He had only been in the second councilor position for about three months when the stake president, L. Tom Perry, was called into higher leadership as an assistant to the Twelve Apostles, which required moving to Salt Lake

City. Richard then became stake president himself. He was as busy as ever, while surveying a wider field.

During this time some of our Boston Mormon women's activities got underway. Laurel Thatcher Ulrich had invited a number of local women to her house to talk about our lives as Mormon women. We met on June 23, 1970, for a "sewing circle" and continued to meet monthly. We talked about our lives, our families, our responsibilities, our housework, our church work, our hopes and dreams. Discussions were often heated. There were tears, headaches, comfort, sharing of good and bad things. Toddlers climbed over our legs and feet. I considered myself a radical, but I could not make up my mind on what it was I wanted.

We sometimes called our group an LDS cell of Woman's Lib, though we were not affiliated with any other group. We did not favor putting down the family, but we did discuss our feelings and our reading on the subject. Our meetings were open to any who cared to join us, but we had a core group of a dozen or so. We developed a reputation and began to get some notoriety. I got a call from Elaine Cannon, an establishment figure in Salt Lake City, whose son had been in Richard's congregation. She had a successful career as an author and newspaper columnist as well as being a prominent Church leader. She said she had heard of our group and would like to visit. She sat in on one of our meetings and talked quite a bit herself. This visit was informative and helpful to our girls, some of whom felt stifled by strong pronouncements from male church leaders about a woman's place and the editorials in the Church newspaper. Most of us felt that while we loved our families, we wanted some personal satisfactions and achievements of our own. We felt that we had not been encouraged to look beyond family needs. I thought that women should be taught to plan their lives so that they would be ready to do interesting and useful things after their children were less dependent. I was invited to speak at BYU during this time and I had lectured on that theme, with the title "The Best of Both Worlds," about how I was a housewife and a student. Many resolutely house-bound women found that topic offensive. We were fortunate to have church work that could fill the void, but I wanted something in the real world. There was pushback from those who favored limiting the female sphere. Our visitor Elaine Cannon argued for more freedom for women and encouraged us to continue to express ourselves, hopefully in a positive manner.

After many more emotional meetings, I suggested that the group might undertake some projects to give direction to our energies. When

our friend Eugene England, a prominent Latter-day Saint intellectual and a founder and editor of *Dialogue: A Journal of Mormon Thought*, was visiting us one time, I "screwed my courage to the sticking place" and asked him if he would entrust a group of bright, underemployed women to produce a special issue of that quarterly—a women's issue of *Dialogue*. He immediately and enthusiastically agreed. I invited Laurel Thatcher Ulrich, already a published writer and the creator of the successful guidebook *A Beginner's Boston* as well as the founder of our "sewing circle," to co-edit. Our twenty or thirty attendees would all be sub-editors, involved in soliciting, discussing, and critiquing the articles, weighing in on each one. We solicited, passed around, edited, and re-edited manuscripts for months.

I was barely keeping my life in order—balancing selected aspects of housework, church work, schoolwork, childcare, and the *Dialogue* project and letting the rest go. All standards, never very high, were slipping because I tired so soon because, that's right, I was pregnant, expecting baby number six. But I couldn't see how I could get out of anything until the semester was over. After school was out, things did get easier. The *Dialogue* issue was shaping up. It might not be all we had hoped, but it would be interesting.

I wrote to my family at this time.

> You would be appalled at how much time I spend as co-editor of our special issue [of *Dialogue*]. Being ignorant doesn't help and I'm sure we worry and discuss more than we should have to, but the correspondence is endless, the manuscripts have to be solicited, edited, criticized, sent back, etc. People get offended very easily and we suffer tortures thinking how unwisely we have handled certain situations. We are heading for a June 1st deadline but even after that there will be mountains of work with final revisions, illustrations, proofing, etc. I hope it's a growing rather than a shrinking experience. May 5, 1971

When I got very worn and discouraged, Richard pointed out that at least I no longer anguished about whether my life had any meaning.

Our youngest and last child was born in 1971. He got a real Bushman name, Martin Benjamin Bushman, the name of his paternal great-great-grandfather. We have always called him Ben. He was born in Cambridge, Massachusetts, after we had moved to Belmont. The children were our best souvenirs of living in those varied and distant places.

I have said that we had decided not to plan our family but to take whatever came. And in general, that worked very well for us. But in Ben's case, although the birth was not planned, it was at least contemplated. At that time of the "emerging woman," I was seriously considering whether I

should try to become a more public, better-educated woman, applying to a PhD program or whether I should have another baby. The thought went back and forth in my mind. I finally decided to do both and from then on, continued to live my rich and exhausting double life.

I really dreaded the delivery of Ben because I had convinced myself that it would be better for both of us if I did not take any anesthetic. I was certainly a coward, and I didn't want to suffer, but I had made up my mind. And the delivery was bad. There was about half an hour when I did not think I could survive from minute to minute. But immediately after the delivery, I felt unbelievably better. I sat up, stood, and moved around with no trouble. I was so high I couldn't even sleep that night.

Life seemed so arbitrary. When I looked at little Ben, already an important part of our lives, I could easily remember how the year before I had had no intention of having any more children. If I hadn't gotten involved in the idea of women's liberation—which just did not work for me—persuading me that having children was really the best thing, we might never have known him. Little Ben was a beautiful baby with two big dimples. I was so happy to have him. He was so bright, alert, and strong—a charmer in every way. Life then seemed easier. I might still wonder whether I should wash the diapers or the dishes or my hair, finish tidying the bedroom, lie down and read, or go water the garden, but I suddenly felt freer. I could make choices.

We were in the throes of producing our women's issue of *Dialogue* for a long time. When we finally submitted the copy for the issue, which dealt with real women's lives and homely household topics like children and housekeeping, a new *Dialogue* editor was in place. He did not like the articles and considered them tepid. He thought that we had missed the boat by not tackling the real women's issues of the Church which were polygamy and the priesthood. I was stung by his disapproval. I can see that those were significant Mormon issues. But they were not our issues. Our actual lives were too far divorced from the history of the Church for us to take those issues seriously. The demands of family and housekeeping, even for bright, serious, and well-educated Mormon women, weighed more heavily on us. Richard thought that it was presumptuous of the editor to tell us what our issues were.

The pink issue, however, was a great success. And it was honored. Many people read it and liked it. A judge of *Dialogue*'s prize competition said that this women's issue "was one of the best collections—perhaps the very best—of worthy writing and brilliant editing in DIALOGUE history . . .

suffused with the religious culture of Mormonism." He praised the "vision as well as the accomplishment" of the editors. A teacher of women's studies at the University of Utah assigned the issue as reading material. She wrote in a letter to the *Dialogue* editor, "If I am to enjoy emotional security, if I am to experience that elusive quality of happiness for which we all strive, I know I must find a place among similar souls. To this end it is my deepest hope that the good sisters who contributed to the 1971 summer issue will permit me to dwell among them and be one of them."

Largely in response to the negative reaction of the editor who had not liked the issue we presented, we undertook to teach an institute class on early LDS women, each taking a topic, researching, writing, and presenting. We had been invited to prepare and present this class by Steve Gilliland who led our local Institute and taught classes on Mormon matters to college students. Where we had lived in the present and in our own houses, we moved into the past, considering the history of Mormon women. Our course was titled "Latter-day Saint Women: An Historical Analysis by Contemporary L.D.S. Women." I called this course Roots and Fruits of Mormon Women. An early syllabus for this Institute seminar in the spring of 1973 lists fifteen women presenting classes on such topics as women's education, suffrage, doctors and lawyers, polygamy, statehood involvement, and their representation in fiction. Much of this course was made possible by the discovery of the *Women's Exponent*, the early Utah newspaper where we made the acquaintance of many interesting women of the past.

We then began an ongoing project, an Exponent Day Dinner. We envisioned a pleasant social evening with an elegant dinner, at the preparation of which many of our women excelled. We invited notable guest speakers to address the gathering on some topic of Mormon womanhood. We had been working with the Church Historical Department where Leonard Arrington, the first professional historian to be the historian of the Church, had great interest in Mormon women's history. We invited Maureen Ursenbach Beecher, one of the editors who worked with Leonard and who had been very helpful to us in our researching, to be our first speaker. The Church historian's office even helped us to underwrite her traveling expenses from Salt Lake City. Maureen discussed Eliza R. Snow. The first of these dinners took place on June 2, 1973, 101 years to the day of the founding of the *Woman's Exponent* on June 2, 1872, at the home of Chase and Grethe Peterson. The crowd, the dinner, and the talk were all beyond expectations.

Juanita Brooks was the second Annual Woman's Exponent Day dinner speaker, staying with us for a week. She was the most distinguished Mormon woman of letters, and we felt very fortunate that she was willing to come. She was a little apprehensive, but her visit was a great success. I counted it a privilege to have met her and gotten acquainted. She brought me four of her books and fit right into our lives. She took Clarissa's room, but she was always offering to share it. Small and slight, she ate like a trooper. The *Exponent II* dinner was delicious and about 120 people paid $3 each to come and hear her talk. The talk was charming, anecdotal, folksy, direct. She wandered a little but pulled herself back. Several cousins, descendants of the "first wife" of her grandfather, came and took her sightseeing. It was a delightful experience to get to know her.

In the program of that event we described our group as having met together to discuss issues of concern to Mormon women for nearly four years. The paragraph noted that we had published an issue of *Dialogue*, presented a seminar on Mormon Women: Their Roots and Fruits which had led to our discovery of the *Women's Exponent*, and were working on a book of essays focused on issues raised by the seminar. I thought that that sounded like real accomplishment. The written versions of the essays came in slowly. I worked them over and passed them along. It was hard for those girls, who were used to talking, to set words to paper. Writing came much harder, and I certainly sympathized. I told them to keep at it—they would feel great when their essays were done. We lost several along the way.

When I finally had a good group in hand, I sent them off to the publisher who had asked me to produce a book on Mormon women. He returned the manuscript without comment. I sent them off to the Church Historical Department, and the people there were not enthusiastic either. Leonard thought that there were some big holes and offered to have the department provide additional essays on pioneer midwives, schoolmarms, and Maureen's essay on Eliza R. Snow. I welcomed these and we tried another publisher, again without success. I put the project aside as the first of our unsuccessful ventures, planning to do more on it later.

Our family continued our busy day-to-day life. Richard worked hard at his teaching and the many additional responsibilities of academia. He continued his all-consuming church life and took on some extra things if they were interesting and paid a little money. He was the acting director of the American Studies program with lots of counseling and negotiating. He worked hard on his two book projects. At one point he took off to BYU for a week to evaluate the history department. He had left as a junior

faculty person and was returning as an important expert. His colleagues there urged him to return to the Y, saying that they would raise money for an academic chair that he could hold. Some relief came when he was awarded a Guggenheim fellowship to work on his origins of Mormonism book and also granted a sabbatical, a year early, providing enough income for a year's sustenance. He continued to give papers at historical meetings. I wished I could get in on some of those trips. He assured me that my day would come.

For our local LDS congregation's conference called Education Week in 1973, I was asked to give a presentation on motherhood as I was considered such a great mother. My children considered this a great joke. I told them that it must be true because I had such remarkable children. In the program, I defined myself as the coordinator of the activities of my children—a dancer, a fiddler, a herpetologist, a sprinter, a patriot, and a transcendent baby. The children continued to grow and develop, and the older three were strongly attached to varied interests that we certainly favored and supported.

Clarissa's dancing continued unabated. She was given the part of the graceful Polynesian Liat in the school's production of *South Pacific*, pretty good for a freshman. Her dancing teacher praised her improvement. Yet there were problems. After one performance her teacher remarked, "Clarissa, it's a pleasure to watch you. And girls," she said, addressing the rest of the group, "she has a worse body than all the rest of you put together." Clarissa explained her difficulties like this: "My two major problems are my body and my feet. My feet have improved in strength and looks, and I have confidence that someday they will be actually passable. My body is another matter. I'm really too heavy. [She then weighed 95–100 pounds.] For street clothes, I am fine; but when those go off and the leotard and tights go on, I don't look bulgy, merely large. Every day is a new diet, and every night the end." Her physical difficulties increased as she moved to womanhood and impacted her future. She wanted to dance but realized that she was imperfectly suited for it. Poor Clarissa.

She worked in other aspects of dance. She did not try out for the school musical *How to Succeed in Business Without Even Trying* her junior year because she was too busy. However, a good friend (the male lead) persuaded her to take on the choreography. Having little talent to work with, she made the dances very simple, usually arm or leg movements, but not both at once. She drilled her dancers so well that the numbers looked very professional, and her choreography was much admired. She was listed on

the program with the faculty personnel and given a bouquet of flowers. That was a great success for her. Brick played in the orchestra.

Clarissa, mature for her age anyway, was one of the oldest in her high school class, having missed the entrance date to kindergarten by three days. She decided to leave high school early, skipping her senior year. She applied to five schools and was accepted to all, choosing to attend Radcliffe, the women's college that merged with Harvard during her time there. She planned to be a commuting student, because there was no scholarship help. This would be a serious stretch of our funds, but we just decided to see if it could be done. She would continue her daily dancing classes, planning to take a leave of absence after her freshman year at Radcliffe to go to New York to dance. She attended the graduation and was awarded the Smith College Prize for "Outstanding Achievement": a fat dictionary. Brick also got an award for being in the All-State Orchestra. By early November, Clarissa got a room on campus, which Barnard Silver, our family philanthropist, helped us pay for.

Clarissa had a great time at school. Her first freshman theme came back with an A and a comment to the effect that it was quite possibly the best of the five hundred or so freshman themes the teacher had read. (Both of her parents had given it the once over.) One Sunday evening after church, as she was walked to the bus stop by two handsome swains, she met two boys from her Belmont High class and was able to introduce them to freshmen from MIT and Harvard. She blossomed under the attention, did well at dancing, and enjoyed her classes. Clarissa wrote, "I have been very happy lately—more happy than ever before in my life. I feel safe & secure, intellectually challenged, and very, very busy. My social life simply does not let up, but then, I wouldn't have it any other way. I am motivated to be good by two Mormon fellows whom I really like." She later looked back on this time as the high point of her life.

Clarissa finished her Harvard freshman exams, graduated from high school, and took off to New York City to dance. She got into an apartment near Lincoln Center with three other girls.

Brick, meanwhile, was devoted to his music, not so much to expert technique as to the social experience of playing music and the music itself. He was in demand as a male violist, and he successfully auditioned for the All-State Orchestra and for the Greater Boston Youth Symphony Orchestra—a great achievement. He later left that for a smaller chamber orchestra run by the New England Conservatory of Music, conducted by the charismatic Ben Zander. He spent two summers at Apple Hill music

Bushman family, c. 1975. Front: Ben and Karl; middle: Serge, Claudia, Richard, and Margaret; back: Clarissa and Brick.

camp where he practiced for two hours a day. He knew most of the best string players of high school age in eastern Massachusetts, and groups often gathered to play chamber music all day and go to a concert at night.

He was invited to join the Young Artists program at Boston University on a full scholarship. He had been unwilling to audition, saying he was not good enough. But they badly needed a violist and took him in. He spent Saturdays with chamber music, a theory class, master classes, and concerts.

Brick, having been using school instruments, began to look around for a viola of his own. His teacher came to town and looked over some Brick had chosen for consideration, and we bought a German Roth, about thirty years old. This seemed both a good instrument and a good buy. We didn't detect any great improvement, but he still liked to play. Barnard helped with that, too.

Brick also took on drama, having a nice triumph in *The Mousetrap* which played to full houses. He was good-looking on stage with his blond hair and could always be heard. He got all As on his report card, except for PE. He was a great hit in *The Music Man* and began to see himself as a song-and-dance man. He made a deal with Dr. Nicholson, the school music director, that if he sang with the concert choir he could audition for the All-State Orchestra. The high school orchestra class conflicted with the fourth-year French class which he had to take for his major. He was also named a National Merit Semi-Finalist, one of fifteen thousand of the one million who took the test.

Karl, a devoted Boy Scout, achieved ranks at the fastest rate possible, qualifying for the Eagle rank before he was thirteen. He continued his interest in herpetology, which I encouraged, collecting frogs and newts in the backyard pond and snakes and his big toad, Freddie, in our living room terrarium. Our anole lizard, Spike, lived on the plants in the kitchen window. We imported insects to feed him but often found them crawling around on the floor or dishes. Grim.

Karl had a two-foot milk snake named Monte Python who lived in a box in his room. When Karl was away, the snake managed to escape. I bought a white mouse to tempt him back and left him in Monte's open box, pleased to discover the mouse missing. Gradually I realized that the snake had escaped, too. The mouse, I managed to recover. Then Margaret was given a big open cage with three gerbils. One day we found only two. We did manage to catch all of them again. But somewhere in our house a snake was loose—or unloosed. Karl caught him on his return. Once when I was playing the piano, Freddie, our large toad, hopped out from under the sofa. It's a good thing that I liked those creatures, too.

Karl, playing bass clarinet in a summer school band program, mentioned to the director that he had a younger brother, Serge, who would soon be in the middle school. Mr. O'Halloran was all ears, wondering what Serge would be playing. Karl said that Serge wanted to play the trumpet and then move on to French horn. Mr. O'H. was delighted and promised Serge a new school French horn if he would take private lessons,

too. We were all pleased with the deal. Mr. O'H. had said several times that Serge would be a great asset if he was anything like Karl.

Margaret was playing the cello and dancing, but she eventually abandoned them both in favor of sports of various kinds. She had remarkable social gifts. She was perceptive and intuitive, very keen and socially sensitive. She skillfully maneuvered towards her goals by demanding, sulking, and being charming and helpful. I hoped she would use her gifts to worthy ends. Margaret and Serge, so much alike and yet very different, were very social creatures, always wanting to visit others or have guests over.

Serge, a new school kid, liked lunch, recess, and the library. He had a gruff voice and was very straightforward. He observed that "the sun is at the side of the sky and it's getting nighter." He liked to have homework. He also liked costumes, and I made him a nice little colonial suit. He dressed up in that or something from the costume box on most days. He had been the silly one, the gruff one, the unwilling one of the children, but he grew up to become an ideal kid, a great help, always good tempered, and very nice to have around.

Our charmer, Ben, got more than his share of love and attention. We called him the King Baby of the Universe. All the neighborhood children loved him, too, and made a big fuss over him whenever he appeared. As he began to talk, he imitated our tones of voice. Ben bawled us out when he was displeased, calling us "you dummy!" or muttering "oh, brother," but he was usually reasonable. His favorite toy was Margaret's little dollhouse. He would arrange the people and furniture for long periods.

One day, I took Ben, almost four, to the library and left him "reading" in the children's room while I went upstairs for a book. While I was gone, he chose four books and took them to the desk, telling the girl to check them out on Margaret's card which was on file. When I came back, he said he had already bought the books and was ready to go.

About that time, he refused to go to his Sunday School class, weeping, hollering, walking out. I finally got him to stay with me sitting there one time. The next week he said goodbye at the door and sat with his class. The next week he recited a scripture with a clear voice and folded arms. Suddenly he was the model church child. He was still a big whiner and squawker, but I had some hope for him.

As for me, I finished my classwork at the university and began reading toward orals. The scheme I tried to follow, one which Richard recommended for his students, was to prepare lectures for a course on the social history of the United States. It took me a long time to even get out of

The Belmont House, c. 1975.

England and Europe and the conditions for migration. In December of 1972, I took and passed my oral examination, a two-hour interrogation by four professors. My performance was certainly not brilliant, but it was passable and after that, I had only to write a dissertation to qualify for a PhD degree. For a long time afterwards, I still had a sinking feeling when I remembered some of my answers, but that eventually passed. I taught summer school at the university. It was a good experience and I enjoyed it, and I was able to send Ben to nursery school that fall, thanks to my summer money.

My parents invited me out to California to bring Ben for a visit. I decided to bring Serge along, too, as he did not have many after school activities. We had a wonderful time visiting the colorful sights in San Francisco. When we flew home, we had three seats in the first row. The children were a little lively, but not when compared to others. As we deplaned, the lady behind us said to me, "You have beautifully behaved children and are to

be commended." I was really proud of myself and of them. We found the family in good shape and spirits. Ben was not particularly overjoyed to see his family again, taking everything with great nonchalance as was his wont. He continued to be our joy and terror.

The house looked very pretty to me. The trees had leafed out, softening the streets. The bombed-out kitchen, which had been under construction for some time, was improved. The counters were all in. The disposal was functioning, and we could sit and eat and fix meals there. The floor was set to go but was not yet in, and the downstairs bathroom was still out. I felt entirely dispassionate looking at the place. I was sure it would be very nice someday. After flooring, plumbing, carpentry, painting, plastering, papering, and furnishing.

I was soon back in the busy swim. One Saturday I found that I was chairing a session of the New England Association of Women Historians meeting from nine to one. I then hurried home, fixed the sweet potatoes for the ward luau, then hurried to the church to start the rehearsal of the roadshow which would be performed that night. What a life!

In April of 1974, plans got underway to publish a Mormon women's newspaper. After some event we had held, I came home and noted with enthusiasm that everything our women's group did turned to gold. I asked Richard what we should do next. His quick response was to start a newspaper.

This was not a new idea. We had been inspired by the *Women's Exponent*, and we even had a person with some real newspaper experience to be the editor. Stephanie Goodson had been a reporter, and she was willing, but she was also the mother of a new baby and the president of the church women's group, the Relief Society. She didn't think that she could edit the paper, too. She asked the ward bishop to release her from the Relief Society so she could do the paper. He refused to do it. She sadly reported this at the next meeting of the women. Carrel Sheldon, our most serious mover and shaker, turned to me and said, "Well, you'll just have to do it." I noted my multiple responsibilities and said that I would do it when we got the book finished. She said, "No, we have to begin right now," and so we did.

Carrel was really the boss and she immediately set about planning on publishing as inexpensively as possible, researching printers and newspapers and getting a post office box. We were all thrifty housewives on limited budgets. We decided to publish on newsprint as it was cheap. We thought we could do quarterly issues for a $2 annual subscription. We

had a little money on hand from our dinners and from the $200 check Leonard Arrington had given us to pay library costs for our research, and we decided to send out our first issue for free. We would send out multiple copies to friends and relatives to distribute.

I set about looking for content. I wanted it cheerful, folksy, informative, not too earnest, and with a dash of feminism. Laurel, later describing our little *Exponent II*, said that it was like a long letter from a dear friend. Sisterhood and good company were what I was after. This tabloid sheet was a warm renewal of the earlier *Women's Exponent*: women spoke frankly and shared their lives and experience. *Exponent II*, still in print some fifty years after its original publication and having been through many editors and boards, is now slicker, longer, more beautiful and art-filled, and much more expensive. I slaved over my first editorial, and it came out like this:

Exponent II is Born

One hundred and two years ago a group of Mormon women began publication of a forthright newspaper called the *Women's Exponent*. This ambitious paper circulated worldwide women's news, reports of the Church auxiliaries, feminist editorials, suffrage progress, household tips, letters, humor and more to sisters from Salt Lake to St. George and throughout the territories. The *Exponent* was published until 1914.

The discovery of this newspaper has meant a lot to women today. Our foremothers had spirit and independence, a liveliness that their daughters can be proud of. Devoted mothers and wives, they tended their homes and children, helped support the family, and turned out a dynamic newspaper on the side. Can we do the same?

The Mormon women of the Greater Boston area have been thinking and talking about Mormon women's issues for five years now. Our network of sisterhood grows constantly. Sisters write us from far off and come to visit our meetings. These relationships have enriched us all, and we hope to catch more of our sisters in this net of common experience and understanding.

To that purpose we begin publication of *Exponent II*, a modest but sincere newspaper, which we hope will bring Mormon women into closer friendship. Faithful but frank, *Exponent II* will provide an open platform for the exchange of news and life views. *Exponent II*, poised on the dual platforms of Mormonism and Feminism, has two aims: to strengthen the Church of Jesus Christ of Latter-day Saints, and to encourage and develop the talents of Mormon women. That these aims are consistent we intend to show by our pages and our lives.

With the help of Jim Cannon, the lawyer husband of one of our members, Connie Cannon, we incorporated our little group as Mormon Sisters, Inc., a non-profit in Massachusetts. This meant that we could apply

Inaugural issue of *Exponent II*.

Founding members of *Exponent II*, 1974.

for low-cost mailing privileges. We changed the name to Exponent II, Inc. when the Church objected to our appropriation of the name Mormon. I was the president of a corporation. Who could believe such a thing?

We sent out bundles of our free first issue to friends and relatives for distribution. Subscribers sent in checks, and we soon had banked enough money to put out three more issues. We got lots of touching letters, women grateful for our existence. I was told that some BYU faculty members had started a pool on how long *Exponent II* could last. The most optimistic said a year. But we were ready to go on forever. I could think of endless things to say. We got a nice write-up with pictures in *Utah Holiday* magazine. People called me long-distance to talk. A Church public relations person interviewed me for a report on women in the Church. It was just great to be somebody. I marveled that our few housewives could turn out such an excellent product. I loved being in a power position for a change.

Our third issue ran sixteen pages and had some very handsome pictures. I decided at the last moment to pull an article on garment reform entitled (ahem!) "A Modest Proposal." The board thought that I was being too timid. Everyone else thought that I was a flaming radical.

Our former stake president L. Tom Perry passed through town, and Richard and I attended a little reception for him and his wife. He was not very well and was more subdued than usual. As he left, he shook each hand and made some pleasant remark. To me he said very seriously, "Stay out of trouble." I hoped I knew how to do it.

I made two big mistakes in judgment. A little newspaper by a group of Mormon women was considered remarkable and I was interviewed by a Boston newspaper. I didn't say anything more than what I believed, but the published article did sound pretty liberal. A copy with sections blocked out in bright yellow made its way to our church bulletin board and to Salt Lake. And then, even worse, we sent copies of our little newspaper to the wives of all the Church's general authorities, in care of the Church Office Building, honestly thinking that we had something going that they ought to know about and would enjoy. We had nothing to hide, but we became impossible to ignore. We were told never to do that again. They were innocent mistakes, but I should have been more careful.

Meanwhile, Richard was bishop and then stake president in Boston, heading our congregation and then our group of congregations. Some people thought that these feminist efforts were unsuitable for good members of the Church, and particularly for the wife of the stake president. A visiting general authority named Robert C. Hales kindly, and on his own

initiative, he said, made an appointment to meet with me after his official meetings. We had known him for a long time. I had been a counselor to his wife in a Relief Society presidency. That was in August of 1975. I wrote my parents to say, "It was good to see Robert Hales. He is very warm, open, receptive, helpful, friendly, etc. We stayed up until 2 am discussing various things. I'll tell you about it sometime."

I did not talk to anyone but Richard about this meeting until September when the *Exponent II* staff went to Grethe Petersen's farm for a retreat. I told my family that we had had a great time, staying up most of the night—eating, drinking, walking around the lovely place. It was a nice break from the usual festivities. But I told the group that Elder Robert C. Hales had advised me to close down *Exponent II*. He said, we would be "irreparably damaged" in the eyes of the Church, that "no good can come of this." I presented his ideas to the group and suggested that we close the paper at the end of the year. I resigned as editor. There was great consternation. But the other workers, believing that the paper did more good than harm, wanted to continue on. They decided to write long personal letters to Elder Hales, telling how the paper had made them better church members and better people. They sent off an impressive sheaf of affecting correspondence to Elder Hales in Salt Lake.

On Christmas Day of 1975, four months after Robert Hales' first visit, I finally wrote to my family as follows.

> I'm sure you have known that this has been a bad fall for me, and I think I should tell you a little about it now that I can talk about it with some rationality. You remember that in August I told you our old friend Bob Hales came to be the guest at our conference. Before coming he set up an appointment to talk to me about *Exponent II*. We had a very long talk after his meetings on Saturday night. He said that he admired what we had done with Exponent II, but that continued publication of the paper would only damage us and bring us all pain. He said he had put an issue through correlation for their comments. The text passed and would have been approved, though the committee thought that some of it was not of high enough quality to be published in church magazines. They dismissed the artwork as subversive. They considered the general appearance unwholesome, like an underground newspaper. Bob was kind, but he was sure that no good could come from it.
>
> At Grethe's farm I rehearsed the whole conversation as well as I could. There was a great deal of discussion as to whether the advice was to me or to the group as a whole. We finally decided to have a day of fasting and prayer and for each of the active group to write a letter to Bob stating her position. The sheaf of letters is very impressive. The result was that L. Tom Perry made a special trip out to talk to the group.

We had a sort of fireside. Brother Perry could be very good-natured and easy going. He said the Church would never close down the publication, but he warned the women that they should be sensitive to issues that would divide the church and to stay away from soft peddling women's rights and other scary issues. He said he hoped the group would be strong enough to publish while it was doing good and strong enough to quit if there were difficulties. He said that I could not be involved because my position as the wife of the stake president indicated official support by the Boston Stake which could not be allowed. I was stunned by this decision because I think it is unjust and short sighted. He said it was just the facts of life. So, not only have a husband who is almost totally preoccupied with matters elsewhere, I am forbidden from acting in any noticeable way in the church community. But, of course, I am obedient, so I resigned from the paper and am now not officially connected in any way. It was too much when I was asked to write a piece for the church magazine, *The Ensign*, commenting on the ways a husband should sustain his wife in her callings—church, family, community, etc. I turned that down. Now that they have made clear the concerns about the paper, it will go on, but without me. All this has been more painful for me than I can say. I brood. I cry. I am paralyzed. But I am getting a little better, I think, and will just have to find a new life for myself.

I later wondered what my mother's reaction had been to this disclosure and checked back in her journals that I transcribed many years after. Would she have been outraged? Like me, she was just sad. In her first account after having read the letter, she wrote on December 29, 1975, "Claudia is sick about the church insisting she give up editorship of Exponent 2. I can see why. She has done a fine job and enjoyed it. So, it will go on without her for a time, anyway." The next year on January 2, she wrote "Claudia is often in my thoughts, with her sadness at having to leave EX 2. I hope she will find something to do to use her vast intellect and time. She is so talented." That comment cheered me up a lot.

My severance from the paper was a difficult time for me. I had certainly thought that *Exponent II* was too much work and I had considered resigning, but to be told I couldn't do it was very hard. I could have refused to comply, but I don't believe in fighting battles that I cannot win, and that would have criminalized *Exponent II* and probably led to Richard's release as stake president, something for which I did not want to be responsible. Richard never told me what to do. Looking back on that time, I think I acted well enough. I have a clear conscience over the whole matter. I did not discuss the situation with anyone who was not present at the meeting except my family, months later. No one has ever bothered the paper or the writers since. I think I kept the respect of Brothers Hale and Perry, both of whom are now gone.

Some Church leaders had identified feminists, intellectuals, and people on the LGBTQ+ spectrum as enemies of the Church, and there was a growing fear of reprisal in the air. Richard, calling from Salt Lake one time, commented on how paranoid the people writing Church history in Salt Lake were. On one hand they feared that the people at a secular university would not consider what they were writing as serious history; on the other hand, they feared the comments of the Church leaders for stepping away from established conservative views.

Sometime before, Richard had written a piece on the prophet Joseph Smith for the current Church magazine, somewhat humanizing him. A couple of sentences in the piece gave the correlation committee, which had oversight of Church publications, long pause. Two years later, when the piece was finally published, Richard got a warm congratulatory note from Ezra Taft Benson, the conservative Church leader. Richard took the note to Salt Lake and showed it around, astounding all. He thought that everybody in Salt Lake was running scared. It seemed such a shame to have dividing lines separating the orthodox from the heretics. We needed more including in, not tossing out. However, I decided not to do any more work on Mormon women, an issue that seemed too sensitive for anyone married to authority.

My dear Exponent sisters were very good to me. They put on several parties for me and created a large, quilted hanging for me which is one of my greatest treasures. The design is basically a tree with a rainbow overhead and birds above that, all hopeful elements in a stylized design. The group contributed ideas of sayings, scriptures, places, and activities which Carolyn Person worked out in the color scheme of a pair of upholstered chairs I had. She provided an ink sketch of the design, citing information on the references. We always give that hanging the place of honor in our houses and hang the framed sketch nearby.

–13–

Belmont Last Days

All this time, I was working on my dissertation which turned out to be the study of a family in nineteenth-century New England, with particular attention to the matriarch, Harriet Hanson Robinson, a determined record keeper. She had written about her early life in the mills and went on to be, as she styled herself, "a good poor man's wife." She had made the best of all the education available to her, writing more books and becoming an early woman's rights advocate. I had discovered that her papers were in Radcliffe's Schlesinger Library, a short bus ride from my Belmont home. There would be a lot to read and work over, but the basic material, as well as a great trove of supplementary material, was conveniently available there. Working on Harriet fulfilled my original aim for a close study of women's work in the past to compare with my own life. Harriet and I lived in close quarters for many years. And I was fortunate to have her as a guide to women of the past.

Still, there was the making sense of all that material—seeing the implications, organizing the disorganized minutia, even as I was living through the same kind of minutia in my own life, and then getting it down on paper. I could not abandon my quest for a degree; I had already invested too much in it. My classwork was completed, and I was working away at the dissertation, but I still had to pay a sizeable annual continuing fee just to stay in the game. I kept on trucking whenever I could stand to get to it. I figured that I had ten chapters to write. During the summer, the children were home to watch Ben. When they were in school, I took him to nursery school, getting in some morning work time. My thesis advisor, David Hall, who chaired Boston University's American Studies program, was less than enthusiastic about my topic and chapters. He liked ideas; I kept coming up with information. I set deadlines, missed them, and set more deadlines. All schoolwork for me was contingent on nobody getting sick and other responsibilities.

I kept plugging along, torn by the problems between specificity and generalization, of dealing with themes rather than chronology. As soon as I worked on one, I lost the other. David's constant direction was to shape my material. But I found that lives, certainly my own, were not shaped very well, and that shaping them flattened out curves. I struggled on. In

November 1976, I piled up the chapter drafts I had written and found that they measured three inches of typescript. I left it sitting to show that I had actually accomplished something in the last three years. I had more than 650 typed pages of manuscript before I finished the tenth chapter. Richard cheered me on by pointing out that I hadn't broken any records for time yet and that I was much farther along than I used to be. All true, but still discouraging.

During this time, we were also publishing our book *Mormon Sisters: Women in Early Utah* (1976), which resulted from the class Roots and Fruits of Mormon Women, which we had taught to the college students and others at the church, and then our efforts to write out the chapters. A book had been solicited, but the press returned the manuscript, saying that the editor had decided not to do any more Mormon books. The manuscript had not found a home. I had put it away for the time being.

Carrel Sheldon, the publisher of *Exponent II*, decided that we should publish the book ourselves—an expensive proposition. Publishing the book was not my idea. I had other things to do. But the group had some unused energy, and so we opened a publishing house. Carrel did some research on costs and banks and arranged for us to take out a loan for $12,000. Twelve of us each signed on for a limited liability of $1,000. This looked like the national debt to me. But we moved forward.

We incorporated as Emmeline Press Ltd. The name was my idea, a reference to Emmeline B. Wells who edited the *Women's Exponent* for many years and was the Relief Society General President. The name also referred to Emmeline Pankhurst, a British suffragette. I liked the name because it was feminine, old-fashioned, and quaint, but significant. The "limited" was a joke. In this case it meant that a limited group of women was involved, that we might publish a limited number of books, and that we needed another letter for our logo. EP just didn't make it. EPL was good.

I began to work over the manuscript. I realized that it was provincial and not a great book, that it was uneven and occasionally repetitive, but that it was still better than anything else in the field. Not to mention the great achievement it was for our group of women to turn it out. We aimed to make it beautiful, too, with good paper and good-sized print. I began to look for pictures. Gerald Horne designed the beautiful title page. We included a good reading list. I put together a comparative chronology of Mormon and national events and women's achievements. I did the index. Carrel hired a printer for the book. The printer hired Nancy Dredge, one of our number and the new editor of *Exponent II*, to retype the manuscript

and embed the necessary codes. What a job it all was! Even numbering the pages took hours. Every page had the potential for thousands of mistakes. But I thought and still think that there was much that was interesting and valuable, and I was glad that we had taken it on and could make the book available to those who were interested.

We ordered 5,000 copies, a great many for a history book by unknown authors. But we already had *Exponent II* going. We offered our quite beautiful 283-page paperback for $4.95 postpaid. We printed up some hardcovers with nice dust jackets as well. *Exponent II* published a long, positive review by Mary Bradford. Carolyn Person decorated the comparative chronology for the centerfold of the paper, and it was gorgeous.

Apart from the book material, I was staying out of the way from the paper in those days, and it carried on very well without me. We urged readers to order our book in advance and promised delivery in time for Christmas. We had enough money in hand to pay off our loan before the book was off the presses. We got word that four classes at two different universities would use it for their reading. We were not only writers and publishers, but we had also created a college text. A quarter of the printing had been sold a month after publishing. We got a lot of very nice praise for the book, and at the next annual meeting of the Mormon History Association, *Mormon Sisters* received a special citation for excellence. Alas! No one was there to receive it.

My mother, who was a real fan of all our publishing ventures, was asked to do a program for her local Relief Society sisters. She reviewed two chapters of *Mormon Sisters* and spoke of the group in the East, their experiences with *Dialogue*, *Exponent II*, and so on. She said that all seemed to enjoy her forty-minute presentation, and that she sold all the books she had, about nine. She felt good about it all.

We could have done better on our costs for publishing with more experience and time, but we did not sacrifice quality as we were tempted to do several times. Publishing books is a hard way to make money. We donated 1,000 woman-hours to the enterprise, not counting the considerable time of writing and editing. The book, with our generous choices, ended up costing much more than expected, as expected. I noted at the time that it was just as well that we hadn't known that. If we had known the future, we might not have published the book, and I am glad that we did. I didn't care whether I ever got any money out of it. The book was a significant contribution to Mormon letters, and it was important historically that we published it.

Richard was working on two books later published as *Joseph Smith and the Beginnings of Mormonism* and *King and People in Provincial Massachusetts*. He was also busy giving lectures on the origin of the United States in the bicentennial year of Independence. The city of Boston invited him to give the official Fourth of July lecture at Faneuil Hall, and he spoke to many groups on the American Revolution. When he was invited to lecture in Munich, I went along, and we had a wonderful two weeks in Germany and Austria. The sponsoring group paid his fee and fare in German marks that we happily spent. Richard's parents had come from the West to care for our children, and we had the vacation of a lifetime.

Czechoslovakia, which we visited last, was then still behind the Iron Curtain and was a chilling gray contrast to the democratic countries. Our train out of the country was delayed as grim soldiers with machine guns searched our car. We all sat silent and scared until they left. Then we cheered as the train finally pulled out.

The children were growing and changing fast. Clarissa came back home after her year in New York City, ready to go back to college. She had become disenchanted with the life of a freelance dancer in New York. She hunted for a college major that might include dancing and eventually settled on history. She got a job teaching daily dancing classes, which she did with mixed elation and depression.

Brick was admitted to Harvard that year. He had done very well in high school, academically and artistically. Brick, a Harvard freshman, and Clarissa, a sophomore, were just a year apart in school again. When it came time to pay for their first year in school, we had some difficulty scraping up the funds for two college students as well as my continuing fees. Brick got a scholarship, but the officials did not consider the tithing we paid to the Church as a legitimate expense, so the scholarship was not really enough. My announcement to my family of this great achievement of two children at Harvard "showed some strain," according to my parents, and my father sent me a check for $500.00. He was really retired, but he kept up enough of his own small business that he had some extra funds to give when he wished. It was a very generous gift. We made it through that year, thrilled to have two children at Harvard! Brick studied German literature as well as French and Spanish. He started out as an advanced student, taking a class where the lectures and reading were in French. He took his notes in French, too.

Also interesting was that Brick and Clarissa became a couple, going places and dancing together. They were better friends than ever and

looked good together, both slight and blond. Clarissa taught Brick lots of dance moves and they won contests. That first year together at school they were both in Harvard's big mainstage production of *Oklahoma*. Brick did some terrific cowboy dancing in furry chaps, and Clarissa danced Laurie's dream sequence.

Karl continued his interest in herpetology. A man from our herp meetings encouraged him to go to a camp in South Carolina where they would hunt and photograph snakes and then let them go. Karl was allowed to bring back a beautiful little corn snake he named Victoria, a very bright rust color and sort of friendly. Soon after, he was offered a month-long campership at Coney Grant Farm, a primitive preserve in northern Maine, because of his "maturity and helpfulness." Half the cost was still $255 for the month, but we decided that it was an opportunity that he shouldn't miss. Karl took his corn snake and hoped to catch live mice to feed her.

Karl left his new five-foot iguana, Solomon, with us. Solomon was fast, big, and very scary—a fierce and threatening creature. His body was the size of a large cat and he had a very long tail. He was an outsize presence in our home, particularly after Karl left. For a time, we were quite concerned that he seemed lethargic and wouldn't eat. When we realized that he was cold, we rigged up a light bulb under a big shade and he spent his days near the light on an eight-foot branch that Karl had dragged in. Solomon flinched when we touched him, but he liked to be stroked and after a while, would relax and close his eyes. At night I sometimes put him into the big cage that Karl had lovingly made for him. That was always traumatic as I could hardly bear to pick him up and put him in, and he certainly wouldn't go in by himself. I would usually stroke him for a while and then pick him up with a t-shirt over my hand. He would fight a little, but I could almost stand it. During the day, he nibbled on lettuce and house plants.

The band was another of Karl's interests. The directors of Belmont's middle and high school bands were both ambitious and demanding. Karl worked hard at playing his bass clarinet, chairing his section, and then he jumped right into the high school marching band, a spit-and-polish operation run with an iron hand by the demanding Dr. Nicholson. On a Saturday, Karl would do a band drill in the morning, play for a football game, and then do a band demonstration at night. He passed up many other good opportunities to work with the band.

I had always loved the Harvard Band, with its great music and witty halftime shows. I took Karl to a Harvard game to show him how it should be done. Karl was very scornful of that august outfit, noting that "their street beat was impossible to march to." He was sure they would be "ragged on the field" which, it is true, they were. At that point, his ambition was to go to a Big Ten school. I was okay with that, and also with his interest in drama and acting. His teachers uniformly said what a superb student he was and how promising. Karl's clarinet career was sadly curtailed some years later when both front teeth were knocked loose in an automobile accident. They were cemented back in but were never strong and were eventually replaced. Karl took responsibility for his life at a young age, and several years later, he also went to Harvard.

Margaret moved steadily toward her identity as a sports person, the most serious one in our family. She had grown her short hair long so that people who always saw her in pants, uncommon then, would know that she was a girl, but in the summer she had it cut short so she could swim daily. In the winter, she and Serge would go ice skating whenever I would let them. She was good at all the sports she tried, as well as the cello. She was less interested in her academic classes.

Serge, as a fourth grader, played the French horn in the summer high school concert band. In the sixth grade, he was invited into the eighth-grade middle school band. This was a tribute to his fine horn playing, and also the fact that horn players were in short supply. When Serge turned ten, he wanted the family to dine at McDonald's. He wished he could have both a Quarter Pounder and a Big Mac and was very pleased that he was allowed to have both. He was a very nice, affectionate little boy. I was so pleased that all my children were doing music.

As Ben graduated from nursery school to begin kindergarten in the fall, I noted that he should develop a nice sense of continuity. He was our only child who had not moved in his early years. He would begin at a school where he was preceded by three siblings along with two friends, Joseph and Lowell, who had been in the same carpool and nursery school for two years. He should be secure if anyone ever was. He began the "bubble blower" swim class and dunked himself fearlessly, showing his security in his world.

About this time, Richard and I celebrated our twenty-first wedding anniversary. I was forty-two and had been married for half of my life. We exchanged small gifts and went out to dinner and a play. We had a good time and realized how fortunate we were with our wonderful children in

Bushman family, c. 1977. Front: Clarissa, Richard, and Claudia, Ben; back: Brick, Margret, Serge, and Karl.

our comfortable and interesting world. (I find that as I write this, that I am now eighty-seven years old and have been married for three-quarters of my life. Richard is now ninety. We have the same gratitude.)

We had been in Belmont for eight or nine years. Our children were known for their abilities and performances. We had many friends who lived in the town besides the many members of the Church who lived there. We were invited into a town activity in a place where the governance was by town meeting and citizen involvement was high. I was pleased to be asked to join a committee looking into the music program in the Belmont schools. It was generally considered that the orchestra program suffered while the band program flourished. Our children had had experience with both. I was also asked to be on the board of The Belmont Music School where four of our children studied music, very much benefiting from their good teachers and proximity. I was later asked to be president of the board for the next two years. That was a great surprise, but I accepted, flattered to be asked and glad to be moving into a position of high responsibility and visibility. I had arrived among Belmont's movers and shakers.

Meanwhile, members of the Church in Belmont thought that the town might be a fertile field for missionary work. We met to consider possible approaches. I described my three-part plan to show that Belmont

Mormons were good members of the community. The three prongs were these: 1) Everybody should do something in the town: take an adult education class, volunteer for something, etc. 2) Every parent should do some little thing in the PTA to show we were concerned about our children. 3) We should run someone for office every year. As a result, one of our number agreed to run for Town Meeting. We would manage her campaign, and I collected $30 to begin the fund. I hoped that this would be the start of something notable. We also volunteered to enter a community fair, exhibiting pioneer artifacts, demonstrating quilting, and selling hot scones with honey butter. That was very successful.

The Belmont Mormon Political Caucus took on some life. We had thirty-five families clustered mostly in three precincts and we soon had a church member running for Town Meeting in each of the three. We would organize, sponsor, provide campaign materials, write press releases, and so on. The church scout troop, as a service project, would canvas the town with a non-partisan flyer urging people to vote. We planned several open houses for each of our candidates, also inviting in a couple of other candidates running for town-wide office. This would be a low-key operation, but we hoped that we could use our expertise in various fields to help our own. We had a photographer, a graphic designer, a scout leader, and copy writers. I outlined several potential years of this to Richard. His response: Do you know why the Mormons were driven out of Jackson County? He referred to the nineteenth-century occasion when excess Mormon political action led their neighbors to force them to move away. We toned it down a little, but we still had some success.

I was also doing church projects, of course. I regretted, as I still do, that ours was the only Christian church cold and empty on Christmas day. I observed that many families were pretty much over their family celebrations and were ready by the afternoon to do something else. I started to plan a nice musical program on Christmas Day, soliciting family groups or nice things that had already been performed at other Christmas programs. People could bring their families and company for a light-hearted break. The programs were easy to do, and I suggested that people bring some of their leftover holiday treats, which they were eager to get rid of anyway, for refreshments. Our family sang, "Will I Get a Christmas Present," the Haydn round. Brick and Karl were such good singers that we had a lot of power. I did those programs off and on over the years, and meanwhile began a new program: a Joseph Smith birthday party with music, poetry, games, and food from 1800–1850, a real Americana evening. Smith was

born in December, and I used his birthday for a Christmas party that varied the usual. I thought it had great potential for a nice annual event.

Richard, in one of his extra things, had submitted a proposal to teach a summer seminar to be funded by the National Endowment for the Humanities. The course would be on the Plain People of Early America. The program encouraged professors at small colleges who did not have access to good libraries to apply to one of several courses offered by notable professors in metropolitan areas to spend eight weeks working on their own and class projects. The government paid those chosen to enroll $2,000 each—a great opportunity. Richard signed me up as his assistant to do the secretarial chores. We were both glad when the NEH chose the Plain People of Early America course and included it as one of the offerings that could be chosen by applicants. I sent out application forms to interested people, and we chose a class of a dozen from all over the country who wanted to take the course.

Meanwhile, Richard flew off to Delaware to see about the job of the chairman of the history department there. Universities value their professors by whether anybody else or not wants them. Richard thought that an offer from Delaware would be good for a raise at Boston University. None of us were interested in going to Delaware, even though it was an attractive place and the job paid well. But then we were not particularly swayed by money then. We seemed to be able to manage anything we wanted to do whether we had any money or not.

Richard found the situation at Delaware very attractive. It soon became possible and then likely that we would be going to Delaware. The school offered everything he asked for and more. Boston University countered with a very generous offer which would have jumped him over the department chair in salary. The university president promised him a position which was not in his power to bestow. But by then, Richard was ready to leave, and he resigned. Richard would never do anything just for money, but the promise of a high academic salary held his attention long enough that he got interested in the job. Then when BU offered him money, he was no longer interested in it. He saw the possibility of developing some new programs and building something on his own.

I was quite distressed, being in the middle of so many things and with no idea of what I would find for myself. The four younger children were unhappy about it. They were then so well situated in school, with friends, activities, and an impressive tradition of older brothers and sisters. Karl had his band and a growing reputation in dramatics even as a freshman.

Serge would go to the eighth-grade middle school band as a sixth grader. Our facilities were so good and so conveniently located. Our neighborhood had so many good congenial people. Our big old house was so spacious and comfortable. Our beautiful kitchen was finally completed. I would have been happy to stay there forever. I was in a position to make a real difference in the music of the town. I hadn't completed my dissertation and I would be "ripped untimely" from my sources. And here we were moving to Delaware. Just as I had reached the final stretch in packing away a good year's supply of food came the direction: use it up!

The decision was made in April. We would not depart until August for Delaware, where Richard would chair the history department at the University of Delaware. We had time to use up, throw out, and pack up. The NEH course on The Plain People of America went forward and we enjoyed it. We planned to finish up our house repairs.

One night I asked Richard, after he had spent a day scraping, spackling, and washing ceilings, whether he had any second thoughts after all this unplanned labor, the miseries of selling a house and buying another, all the grief he had brought his family, and so on. He said, "Not a bit."

One of the sorrows of this time was that we lost Solomon, our iguana. We didn't talk much about it, but Karl wore a black armband for a week.

I told people I was enjoying the best of all possible worlds, a little scholarship in the mornings, a few boxes to pack in the afternoons, and a party every night. Many nice things happened. My *Exponent II* sisters invited me to give the Exponent Day lecture for the year. The date was June 17, 1977. I wore a very beautiful colonial dress that my mother had made me out of a flowered sheet as a Christmas gift.

Another nice thing was that friends threw a wonderful big party for us with Belmont people. As part of our larger strategy to integrate the Church into the community, the guests were mixed, and it was extremely successful. Large numbers of both crowds came and stayed for a long time. It rained so the outdoor party was transferred inside and it was just jammed. The last people were shooed out at half past midnight. We had a good time. I was very glad to see the groups interacting and could only think that it would bode well for both.

Before leaving town, I went to see David about my dissertation for the last time. He was in a kindly mood, which I appreciated as he could be quite savage. He had written a number of comments on my pages, most of which were very helpful. Some I could not manage to decipher; neither could he. I planned to write it again, let him read it once more, make final

revisions, type it, and submit it. In some ways, it was close to done, but I needed to keep slogging forward, checking quotes to make sure they were accurate, checking books for the bibliography. David was never complimentary or encouraging, but he was then in his most generous form.

On our last day in town, we planned to get away in the afternoon with our kids and a few remaining suitcases. A moving truck had already gone off with furniture and boxes. Late in the day, the knob came off the front door, making it impossible to open and close. Unable to make the repair, Richard drove to the home of the people buying the house and gave them the knob. The car was loaded, and as the sky darkened we climbed into our seats. Richard swung the knobless door shut for the last time while the neighbors who had gathered to see us off clapped and cheered. Then we drove off into the night to a new life.

–14–
A Bishop in the House

Soon after our engagement, I foresaw what life would be like as the wife of an active Church member:

> Today is my (our) anniversary. We have been engaged for a lovely calm month. I'm not used to being assumed this way but there is something quite nice about just being expected to be there. Dick has been so busy and always will be, I suppose.
>
> I find myself making bitter comments sometimes when Dick is in a meeting and I worry about it because if it gets back to him it will only make him unhappy; I don't really feel bitter, I understand that he has responsibilities and am proud that he is a "leader of men." If I didn't think that I would come first, well second, I'd require more attention.
>
> <div align="right">CLB Diary, March 1955</div>

As mentioned before, my father was a bishop when I was born. Bishop is an important job in the Mormon hierarchy. The bishop shepherds a ward or a congregation. He's the one that people look to and call for help. He's the one who cares for his flock and tries to guide them through the horrendous and often insoluble problems of their real lives. He's the one who establishes the tone and interaction of the congregation. He is often greatly beloved and respected, and sometimes resented. He gets a lot of strokes from his people, but he is also on constant call. He carries the burdens of the congregation, along with his own, on his shoulders.

There are higher administrative jobs in the Church: the stake president supervises a cluster of wards and their bishops, the area authorities supervise clusters of stakes and their presidents, and the general authorities, consisting of the president of the Church and the Twelve Apostles, survey and supervise everyone. All of these leaders have counselors and advisors and oversee any number of other people. They certainly hold demanding jobs with heavy responsibility, but they are more distant from their people than the bishops.

Church leaders are expected to be good men, and to a great extent they are. The Church has amassed and developed an incredible stable of wise and perceptive leaders who lead by persuasion rather than intimidation or force. These are strong public speakers who man their outposts as bishops, stake presidents, temple presidents, mission presidents, and area

leaders. These men are impressive in every way. They have been tried by many circumstances and have proven themselves worthy of responsibility in carrying out church programs. They are skilled and practical, powerful leaders who would compare well to any group of men in the world.

No leaders in The Church of Jesus Christ of Latter-day Saints are trained for their jobs. They are usually called to jobs a level higher than their experience; they learn on the job. Except for the very highest levels, this is an entirely amateur clergy. There is no financial compensation. The new leaders are invited to participate, to take certain positions. They receive calls from their higher-ups, and they are often asked to do things for which they are not prepared by experience, temperament, education, or ability. When the pool of potential leaders is shallow, leaders make do with some who probably would not be asked in other places. Church congregations work with what they have. New leaders have examples from their own past; they may have some training sessions; they have some published instructions. But these leaders are essentially alone, and they do the best they can. Not all leaders are constantly virtuous. There are occasional breaches of financial and moral standards which are generally dealt with quietly. Church courts sometimes punish infractions, hoping that punishment will bring repentance and better work in the future.

Congregations often have people with little experience or administrative skill. Even in the best circumstances, church leaders learn on the job. This means that congregations tend to be supportive and forgiving of their leaders—for a while anyway. The leaders take on these additional jobs without compensation of any kind. Congregants know that they may be serving in the same positions down the line and will need local support. The bottom line of all this is that most Church members learn how to run programs and do things and that there is a great deal of built-in cooperation and support.

Of the thousands of strong Mormon leaders in many different capacities making policy and carrying it out, the bishops are the real shepherds of the Latter-day Saint flocks. Having a bishop in the house is a great personal advantage. The bishop's family hears the news—all that is not secret. The bishop's children become pets of other ward members so that they live in a nurturing village instead of just a nuclear family. People are interested in their school experiences, their new clothes, and their romances. The bishop's family gets to meet important visitors. The bishop's wife is protected to some extent. She can usually manage to do special activities and programs without the effective opposition of others. My mother had

great scope to work out her ideas and plans when my father was bishop. The bishop's family can visit other congregations during their meetings, and they are generally treated as important guests. All family members are respected citizens of a significant community.

On the other hand, the bishop's family shares their husband and their father with a great many other people, and a very great amount of his time. The bishop is frequently preoccupied, having to spend the time he is not working for a living dealing with his flock. Because of course he must serve as bishop in addition to carrying on full-time employment. Being a bishop will take him at least ten to fifteen hours a week, plus the time of many unexpected emergencies. He has three big jobs, and that of father and husband yield to that of bishop.

Not only did my father not recognize me as his daughter when he was bishop, but he was also preoccupied when he was home. He carried a great weight of responsibility on his shoulders. We ate our dinners at the kitchen table in our San Francisco house. Dad often missed these dinners, working late or off at a church meeting. When he wasn't around, there was the pleasant or unpleasant give and take of family life. When he was there, the rest of us ate in silence as he took one call after another on the black telephone with a long cord that stretched from his study to the dinner table. He never really minded missing my mother's good dinners as he was happy with the simplest food, bread and milk with a few raisins being a special favorite. And to tell the truth, it was just as well that my father was preoccupied with work and church. When he focused his full attention on us, he often found pretty serious fault with the things we were doing.

Bishops don't go to church with their families. They go early for meetings and stay late for appointments. They sit through meetings away from their families on the stand—the raised section at the front of the chapel—speaking from the pulpit which generally has a microphone, symbols of authority and importance. The wife of the bishop, often with several small children to supervise, has no help from her husband during church hours or much of the rest of the time. Still, many bishops' wives love their positions and are grateful that their husbands are such good men that they have been elevated to this trustworthy post. Most men rise to their new responsible positions and serve with honor and distinction. Most families make their sacrifices willingly and try to do what they can to ease the bishops' burdens.

That being said, people like my mother, my sisters, and me who like to do special programs and projects can have significant influence in shap-

ing the church life of some members. I grew up in a church that provided teaching in public speaking, music, drama through pageants, three-act plays, exhibition dancing, and choral singing. Through those large programs we all learned to speak in public, act onstage, sing in parts, dance the tango, and plan programs and outings—skills that transferred in other directions as well.

It is true that most serious leaders in the Church are male, and such programs as mentioned above are either encouraged or curtailed by men in leadership roles. Lots of male leaders are still open to such additional programs, but the programs are simpler and fewer than they were in the days when I grew up. I strongly value these experiences from my youth and have been able since to do all kinds of programs and projects for which these early experiences prepared me.

But there are certainly problems. Ones that I cannot and do not forget. I resent the disinterest and lack of involvement of such leaders with their families. I resent that the Church, with its vocal support of family life, divides up families regularly for jobs that they cannot share. I resent that the hard-working fathers of young families are preempted to solve the problems of other families rather than their own. I accepted much better my father's preoccupation as he had only daughters and could not be expected to bother much with them. But I was less understanding during my husband's tours of duty as a bishop and as a stake president. I seethed with anger during the many times I sat in the congregation, in the shadow of the pulpit, so as not to distract the important leaders who sat on the elevated, raised stand. Our six children were born during his times of heavy church responsibility. I had the sole responsibility of managing those children while he was otherwise engaged with more important business.

My husband was branch president or bishop in three different states with widely varying congregations. He first served as branch president in Providence, Rhode Island. We were there for Richard's fellowship at Brown University from 1963 to 1965. He studied and taught history and psychology. Our fourth child, Margaret, was born there. He was called to be the branch president of the Providence Branch, a sort of junior ward, the second year.

This was a long-standing congregation with some very stable, old families and a sprinkling of interesting students from Brown University and the Rhode Island School of Design. The group was small and did not grow much during our time. Although this was not considered a strong branch, the group had a long tradition of working together to host wonderful so-

cial events. They had met for many years in a small and modest chapel on Benefit Street, high on the hill near Brown University. Before we arrived, they had raised the funds to build a new chapel in Warwick, Rhode Island, some ten miles south of Providence. The building was erected in phases, and we always met there, even as the building was being constructed. I had a good time in that ward, getting to know the old-timers and directing a choir. When I left, they gave me a beautiful wooden music stand, a baton, and some recordings of J. S. Bach.

The women there navigated the female church role by selective obedience. As the completion of the chapel neared, they were told to host a big open house for all their friends. The event itself was quite spectacular with special exhibits, great programs, and exquisite food. Each sister was asked to bring four friends. I sweated blood over this requirement. We were new in town and had few friends outside the Church. I did obey the summons, however, and strove to find some suitable candidates. On the day of the event I had three people who promised to go: a neighbor with friends the ages of our children, another mother from my son's nursery school, and a student wife at Brown. The last canceled on the morning of the event, but I still brought the first two to the event, hoping I would be forgiven for my poor showing. It was a lovely event. My two guests were the only visitors. The women were willing to put on a big event, but not to bring any friends.

Another memorable event occurred there when a man in high office, high above our locals, told me that I was to go to another sister, whom he named, and tell her that she had done certain bad things that would not be tolerated. I was to take another woman in our congregation with me to do this deed. This other woman was very doubtful that we should carry out the assignment, but I assured her that I had been told to do it by this important person, and I did indeed do as I was instructed. Of course, the receiver of this action was badly offended, and it was a long time before we were friends again. This incident persuaded me that I must consider for myself whether I should carry out the instructions of Church leaders. Another time I would say to the leader that the woman had not offended me and that if she had offended him, he should certainly tell her so himself.

After Providence, we lived in Utah for three years before we moved to Massachusetts for Richard's fellowship at the Warren Center. We had planned to be in Massachusetts for only a year, but we ended up staying from 1968 to 1977. While there, Richard was called to be the bishop of

a Cambridge Student Ward from 1969 to 1973. He first presided over a congregation of married students, many of them attending Harvard Business School. This was an impressive group of young male leaders, tall and handsome with beautiful wives. Many of them went on to fame and fortune. While they were there, these high-powered competitive guys formed a basketball team that completely dominated a local league.

Richard's ward met at another time than the family ward, my official congregation, to which I took my young children so that they could attend their own Sunday School classes. My ward of somewhat older people was also highly transient. I was the source of pity from some who occasionally asked if my husband was a non-member or an inactive Mormon. I could tell them with truthful irony that my husband belonged to another church.

Later the wards were reorganized, and Richard's new ward consisted of single young people: lots of converts, many students, many nannies, many confused young people trying to find their way. This group had many struggles in their lives and required lots of counseling. We had many big parties at our house to add some warmth to their lives, all-day events on Christmas Day, for instance. We had a wedding in our house, and Richard performed other marriages. During this time, Richard left for a month to Antarctica where he taught American history to enlisted men stationed at McMurdo Bay. His flock survived without him, but he was sorely missed.

In 1974, when Richard moved into the stake presidency and then became president himself, he was even busier and at a greater distance. He held that job for four and a half years. This meant that he was gone all Sunday as before, but to some far distant place, having had to leave much earlier in the morning and stay much later at night. He was always traveling, interviewing people, managing things. He carried out some very big ambitious projects. He was stake president in Boston until we moved to Delaware.

I was generally a very bad sport about all of this. I resented having to get my children ready all by myself and transport them to church on the bus, walking the last few blocks. One time, I rebelled and called a cab. Disembarking from this luxurious transportation, I saw the scowls of several men in our congregation. One bawled me out royally for making the poor cab driver work on Sunday and for not asking for help from other members, not mentioning, of course, that there were six of us and their own cars were already full. He didn't worry about making the poor bus drivers work. I was a depressed young mother, and I spent a great deal of energy furiously seething.

A Bishop in the House

My memories of being married to authority are mostly anti-memories of being excluded, of being passed over, of being less important in the scheme of things than the official person who was going off to do important business, who was honored by all. I know that my values here are skewed, that it wasn't all fun and games to go to endless meetings and give endless talks, to deal with incompetent subordinates, and to attempt to help many people in unfortunate situations. But my memories are true memories. Women are excluded from positions of importance in the Church, left to deal single-handedly with family situations that should be shared, permanently excluded from administrative responsibilities that they could very well handle, treated with a paternalistic infantilizing. Of course, the leaders love women. Of course, they know that they are sweet, good spirits who love to serve others. Of course, they wish that they, the men, were as good as women are. But the women are, unfortunately, not to be the leaders.

I was probably about ten when I remember asking my mother why the Church made so much more fuss over boys than girls. She said that the boys needed it more than the girls. Girls were happy to be included in the rich cultural offerings of the Church. Most of the boys found them less attractive. Girls were considered easy; boys were hard. And boys were essential to the program. To have them drop out was considered very serious. Boys needed to be trained as future leaders in the Church. They were required to carry out the priesthood functions essential for missions and marriages. My poor father, without resources to carry on basic programs and without sons, drafted his daughters to prepare the sacrament. That would never happen now. We also counted the tithing money, which would also never happen now, and cleaned the chapel, which still happens.

The hardest and longest time with a husband in power was when we lived in Massachusetts. This was in the time when the Church held Sunday School for a couple of hours in the morning and then the sacrament meeting again in the evening for an hour and a half or so. Much travel back and forth was required. The children were young and lively, easily bored. Much was then made of the importance of keeping children in their best clothes all day Sunday and having them engaged in activities other than playing in the street with the neighborhood rowdies. They were to do genealogy projects, write letters to the missionaries, visit the sick, act out Bible stories, things like that. But my children were good at sneaking out to play with their friends. I figured that I had to get them away from home. So, my children and I made Sunday cultural expeditions. I

hoped to engage them in uplifting experiences that I could also enjoy. The children responded badly to being kept from their friends, and these were difficult times. It was a fight to get them to come with me. We traveled on the bus and subway as the car was generally used for important stake business. It seems that we did this for many years.

We did have some successful outings. We went to Harvard's ethnographic and natural history museums, the latter being the home of the famed glass flowers. We did like to see the stuffed animals and birds, the huge whale skeleton, the minerals that glowed in the dark, and the dioramas of the potlatch ceremony. The biggest draw, however, was my modest purchase of a small pair of plastic animals after each visit. We were building up a cast of characters for Noah's Ark. Getting those little animals became the great prize, and sometimes the kids would whine to go right to the gift shop and then home.

The little rewards were a big part of getting them to go at all. We used to do Boston's Freedom Trail from the Park Street Station to the North End. We began to follow the red brick road at Park Street, stopping off here and there to see the historic sites. When we got to Faneuil Hall, we would search the market for yesterday's bread and fruit, frequently scoring a few old rolls and some bananas. If we went the whole distance to Old North Church, which was not often, we would visit a choice Italian bakery and get a few pastries there.

We also went to the Boston Museum of Fine Arts—a favorite destination—and wandered through the Egyptian and Greek collections, making much of the current shows, some of which were quite memorable. Our favorite over the years was the Earth, Air, Fire, and Water exhibit in which artists created such imaginative artworks as a field of clover (for earth), built right into a museum gallery! The children also learned to identify the work of a number of famous artists. They fought going to museums for years, but now they all enjoy that happy pastime.

We were fortunate to have so very many delightful destinations. One of our favorites was the Mount Auburn Cemetery dedicated in 1831, the justly famous landscaped graveyard part of the rural cemetery movement. This is the resting place of many of Boston's important citizens, and there are rich stories about its long-term inhabitants. It was rumored, for instance, that Mary Baker Eddy, the founder of Christian Science who died in 1910 and who did not believe in death, had a telephone installed in her crypt so that she could ring up her followers to dig her out when she arose. We loved the picturesque grave sites, but we preferred those farther into

the 174 extensively wooded acres (planted with 5,500 trees), dramatically landscaped on a rolling terrain. One Easter Sunday, the children and I were visiting the cemetery and our group divided and went off in several directions. When we were ready to leave, our three older boys Brick, Karl, and Serge were missing. We couldn't see them, and we couldn't find them. It's hard to imagine a cemetery so large, complex, and forested that such a situation was possible, but they were lost. We wandered and called for a long time. Serge remembers the incident like this: "It was me that got lost first in the Mt. Auburn Cemetery. I always tell the story that as some of the kids found each other, we prayed, and Brick tossed his 'magic cuff link' to tell us where to go. Then you pulled up in the station wagon. This is the best answer to prayer example I can think of."

An appealing part of the cemetery was in the back of the park where the gardeners were still developing the grounds. A good-sized pond had been introduced, maybe ten by twenty feet, and landscaping was underway. Most graves were still distant from this newly shaped area. The place was generally free of people on Sundays but full of birds and butterflies and the amphibious creatures much beloved by me and my boys. We could observe and sometimes catch frogs and turtles and even some little fish, occasionally bringing home a few prizes. We were grateful that the far-sighted planners of Mount Auburn had furnished us with such a desirable playground.

Sometimes we went to concerts. I was always hesitant to attend cultural events that cost money, having limited amounts to work with, but sometimes we could go to a concert or a recital in a museum. We came to enjoy these outings and aesthetic experiences, perhaps more in retrospect than at the time.

One shameful event, entirely my fault, stands out from those years. We had been on one of our outings and I had spent all the money I had, except for return carfare, on small treats. We had decided to walk the Freedom Trail which we had not done for some time. It was the spring of 1971, and I was pregnant with my last child, Ben, who was born in June of that year. I remember that I was wearing my light blue jersey maternity dress with a blue tweed sleeveless overcoat. There is really too much to do on the Freedom Trail so we were glad that some of the buildings were closed and we could concentrate on the old churches and exteriors. We took the subway down from church, spending about three hours wandering along the red paths. Finally, ready to stop, we took the long walk back to the subway station, one we never used. The five children, Clarissa, 15;

Brick, 12; Karl, 9; Margaret, 6; Serge, 5, and I were waiting for the train. As the train approached, I checked the three older children standing by me, and I noticed that Karl was missing. I sent Brick to look for Karl and soon saw Karl back among us. The train came and we boarded and sped on into the dark. I checked to see if we were going in the right direction and found that we were not. I gathered the kids, and we got off at the next stop, crossed over to the other side, waited for the return train heading back to the earlier station. I counted the heads again and realized that Brick was not there! Horrors! Was he still on the train or had he been left behind? I was very much aware that I was out of money—no telephones then—and really helpless as well as irresponsible. Our poor little twelve-year-old blond son, so handsome and innocent, had been abandoned to whatever fate.

We reached the station and hurried over to the other side to find that Brick was in the protection of a kindly passenger. I apologized again and again to the woman and to Brick, who had told the woman that he was sure that his mother would come back for him, but it was clear that I was a thoughtless, negligent mother with too many children, bringing yet another into this world. This was the time that many supported "Zero-Population-Growth." People openly insulted expectant mothers on the street and defiantly refused to give up their subway seats. Here I was having another baby when I already had too many children, even as I had carelessly abandoned one of my defenseless little kids.

The kindly women who clearly disapproved of me insisted on driving us home. We were very appreciative. I had gotten a good dose, however, of how the other half viewed irresponsible people like me.

I was often off and alone. Being the wife of the bishop and stake president was often a lonely and silent position. But occasionally I felt that I was able to speak out in a way that made a difference.

When my husband was stake president, he had two counselors of the old school, hearty and bluff men who considered themselves superior to their women folk, even though they both had very capable and attractive wives. At conference meetings, these men gave religious sermons, often spicing them up with amusing anecdotes about their everyday lives and frequently telling funny stories about their charming but ditzy wives who appeared clueless and dithering. The wives sat in the congregation listening to these amusing and belittling stories, unable to defend themselves or to comment. My husband never engaged in this practice, I am glad to say.

A Bishop in the House

But one day I realized that I was not helpless. I had a voice, even if it would not be heard by the whole congregation. I went up to these men after one of these meetings and confronted them. I said that it was improper for them to find their wives so amusing and to insult them before the congregation, that it was unchristian and unsuitable. And that I knew enough of their lives to know that this was not a fair presentation. They were both taken aback. Their behavior was generally considered okay then. They were just joining in a standard practice. But they also knew that I was right and saw that I was exceedingly angry. They never gave those talks again. I was glad to see that something I said or did, even in that male-superior culture, could make a difference.

I had another memorable experience in that line where I was able to speak up and out. A solemn assembly of priesthood leaders was held in Boston when my husband was stake president. All ordained leaders above a certain level, from a wide area, perhaps all of New England, were gathered to hear a message directly from the "prophet, seer, and revelator" of the Church, then Spencer W. Kimball, and other leaders. Limousines were to meet the plane and drive right up to the airstrip, followed by a security car to pick them up. The local men were invited to gather for a program of speeches by important leaders and have a dinner before they went back home. Some of the lesser mortals—that is, the women, the wives of the men who attended this significant leadership gathering—were, if they came to Boston that day, invited to attend the dinner afterwards. The Solemn Assembly, was, of course, a Solemn *male* Assembly. I was asked to gather and entertain any women who had come along, which I did by taking them on a tour of Boston sights. I think we had a good time.

Later at the dinner, when social rules prevailed over ecclesiastical ones, I was seated beside Spencer W. Kimball, the president of the Church. He was a wise and charming man, and we had a very pleasant dinner table conversation. Enough so that I was emboldened to ask a serious question. Why were not the wives of the leaders and the other women of significant leadership office in the local church invited to attend the Solemn Assembly? I had taken a real risk. In that church culture, asking such a question was a daring or ignorant breach of protocol. I was only asking the question. I was certainly not going to start an argument or make a demand. Getting an answer at all was more than I had hoped for, but I did get one. What he said was, "That's just not the way we do things." No apology. No justification. No punishment. He simply asserted the status quo, the unquestioned current state of the Church—male superiority.

And I was satisfied. I didn't push it any further. He didn't say anything that I could disagree with. That was the standard practice. At another time I might have asked for more.

Some forty years later, women did more than ask the questions. They demanded to be included. They publicly demonstrated for change in the Church's priesthood structure. Some then paid the price for going against church practice by losing their membership. I regret that. I don't think that making demands is a promising way of dealing with authoritarian leaders. They do not like confrontation. They just brush away complaints and retreat to their bastion of power. And I think that the power is good for them and keeps them involved. If women had the same power, I think the men would retreat as they have done in other religious communities. My stance is to ask those asking for power what they would do if they were given power and then to suggest that they just do those things anyway. I do many things that I am not officially entitled to do.

Despite my smoldering resentments, I remain a member in good standing. I love the Church and would be very sorry to be severed from my connections. I love having a warm community and a structure for a good life. I love what the Church has done for me and what the Church has allowed me to do, operating from within the structure and perhaps having a favored position because I am related to power. The local leaders, now all much younger than I am, usually listen respectfully when I make suggestions. Sometimes they even take them. I think that women, instead of fighting for inclusion, should build their own structures within the system and carry on their own programs rather than demanding entrance to the priesthood. When they make demands, they offend the Mormon stereotype of the good woman. It becomes much easier for Mormon men to dismiss and punish women who step out of their approved role.

Actually, my husband was more sympathetic and understanding than many others. It's true that I became angry and made things difficult for him. But he did not fight back. He maintained the suffering silence that he was so good at, patiently waiting until I became calm again and then going on as if there had been no difficulty.

Richard was released from his Boston church job when we moved to Delaware for his position as chair of the university history department. We lived in the college town of Newark. The wards in the stake were growing in size, and after a while Richard was called to be the bishop of a small congregation just over the state border in Elkton, Maryland, a congregation that had purchased a small chapel of its own. This ward had some old,

established, multi-generational families, but also many new people and a good group of students. Richard was a pretty mellow bishop by then, not as exercised by insoluble issues and quite able to keep things going.

During those years—1980 to 1985—he used his position to carry out an important historical exercise. He and I were regretting that so little was known about the real religious practices of the early Mormons. We decided that we should do a big project, one that would involve everyone in the ward, active or not. We would keep a record of everything that happened in our ward during one calendar year. We enlisted a group of lively members to describe, record, and collect everything that went on. We called 1984 "The Record Year." The group recorded and transcribed more than one hundred oral histories, wrote accounts of all activities, kept special journals about church matters, collected every piece of paper handed out, and generally made history by recording history. The purpose was to create a huge archive for future study, but along the way, we all got to be better friends. One sister created a yearbook, and Susan Buhler Taber wrote a book called *Mormon Lives: A Year in the Elkton Ward* which is still the best account of the people in a Mormon congregation, what they do, and how they feel. Looking the book over, I see that I said the following:

> I never like to be the bishop's wife, and this is my third time. It is a job without a job description. You're supposed to be much more unfailingly calm and generous than I ever care to be. Being bishop is very demanding of Richard's time and I don't like that either. Every ward has so many people who are in impossible situations. Their problems take endless time and can never be solved. I have made a life for myself. There was nothing else to do. (*Mormon Lives*, p. 116)

It should be mentioned here that as part of the life I created for myself I became involved in Newark, our town. I taught historical classes on it and with my students organized the Newark Historical Society, a group that still meets. We had scheduled a first meeting of our society to gather people and engage them in our work just as Richard was called to be the bishop in the Elkton Ward. The night of the first historical society meeting was the only evening that the new bishopric could get together to organize the new ward. I was not surprised by this. It was all very familiar. What surprised me was that Richard called off the bishopric meeting and went with me to the historical society to move chairs and be helpful. That was a gesture I very much appreciated.

After some time in Newark, Delaware, we moved to New York City in 1989. Soon after we arrived, we heard that the stake president would be moving away. It was announced that an important Church authority

would be attending our next semi-annual stake conference. Such authority was needed to choose a new stake president. The protocol called for meetings and interviews of priesthood leaders all day Saturday, with a decision by the end of the day and an installation at the Sunday meeting the next morning. Once the visiting leaders decided on the man they wished to call to office, they invited in his wife to ask if she could support her partner in this new enterprise. I dreaded this event as I feared that Richard would be once again drawn into the stake presidency.

It was with a heavy heart that I received a phone call from Richard saying that he was coming home from the church to bring me back for an interview with the visiting authority. I was beside myself. I just did not think I could stand it. Hadn't we had enough of this? I was close to tears as we approached. I was quiet and grim as the visitor made small talk with me before getting down to business. He began, I braced myself, and he called my husband to be the stake patriarch, a job that is usually filled by a sort of senior statesman. From unrecognized sense of pride or fittingness or whatever, came an unexpected and unsuitable response. "What?" I exclaimed. "That's not a good job for him. That's putting him on the shelf." Could I have wanted him to be stake president?

In any case, he served as patriarch from 1994 to 2007 and again from 2012 until the present, giving blessings to the young and the old, converts and kids, whoever wanted them. In this new office he was to "give voice to prophecy," and he pronounced hundreds of blessings that people carry around with them, reading them often for help and inspiration. Years later people remind him of these valued blessings.

Untrained Church leaders vary greatly in tone and practice. A bishop can interpret the situation in his ward very differently than another bishop might. And sometimes leaders, elated by their power, can interpret their responsibilities in ways that seem more pharisaical than in the style of the humble shepherd. Sometimes they bring pain and suffering to their congregants. Generally, ward members are sympathetic and supportive of bishops, knowing that they have a hard job. Sometimes the bishops are called to repentance by their superiors.

Ward members do not always make it easy for their bishops. They may complain loudly and make a fuss. One time, for instance, I objected that our congregation did not commemorate Easter. I thought that this was a terrible lack in a Christian congregation. What we did for Easter in the Elkton Ward was a big fundraising effort to pay ward expenses for a year by making and selling chocolate Easter eggs. The women of the ward

were requested to make and donate maybe ten batches of fondant candy each. Then in a big all-day event, the batches were flavored, shaped into eggs, dipped into chocolate, packaged, and given out to be sold to all of the friends, relations, neighbors, and coworkers of the ward members. The ward had been doing this successfully for years. I thought that it was terrible way to commemorate the crucifixion, the resurrection, and the atonement of Jesus Christ. I told the bishop, who was not then my husband, that if we were going to celebrate Easter by selling candy then we should at least have some slight religious observance of Easter Sunday in our ward meeting.

He was sympathetic to the situation, but he regretfully noted that a visiting high councilman, a representative from the stake, would be speaking that day and that the program would be up to him. These high council speakers came one Sunday every month. The bishop checked with the speaker who agreed that we could have twelve minutes for an Easter celebration. The bishop gave the time to me. I directed the choir at that time and thought that the best we could do was to sing some of the music of the great master, Johann Sebastian Bach.

That seems a very bad idea now. Our congregation of modest people cared little for music, and many had probably never heard of Bach. We should have had a short talk, maybe an Easter hymn that people knew. But I was ambitious for our choir and we *did* sing good music, and we were working on Bach's great Easter cantata, "Christ Lay in Death's Dark Prison." I carefully timed various portions and decided that we would sing a big chorus and the concluding chorale, which totaled a little over eleven minutes. We had a few good singers who brought the others into line, and I felt that the glorious music was a fitting Easter tribute.

On Easter Sunday our music was announced, and we stood to sing. I was so engrossed in the music and the singers that I was not aware of what was happening on the stand above the choir. What happened was this: the visiting speaker spoke to the bishop and said that the music had gone on too long and that the choir needed to stop. The bishop, who was not my husband, asked his counselor next to him to tell the choir to stop. The counselor said, "*I'm* not going to tell them to stop." The bishop asked his other counselor to tell them to stop. The counselor got up and went down to the organist and told her that the bishop wanted the choir to stop. She said, even as she continued to play, "Well, we're not going to stop." As we finished the big chorus and began on the chorale, the bishop stood at the pulpit, said that we were taking too long and to stop. We stopped.

The visiting high councilman was introduced and said something about how the music was all very well but that we had to get to the important part of the meeting—his talk. I was furious. I went to my seat and then got up and walked the halls, weeping. I was so angry. I had been so insulted, so publicly humiliated. I went out and sat in the car. I would have just gone home, and perhaps should have, but I had our only car and had to wait for my family. I was obsessed with the incident for days.

What was the fallout? I prepared an angry little speech reacting against the disrespect shown me and the choir, and I rehearsed it a thousand times as I relived this painful slight. And then, at the choir rehearsal the next week, when the bishop unexpectedly came in and cheerily said that he was glad to see us all there, I had the satisfaction of publicly delivering it. My little speech was pretty effective, and I could never have done it without such careful preparation. I knew at the time that I was being childish and theatrical, but it was a good performance. The current stake president, who had not been present on Easter, was told about the event. He called and invited me to speak at the next stake conference. That was a sign of honor and support, and I appreciated the invitation. The high councilor, the speaker who had stopped our performance, was immediately released from his job—which is to say he was fired. That poor man, who certainly thought he was doing the right thing and who saw no redeeming qualities in Bach, was also just learning on the job as all converts, given authority, must do. The bishop, to his great credit, never excused himself by saying that the high counselor had told him to stop the singing. He was learning on the job, too.

From this position in my life, I remain grateful to have been born into The Church of Jesus Christ of Latter-day Saints, grateful for the opportunities of a life of activity and fellowship with the Saints, grateful to have kept my membership through my life. The Church provides a style and pattern for life beneficial in many, many ways. It provides a community that has been valuable for us through frequent moves, that extends over the nation and over the world. The Church provides an arena for activism and people who will join in any good effort, officially sanctioned or not. The Church provides a useful educational program, helping members socially, economically, and spiritually. I did prefer the educational and cultural opportunities of my youth, but I will still say with some truth that everything I needed to know, I learned at church.

–15–
Newark

We left Belmont for Delaware on August 9, 1977. I was sorry to leave Massachusetts; I didn't feel that I was finished there. I did not feel ready or able to make another major move. Although I had moved quite happily back to Boston, it has been my experience that husbands move from something to something and wives move from something to nothing. It takes five years to build up any kind of a new basis for a life. I didn't look forward to trying to find a new place for myself.

Like Rhode Island, where we had lived before, Delaware was a small state. Our new home was thirty-five miles wide at its widest and ninety-six miles long. A person could travel from the top of the state to the bottom, do something there, and be back by dinner time. The state was named after Thomas West, the third Baron De La Warr (1577–1618) who was the first governor of Virginia during the time Europeans first explored the Delaware River. The territory had been settled by the Dutch, the Swedish, and the English. Both Pennsylvania and Maryland had annexed it. At the time of the Revolutionary War, Delawareans were enthusiastic about cutting free from Great Britain. Caesar Rodney rode seventy miles to Philadelphia through a thunderstorm on the night of July 1, 1776, arriving "in his boots and spurs" to break the Continental Congress's deadlock vote for independence. During the Revolutionary War, there was only one local encounter with the British, known as the Battle of Cooch's Bridge. Some say that the Stars and Stripes flag was first flown in battle there. Delaware decisively claimed the position of "The First State" when she speedily ratified the Constitution of the United States, the first of the thirteen to do so. All this was to become very important to me in future years.

In 1977, when we moved there, Delaware was a prosperous, forward-looking place. Its ruling family, the DuPonts, were still very much a presence, their chemical-making company still flourishing as successor to their early gunpowder mills. The DuPonts had also endowed world-class cultural institutions, Winterthur Museum, Longwood Gardens, Hagley Museum and Library, The University of Delaware, and others that dotted the landscape. Their prominence and influence were inescapable. When we first went to church in Delaware, we were asked if we were DuPont people. My answer: No, we're Mormons.

Newark, chartered in 1758, was a city with a small-town feeling. There was a very traditional Main Street, a hill where rich people traditionally lived and side streets down to a lower street with housing for their workers. The workers' descendants still lived there, forming a very present Black community known as "Browntown." A few housing developments and shopping centers had been added over the years. Delaware had been a southern tobacco-growing colony with a large slave population who were almost all freed before the Civil War. More than 90% of Black Delawareans were then listed as "free colored persons." But grim stories of past segregation still abounded. A Delaware case on school equality was one of the bases for the Supreme Court decision on *Brown vs. the Board of Education* in 1954. The required school integration decision was still being worked out when we arrived. Our children were involved in the solution.

Newark had an old paper mill created in 1798, the oldest in the United States. There was also a Chrysler plant built in 1951. Both of those—very active in our time—are now closed. This was mostly a university town with a large, distinguished, rich school with a long history and lots of students. The university traced its origin to a grammar school founded in 1743. When it was the Newark Academy, it was attended by three signers of the Declaration of Independence. After much change and reorganization, the surviving institution was named, in 1921, the University of Delaware.

Richard immediately took over the university's history department. He began a plan to expand the study of the rich available material culture of the region, adding a doctoral program in American Studies and in museum studies. The university already had masters' programs in decorative arts and technology linked to Delaware's cultural institutions Winterthur and Hagley. He also began the material culture seminar featuring the presentation of research papers and discussion. His innovations enriched and broadened the university's offerings. I completed the certificate program in museum studies while we were there.

During his time in Delaware, Richard published two major books. The first was his colonial history book, *King and People in Provincial Massachusetts* (1985). He had been working on it for fourteen or fifteen years. He had meant it to be a psychoanalytical study resulting from his previous study of psychohistory at Brown University some years back. He originally planned to compare the mindsets of Jonathan Edwards and the revolutionary ideologues, but the book became more of a political and ideological study. Richard maintains that this book is truer than other

books on the subject, though largely misunderstood, but it was less timely than his Connecticut book. The book did get one really excellent review.

The other book was on the early life of Joseph Smith and his milieu, *Joseph Smith and the Beginnings of Mormonism* (1985). Richard felt that this book was easier to write than *King and People*, and that he had worked through and solved some serious problems on the topic. He was able to write candidly of the Smith family as he was to do later in his more complete biography, *Joseph Smith: Rough Stone Rolling* (2005). *Joseph Smith and the Beginnings of Mormonism* was to have been the first in a series of sixteen volumes commissioned by Leonard Arrington, the LDS Church historian, to lay out the full history of the Church. This was the pre-existence volume about the Church before it was organized. But the new openness brought new problems. While some publishers thought that Richard was too kind and friendly to Joseph Smith, some Church leaders felt that he was not friendly enough. Richard's book was published by the University of Illinois Press, and the plan to publish the other fifteen volumes of church history was canceled.

After the publication of these two volumes, Richard was awarded a year-long fellowship at the Smithsonian Institution in Washington, DC to work on a topic that his expansion of the study of high-end material culture and the related study of the refining impulses in Anglo-American culture engendered: What forces had persuaded ordinary people to work toward gentility and fashion? Richard thinks that this book, *The Refinement of America* (1992), is his best book, along with the Joseph Smith biography. He says that since his first big book, *From Puritan to Yankee*, back in 1967, when he accidentally plugged into the very heart of fashionable historical thinking, he has been at odds with current historiography.

Richard's position as chairman of the history department led to a very pleasant Delaware social life when we were integrated into events with the cultural leaders and shakers of the state. Richard and I attended many fabulous black-tie dinners and events. He looked distinguished in his rummage sale tux, and I did my best to be respectable. Delaware advertises itself as a place where you can be somebody, and we did, in actuality, become somebodies there.

We were also integrated into our local religious community. We had previously been acquainted with some of the leaders there. Richard told the stake president that he would do anything he was asked, but that it had been nine years since he had been able to attend church with his family and that he would appreciate some respite from the heaviest re-

sponsibility. The stake president went along with this, and Richard was a devoted Scoutmaster for several years, taking his boys on significant outings, including a five-day hike and camp out along the Appalachian Trail. He also taught teenagers in early morning seminary classes.

I did many of my usual jobs and also some special ones. It happened that the Delaware stake president asked me to come up with a stake event for the 150th anniversary of The Church of Jesus Christ of Latter-day Saints. That would have been for April 6, 1980. I could do anything I wanted to tell the story of Church organization. Richard and I were then teaching at the University of Delaware; one of the significant resources was a media library open to all professors for their classroom use. We chose illustrations for our lectures from books or other visual sources and brought them in to the media library to be copied as slides. One copy was referenced and filed away for future use, and for a few cents we got our own personal copies. We were all thinking visually in those days of slide projectors and carousels. Today we would certainly make a film; then we envisioned a slide show. Richard suggested that we might use Lucy Mack Smith's biography of her son Joseph Smith, who organized the Church, for a frame. This narrative, dictated to Martha Corrill after the murder of Joseph and Hyrum Smith in 1844, provides most of the early history of the Smith family. I read through the book, choosing half a dozen sections that made good scenes leading up to the organization of the Church. We would pose our cast for still shots and later record the soundtrack that we would show the slides against. I recruited a DuPont engineer named Bob Daum, known to be a good photographer, to take the pictures. He was unfailingly cheerful and willing. Whatever I suggested, his answer was, "No problem!"

With a text, an event, and a photographer, I began to think cast, costumes, and setting. To simplify things, I would use my own family. I decided that I could be the feisty Lucy Mack Smith, voicing the introductions and interludes which could be excerpted from the book. I had a black silk dress which would be a good costume, even if it was of too late a period and too fine for daily wear, and I could make myself up to look old. Surprise! I was just the right age. And if I was Lucy, Richard could be Joseph Smith, Sr. He would have a very difficult scene at the end, Joseph Sr.'s baptism, so I needed someone to do me a big favor. I used birth dates and ages to cast the characters, and it turned out that our second son, Karl, was just the right age to be Joseph. A pretty, dark-haired young woman who could manage the ringlets was Emma. Several of Karl's

friends were the other young men engaged in organizing the Church. For Martin Harris, we drafted the Boy Scout leader. I had made and collected a considerable stack of historical dress clothes and accessories—shirts, coats, vests, suspenders, hats—which could be put together to look like the country farm outfits shown in the nineteenth-century paintings of George Caleb Bingham and Eastman Johnson. I had a cast and costumes.

Now for a setting. It happened that I had taught a couple of courses for the University of Delaware at a couple of historic houses then belonging to Delaware's great museum Winterthur, located in the small town of Odessa some miles south of our home. The Wilson-Warner and the Corbitt-Sharp houses were relics of the fine aristocratic lifestyle of some Delawareans in the eighteenth century. Handsome, spacious brick houses on fertile acres near the river, these houses were used as laboratories for learning about early American life. My students studied remaining documents about the houses, role-played the people who lived there for public events, and cooked period food over the open fire and in the beehive oven. We forced ourselves to consume the muskrat stew and turtle soup we created from scratch. One time, as the girls kneaded bread dough, I told the boys to build a hot fire in the oven—a really hot fire. They outdid themselves with a blaze hot enough to make steel melt, and we all burned our eyelashes off before we were done. I knew the director of the houses well enough that I thought he would let us use these historic houses for our sets, and he agreed.

The houses were too elegant for anything that Joseph Smith, Sr. and Lucy Mack Smith would ever have had to live in, but we used the nice and dark Wilson-Warner kitchen for their main room. There, Joseph told his family about ancient civilizations, sitting before a roaring fire. We put the courtship scene of Joseph and Emma in the lovely parlor of the Corbitt-Sharp house. That house was too fine for Isaac Hale, a middling farmer, but it was beautiful and romantic. When Emma was ill, we put her to bed in an antique nightgown in a modest spindle bed in a bare bedroom. She lay like Snow White in her glass bier. Joseph sat by her side, his head in his hands. We used the school room for the printing press where Joseph confronted Abner Cole. We shot other scenes in hallways and out on the grounds.

So far, so good. Our little cast would meet on location to "do a shoot," recreating stories we all knew well for the eventual program. But our story had to climax with the organization of the Church and the baptism of Joseph Smith, Sr. in a river. It was March, cold and icy. Where could we

stage such an event? Here again, I had a good connection. Delaware boasts many beautiful and historic sites. One such place is the Hagley Museum, the site of the DuPont family's first factory to make the explosives essential to young America's early military victories. A small eighteenth-century industrial village grew on the banks of the Brandywine River. This attractive site has been preserved and interpreted as a museum with DuPont money.

We knew the Hagley director quite well and considered him a friend. We also knew that he thought our religious beliefs were less than respectable. However, I thought that his acres of the Brandywine River offered the best locale for our project. I called him and asked if we could borrow his river to stage a baptism some time when the museum was closed. Gentleman that he was, he batted not an eyelash and answered politely that he would be happy to cooperate. He would have the head groundskeeper look over the river and choose some suitable places, noting the approaches and the scenery, poling the depths, and so on. I went out a few days later, and he showed me several possible places. I chose one.

Then he asked if we needed a place to organize the church. He took me to the charming Sunday School building where the DuPont daughters taught the working children to read and write on Sundays, their only day off work. I said that it was lovely and although of the right vintage, it was much too fine for such an event as ours; Smith had probably organized the Church in a modest farmhouse. He suggested I see a small cottage, not open to the public, where the DuPonts had first lived. This little house in the woods, a place where the Three Bears might have lived, was charming but cold and empty. Leaves had blown in under the door to cover the stone floor. I said that that place would be perfect except that it wasn't a place where people lived and that there was no furniture there. He told me not to worry; he would take care of it.

So it was that our little cast, families, staff, and hangers-on gathered at Hagley Museum on Sunday, April 1, 1980. It was Easter as well as general conference. Our little group would be acting out our church meeting in the Whitmer house in Fayette, New York.

On that clear icy day, the groundsman had wrought a small miracle. In the DuPont cottage, a bright fire burned. The floor had been swept and rough benches had been brought in. We had space for the thirty or so costumed first members of the Church. We sang some hymns and then "Joseph" organized the Church. Our pictures showed the congregants with arms to the square. That may not have been historical, but it certainly felt right. Then it was out to the river where Joseph Smith, Sr. was baptized into

the "one true church." Poor guy, we didn't break the ice, but it was about that cold. We got the shot, he did not die of exposure, and it was as memorable an Easter, church anniversary, and experience as we could ever want.

So, was the show a great success? Actually, it wasn't. Some of the pictures were too dark. The soundtrack, with its period music and earnest voices, sounded canned. I lost my temper and snapped at the stake president. People were familiar with the story and lost interest. They were complimentary, but no one asked us to put on the show again. It was an ambitious, but not fully realized project. At a later point, I distributed the slides to the people involved, so it no longer exists. But as with so many other things, the creation was memorable.

Richard was later called as bishop of the Elkton Ward, a small group that met just over the Maryland border. This group hung together pretty well despite a decided town-gown split between the southern factory workers and the university imports. At one point, Richard and I noted that we knew little of what went on in early Latter-day Saint meetings. We decided that while we could not reconstruct those early meetings, we could document some of our own for future use. During his tenure (and because he was the bishop), the ward undertook a significant and extensive project called The Record Year, an effort to record a calendar year in a contemporary Mormon ward.

With Richard's supervision, some funds from BYU and the Lilly foundation, and the good work of a dozen or so members, we taped meetings, took pictures, kept journals, collected handouts, wrote up activities, and interviewed and transcribed more than one hundred oral history interviews. This collection occupies ten feet of shelf space in Special Collections in the Harold B. Lee Library at Brigham Young University, and a book by Susan Taber describing the year and people was published by the University of Illinois Press as *Mormon Lives: A Year in the Life of the Elkton Ward* (1993). We figure that eventually this archive may become valuable and useful.

Richard chaired the university's history department for six years and that was enough. He decided that he was too thin-skinned to hold the position. The Europeanists complained that there was too much American emphasis. He grew to dread the department meetings where the old-timers grandstanded their indignation that attendance at department meetings was not enforced. They did not like the way Richard worked at his research in the mornings rather than sitting at his office desk or the way he kept his office door closed when he was there. He continued as a professor there.

In Newark, we bought a twenty-year-old brick split level house in perfect condition, close to the university. The new house, smaller than our Belmont manse, still had five bedrooms; two and a half baths; good-sized living, dining, and family rooms; a double garage with a loft over it for the kids to play in and for storage; a large utility room above ground; eleven closets; and a very large, beautifully kept garden including a thirty-foot Dawn Redwood tree. The house seemed a wise purchase and a potentially comfortable home. We could easily walk to Main Street and to the university, and there was a community swimming pool just a block away.

Our family was diminished. We had been a family with six children. We now had only four in tow. We realized that in just seven more years we would be down to one child. This would be a major change in many ways. Brick and Clarissa were both off at Harvard and would never come "home" again. They were living new lives. Actually, all of us, the children even more so than their parents, were living new lives. Brick and Clarissa were in another Harvard show together, *Two Gentlemen from Verona*. Clarissa continued as a history major and graduated three years later with honors. She met Charles Ortel, a Yale graduate who was at the Harvard Business School. He persuaded her that while there were a few stars on Broadway, there were many stars on Wall Street. She went on to get an MBA from Columbia, to work for an investment firm, and to marry Charles.

Brick, who began Harvard at seventeen, majored in French and German literature and was the first to pursue such a concentration. He worked with the dorm crew, cleaning bathrooms as part of his scholarship. He sang in the glee club and the university choir and played in the orchestras for various Harvard productions. He went on tour with the Bach Society. He enjoyed the music and theater and liked the feel of being an academic, but he always had his eye on Wall Street and worked part-time at Lehmann Brothers. After his sophomore year, he left Harvard to go on a church mission to Germany for two years. He served as the mission secretary and later as the assistant to the mission president, Enzio Busche, whose family he felt close to.

Brick brought back an anecdote that always characterized him. In Germany, he drove to the airport to pick up a visiting general authority of the Church. When he introduced himself as Elder Bushman from Boston, the knowledgeable authority, whom none of us had ever met, began to trace out his lineage, his father's position, his relations and their church positions, and so on. Brick's comment: The question is not whether you can ever go home again. The question is whether you can ever leave.

Bushman family, c. 1985. Front: Richard, Serge, Karl, Margaret, and Claudia; back: Charles Ortel, Clarissa Ortel, Ben, and Brick.

When he returned to school, Clarissa had graduated, but Karl was now a Harvardian and they met up for church things. Brick continued to sing and play in groups, becoming interested in a capella singing groups. He saw the potential in a brothers' group. At home he organized his brothers Karl, Serge, and Ben as a quartet, and they have sung their limited repertoire of doo wop standards ever since. Brick joined SKS Phenix, a final club. After graduation he was hired at the Chase bank. He worked in New York for a year but was soon transferred abroad to Paris, London, Bahrain, and Africa. In January of 1985, he met Harriet Petherick, a British girl who was an LDS convert and had served a mission in Italy. They were married six months later. In 1987, the stock market suffered a tremendous crash, and with the financial world in smoking ruins, Brick took a job in Saudi Arabia. Helena, the first child of Brick and Harriet, was born in Jeddah in 1987.

We had made the move in August. In early September, I had a telephone call from my father. My mother, Jean Lauper, just returned from a visit with my sister Bonnie, had suffered a stroke. I did not go west at once. My more capable sisters were closer at hand, and we thought we

had better prepare for a longer convalescence. My mother, in the hospital, responded to the cheerful conversation and laughter of my sister Paulie, but she did not open her eyes or awaken. I had not seen my parents for a couple of years. We kept in touch with rare phone calls and frequent letters. Mother was always at her best in letters, wry, clever, with specific descriptions and cynical comments. My sisters had told me that she was not up to par, but her letters had continued as good as ever.

When it became clear that Mother was slipping away, I flew from Philadelphia to San Francisco. I called the hospital from the airport and found that Mother had died the hour before. I called my family in Delaware with the news, and my husband said that there had been a letter from my mother just that day. He read it to me, and it was very lively, full of her latest exploits and enthusiasms.

At my girlhood home, my three sisters were cheerful and busy, my father subdued and grim. Mother's things were all around: her genealogy papers, her piles of fabric, her books, her souvenirs, her clothes, her pretty things. The girls were hunting for the list of her funeral preferences and the disposition of her treasures. We searched room after room before we finally found her list. Mother specified organ music, named the speaker she wanted to "say a few nice things about her," and stated her wish for a white coffin and white flowers.

We worked together to make her last dress. We remembered how she had finished up three or four little dresses the night before some event. None of us had any experience in dressing the dead, but we decided that we should dress Mother for her burial. Our Aunt Jane came and helped us. We thought that readying Mother for her grave would be a last opportunity for closeness and service.

At the mortuary I finally confronted reality, for there was my mother, cold and dead, her naked body laid out under a sheet on a high platform. Her face and hair had been nicely done, and she looked as if she were asleep. I knew why we had come, but the shock of seeing her there, her presence so familiar and so different, distressed me greatly. We wept a few tears, trying to accept and understand the great and alarming mystery before us, and then we set to work.

The question of how to confront death was put aside when the practical need became putting complex garments on an inert and stiff figure. Aunt Jane taught us some of the necessary techniques. We worked together turning the body, easing here and slipping under there. We bustled

about as if this were some regular housekeeping task, as it has been for women over the ages.

When Mother was dressed, we stayed around discussing arrangements. We were more comfortable with her body now, and one or another of us held her hand as we talked. She felt just the same, but cold. We stepped out while the men transferred her body to her white coffin with gold accents. We added a favorite piece of music to the coffin, "Ah, love, but a day, and the world has changed." I felt that our morning's work had been well done. We felt closer to Mother and to each other.

Mother disliked viewing dead bodies. She had once told me with some heat that if I ever had anything to do with it, her body was not to be displayed in an open casket. Friends at the funeral found a closed coffin with a recent, flattering photograph on top. The funeral included organ music, the nice words from her favored speaker, and an account of her life edited from her own writings. We felt her presence.

Mother disliked the long ride to the cemetery after a funeral service. We adopted her preference of a family burial in the morning and a memorial service in the afternoon. After the service, the family was available to speak with her friends and admirers.

The four children remaining with us began school in Delaware that year. The move was difficult for Karl, Margaret, and Serge. Belmont had had a solid middle-class population, good schools, and extensive community involvement. Newark, of a similar size to Belmont, was more diverse with less emphasis on academic achievement. Belmont had good orchestral students. Delaware was a band state.

Karl entered high school as a sophomore when high school relationships were already established. He did well but decided to leave early to attend the University of Delaware. After a year there, he began again at Harvard as a freshman, always with the plan to attend medical school and become a doctor. He was called on a Spanish-speaking mission for the Church in Ogden, Utah. But after a brief period studying Spanish, he was sent out to Salt Lake to do French tours of Temple Square. He had already studied French. He later went to Ogden and taught lessons in Spanish. He had the distinction of using French, Spanish, and English in Utah. After Harvard, he attended the Albert Einstein College of Medicine in the Bronx. In 1987, he married Diane Spurgeon, a medical technician from Illinois.

Margaret, in Delaware, became even more athletic, moving with a tough set. She attended Brigham Young University for a year but decided

against returning. She transferred to Simmons College in Boston where she rowed on the crew and played basketball and field hockey.

Serge made the move to Delaware at the end of his fifth grade. He had really liked Belmont, but by high school he was happy enough to be in Delaware. In Newark, he finally got a hoop on the garage and could practice his shots. Playing basketball in a town league, he became known as Last Second Serge who shot several thrilling end-of-game baskets that won the games. Music was a saving force for Serge, providing friends and activities. He organized several small bands, including a heavy metal rock band, each time thinking that he might have a winning group. He played French horn in the band at school and in the brass ensemble I organized at church. He was the handsome drum major in the band, marching in parades and playing for school games. He was one of Delaware's two representatives in the McDonald's All-American High School Band, organized to march in the Macy's Thanksgiving Parade. The organization used his picture playing the French horn on their poster the next year. When he graduated from high school, he went to Boston University, leaving after a year to go on a Tongan-speaking church mission to Oakland, California.

Ben made the move more easily than anyone else. He had never moved before. He missed his good friend Lowell, but soon made new friends. He liked the location of our new house, so convenient to the swimming pool, the university, and downtown. He was bused to distant schools from the fourth to the sixth grades to integrate Delaware's schools, rides that usually took forty-five minutes each way and gave him a headache, but he did not complain. He also spent a lot of time in music, playing his trombone and playing in different groups. He was also the high school band's drum major. But he is not as keen on music as some siblings and wonders if he should have spent more time doing other things. He had a very active social life, attending nine senior proms his last high school years, an activity somewhat eased by our large collection of dress clothes. He never had to rent a tux. He had access to a car, and he was a very good dancer. Ben had come to Delaware as a little kid. He left with us, driving up to New York after graduating from high school, to attend Columbia University. He left Columbia after his freshman year to serve an LDS mission in Japan. Later, he returned to Delaware for a summer to do an internship with his old friend Dr. Byron Pipes of the University of Delaware's physics department. There he saw many old Newark friends and felt some pride that he had moved on from his Delaware days.

Back in Delaware that first year, I completed my dissertation. I was already an old lady, not a very desirable candidate for any real job. My dissertation was published soon after as *A Good Poor Man's Wife*. This study of a middle-class housewife and mother, driven by her need for identity, to work in various reform efforts and to write several books, resonated in my life. Writing about Harriet Hanson Robinson metaphorically satisfied my need to create a life of my own. As I often say, all we ever write is autobiography.

Richard's position as chairman of the history department meant that, because of nepotism rules, I could never do anything in the history department at the university. I did teach classes as an adjunct out of ten other university departments, mostly out of the honors program where I prepared interdisciplinary seminars relating women, history, and literature. At one point, the women's history department refused to cross-list my honors program classes because I was a Mormon. The Church was getting very bad press because of its stand against the ERA and the excommunication of Sonia Johnson. I suppose that they feared that I might indoctrinate the defenseless students with some dark cultish Mormon secrets. I was wounded and humiliated. Once again, I thought that my life was over. I challenged this ruling at several levels, but I was a part-time adjunct professor with no standing at the university. I dropped it and tried to move on. At that point I gave up doing women's history.

I felt myself at a double disadvantage. My experience in Boston indicated that getting into a visible position and talking about Mormon women could well bring censure. If I was exploring our genuine past and writing about it, I was not a good enough Mormon. On the other hand, if I remained an active Mormon—as I had every intention of doing—I was, by definition, unsuitable to teach women's history. What to do?

I became a local historian. The small state of Delaware was comprehensible and had an interesting past, not too overworked by the zealots who mined the records of states like Massachusetts and Virginia. I knew the few noted Delaware historians. I took some classes, read some books, and became somewhat knowledgeable about my new state. Delaware has some preserved and reconstructed towns which people consider historical: New Castle, the colonial capitol, and Lewes, the ancient port. Wilmington was our big city and Dover our state capital, and they had some past. I taught some courses at the university relating to state history and then took on the history of our college town—Newark, a place widely considered to have no history, despite its two hundred years of existence,

colonial academy, nice old buildings, and a notable preaching meeting in 1739 when the eminent Methodist evangelist George Whitefield addressed eight thousand people. My students explored various important local sites. We read documents. We had guest speakers. We thought we were on to something.

I had a new topic for cocktail party discussion. Why did Newark have no historical society? Why were the real monuments of Newark not more celebrated? I reported all this to my class. With the help of my students, the city planner Roy Lopata who had a PhD in history from the university, some UD faculty members, some amateur historians, a patriotic fire fighter, a patrician architect, and the wife of a real estate developer, we organized the Newark Historical Society.

We first met at the Newark City Hall. Roy got us the space. We planned a program. The kids in my classes papered a few parking lots with announcements of our meeting, for which we got into trouble. We had a little newspaper coverage and a great first meeting with a big crowd. That was 1982.

Richard had been named as the bishop of the Elkton Ward that week, and the only possible time for him to meet with his new counselors was the evening of the first meeting of the Newark Historical Society. I was surprised and grateful that he canceled his bishopric meeting that night. He came instead to the city hall to set up chairs and be helpful. His support was very much appreciated.

In the Newark business, I was an audacious interloper. I was not a Delaware native and not even a longtime resident. I was willing to get the Society started, but I didn't think I should be president. However, no one else would shoulder the job, so I took it on. Others were willing to take the other jobs, so we had a good working group. We produced a series of charming events, public meetings, publications, and exhibitions that surprised and energized many people.

I could do those things. I do projects, a choice inheritance from my mother, who navigated her life through a similar series of extracurricular activities. She would wake one morning with a vision. Then she would feverishly make plans, and she was soon on the phone, suggesting, requesting, and cajoling in her most charming manner. When she had put legs under her project, she proceeded to carry out the idea, doing every part of the preparation, supporting it with her will and her finances, working like a person possessed. Though she hinted at it darkly throughout the preparation process, I never knew her to fail.

I have not been as single-minded as she was. And I think I have more strings to my bow than she did. Her projects were almost always musical. I do musical things, church things, feminist things, historical things, and other things. I have had a wider perspective, more opportunities, more connections, more talent to work with, and better communications. But I do not think that I come close to her drive to get things done or her willingness to force people to support her vision.

During some of my mother's creative periods, she was not well. She spent hours on the bed every day, resting up and preparing for her next onslaught. With the vision of the possible project, she also received the plan for making it happen and the energy to carry it out. She gathered power for public events, and when she was performing for a group—when she was "on"—there was no one who could approach her. Her remarkable talent and vision were unequaled by anyone else we ever saw in action. She did later come to say that just because she had thought up a project didn't mean that she had to do it.

My projects also come as visions, suggested by clues of various kinds that I have stored away in my mind. I can then see how to carry them out, and I generally have the energy to make them happen. The Newark Historical Society was one of my projects. Frequently these projects take on lives of their own, which is my favorite way. Let them live on without any more input from me. Many years later, the Newark Historical Society is still lively with regular programs, annual meetings, a collection, an exhibition space, and loyal members. As I am a lifetime member, I recently voted for new officers. I'm so glad that it all carries on. I thought we did some good things during my time there. We used the connections available to us: the university with its many riches, other historical societies, and the Delaware Humanities Forum which is the local chapter of the National Endowment for the Humanities. Collaboration was the name of the game.

I called on the president of the University of Delaware. I wanted the university to host us for regular meetings as the town hall room was too small. President Arthur Trabant was a very charming man, very obliging, very interested in cooperating with the community, but the rules were plain: the facilities of the university could not be used for such as us. I was privileged to hear his side of the conversation with someone he called to try to reverse the policy in our case. He repeatedly said that he knew what the rules were, and why they could not be changed for the Newark Historical Society, but asked why they couldn't make an exception. By

the time the conversation was over, he had worked it out. We met at the university regularly during my tenure.

Our first special event took place in the old Newark Academy Building, the eighteenth-century academic institution our Declaration of Independence signers attended, the forerunner of the university. The building, part of the university, has been much worked over and remodeled, but was underused. I was able to get the clean, empty, spacious, white-washed front room for our first exhibition.

Many years previous, a Newark artist named Leo Lascaris had been commissioned to paint a mural of Newark for the city hall. He wanted to do a border that showed the buildings of our downtown Main Street. He photographed the buildings and then painted them on his mural. We borrowed his old photos and enlarged them. We had someone do contemporary photographs of the same buildings and spaces. We mounted these old and new photos together with descriptive labels that included a lot of our town history and called the show *Main Street: Then and Now*. Many people visited this show.

We got a grant from the Delaware Humanities Forum to republish the small extant history of our city by E. G. Handy and J. L. Vallandigham, Jr. titled *Newark, Delaware: Past and Present* (1882). The new edition of this little book was published jointly by the city of Newark and the Newark Historical Society. It had become a rare commodity. People were very glad to be able to get copies for a small sum. I wrote a new introduction.

Sticking with exhibitions, we continued the visual aspect for our next show in 1985, *Views of Newark*. In this one we featured paintings that had been done of the city. Gathering these from official and domestic sources led us on many adventures. Whoever thought there would be so many? We hung the show in the large lobby of Clayton Hall, a university building with lots of traffic. I edited the catalog and wrote an essay for it. The show was terrific, in a large and heavily traveled area, well hung, full of new things to see. We got a lot of credit for mounting that exhibition. The best aspect to me, however, was the print materials that Martha, a UD faculty member and graphic designer, arranged for us. She took an attractive nineteenth-century watercolor of Newark owned by the university and adapted it for use on all the exhibition materials. She arranged variously trimmed images of two sizes on a single sheet of paper. She printed many postcard invitations to the exhibition to be sent to Historical Society members and given out all over, as well as a lot of postcards with just the image for future use. She added an image the size of the actual watercolor

painting suitable for framing. She cropped the top and bottom of the full-sized image to make the outside cover of the catalog. All these items were printed at once and trimmed for various uses. We got wonderful images for very little money. The Delaware Humanities Forum gave us a little grant, and we had space from the University of Delaware.

I'll mention one other exhibition we did, again cooperating with our local institutions. An old Newark family, moving from their big house, gathered up several pillowcases full of old textiles: clothes, handiwork on pillow slips, dish towels, and the like. Much of this was stuff from the 1920s and 30s. I called up the university's home economics and museum studies departments and asked if they would like to collaborate on a show, preparing the items for display and writing labels for them. They were delighted to participate, and we had a smashing show. All the items were in good shape and were made to look beautiful. We added some old photographs and historical items. The hit of the show, called *Worn in Newark*, was a beautiful, beaded, sequined flapper dress. After seeing it on display, the family had second thoughts about giving it up, and we gave it back to them. For months after that show went down, people who had missed it asked if we couldn't please install it again.

We did lots of other things. We had monthly meetings, annual dinners, and lots of participation. We sold numbered posters, paintings of the city's historic buildings. We silk-screened bumper stickers that said "I (heart) Newark" which is pronounced New Ark, sounding enough like New York to make a nice pun. Leo Lascaris designed a city quilt which local embroiderers made up. He wanted the center to be the city seal, but we discovered that the city had no seal. I told Leo to design one. We took it to the city which then officially adopted it. When Leo looked at the quilt as it was coming together, he told me I had wrecked my embroidered square. So, I did it over. The quilt hung for years in the city hall, later moved to the town's old folks' home. The Newark Historical Society was a great success. The city, the university, and the state-wide historical agencies were all willing to work with us. It was rewarding work. I got deep into the Delaware landscape and archives. For an outsider, I got to know the city and state pretty well. Later on, the city gave the society an old railroad station for an exhibit hall.

–16–
A High Time in The First State

In the meantime, my work with local history led to a job offer to supervise the work of a small state agency, the Delaware Heritage Commission. The commission, a politically chosen group of citizens charged to celebrate the state's history, had lost its state funding in recent years but was trying to stay alive to commemorate the anniversary of the creation and ratification of the United States Constitution, just a few years away. That would be a big event in Delaware, The First State to ratify that august document. The Delaware delegates, close to the constitutional convention in Philadelphia, could easily get back home and set up a ratification convention. Besides that, Delaware, as I have had occasion to say many times, was a big winner in the representation compromise. The tiny state was granted as many senators as any of the larger states. Delaware citizens, who are not all that numerous, are close to the national capital with elected officials who often commute. As a result, Delawareans are the best represented citizens in the nation.

A University of Delaware professor and member of the commission, who had been aware of the historical society, recommended me for the position of executive director of the Delaware Heritage Commission. I took the job part-time, administering their scholarship program, and later, when the state restored funding, I worked full time coordinating commemorative programs throughout the state. This was a good time for me. Although I was busy and strung out, I felt real power and satisfaction. We had excellent publicity. I got along well with the press and was often written up in the newspaper. Because the board had few ideas, I was able to conceive and carry out my own imaginative program, and we had the best and most extensive program of any of the thirteen states. Because important state officers had another agenda, trying to circumvent the commission and to replace me, I felt I had nothing to lose and acted boldly and decisively. There were unsuccessful plans and efforts to fire me. And I was not that unwilling to go. At one point, a Commission member told the papers that I had been fired even though they hadn't gotten around to it yet. I told a reporter that as soon as it happened, I'd tell him all about it. It was a rough time, but not a serious one. I'd been fired before, and that

job was not my children's bread. Eventually I got some grudging respect from the very tough Delaware pols.

We had a small group of talented housewives who worked part time for little money, and we cooperated with every civic, educational, lineage, patriotic, and religious group in the state. We accomplished a great deal with our very limited funds and manpower. I was sorry to leave Delaware because it would have been a good place to grow old and die. I am sure I would have gotten a very nice obituary there.

In my time at the Heritage Commission, we did everything we could think of. We started a publishing house, The Delaware Heritage Press, and published a shelf full of books. We reprinted old Delaware classics and published picture books of the beautiful scenery, a state history for children, two volumes of official documents, and a cookbook. We reenacted such events as the ratification of the constitution in the Delaware legislature, the election riots in Georgetown, and the inauguration of George Washington himself which was followed by a levee at the Delaware Historical Society. We held ratification events in all the volunteer fire halls, laid wreaths at the graves of ratification signers, and staged the largest parade in Delaware history. We hosted a state visit for the chief justice of the United States Supreme Court, the Honorable Warren Burger. We invited the descendant of the state's namesake, Lord Delaware, along with Lady Delaware of London, to visit. They were friends of our then Senator William Roth, of the Roth IRAs. We arranged for Lord Delaware to address the state legislature and to receive an honorary degree from the University of Delaware. We prepared gorgeous posters and school materials at suitable grade levels. We ran our high school scholarship program and published an excellent newsletter. We created pins, scarves, ties, flags, and banners with our logo on them. We got the highway commission to erect signs advertising our designation as The First State at all state highway entrances. We commissioned a thirty-minute film which was shown on TV, and we commissioned our symphony orchestra to perform a patriotic program in each of our three counties. We put up two sculptural monuments and commissioned some new murals for the state house. We had a man do sky writing for us. We introduced two postal stamps. We did more things, but I think that many is enough to mention. Our program was certainly the richest and most extensive of the thirteen ratifying states. We did enough projects for anyone's lifetime. I will describe two.

The Great Bicentennial Ladybug Launch

It happened that I was invited to give lots of talks to groups. I was even invited to testify before a Congressional committee in Washington. I talked some history, described some of our historical leaders, laid out some of our plans and projects, and encouraged participation. That got a little tiring. To jazz up my presentations, I began to dream up fanciful activities such as a barge flotilla on the St. George Canal and parades filmed from above. One of my best imaginary projects was The Great Bicentennial Ladybug Launch.

All these ideas have backstories. This one was inspired by the long-ago wedding of the Shah of Iran and his beautiful wife Farah Diba. She, a student in France, had the requisite beauty, intelligence, and style to continue his dynasty, but she had no children and was set aside. The Shah himself also proved mortal. But the wedding was memorable.

Among the many imaginative touches was the gathering of thousands of butterflies in nets high above the crowd to be liberated at the climax of the wedding ceremony. The butterflies, however, were very fragile and died in their net cage. The raining of dead butterflies on the audience created an unfortunate effect. I remembered thinking that they needed a sturdier insect for such an activity.

Later I read that the ladybug had been named the state insect by the action of the legislature. An elementary school class had visited the state house and petitioned to make the ladybug the state insect. The students learned how the government worked by this action, which made it an excellent educational activity. Plus, the ladybug had other virtues, feminist connotations, availability for gardening purposes, sturdiness, and besides, the creature is the one of the only insects that people don't hate.

I put these ideas together and suggested that a great bicentennial event would be the "liberation" of a million ladybugs statewide. One day the legislature could "liberate" theirs. The next day we would have launches at schools all over the state. I made this project sound pretty good, as I was in the business of giving a lively talk. But I was surprised, amazed, and delighted when several women came up after one of my talks to say that they represented the statewide PTA and that they wanted to work on that project with us.

So it was that the Heritage Commission purchased more than a million small red creatures, inexpensively harvested full grown and sold to fight garden pests. A million plus ladybugs made a very tidy package. We publicized the event and made connections with the legislature. The

PTA ladies dealt with the schools, divided up the little red creatures, and delivered them to the schools where they were again divided into baggies for individual distribution.

I went to the state capitol and listened to the patriotic intonations of the legislators, the wisdom of our ratifiers, the comments about the state insect and the school children who caused that designation to be, and then went out where the actual creatures were freed from their baggies. It was a beautiful day. The bugs dropped to the ground, or flitted a little distance, and occasionally flew away. The same scene was reenacted the next day statewide.

I'd call the event a big success. We got great statewide publicity. We spent very little money. We leveraged a couple of simple ideas to create an event that made a splash. We involved thousands of people. We always felt we had really succeeded when the Pennsylvania newspapers used our stories, and this one made *The New York Times*. When interviewed, I got off a couple of good comments. When asked why we were doing such a bizarre thing, I said that it was so the school children would remember their activities on a special day. When asked whether the ladybugs had performed as they should, I said that they had fulfilled the measure of their creation, that they weren't exactly eagles. I now collect all things ladybug. I love ladybugs.

Horse Time

We got lots of interesting calls at the Heritage Commission. People would offer to write new state songs, to bring in a live bald eagle, to display a copy of Great Britain's Magna Carta, to truck in a replica of the Liberty Bell. I loved these extras and always worked them in if they did not cost us much money.

One day a man called and offered his horses for some event. He had several himself and access to others. He knew the rich people with carriages and matched bays. Horses were certainly involved in the eighteenth century. Wouldn't we like to have some good-looking ones? And so we put together an event in Delaware's historic state capitol in New Castle.

Before the actual constitutional convention in Philadelphia, there was a trial run in Annapolis, Maryland. Delegates from Delaware attended. We planned an event where we would see off our Delaware delegates. We would have three of the members of our Heritage Commission dress up in colonial garb. We invited the state's chief justice, a real history buff, to dress up and give a public speech, exhorting our delegates and instructing

them on their behavior at the event. We would energize the event with singing children and a fife and drum corps, and then the horses would carry away our delegates in Delaware's most elegant equestrian equipage, driven in this case by the owner, one of our local rich people. The planning proceeded.

My horse people, however, wanted more horse time. And so it occurred to us that representatives of the delegates might even ride horseback all the way to Annapolis, roughly eighty miles away. They would ride all day, go home at night to sleep, and pick up the next day where they had left off. This would be about a three-day journey on horses. So then, I had another idea. I called up a friend and colleague in Maryland who was doing the same kind of celebratory things that I was and asked if it would get in their way if our people really did arrive—that is, as they had left—in costume and in an elegant carriage. He said that would be fine and they would schedule it in as a highlight of the day.

The carriage and horses were trucked into Maryland and the three delegates met them there and were driven several blocks, in real style, up to the door of the Maryland state capitol where they were greeted by Maryland's governor. The Delaware governor did not attend, although there had been talk that he might. As the Delaware delegates mounted the state house steps, about fifty newspaper photographers jockeyed for position. Light bulbs flashed. Someone called out to ask which one was the governor. One of our delegates suavely spoke for the three actual delegates, saying that they had all been governors in their day. I got an elbow in the face and a black eye from one photographer who wanted a good shot, and we had pictures across the country the next day of two handsome colonials shaking hands. At a reception afterwards, Strom Thurmond, the late amatory US senator from North Carolina, thanked me for the event and kissed me. Imagine.

But there is another part of the story. As I said before, our horse people wanted more horse time. The man who had first contacted me heard that there would be a big event at US Army Fort Meade in Maryland after our delegates arrived. The army would be on display with all their materiel and a special message would be delivered from George Washington by an equerry on horseback. My horse guy wanted to be that equerry. I suggested this to our Maryland connection, who passed it on to the military. The request was turned down because strange horses could not be counted on to behave well. They tended to rear and back up. I told my horse man, but he appealed to his horse friends in Delaware and asked them to contact

their friends, the Delaware elected officials, and the beneficiaries of their campaign contributions. The politicians took the matter to the Pentagon. And so it was that my horse friend and I were summoned to a meeting at Fort Meade in a room full of high-ranking officers in full uniform with very stern faces. They asked us just what it was that we wanted because they had been instructed to give it to us. I was appalled. I had never seen this kind of raw political power before. I was to see it several times in Delaware. The officers were relieved and almost cheered up that we only wanted to have our man deliver the message from General Washington. He did deliver the message at Fort Meade before a cheering crowd of thousands. His horse did back up and rear.

I had many happy adventures with the Heritage Commission.

One time when Richard was away, he got a phone message from Professor Eric Foner at Columbia University in New York City. Eric wondered if Richard would be at all interested in a position as a colonial historian at Columbia. We knew that there was a job open there. Several of Richard's friends had asked him to write letters of recommendation for them. Apparently, none of them had been employed. I told Richard about this call when he returned, but he showed little interest. I had made so much fuss about going to Delaware that he did not want to consider moving again. I pointed out that if he got that job, it would mean our two younger boys could go to Columbia for free. Getting our children educated was a very expensive proposition. We still had two in college and two to go. I wasn't really that interested in moving to New York, but maybe he should think about it. So, with nothing really to lose, he went up to Columbia to give the requisite "job talk." Eric said it was the best such talk he had ever heard. Richard was offered the Columbia job.

With the offer in hand, Richard wanted to move to New York and Columbia. It was a great move for him. He would be going back to the Ivy League where he was happy to be. I didn't really want to go, and he was not going to force me into it. But the financial bottom line was undeniable: free Ivy League tuition for our two youngest sons. We considered two households and a commuting marriage, but we decided against it. We eventually decided that he would go and then we decided that we would both go. This became another chapter in the charmed academic career of Richard Bushman, who had never applied for a job, asked for a raise, or gone up for tenure. For me this was another move from something to nothing.

A diary entry at the time summed up my thoughts:

How do I feel about this move to New York. I dread it because of the work involved, getting two houses in order. I also most particularly hate to lose my income and my identity. On the other hand, it is sort of exciting, and I look forward to getting to know New York while I fear the danger, the dirt, the homeless, and the expense. I resent having to start over again. But I do feel that I put this move into the works when I began to overpay my tithing and pray for a new direction. And it is working out very well for Richard and for the boys. And it will bring the family together for a year or so. And there is really little risk. So I will try to be a good sport.

Part Three
New York

−17−
My Life as a Scholar

Richard and I moved to New York City in 1989. He was hired as a full professor and was soon sitting in a Columbia chair as the "Gouverneur Morris Professor of History at Columbia University in the City of New York." Gouverneur Morris, a graduate of King's College (the school's original name), was the man who drafted the United States Constitution. Richard continued and improved on his role as a very distinguished person.

People were good to us when we left Delaware, inviting us to dinners and parties and giving us presents. Every group we had been involved with hosted a nice event. The news organizations were particularly kind to me. *The News Journal* ran a list of significant people whom local citizens should be aware of and included me along with college presidents and company CEOs. One reporter arranged to have a new picture of me taken and ran it on August 14, 1989, as the top half of the page, along with a very nice, long article under the title, "She'll Take Manhattan!" Another reporter wrote a long article on the Heritage Commission, which came out more positive than expected. He referred to

> . . . the imaginative touch and the serene smile of Claudia Bushman. In her five-plus years as executive director and in her earlier tenure as a consultant, she became the most visible symbol of how interesting and exciting history can be.
>
> Her legacy runs the full range from a cloud of ladybugs and a laser light show to the reprinted minutes of Delaware's 1792 Constitutional Convention. Claudia Bushman showed you didn't have to be part of a multi-generation Delaware family to love, treasure and promote the state's heritage to all Delawareans.
>
> It would be fitting if Gov. Castle and the state's various historical and patriotic groups sent her off with some formal honors to recognize how she made all Delawareans, old and new, aware of the State's rich past.

Joe Biden, then a long-time US Senator, sent me congratulatory letters. Eventually, the governor invited Commission members to a posh dinner and bestowed the state's highest honor, The Order of the First State, upon me and upon the Commission's chair. I knew that people were so nice to me because I was leaving.

"Benny and the Pork Chops": Brick, Serge, Karl, and Ben, c. 1985.

We threw ourselves a party in our beautiful backyard. Richard, who likes to prune, cut down ten years of garden growth for the occasion. We invited three hundred people with printed invitations. We had a tent. We engaged a swing band at a cost of $400. Twenty-five band members played music from the forties and fifties. People danced on the grass. All of our children, though not all of their spouses, attended. Benny and the Pork Chops, our resident singing group, ran through their repertoire. It was a great event.

Before we left the state, I shed my past. We had big closets and an attic full of wonderful, valuable stuff. I dealt with two boxes a day and eventually we dispersed, destroyed, and divested ourselves of our accumulated treasures. First, all the things I didn't want. Then, all the things I didn't need. And finally, almost everything else. We were going together to a fresh new life, an uncluttered life in a city apartment. I was coming from a state of 800,000 where I had been somebody to a city of more than 9,000,000 where I would never be anybody. We were starting over again, and once more I was anonymous and without a life.

The first time we came to look over the city, I was mugged. This happened on a Saturday morning about 10:00 a.m. as Richard and I headed to the Metropolitan Museum of Art. We were in a good neighborhood. I was going up the stairs to the elevated subway at 125th street and Broadway,

when a man coming down the stairs had about three seconds to decide to rip the gold pendant from my neck and sock me in the chest. The necklace, a museum reproduction, could have been real gold, but it wasn't. The blow, so sudden and invasive, hurt and I started to cry. We woke up to our vulnerability and the ease with which we could be invaded. Should the New York move be reconsidered? We decided to carry on.

Columbia had asked if we wanted to rent one of the many university-owned, price-subsidized apartments. We did. We were invited to see the apartment we were offered. No choice. My idea of a New York apartment was the spacious, white, Art Moderne places in the movies—you know, the ones where Fred Astaire and Ginger Rogers lived. Well, there was no sunken living room, no space for a white grand piano, no veranda overlooking the bright lights. Still, the apartment had a reasonable living room, a large dining room, and a spacious front hall, as well as the kitchen, bathroom, and two tiny balconies. We had two good-sized bedrooms and an additional small "maid's room" with a private bath. They would paint the walls, refinish the floors, build in new cupboards, and redo the kitchen and the baths to turn the old rooms into a very nice New York apartment. And the place had advantages we did not then sufficiently appreciate: an unequaled view of the Hudson River and the New Jersey shore traversed by interesting ships, a morning and evening parade of airplanes flying toward us and turning at the river to land at the airports, a changing canopy of beautiful trees in the park across the street, and an address on Riverside Drive, which I now consider the best residential street in town. All within a short walk from Columbia's campus.

At that move I shed another long-term role: resident mother. Clarissa was living downtown in an apartment, and upstate in a nice country house in Ancram, while building and then adding to a Baronial Salt Point, New York, mansion. We sometimes visited. Clarissa's husband, Charles, disliked visiting us because, as he said, all we ever did was wash dishes and sing, which was a pretty good description of our life. Brick had married Harriet and was living in Saudi Arabia. We would be closer to Karl and Diane, attending Albert Einstein College of Medicine in The Bronx. Margaret was back in school, working on a master of liberal studies degree at Columbia University. Our son Serge, who had been studying at Boston University, had transferred to the University of Delaware to enroll, with free tuition, in two semesters abroad in London and Paris before transferring to Columbia. He moved in several blocks away. Our youngest son, Ben, who had just completed high school, drove up with us to New York to

attend Columbia's school of engineering. He helped us move in and then checked in at his dormitory. He promised to visit at Thanksgiving, but he was back that afternoon as the dining hall was not yet open. Clarissa, Karl, Serge, and Ben would be nearby. Margaret would live with us, but she was already an adult. We no longer had children at home.

We came to town having avoided the worst NYC difficulties—finding a job for Richard and finding an apartment. Still, coming from a university town with almost no elevators to the greatest of American metropolises took a lot of adjusting. I missed Delaware, widely and correctly advertised as a place to be somebody—which I had managed to become—and I knew that I would never be anybody in New York City. Once more Richard moved from something to something else, and I moved from something to nothing.

Growing up on the west coast, I occasionally heard the name of Columbia University. It was far away and exotic and suggested the poetic founding of the nation. The institution's football team occasionally surfaced, playing in some match on the radio.

I had actually visited it myself when I was a freshman at Wellesley, on the way home from a spring vacation in Washington, DC. I was staying on New York City's Upper West Side with a friend of my mother; she suggested that I visit the important sites in the neighborhood, including Ulysses S. Grant's elaborate tomb, the Cathedral of Saint John the Divine, Riverside Church, Harlem, and Columbia University. I spent a few hours inspecting them. I never imagined that one day I might live in the same neighborhood.

Columbia University looked heavy and impressive. The majestic buildings set in neat, landscaped quadrangles projected a heavy power of age and importance; the imposing domed Low Library proclaimed the supreme importance of the life of the mind. The University of Delaware, where we had recently been, was very nice, with clean rectangular architecture and a couple of beautiful old buildings, but it lacked the heavy power of age and significance of Columbia.

Columbia had grown and migrated over the years. Her location on Broadway at 116th Street was already her third in the city. She had been founded in the southernmost part of the city in 1754. In 1857, the college moved from Park Place in lower Manhattan to 49th Street and Madison Avenue, in midtown Manhattan, where it remained for the next fifty years until the site became Rockefeller Center.

My Life as a Scholar

In 1896, President Seth Low, eager to expand Columbia, moved the college sixty blocks north, from 49th Street to its present location in Morningside Heights. The trustees officially authorized the use of the name Columbia University.

Columbia continues to grow and expand, now spilling over to an additional new campus on 125th Street in Harlem. 116th Street cut through the two main parts of the campus until Dwight Eisenhower, then president of Columbia, had the street closed. Now walking along the path between Broadway and Amsterdam Streets, a person passes between the large, newish Butler Library on the right, and the elegantly old Low Library with its impressive vocabulary of classical enhancements on the left. Low Library is the grand million-dollar gift of past university president Seth Low to honor his father, Abiel Abbott Low. Designed by the architectural firm of McKim, Mead & White and built in the 1890s, the building now houses official offices and is used mostly for ceremonial occasions, having proved inefficient for the retrieval and perusal of books. Butler Library is also increasingly inefficient as current students go online for their information. But there they are, two massive buildings standing as monuments to the grand idea that books provide the wisdom of the world, even as the importance of books diminishes in the light of technology.

We had been to Low Library once before when Richard received the Bancroft prize for one of the best history books published in 1968—his first book. The building remains impressive, a monument to learning. Years later I was thrilled to have an office high in the building, up near the roof, overlooking and open to the great rotunda. I had a key to that throwaway storage space. There was no electricity up there, and it got very dark in the late afternoon, but I loved it. That wonderful space up in the library's dome, far from the marble floor below, was perfect for a ritual suicide should I have ever been so inclined.

There was much that was modest enough at Columbia, but the traditional academic grandeur was inescapable. Richard, as a new professor, moved into a huge campus office in Fayerweather Hall. He decorated it with a large oriental rug, a very large library table which he used as a desk, as well as many large and ancient tools of agriculture (his interest at the time). It was imposing. It was New York. It was, as Columbia undergraduates Rogers and Hart wrote in their Columbia song, "a college on Broadway."

Richard was appointed Gouverneur Morris Professor of History at Columbia. He was an important person. I would love to have been an

important person at Columbia, too, but I wasn't. I did not have tenure. I was not a noted campus personage. I was a small speck on the carpet floor, but I was a part of things.

Richard asked a colleague with a historical advisory business if he had a job for me, and the obliging man offered me a small historical operation that interpreted the United States Constitution and invited school children to Federal Hall, a historical building on Wall Street where the first congress met and where Washington took the oath of office. Within its historical walls, children came to roleplay historical events. I worked there for a couple of months, but I did not suit and was fired. All very painful. I remembered my days in Delaware when people thought that I was very effective. Of course, they had wanted to fire me there as well, but they had not managed to do it.

I was glad to escape the exhausting commute to downtown Manhattan at rush hour, but what was I going to do with myself? I didn't have to work. The several jobs I looked at in historical administration required too much commuting. I had burned my bridges and saw nowhere to build new ones.

One day, walking on Central Park West, I was thinking how the Heritage Commission back in Delaware had begun to plan for the 500th anniversary of Columbus' first landfall in the New World. Thinking of Columbus, newly discredited, I entered the New York Historical Society. Maybe I could find something useful for Delaware in the library. I wondered how Columbus had been celebrated in the past. Replaying historical events and commemorations had been entertaining and instructive. The books had some useful information for a talk about Columbus. Maybe I could write an article. "Wait a minute," said I, "there's a book here!" So, I became a scholar again. Soon I was writing *America Discovers Columbus: How an Italian Explorer Became an American Hero* (1992), a title suggested by Richard.

The Columbus book became my vehicle to make my home in the city. I went to the New York Public Library and the Historical Society, exploring Columbus, who was omnipresent in the city. Did I not walk on Columbus Avenue and audit classes at Columbia University? Was not Columbus Circle, at 59th Street and Broadway, where Italian immigrants had raised an undistinguished statue of the great explorer, the center of New York's West Side? But Columbus had never set foot on mainland North America. Why was he so celebrated?

I worked hard on the book, and it was published in time for the celebration. I concluded that Columbus deserved to have been remembered as the cruel, grasping Hispanic explorer that he was. Vain and ambitious, he desired honor. He had not been much mentioned in the annals of the American colonies before the Revolution, but he became important at the birth of the United States. American colonists seized on him as America's founding grandfather. He became the link to America's European past, bypassing England during the Revolution. Columbus was drafted as the founder of the Americas.

As a scholar again, I went by myself to a conference at Brown University in Providence, Rhode Island, on my way to Worcester, Massachusetts, for a month-long fellowship at the American Antiquarian Society. From there I went on to Pasadena, California, for a month-long fellowship at the Huntington Library where I read old books and gathered imagined images of the great man. I had a good topic and people began to take me seriously. The University Press of New England, which had published my dissertation as *A Good Poor Man's Wife*, rushed the Columbus book into print. In a very crowded field, reviewers noted that the book was different from the many other Columbus books and commented on its good writing and entertaining nature. I was a scholar again and decided that that was a good place to be.

As we settled in New York, we began to think about the sabbatical that would take us away. We planned a grand joint writing project on farming in the northern and southern hemispheres of the Americas. Richard took me into the project because I so frequently complained of being left out. The project, he now says, was all for the love of me. He worked up collaborations with outdoor museums such as Colonial Williamsburg and Old Sturbridge Village, aiming toward a major comparison of northern and southern farming. We would both work on farming for three years. He applied for a big grant from the National Endowment for the Humanities. He did a lot of preparatory work on that big, long-term project—so much so that he has always been grateful that he did not get the grant. He eventually published the book in 2018.

To pursue his research on farming, Richard applied to the American Antiquarian Society in Worcester, Massachusetts, and the National Humanities Center, a scholarly community in the Research Triangle Park of North Carolina between Raleigh and Chapel Hill, for sabbatical grants. That last one came through first. When he was awarded the North Carolina fellowship, we planned a year to discover southern culture as well

as do research. While there, we learned about tobacco production, gorged at pig pickings, danced the Texas two-step, and met daily at the Center with a couple of dozen scholars. Each was assigned a spacious study in which to work, and I had a corner of Richard's.

I was always watching for ways that I might be treated differently—as the stupid wife—but people were certainly nice enough to such second-rate intellectuals as me. Richard did very well in those situations, continuing to fill his notebook with bits of thinking which he intended to add up into a book. He said he was just following Joseph Smith's admonition to take what light he had and do something with it. I was fifty-seven years old and still felt that I was nobody.

We traveled around the South quite a bit while we were there. I loved the extravagant wildlife, seeing big birds—egrets, herons, and pelicans—in the air, their long legs trailing behind them, or wading in ponds. On a trip to Georgia, I made a special point of stopping at the Savannah National Wildlife Refuge. I was thrilled to see a sign warning us not to harass the alligators. Would I actually see an alligator in the wild? We drove through the winding paths of the preserve, stopping at various dykes, and when we reached the final long canal, we saw many alligators—big ones, little ones, all lying very still, grinning out of their big flat faces, apparently made of brown and black and purple scales. Before we left the park we saw an alligator swimming, his snout riding high above the water. I felt fulfilled.

At the University of North Carolina's grand Southern History Library, we began a search for primary historical material. Right away I found a promising and extensive journal with daily entries of useful farming details. The writer, John Walker, a shopkeeper before he began farming, was an excellent record keeper who lived in King and Queen County, Virginia. He was a middling farmer, not too rich, and the owner of a dozen or so enslaved people, about half of whom worked his fields. He kept an extensive, many-volumed journal in a series of account books with dated entries from the front and financial dealings from the back of each book. When the categories met in the center of the book, he shelved it and began a new volume.

He began each daily entry by recording information in four categories: the weather; the work of the day; who was sick, requiring which Thomsonian medical remedy that he, as a certificate-holding doctor, administered; and finally, the strong testimony of a fervent Methodist. He grew wheat in Tidewater Virginia, a premier area, after tobacco farming had moved south. Each birthday he gave a long account of himself. He be-

gan his farming journal, which had been transcribed, at his farm Chatham Hill in 1824 and it ran through 1832—eight years. He frequently referred to himself as "a poor illiterate worm." The journal was good reading.

I was later thrilled and amazed to discover that Walker's journals did not conclude in 1832 with the typescript in North Carolina. Walker later owned another family farm, Locust Grove, and his record of it extended on through the Civil War to 1867, available on microfilm and held in Virginia repositories. Walker's journals provided forty-three years of diary and farm accounts, from 1824 to 1867, on two farms. Walker taught me a lot about farming, record keeping, and many other things. I would spend many hours, many years, with John Walker before my book, *In Old Virginia: Slavery, Farming, and Society in the Antebellum Journal of John Walker* was published in 2002. My first childhood ambition had been to be a farmer's wife. And though I would not have much cared to be married to John Walker, a rigid, self-important person, I do love him and owe him a great debt for recording his life.

When we first arrived in New York, I audited Columbia classes, very much enjoying the bits of arcane knowledge that stuck in my mind. Soon after, Richard got me a little job at Columbia advising MLA (master's in liberal arts) students, Columbia's gesture toward adult education. In 1990, I began to teach the introductory course in the program, and later courses in women's history and American studies. It wasn't a real or good job, but with research, writing, the children, and the city, I had enough occupation. Many of these people were not quite settled in the world and were looking for something else, a continuation of their college days, a bridge to the future, or even just something to think about. The classes were not large, maybe eight to twenty students. The students were good about doing their assignments. They were motivated. College was recreation for them.

My courses went well. These older, returning students were glad to be back in the classroom, eager to read and talk, grateful for the extra community that our events and programs provided. We had many special events and potluck suppers at our apartment which was close to the campus. Richard and I began to invite our classes together for events of mutual interest. We had some very interesting sessions. Because we were in New York, we could engage some notable people, even the authors of the books we were reading.

Our strangely assorted group came faithfully to meetings, volunteered to do scut work, came up with lots of great ideas, and seemed grateful for the opportunity. I worked with those MLS students for some time, living

a very good life with work to keep me busy and enough extra money to spend on presents for the children. I was sixty years old.

Getting to know my students was a rich experience. They were promising people, many from faraway places, some foreign students. One Japanese girl with a Rotary International scholarship told me that she had reported on our class to her Rotary advisor who had been a travel agent and was now a restaurant owner. He thought our class sounded interesting and wondered if he could visit. He came, enjoyed the class, and enrolled in the program. He took more classes and earned a degree. He hosted us at his restaurant. When we planned a trip to Istanbul, he advised us about hotels. He called a friend in Istanbul and asked him to show us around the city.

One memorable evening we had the former mayor of New York City, David Dinkins, come to our apartment and speak to the students. He and his aides got stuck in our elevator both coming up and going down on the way home. We had lots of great events. My students began an American Studies journal. I really loved them, and I know that they valued me. I was a professor at Columbia University. But, of course, I was always also cursing my fate that I didn't have a real job.

Some years later, I got involved in another Columbia activity. The university had begun plans to celebrate its 250th birthday in 2004. Columbia had been organized as Kings College in 1754, before the American Revolutionary war that divided the colonies from Great Britain. The little college had been founded down at the southern tip of Manhattan near Trinity Church. Kenneth Jackson, a professor of American history, had been put in charge of the event which would take place in 2004. This had some interest for me because of my experience in Delaware. I liked to celebrate things and had some good ideas for doing it.

I called Ken and offered my help, and he immediately invited me into the organization. A young woman with a Columbia doctorate oversaw committees of faculty members and others meeting and moving along the long-term plans. There were lots of committees and she was happy to give some up. I was asked several times to take over more responsibility and to be in charge. I said that I was very happy to work on things, to make plans, and to keep committees moving along, but Richard had a sabbatical coming up and we would be gone for a year. We would still be back in time for the real anniversary.

With New York City as our base, we traveled around. Richard had frequent sabbaticals and I went off with him, as well as on my own research grants. The life of a scholar is very pleasant, with new places to explore, new

collections to excavate, new people to hang out with, opportunities to do your own work as well as that of the home institution, a change of residence, an excuse to take time off to look around, friendships and mementos to amass. We enjoyed our time away, just as we really enjoyed our New York life. Columbia was a great place to be. The city was full of riches, and we marveled daily at our generous view of distant New Jersey, Riverside Park, and the Hudson River. A spectacular, original sunset every single day.

On occasion, I turned my attention to family history. For some time, I had been gathering my father's recollections. I wrote them up and had them reproduced in a Kinko's edition. When my father sent me a long list of errors in the published work, I corrected them, added more things that he remembered, and had many more copies created. I am forever grateful that he was willing to talk to me about his life. In August of 1991, my sisters and I flew out to San Francisco for a big nineteenth birthday party for our dad, Serge James Lauper, at the Latter-day Saint chapel where we had all grown up and which my father had been responsible for building. I was the master of ceremonies for the event, and there was much singing.

I kept in touch with Dad through visits and telephone calls, as did others in the family. On one phone call, he reported that our daughter Margaret had visited him and that they agreed I was a driven person. I was surprised and very flattered to hear it. I always feel that I am a lazy bum. I love to have people think that I work hard, and I wish I did.

Two years later, we gathered at the bedside of Serge J. Lauper for the last time. He whose life spanned almost the whole of the twentieth century (1901–1994), whose capacity for work and whose devotion to The Church of Jesus Christ of Latter-day Saints and the gospel of Jesus Christ were almost unequalled, was laid to rest. When I once discussed his preference for an epitaph, he suggested a line from a hymn: "Wake up, and do something more!" He was a fortunate man to die in his own room, unattached to machines and unmedicated, surrounded by his family, retaining his faculties to the last, mourned by the friends he had not outlived. At his funeral, all the speakers quoted from the book of his recollections that we had put together.

All this time, I suffered from a recurring depression that caused me to say things like this in my journal:

> Oct. 12, 1991. I lay abed this morning weeping a little, wondering where to go and what to do. The way ahead is dark for me. All I can do is keep doing the things I›m doing which just doesn›t seem like enough. How could I have spent 57 years getting ready and still have missed the boat? I feel completely worthless.

I would eventually make a list and do a few things before slipping back into the doldrums. Here's another example.

> Sept. 23, 1993. I realize that no one in the whole world gives a damn what I do or am. Richard is preoccupied with other things. The children are rightly involved with other things. I decided long ago that I would not kill myself no matter what, just as I would not leave the church no matter what (although, there were times when I thought it might choose to leave me) and I would not get a divorce no matter what.

Some days I couldn't get out of bed. I didn't answer the telephone. One day, an ad in *The New York Times* invited people suffering from depression to volunteer for an experimental study at a nearby hospital. I pulled myself together, called for an interview, and answered the questions. Imagine my state when I was told that I wasn't depressed enough to be accepted. What a failure I was! Not even depressed enough to be considered depressed.

I blamed my left-handedness. We lefties were nature's mistakes, dying young from accidents in an alien world, susceptible to alcoholism, drug dependence, and depression. I was grateful that Mormonism had saved me from some of the worst of that.

Richard sent me to a psychiatrist who put me on the antidepressant drug Fluoxetine, an inexpensive generic Prozac, often prescribed for nervous dogs and cats. I improved immediately and to this day, I am reliant on those pills. For years, I tried to cut my dosage, but it never worked. I now just try to remember to take my daily pill. When I begin to fall apart, Richard sternly inquires whether I have taken my medicine.

I am ashamed of being depressed and left-handed. I am especially ashamed to be a druggie. I am ashamed of being deaf, often unable to understand what is said, even when wearing two very expensive hearing aids. My third area of shame is that I have worked hard, often at things that I liked doing, and have been poorly paid for my efforts. Though I would probably have done those things for free, I still feel undervalued. I wish I had done better, that I had managed greater monetary appreciation. Still, I always do realize my great good fortune to have lived an interesting life to an old age, even as I continue to get lost and can't tell right from left.

Being a depressed left-hander, always in danger of feeling that I was living a worthless life, I am happy to remember that when we were packing up to leave Chapel Hill, a dozen women from the church group came over "for a presentation." Those good sisters sang a hymn to me, "Each Life That Touches Ours for Good." They said they loved me and would miss me. I was very, very touched by this kind gesture.

My Life as a Scholar

A series of events in 1992 was a particularly dizzying sequence of scholarly and family happenings. In May, we drove a truck north from Chapel Hill where we had spent a year at the National Humanities Center, some 1,690 miles to New York City. After depositing our belongings, we drove on to Bar Harbor, Maine, to the wedding of our daughter Margaret and Michael LaBianca. They were married outdoors on the shore of the Ocean Front Mission in the town where Michael's family had long summered. It was a beautiful wedding. Margaret had asked me to write the wedding ceremony which was spoken by the head of the mission there. The family all sang a John Rutter song with a line saying, "Peace of the rushing wave to you." After a reception aboard a boat in the harbor, the newlyweds set off to honeymoon in Italy. We drove back to New York, and the next day we also flew to Italy.

We were headed for a five-week scholarly residence at the very posh Villa Serbelloni in Bellagio, Italy. A dozen or so scholars at a time are chosen from many applicants. The scholars bring their work to this Rockefeller thinktank on Lake Como, near Milan. They stay in beautiful rooms in a large and elegant villa. The scholars gather for meals, programs, and social times, mingling happily, exploring the gorgeous countryside and Italian culture, and enjoying wonderful food, accommodations, and good company. Each scholar also has a study in its own small building on the spacious grounds. Richard and I shared a study on a wooded hill, adjacent to a pond full of tadpoles. Our daughter Margaret and her new husband, on their honeymoon, came to lunch one day.

Following some elusive creative urge, I wrote songs and made crossword puzzles for our evening's activities and farewell parties while we were there. One set of lyrics to "God Bless America," has survived and describes what I believe half of the time.

> What good is scholarship?
> Why write that book?
> No one needs it,
> No one reads it,
> No one knows all the misery it took.
> Years of research,
> Stacks of footnotes,
> Reams of paper,
> Poor reviews!
> What good is scholarship? I sing the blues.
> But I do scholarship. It's what I choose.

We also visited the Italian town of Turin to attend the wedding of Martin Petherick, our son Brick's brother-in-law, and his Italian fiancée, Speronella—a fabulous event. In Turin, we also saw the "Shroud of Turin," possibly a real Christian artifact! What a life!

At the end of this period, I figured that we had lived in five states: New York, Delaware, Massachusetts, California, and North Carolina, as well as abroad. We had also visited in Utah, Maine, Virginia, South Carolina, and Georgia. And unfortunately, we were still trying to sell our house in Delaware.

Over the years, Richard and I did more things together. We taught a course at Columbia one spring. We gave a joint week-long faculty workshop at BYU in the summer. We jointly taught a course on the interpretation of neo-classical furniture at the new Bard Graduate Center for Studies in the Decorative Arts, formed and run by Susan Soros, then the wife of George Soros. We wrote a joint article on Mormon family life for an ecumenical book. Richard was always looking for things for me to do. His book on Refinement won the Old Sturbridge Village prize for the best interpretation of early American history.

Still very much engaged with John Walker, I was thrilled to get a fellowship at the Virginia Center for the Humanities in Charlottesville, Virginia. I had asked the Foundation for three months, two months, or even one month. They called and asked if I could use four months. Hurray! I thought that I might be able to finish up the book the next year if I worked very hard. I was grateful to be acknowledged as a scholar, receiving this grant in a good place to do my research. I could go easily go over to King and Queen County to visit Walker's farms.

I spent my four months at the Center, mixing with the fellows there, very much involved in the life and times of John Walker, and participating in the church scene. It was a cold, icy winter in Virginia. I was snowed in for my first week. I got stuck in the snow, slipped on icy roads, and frequently got lost. I developed a good relationship with the man at the service station, and I managed.

I was on my own for the first time, something I had never been to that date. I did have the Center, which kept me going, and a nice little apartment in a nice neighborhood of Charlottesville, which I soon began to call C'ville. A shop there where The Barber of C'ville plied his scissors made it a special place for me. My one-room cottage, a former garage, was at the home of the widow of a University of Virginia professor. There was a bed with an easy chair and a TV on one side, a kitchen corner with a

My Life as a Scholar

little table, and a bathroom with a shower. I paid Barbara Younger, a most gracious landlady, $250 a month. She invited me to her parties and took me along to many others.

During that time, I also had a week's research time at the Virginia Historical Society in Richmond, Virginia. While there, I ordered up some John Walker papers. The library page, who brought up the papers, remarked that he knew those people. I noted that they had been gone for more than a hundred years, but he said he knew the current generation of Walkers, the descendants of John Walker who were still living at Locust Grove.

The page, Joseph Robertson, later wrote a letter to me saying that he had spoken to his friend, Jerry Walker, with whom he hung out at the King and Queen Volunteer Fire Company. Jerry told Joseph to tell me that he would help me in any way he could and that included a visit to Locust Grove, where Walker was born and a place which he owned, along with Chatham Hill, which Walker owned by the end of his life. Walker was able to bequeath a farm to each of his two sons, Melville and Watson, who were both veterans of the Civil War and named for Methodist divines. The current owner of Locust Grove, Jerry Walker was a bachelor lawyer who commuted to Richmond to work and rented out the farmland, but he lived in the old Walker Locust Grove house with his widowed mother. I met Jerry Walker and his mother, Leticia, dined with them, and visited them several times. I got to know some other people in King and Queen County. During those four months away, Richard and I got together in Virginia, Washington, Manhattan, and for a week, Hawaii. I missed him, but I made friends and had good times, even when he was not there.

Women's issues in the Church were heating up again. Strong messaging was heard that the role of women was motherhood, and that any dissent threatened the Church by destroying testimonies and unity. We heard that the publication of views contrary to the standard message would be punished. Speakers at the Church's general conference gave strong talks about wolves in sheep's clothing.

Some feminists had been excommunicated. I was sure that I was still on various forbidden lists, but I had no agenda to push. I had no interest in demanding greater inclusion and power. There is no winning that fight, and I do not take on causes that I cannot win. I thought and still think that if church power and authority were shared by women, the men would retreat as they have in other churches. The men would stay home on Sundays and watch the ball games. I had obeyed all direct instructions

from leaders, and I was told that although I had done nothing they could quite condemn, that they feared what I might do. I was very flattered to be told that my very presence might arouse a female mob into taking some frightening action.

At meetings with old friends, I surprised myself by my conservative stance. I was in tears once, saying that I did not want to be excommunicated from the Church, that I was not ready to go down on the issue of women's rights. I did not want to spend any capital I might have left, tempting fate or the authorities. Those brethren may say that they forgive you for whatever you did or might have done, but they never forget.

The Relief Society, the Church's female organization, with a long history of initiative and activism, was being carefully watched. Their church-wide leadership was strong and smart, but male church leaders were keeping a lid on the organization. There were hints that the Society had sometimes gone too far, but the leaders remained in office under male supervision. The women were not allowed to write the lessons for their own classes of women. Gradually their weekday meetings, their monthly magazine, their independent activities, even their finances (some that they had raised themselves) were taken away from them. At this writing in 2023, the Relief Society is a Sunday School class that meets for a scant hour every other week, to discuss a talk previously given in the Church's semi-annual general conference by a male priesthood leader. When I was a young mother, the Relief Society had been a powerful organization with a rich program.

Back in New York, a spirited young woman convened some lively women, including me, to meet with the stake president to discuss women's treatment in the Church. The women had a long list of grievances. I suggested that we should present a short list of modest reforms that we might possibly get. But others wanted dramatic action, recognition and discussion about their mother in heaven, a sensitive topic that women are not encouraged to pursue. While the Church officially recognizes such a being, imagination and discussion about her personage is off limits. Several of us met in advance to plan strategy, urging delay in bringing up all the issues and not putting the authorities on the defensive. But at the meeting, the women were aggressively onto the heaviest demands in the first minute, extending their complaints. When the leaders did answer, their remarks were about the order of the Church. One was more willing than the other to think about ways of getting around the limits of church practice and setting up some measurable standards. He wanted the group

Bushman family, c. 1995. Left to right: Brick, Clarissa, Karl, Richard, Claudia, Serge, Margaret, Ben.

to meet again to discuss them. But the women had expended their discontent and the fire had burned out.

I spoke little at the event, but I kept notes of what was said. The stake leaders asked for those which I typed and supplied. But nothing ever came of it. We had aired our complaints and had heard some explanations.

Meanwhile the family multiplied. Each spring for six years we welcomed a new grandchild: Helena, William (now Sloane), Raffy, Ted, Max, and Luke. We had a granddaughter and five grandsons. And in March of 1993, our second granddaughter, Montana Emily Grace, was born to Clarissa and Charles Ortel. Later that year Peter was born to Serge and Patty, and Nadia was born to Karl and Diane the next February. The family was growing by leaps and bounds. Peter's parents, Serge and Patty, had an option on the grandchild for the next spring which they filled with their new daughter, Shelley. This list may well be complete as we have begun the next generation.

Here is a chart of the grandchildren, their births, and their parents, complete as of 2023.

Grandchildren of Richard Lyman and Claudia Lauper Bushman

Name	Parents	Born
Helena Claire	Brick and Harriet	1987
William (Sloane R. V.)	Clarissa and Charles	1988
Richard-Raphael (Raffy)	Brick and Harriet	1989
Ted Spurgeon	Karl and Diane	1990
Christopher Maximilian (Max)	Brick and Harriet	1991
Luke Edward	Karl and Diane	1992
Montana Emily Grace	Clarissa and Charles	1993
Peter Whiting	Serge and Patty	1993
Nadia Pauline	Karl and Diane	1994
Shelley Jean	Serge and Patty	1995
Caroline Elizabeth	Karl and Diane	1995
Reeve Benjamin	Ben and Deborah	1996
Isabella	Brick and Harriet	1996; d.1996
Claudia Dora	Margaret and Michael	1997
Gwyneth Ann	Ben and Deborah	1998
Suzanne Claudia (Suzy)	Karl and Diane	1998
Frances Hildegarde	Margaret and Michael	2002
Elizabeth Leantonia (Libby)	Margaret and Michael	2004
Ayden Edwin Leo	Ben and Erika	2005
Benjamin Asher	Ben and Erika	2008

We also have four great-grandchildren, Margaret Clarissa Davina and James Richard Montague Woodhouse, the two children born to Helena and Jack Woodhouse, and Hazel Autumn and Griffin Cloud Conkling born to Nadia and Ximmer Conkling.

We sing the Alphabet Song listing the grandchildren in their order. Inclusion requires adding more names to the last line as new grandchildren and the greats are born. It currently goes like this:

> Helena, Sloaney, Raffy, Ted,
> Max, Luke, Montana, Peter, heart of lead.
> Nadia, Shelley, Caroline, Reeve;
> Isabella, Claudia, Gwyneth, I believe,
> Suzy, Frances, Libby—Ayden, Asher, too,
> Margaret, Hazel, James, 'n' Grif complete our crew.

The intriguing "heart of lead" was added in the early days of this song by Peter to make the lines rhyme. Any deeper meaning is now lost.

The children moved on. Clarissa was dancing again after the birth of Montana, aiming to be impressive at her fifteenth Harvard University reunion. Charles had begun his own company, Chart Capital, and was working on nineteen deals.

We visited Brick and Harriet and their beautiful blond children in Saudi Arabia where he was managing the investments of a Saudi prince. We had a fabulous time in the magical desert, sampling their civilized, international life. We went on to visit Egypt.

Karl, nearing the end of his medical education, began real practice in Pittsburgh—with a whopping debt of $80,000 to be repaid from a practice which paid about that much a year. They bought their first house.

Margaret was named as full-time news editor for the upstate New York newspaper *The Columbia Independent*, where she had been a part-time reporter. She and Michael celebrated their first anniversary and his twenty-eighth birthday by moving to a small lakeside house that came with two small boats. She began to think of law school.

Serge passed the first of three parts of the demanding CFA (Chartered Financial Analyst) exam. He was studying Russian, hoping to work in Russia. He had married Patricia Shelley and graduated from the Harvard Business School. On a tip from Brick, he called on a financier opening a bank to lend American money to Russian businesses. Hired on the spot, he and Patty were in Moscow within a month.

Ben, called on a church mission to Japan after his freshman year, moved back in with us after his return. He sang with an octet and stroked Columbia's varsity crew. Near the end of his school years, he and Deborah Norton, a pretty redhead with a beautiful singing voice, announced their engagement. Offered a job in the management consulting division of Price Waterhouse, Ben began work soon after the wedding. They produced two children, Reeve and Gwyneth.

On the day after our thirty-ninth anniversary (August 20, 1994), I could look back on many happy years. Few women had it as good as I did. In New York, we realized that we were at the center of the universe. Our family came from the ends of the earth to see us. Ben and Clarissa still lived in town, and Margaret frequently visited. Karl and Diane were game about traveling to what their son Ted called "Granny's World." Within a two-week period in October, we had Brick, Raffy, Serge, Patty, and Peter as visitors. While these last were in town we had a dinner/cabaret for about

fifty people in the style of the Cabaret Colonade which Serge and Patty used to host. All those performing at this festive event, including Patty, the Porkchops, and Ben's wife, Deborah, sang New York songs.

> On this day, June 1, 1994, I walked in the park, weeded, fed the pigeons and squirrels, and picked up trash. Back home, I washed and was ready for the day. Would that I always did as well. In two weeks, I would be sixty years old. Why had I nothing more to show for my life? I might have another twenty good years. I decided to try to be cheerful and charming. I would work on Walker material, prepare for classes, and advise students. I would keep trying.

–18–
Four Projects

My mother, Jean Gordon Lauper, was a master at projects. She was always getting an inspiration for something she could do. Her projects were mostly musical. She planned, directed, and conducted a musical every summer for the young people in our church when my sisters and I were teenagers. She took her ladies choruses to sing at The World's Fair and the opening of Cinerama. When in the throes of conceiving, planning, and preparing for one of these events, she was brilliant, inspired, and unstoppable. I am very grateful to be the recipient of this inheritance. I love to think up and do projects. I do lots of them. Here are some.

The Living Nativity Scene

Our New York City Latter-day Saint congregation meets on the third floor of what looks like an office building on Columbus Avenue where it intersects with Broadway, across the street from Lincoln Center. Thousands of people traverse these busy streets every day.

I was sitting in our third-floor chapel some years back, attending the annual Christmas program, a gathering of such talent and charm that I wished people on the streets below could see it. I thought of the remarkable people in our congregation, our beautiful young couples with their beautiful little children. I doubted that any other city congregation had such attractive young families. I thought that our families and our location were certainly among our greatest riches and wondered how we could use those to advantage. I came up with the idea of doing a living nativity display.

The next day at church I approached the laconic artist and set designer, Doug Ellis. I don't think we had ever exchanged a word. I asked him to come down to our first-floor lobby to talk about an idea I had. I suggested placing a set for a living nativity show in a front corner, to be seen from the front and side windows and from inside the lobby. I said that we could use our own real families, with their own beautiful babies in a nativity setting as a living Christmas card for our neighbors and people passing by. We could show that this anonymous building was a church. I asked him what he thought.

He, speaking for the first time, improved on the idea. He suggested reorienting the setting to another lobby location and described an elabo-

rate stable with a raked stage and space for shepherds and a view through a stone-arched window of Bethlehem with twinkling stars. He said that he would do the set. This was already the first week of December. By the end of church that day, he had given me a sketch.

That afternoon I met with our congregational leaders about a new church assignment I had been asked to do. While there I described the living nativity that Doug and I were planning. The bishop offered help. Did we need any money? This was an austere time and there was no extra money to be used on such activities, but he said that it was the end of the year and not all pots of money had been depleted. He suggested that I write a letter describing the project and asking for a church contribution. I asked him how much I should ask for. He said to ask for $500. I was amazed! Thrilled! I wrote the letter, the bishop checked on unspent funds, and the next time that I saw him, he said that he had found $600. I asked Doug if he could do the set for $600. He said no, but he would do it anyway.

We had already come so far that we decided to open the show that very year, within three weeks. I began to recruit families to be on the set for an hour at a time. We would have our living vision two hours each night and all-day Saturday and Sunday. I found a designer who went with me to the costume institute where many years' worth of Broadway costumes were available for non-profit groups to borrow. We got our very beautiful costumes there for the first two years. But we had to pay cleaning fees each year by the pound, and since we had chosen many long, heavy robes, the costs mounted quickly. The next year my daughter-in-law made a set of simple earth-toned robes for the men and gowns in red and blue for Mary. They disappeared one year. So, she made another set. We eventually amassed quite a few nice pieces and were always surprised by the ingenious combinations that our families put together from the racks.

Doug borrowed a big garage in Brooklyn and began to construct a set. He built it strong and to last, in portable pieces, working on it as he could. When he completed the construction, he called in his artistic friends to paint the set. They turned out a very beautiful, sturdy, large "stone" stable. He built a little manger. I got some hay. He set up the blue curtain in the window for the night sky with a light behind it for stars. I gathered baskets, boxes, skins, textiles, and other items to dress the set.

I spent my December evenings at the manger in those years. Our young families would arrive red-cheeked in their hats, boots, and parkas, bringing their babies in snowsuits and backpacks. They would go upstairs

and assemble outfits from the gowns, robes, and shawls that I had gathered and then return as timeless Holy Families. A miracle. Mothers could recall the grand truth that each of their beautiful babies had briefly been The One.

I thought our little nativity was the best that I had seen, entirely because our living babies were the focus, worked with by real families. Sometimes they cried. Occasionally, they slept. Visitors could come in and sit on benches, but mostly they gathered outside the windows. Our families, sometimes exquisite and sometimes amusing, were always interesting.

There were times when the Holy Family wore wristwatches, eyeglasses, and gold-toed socks. On occasion, little Jesus wore earrings and barrettes. We took girls as well as boys, until they could crawl. We had several sets of twins which we billed as visits from Cousin John the Baptist. Pacifiers, baby bottles, and nursing were not allowed on the set, but they all appeared from time to time. Young missionaries portrayed handsome and earnest shepherds, but when bored, they played hockey with their shepherds' crooks, did dance steps, and clowned around. Sometimes the Holy Families, in their timeless zone, waved to visiting friends. But all that was okay with me. What we were doing was folk art.

About three hundred people stopped at our windows each hour. People were surprised that Mormons cared about Jesus Christ. Some wept or crossed themselves. Some called the Church with queries. Some gave gifts to the Christ Child. Spending Christmas at the stable was wonderful for me. I spent Christmas and much of December at the manger in those years, the best Christmases of my life.

We tried some other things: the three kings (in wonderful costumes) traversing the streets, following the star. They would arrive and worship. One night, as they paraded through Barnes and Noble, the local bookstore, the clerks called security. But mostly, we did not do action. We did stasis. The family was not to see people watching them. They were alone in their own world. Many very beautiful Christmas pictures were taken to appear as cards. When it was dark outside, our jewel-like scene was easily seen on two sides through big windows. Sometimes people came in. More often, they would stay at the window for a long time. Sometimes they offered money, cried, or thanked us.

I have particularly warm feelings for all the families who occupied that little stage over the years. They remain beautiful Holy Families to me.

One of my favorite stories concerned our generous bishop. Both his counselors, with their wives, had babies and were recruited for our little

show. The bishop and his wife, with no children, were considering adoption. Three weeks into December they had a call from LDS social services. The agency had a baby for them, even though the family had not yet filed papers. The bishop, his wife, and their new daughter became a Holy Family that first year.

After some years, the church remodeled the lobby, eliminating the front window view. Doug repurposed the set to be seen from the new side windows, which proved an even better position. After the holidays, the set was taken apart and stored in church buildings some miles north.

One year, Doug went to Westchester to get the set and found it gone: no set, no costumes, no props. We feared that this excellent sturdy, permanent structure and our boxes full of good stuff had been discarded, lost forever. In some ways I was relieved, but mostly I was sorrowful.

But the nativity set reappeared. By some Christmas miracle it had been translated from Westchester to New Jersey. By then, December was half over, and I suggested to Doug that we skip it for the year. But he wanted to go on. I made the calls, and we opened on time.

I justified this project because it put Christ and the Christmas story into the center of many lives, reminding them that Jesus was once a little child. The scene said that this was a Christian church. The project made much of our greatest assets, our location, our beautiful families, and Doug's great abilities.

After years of Christmas nativity shows, the building was remodeled, and the excellent window views disappeared. The building later incorporated the Manhattan New York Temple. The space is unrecognizable today. The set was bundled off to Scarsdale, or Union Square, or New Jersey, or somewhere else. The costumes appear from time to time in some program or another. It's over. But once it was Bethlehem.

Manhattan New York Temple Youth Jubilee

In 2003, as new Mormon temples were dedicated, they were accompanied by add-on activities called youth jubilees. Large and colorful events in Brazil and Ghana, in Anchorage and Copenhagen, heralded new temple commemorations. These were a direct result of a comment by Church President Gordon B. Hinckley. He wanted the building of temples to be associated with a particular kind of celebration: a jubilee for the young. He said he wanted "the youth to remember this the rest of their lives." The emphasis was on large events with many young people celebrating an ethnic heritage.

Richard and I were both members of the Manhattan New York Temple committee, involved in making plans for the dedication of the temple. I was out of town and missed the meeting when visiting officials told our committee that New York should have a jubilee. When the new program was announced to the Manhattan New York Temple committee, chairman Brent J. Belnap exclaimed, "This project has Claudia Bushman's fingerprints all over it." When I got back to town, he asked me to make some preliminary plans, and I was happy and excited to do it. The people in New York were certainly willing to undertake a large program, one that would involve all the young people of the temple area's fourteen stakes and districts. But to find a large enough venue in this expensive city was a challenge. One after another, public places were considered and dismissed as too costly.

At this point, President David Checketts of the Yorktown Stake suggested that Radio City Music Hall, which describes itself as the largest theater in the world, might be available. Checketts had a long history with RCMH as manager of Madison Square Garden. With its huge stage, the RCMH could handle our hundreds of young people. We still had no budget, but the project began to move forward.

Conceiving of a show that could be produced given the area's huge numbers of young people—more than 2,500—many far distant from the performance site, with only the day of the show available for rehearsal, was a challenge. Then there was the lack of stage experience of our young people and our lack of funds. Every difficulty was insuperable. How could we manage? It was decided that program segments would be created, produced, and rehearsed locally, for the convenience of local people. We divided our huge group into six segments and gave each of them a theme—Pioneer, Harlem, Broadway, Asian, European, Latin—which they were to interpret in whatever ethnic, stylistic, or historically diverse manner they chose.

The overall aim was that every young person possible be involved in the show and have a good experience. New recruits would be enlisted until the end. Young people not willing to be on the stage could still attend and sit in the audience with their groups for other parts of the show. All participants and leaders would be issued t-shirts with the show's logo, "A Standard for the Nations." These shirts were furnished to all the young participants and their leaders, each group with a different color, to be used as costumes. Some groups also managed pretty elegant costumes tailored to fit their themes.

These six, eight-minute, locally created segments made up the bulk of the show. All the leaders met weekly on a mass telephone call to discuss problems and make reports. The director, a theatrical professional, traveled from one group to another, making much of each show's virtues and suggesting improvements. To him goes the credit for a cohesive and fast-paced show. To keep us on time, we recorded the whole show and performed to the sound track. It would cost us extra money if we went over time.

Pioneers was the segment staged by Morristown and Caldwell New Jersey Stakes and the Paterson New Jersey district. This show told the story of the trek across the plains with song and dance, morphing into the message that our young people today are pioneers just as their ancestors were. The moment when the young men, dressed as contemporary missionaries, came forward was met with fervent applause.

The segment dealing with European immigrants, through their varied dances, was performed by Plainview New York Stake and Lynbrook New York District. These beautifully costumed dances, with their authentic steps and music, struck many ethnic tones, from the sailors' hornpipe of the British Isles to the flamenco flavor of Spain.

The Harlem segment was performed by the New York and Brooklyn Stakes. Using music recorded by Gladys Knight and her gospel choir based in Las Vegas, the Harlem group's choreography reminded the audience of their colorful locals.

The Latin group, featuring the New Jersey stakes of Scotch Plains and East Brunswick, was the largest in the show with more than six hundredd performers. Dancers demonstrated a number of Latin dances as well as put on a full-scale fiesta accompanied by a large drum band.

Asia, the segment produced by Queens New York West and Richmond Hill New York Districts, was colorful and lively. Beginning with an Asian version of "High on a Mountain Top," the group performed dances from China, Japan, Korea, India, and Samoa. Dances were punctuated with appearances by a sinuous, thirty-foot-long dragon manned by a dozen young people and four large and small lions doing tricks.

The concluding segment was Broadway, a pastiche of many catchy show tunes, featuring young people from Newburgh, Westchester, and Yorktown Stakes. This segment featured a specially produced soundtrack morphing from one show to another. The young people went from "Oklahoma" to "West Side Story," from "Bye Bye Birdie" to "42nd Street."

I especially liked the transition from "O K L A H O M A / to that spells Dallas, my darling, darling Dallas."

The show began and ended with a Primary chorus which sang songs about light as all the young people in the orchestra seats flashed small lights to show the powerful symbolism of light in a dark world. We follow the light. We become the light for others. The hall was full of these bright pin-points.

The segments were laced together by video interviews with the young people and shots of them practicing, historical vignettes about the past years of the Church in New York, and interviews with three of the Church's Twelve Apostles who had lived in the area: Elders Henry B. Eyring, who grew up in New Jersey; Robert D. Hales, who grew up on Long Island; and L. Tom Perry, who lived with his family in Connecticut during much of his working life. These video bridges greatly enriched the program while also providing a chance for the large casts to get on and off the stage, a real problem in this old theater. People marveled at the smooth transitions between the huge groups.

Because of the New York location, the jubilee was able to enlist the talents of many area professionals. Don Gilmore, who produces Broadway shows and has great familiarity with local venues and workers, was the production manager. He planned the production, ordered necessary equipment, hired workers, negotiated with Radio City Music Hall, and generally made it happen. He is the one who warned us early that "show business is not for the faint of heart . . . and it will, at some horrible moment, all seem impossible. Then we'll get through it and it will be wonderful. . . . But it is all so worth it. . . . The really good thing about THIS show is it IS important—not just some fluffy commercial venture—we will help people touch other people's lives—nothing can beat that!" His paragraph became our mantra. The professionals at RCMH could not believe that we could even attempt such an ambitious and complicated show with volunteers. Don was joined on our team by prize-winning lighting designer Brad Nelson, who made everyone look wonderful.

Because the hall was not large enough for everyone who wanted to attend, we broadcast it to all nearby church buildings with satellite dishes. Jubilee participants were very fortunate when Andy Rosenberg, a prize-winning sports broadcaster, signed on to direct the broadcast that went to Salt Lake, then up to the satellite, and down to all of the Manhattan Temple district. Andy arranged that we would have boom cameras—on the stage to give shots of the depth of the choreography—and other cam-

eras around the hall so that the show and people could be seen from many vantage points. Andy and Scott Tiffany edited the final video film, copies of which were then distributed to all participants.

When the performance day actually came, the marquee outside of RCMH proudly stated "Youth Jubilee Church of Jesus Christ of Latter-day Saints Manhattan Mormon Temple A Standard for the Nations." As people arrived at the hall, they cheered at this sign. President Hinckley, when he arrived, read the marquee and mentioned it several times in later talks. To him it was a sign that the Mormons had arrived in this city.

Many of the young people in the show left home at 6:00 or 7:00 a.m. on performance day. Those from southern New Jersey, from far out Long Island, from far north in Newburgh, had to board buses from their stake centers very early to make it to Manhattan. Then they waited in long lines to be checked in by name from lists the leaders had provided. This took so long that the security people finally approved participants in their t-shirts. Just getting people inside was a big job.

Groups that lived closer, arrived earlier. The Harlem and Asian segment people arrived about 10:00 a.m. and had the chance to run through their eight-minute shows a couple of times. The Young Single Adult chorus, more than three hundred strong, also came early to get their sound levels set. They would sing for the fireside portion of the program. Many of them stayed around to help with various chores. From noon to 1:00 p.m., other cast members streamed through the doors, finding their places to sit, excited about their debut on one of the world's great stages.

At 1:00 p.m., the last groups took their turns on the stage, and at about 2:00 p.m., Director Erik Orton, ever cool and in control, with a baseball hat, a bullhorn, and a microphone in one ear, began the first and only complete run-through the show was to have. It looked like a first run-through.

At 3:30 p.m., all rehearsal was suspended as the house opened to ticket holders. A group of young adults and other volunteers passed around a healthy snack to raise the energies of the players, and at 4:30 p.m., the show began. President David Checketts served as master of ceremonies, welcoming all to the hall, introducing important guests. He was followed by the Primary chorus and then the whole show. All went admirably and according to plan. One Pioneer segment leader noted that she was in awe at what she saw. She had never seen "the lines so straight, the steps so perfect, the energy so high, and everyone singing, every worrisome spot performed without error. But oh, when the missionaries came forward!

We had had adults crying during rehearsal at that part, but nothing could have matched the power of that image on the Radio City stage of this new generation of Pioneers!" The audience was transfixed. One observer was astounded. He kept saying things like, "I can't believe how much time and effort everyone must have put into this! I can't believe there are so many people willing to give that much time!" It was the perfect LDS project, everyone consecrating talents to produce an admirable whole.

When the curtain came down on the jubilee, there was a full hour of break. The young adults passed around box lunches to all the people on the ground floor, completing the full distribution in eight minutes. The group ate the lunches about that quickly too. President Hinckley left the hall to rest before his talk at the fireside. As he left the hall, he was heard to say, over and over again, "stupendous, wonderful, absolutely wonderful" as he exited.

The fireside at 7:00 p.m. featured the choir and several speakers. Elder David R. Stone, of the North America Northeast Area Presidency, conducted. He and his wife, Rosalie Stone, later spoke, as did Elder Robert D. Hales of the Quorum of the Twelve and his wife, Mary C. Hales. The final speaker was President Gordon B. Hinckley, who was greeted with cheers and applause. He admonished the young people to save that for later, that this was a church meeting, and they did. When it was all over, the groups followed their leaders out to the buses. All tired, happy, and exhilarated, they agreed that they would never forget their debut in Radio City Music Hall.

When this show was finally successfully concluded, if it was asked of me, I would gladly have crawled to Nauvoo on my knees.

The Joseph Smith Statue

We anticipated the 200th anniversary of the birth of Joseph Smith, first prophet of The Church of Jesus Christ of Latter-day Saints, on December 23, 2005. This was a very important milestone in our family as my husband Richard was writing a biography of Smith, aiming to get it to the publisher and printer to be out for the anniversary. Richard worked for seven years on this lengthy biography, retiring from teaching at Columbia so that he could complete it.

Our little history committee, formed to answer President Brent Belnap's call to write a stake history, was very much aware of the occasion. Our job was to celebrate such things. What should we do? From somewhere came the idea that we should think about a statue. One of our

members was going to Salt Lake City with his wife, who was running a marathon. Because I am of the old school who thinks twice before calling long-distance, I asked him, seeing as he would be out there, whether he could find out how much a life-sized statue of Joseph Smith would cost us, just in case we could raise the money for such a thing and find a place to put it.

When he came back, he reported that the cost would be more than $350,000, but that the artist and his friends were going to give it to us. They would contribute the statue. Really! That seemed a pretty good sign that we should try to put a statue of Joseph in New York. Joseph Smith had visited New York City himself in 1832, traveling with Bishop Newel K. Whitney who was purchasing stock for his dry goods store in Kirtland, Ohio. Smith wrote to his wife Emma that "the inequity of the people [was] printed in every countinance." Only their clothing made them look "fair and beautiful." He walked through the best part of the city and noted that "the buildings are truly great and wonderful, to the astonishing of every beholder." Smith had had the New York experience.

So, where to put our statue? Church property was judged off limits to avoid any suspicion that we worshiped graven images. The city nixed any idea of a gift. New York already had more statues than the Metropolitan Museum of Art, and every statue requires maintenance and is a headache to them. I learned a lot about city politics and agencies. New York City did have a program, however, where statues could be placed in the city temporarily: The Temporary Public Outdoor Art program. I began to pursue that, putting together an application with letters of support, pictures, and maps. I requested a place in a landscaped strip in the middle of Broadway, just across from our chapel. The Church supports the landscaping there. I thought that the Frontier Prophet would look wonderful under a small tree by the grate over the subway, near the intersection at Sixty-Fifth Street. I saw echoes of the rural life and the sacred grove.

But the agency turned down that request and my second one. They did not want statues on Broadway, although there have been many statues and artworks there since. But we were offered a different site near Wall Street, near the site of the Pearl Street boarding house where Smith had stayed in the city. It was near the site from which the ship *Brooklyn* had departed in 1846, where we had already installed a commemorative plaque. I said that that location would be perfect. Dee Jay Bawden began to sculpt a brand-new eight-foot "Frontier Prophet" for us.

Four Projects

Every square foot of space in New York City is contested space. Fourteen agencies claimed some jurisdiction over our location—a small, landscaped cement island among skyscrapers, beneath which the subway churned along. The agencies with jurisdiction included the police, the fire department, the parks department, the Downtown Alliance, the Department of Citywide Administrative Services, NYC Transit Authority, and others. We soon had the permission of the Parks Department and the city. But NYC Transit kept calling for more and better maps, finally to the inch, of the location we wanted. They needed detailed information on installation. How would the statue be secured? What kind of heavy equipment was required? What training and licenses did the installers have? What was the formula for the adhesive? How much would the statue weigh? I submitted answers for these questions and many, many more.

Next, I approached Community Board No. 1, the citizens' advisory group that oversees land use. We went before their Art and Entertainment Committee. The group eventually approved our petition, but just barely and not enthusiastically. They wanted upbeat art after 9/11. Why a representative of one religion? Why not on our own land? Who was Joseph Smith? Our request eventually passed. Next, we went to the full community board. As we had been approved by Art and Entertainment, I thought that our proposal would pass easily. I did not pressure Mormons to attend that meeting, as I had the previous one. Our proposal was the last thing on the agenda—after three hours of talks, presentations, discussions, comments, and other business. The group was tired, offhandedly approving everything that came before them, until, that is, the chairman presented a proposal for a temporary statue of Joseph Smith. Then the crowd was fully engaged. One man said that Joseph Smith was in no way worthy of a statue of any kind. Another said the Church was founded on fake miracles. Other negative comments followed. One man finally said that he knew little of the Church or its people but that he would rather give them the benefit of the doubt than vote them down like a bigot. The chair gaveled the unruly meeting quiet and called for a vote. The vote was eighteen to seven against the proposal, with four abstentions.

The incident was very painful. How should we respond? A newspaper reporter called me the next day, saying he found it remarkable that the board had overruled its own committee. He wrote a nice piece in his paper. Another man told me that the vote had been illegitimate, that the committee could only vote on artistic quality, not on the beliefs of the installing group. He said we should get a lawyer and fight the action. I

certainly would not do that, but I wrote all this up and sent it out to all involved. A few days later the parks administrator called to say that they had decided that the project had already come a long way and should proceed.

There were many other complications, contracts, and demands. The hardest thing was the race against time. We had to dedicate the statue on December 23, the 200th anniversary of Joseph Smith's birth. $4,000 for a security deposit and an insurance of $3 million had to be in place. The Mormon Historic Sites Foundation, a nonprofit foundation, was willing to be our legal sponsor and supply the funds, but there were procedural delays. The people in Provo were on edge, wanting to know if they should buy $2,000 worth of airplane tickets to come see Smith installed. Smith himself would travel out in a pickup truck. We told all to carry on! Mighty faith was required, but all was completed on time.

On the appointed day, a group of strong men lifted the bronze prophet from the truck's bed and put him down in the proper place, maneuvering a little this way and that until all present were satisfied. Then he was tipped up so that the four brass flanges on the base were visible. One man spread the adhesive on the bottom of each flange—the statue was raised and installed in the blink of an eye. The representative from the city's Arts Council said she had never seen such an efficient operation.

Sculptor Dee Jay Bawden said the occasion called for some music. He pulled out his harmonica and skillfully played a rendition of "We Thank Thee, O God, for a Prophet." It was a magical moment. Joseph Smith took up his residence at Old Slip. It was thrilling. We had a wonderful dedication ceremony and church members began to make the pilgrimage to Old Slip to see their long-fallen hero.

But there were more problems down the line. We had made the strong effort to present Joseph Smith as an important New York historical figure. We had downplayed religious aspects on the explanatory legend that identified him, that had been cast with and attached to the statue itself. Every word had been carefully chosen. The legend itself was at ground level and required stooping to read. I had been over the draft so many times that I did not even check it at arrival. It turned out that an additional sentence had crept in, noting how Joseph Smith had been visited by God the Father and his son, Jesus Christ. This sentence was added by some ardent believer after the copy left our hands. Someone visiting the statue actually read the label and complained to the city about this religious intrusion to a secular program. I got an angry and tearful phone call from the woman I had worked with at the Parks Department. She said she had trusted me. She

gave us the option of getting rid of the statue or the offending sentence *right now*! I made some phone calls, and we had a maintenance man from a nearby building come over and burn off the offending sentence. We had to deface our own statue. People began to call and report that someone had vandalized our statue. This was all very painful, but Smith had been duly installed and dedicated, and he held the ground at Old Slip for six months. After that he came down and disappeared. I expect that he was melted down to morph into some other statue.

The Harlem Bridge Builders

For several years in New York City, I chaired the Harlem Bridge Building Committee. The use of "Bridge" here is metaphorical, meaning the creation of new human connections. A map of Manhattan shows that my neighborhood, Morningside Heights, with Grant's Tomb, St. John the Divine Cathedral, and Columbia University, sometimes called the Acropolis of the Metropolis, is immediately adjacent to Harlem. But if you visited the area, you would notice that Morningside Heights is on a hill, and Harlem is down in a valley. A person can easily walk from my place on 118th Street to 125th Street on seven short blocks north and be on Harlem's main thoroughfare. It's almost all downhill. We are very close, but the two places are geographically and culturally divided. Six more blocks east or so now take you to the Harlem Chapel of The Church of Jesus Christ of Latter-day Saints. But that building came to be only after a long effort in which I played a part.

When Richard and I first moved to the city in 1989, we would visit an LDS woman in Harlem, where our rare white faces were viewed with suspicion. But Harlem is now increasingly racially mixed and gentrified. Attractive and inexpensive housing has been snapped up by people who would not have set foot in the district a couple of decades before. National chain stores have moved in. Prices have gone up. Local residents have felt invaded. Columbia University has expanded into Harlem, creating their Manhattanville Campus with several handsome new buildings and more to come. The Mormons have moved in, too.

Some years back, a small group of Black and white Latter-day Saints began to meet in Harlem at Sylvia's soul food restaurant. Sylvia's son was a church member. Later, a tiny old Kingdom Hall was purchased from the Jehovah Witnesses to accommodate the growing number of members. The members were glad to have their own little place, but Salt Lake City heard the repeated pleas of the crowded Harlem Saints and purchased a

big, old, rickety, actually condemned building on Lenox Avenue, adjacent to our current building. The plan was to knock down the old structure and erect a new five-story chapel. The construction of a new chapel promised respectability for our little band, even as it threatened old-time residents.

When church officials applied for permits to tear down the building, they discovered that a resident in the building was still using electricity—a squatter. He was there illegally, but he refused to leave. I was told that he had refused a check for $40,000, though he would have accepted small, unmarked bills in a paper bag, under the table. Church leaders staked out the building, and when he left one day, they locked him out. They meant to move out all his possessions, but the word was that the building was so much in danger of immediate collapse, and so they were afraid to enter. The squatter was not allowed back in. The building was soon flattened and destroyed. The squatter complained to the politicians and to the press, and he got a lot of dramatic attention.

In New York, even squatters are considered to have rights, and public opinion was against that rich church of tall, blond, smiling young men from Idaho. Politicians spoke out. Newspapers wrote editorials. The Mormons stood condemned. Harlem people felt that the squatter had more right to be there than did that LDS Church that was full of evil interlopers. The politicians were up in arms about our high-handed behavior. The squatter picketed the building site, which was his destroyed home, and the LDS stake center in mid-town Manhattan. He wrote furious letters to the president of the United States. When the stake president presented plans for the new building at the community board meeting, he was heckled.

At this point, I was called to chair a new committee: the Harlem Bridge Builders, which was a group created to build human connections to the Harlem community. I was currently in a pleasant, easy church position as counselor to the president of the stake Relief Society. I assisted the woman who supervised several congregational women's groups, all of which were full of capable women. We visited local units, put on special multi-congregational events, gave talks, taught classes, and had a good time working together. My new assignment was to gather a group of good church members, to go into Harlem, and to make friends. Great. I go from a job where I cannot fail to one where I cannot succeed. Who would want to be friends with us?

Nevertheless, we gathered a good group of our church members. I was the chair and Richard came along as a backup supporter. It was an exhila-

rating time. We were working on the boundaries of the Church, the real cutting edge. We had a few Harlem Ward members and Herbert Steed, the dapper Black counselor in the bishopric. He got himself named to the community board, one of our great, great successes. He also got himself kicked off for non-attendance. Win some, lose some. We had some social workers who pushed the Church's Family Home Evening program hard for a while. We had Agnes Martinez and Elena Nieves, very talented Hispanic members, and Delores Zecca, an eighty-year-old Black convert who made her way around with a walker and an electric wheelchair. She was the best politically connected person in our stake. We had some colorblind couples, some interested singles—Black and white.

We already had one ongoing annual activity in Harlem. We manned a booth at a big street fair during Harlem Days where we provided free genealogical information, giving out computer discs with information from the Freedman's Bank, a post-Civil War financial institution for Black depositors with names and family relationships. We were known for providing this service and many people appreciated it. What else should we do?

We eventually saw our mandate was to make friends with the politicians, with the neighborhood agencies, and with the ministry. The first was the easiest. We made appointments and called on politicians, telling them what we stood for, what we were doing and saying how we hoped to be good neighbors. We began to furnish drinks and cookies for annual events. We were later asked to see if we could contribute Christmas gifts to children. Our committee solicited help from the Harlem ward and then other wards for gifts. We solicited funds from our wealthy LDS members to provide working capital for us.

We joined neighborhood groups, attending local meetings of the community boards, the police, fire, and Salvation Army groups, and our local neighborhood agencies. The rule was that we should go early enough to have a meaningful conversation with someone. Who are you? What are you doing? Do you need any help? We tried to be helpful. Our people signed up for courses and committees. They were honored by the agencies. When the agencies needed something, they often asked if we could help, and we tried to do so.

One of the great pleasures of the Bridge Builders was getting to know Ralph Acosta, the mayor of the block that both our old and new church buildings were located on. Ralph Acosta was a convert to the Church. He had been sitting on a chair in front of his apartment, monitoring the neighborhood, when a woman went by that he liked the look of. She was

an LDS missionary, and she invited him to church, then meeting in the modest, old Kingdom Hall. He came and stuck. He was the acknowledged leader of the block, always hatching big plans. I could usually get him a little money to help. He and I spent a lot of time planning block parties.

Ralph had many health problems, and he died a couple of years into our committee work. His funeral was held in our sorry little old chapel and, suitably, it was an event to die for. The place was jammed with his family and friends. Ralph was buried in the good brown suit and the white hat he always wore while patrolling the neighborhood. The RAC gospel singers, the initials standing for Recovering Addicts Choir, came to perform in their brilliant red and yellow gowns, and they were unbelievably terrific. The place really rocked. Ralph's large family, who lived somewhere else, attended. Who knew that he was even married? His granddaughters did an interpretative dance. Everyone wept copious, noisy tears. Our kindly white Mormons, conducting and speaking, were certainly colorless by comparison. The funeral was written up in *The New York Times* with a colored picture. We really missed Ralph, our best connection to the real Harlem world.

We tried to add a big new project or event every year, learning things as we went. We smoked out distrust when we could and had some shocking and memorable adventures. Once we were invited to a meeting of young Black entrepreneurs to give a genealogical demonstration.

When the leader of the meeting announced that the Mormons would be in that back room talking about genealogy, a good-looking, well-dressed Black woman raised her hand to ask, "Isn't having the Mormons here like inviting in the Ku Klux Klan?" As the meeting proceeded, the woman went to a computer in the building and printed out some two hundred copies of negative sentiments about Black people from nineteenth-century Mormon leaders. She distributed these handouts to all in attendance. People came into our demonstration to see how we were responding. But we were cheerful and unfazed.

Another time I talked to a local person about a political information meeting he was planning. I asked if he needed any help. He wondered if I could get a sound system. I said I could and supplied it from one of our theatrical people. The meeting itself was a fizzle; no politicians showed up. On our way out, an angry woman told us that she would do whatever she could "to keep the Mormons out of Harlem." She didn't want any more "Jesus people." She said that "your founder was an embarrassment." All very shocking, but useful to hear.

The hardest group to reach was the local ministry. Harlem has lots and lots of little household, storefront churches, maybe a dozen in our single block. These people make their livings off their little congregations. They are certainly not interested in befriending people from that racist Utah megachurch with the bottomless resources. We sent letters and invitations, but even trying to assemble a list of the local churches and their ministers upset many people. We learned a lot of things.

For a time, while our new church was rising, Harlem had great hopes for our five-story building, that it would be a community center for the neighbors. Members of our congregation, hoping to make friends, had promised access. Would we not have basketball standards? People discussed and lusted after our facilities. Once, after I had shown a group through the unfinished building, I was asked by a visitor to show her the swimming pool. She refused to believe my repeated denials, sure that the pool was there. I finally took her over to the unfinished baptismal font and noted that it was only for very small swimmers. The bishop eventually set up guidelines that the building could be used by friends of members if it was not being used for church events and the sponsoring friend was there. Much was desired of us which we did not deliver. We did not set up a nursery school in the building. We did not have a formal tutoring program. I tried to get concessions out of the city. They wanted concessions from us.

But we had our successes. The NAG, or Neighborhood Advisory Group, that I regularly attended, which had put up with me for a couple of years, specially praised the sweet potato dish I had brought for their Christmas party. We finally felt like real members of that group. I was grateful for anything positive.

The politicians caught on fast, and they became very supportive. They came to our events and we went to theirs. Scott Stringer, a local political leader, wrote a letter in support of the Joseph Smith statue we erected in downtown Manhattan. Some of the politicians, even some who had been very virulent against us, began to welcome us and to attend our special events. But then they're politicians.

One of our greatest successes was offering help to those researching their genealogy. We gave out many copies of the computer disc with instructions of how to use it. Our genealogists would give practical sessions on finding your ancestors. We organized several large conferences with good speakers, well attended by local people.

At one of our conferences we had a guest speaker, a Black geneticist from Ohio who badly wanted a good sample of Harlem DNA. He brought out his four-man crew of lab workers, and we were able to offer free DNA tests to all who attended. Rick Kittles, the lively showman from Ohio who made the arcane topic of DNA interesting and intelligible, was charming and entertaining. His workers put in a solid day, testing large crowds of people. We had hoped and prayed that we would have a good enough Harlem sample of people to justify his team's travel, and we certainly did. And Rick's presence and his featured spot on "African American Lives" meant that we had CBS news with us all day, filming and recording the whole program, talking to people, taking lots of pictures of the beautiful new Harlem Ward building. The finished piece dealing with a CBS reporter searching for her roots was shown on the CBS Early Show, probably for two minutes. But, I mean, imagine CBS showing our new Harlem Ward to its advantage even briefly. This was a bonus that we could not have dreamed of. And one we could not even think of aspiring to. We had many things to feel good about: a full house of attractive, receptive people who seemed happy to be there and who stayed a long time. Our Harlem city councilman was in attendance. The conference was a complicated day, both in planning and execution, but a great success. We happily doubted that we could ever top it.

And imagine my surprise to receive the results of my DNA test by mail later on and discover that I was designated 10% Sub-Saharan African! An inexplicable result, but one that was very useful in meeting and talking with Harlem people. No one else in my family ever saw such a result, and I have determined that I acquired the blood identity by osmosis, by working in Harlem. And it was certainly a very useful talking point for meeting Harlem people.

I worked with the Harlem project for more than three years, and I am happy to measure improved relationships with the government, with the civic agencies, and with the neighbors. We didn't make much progress with the churches who always wished that we would just go away.

The biggest and best result of the Harlem Bridge Builders was the close relationships our group developed as we met, decided on our plans, and carried them out. I love those people. I would die for them. When we get together, we remember those days as our best days. Some built on their experience. Agnes Martinez, a former schoolteacher who now cares for her grandchildren, became a skilled operative, serving on the board of a group of poor people who teach others how to work with local govern-

ments. She was invited to the White House to meet the president. She was drafted onto her community board and was honored as a community leader. Agnes became a leader in a movement for better housing for poor people. She says she owes it all to Bridge Builders. And I met a host of people and learned to work in a new and strange arena. I could certainly do it all better now. How fortunate we are in the Church to be given hard things to do and to have to learn how to do them.

LaVell Edwards, the very successful, long-time football coach of Brigham Young University, and his wife, Patty, were then on a public service mission in New York, and they worked with our committee. LaVell also regularly visited a white family whose son attended a charter school in Harlem. A teacher there, a former professional football player, had organized a football team. The son of the family that LaVell visited was on the team. Hard as it is to believe, Harlem had had no football. No teams. No stadiums. No games—largely because there is not enough space for football fields. LaVell offered to help this fledgling team, then practicing on a wooden floor in an old building, soliciting a grant for some equipment from the NFL. When he gave motivational talks to other teams in the vicinity, he compared their great riches to this poor little team in Harlem, named the Harlem Hell-Fighters after a World War I Black regiment. He often brought back donations for the team. He later called these groups to schedule the first season of games for the team. The coach told the team that he did not expect them to win, but he did expect them not to give up. Some young LDS students began to coach the team on their schoolwork. Our committee began to host their awards banquet events in our chapel building, attended by lots of happy families with their beautiful children, politicians, scouts, and coaches.

The team didn't give up, and then they began to win a little. After four years, the Hell-Fighters played in the Division I finals. They didn't win, but they had come a long way. One boy played for Harvard on scholarship the next year. Three others had scholarships to Division II schools. LaVell used his unique skills to further the Church's interests. That's something we all can do.

Our committee work was demanding. Lots of people couldn't stick with it. I was busy recruiting new people all the time. The members who stuck got better and better, were elected to city positions, were tapped to be leaders, were recognized as natural talents. People who were marginal in other congregations became essential and central.

Though the Church has not perfected its relationships in Harlem, we do carry on there and we have made a difference. Eventually, the local leaders decided that they could handle the Bridge Building locally. I was a carpetbagger, after all, coming from outside the congregation. I was thanked and retired; I was sorry to go. I think working on the edges of the Church with people who don't think much of us is the best job. Everything is a plus. The Bridge Builders was not a project that I thought up, but it was one that I am very glad to have been part of.

–19–
The Little Pink House

Life is full of major watersheds. One came to us when we moved from Delaware, a small state, to New York, a great city. We moved from being people with a house, a lawn, a backyard, and multiple bedrooms to being apartment dwellers with limited space. We evolved from being the parents of a large family, to being empty-nesters—at least in theory. Our youngest child had graduated from high school and was off to college.

This change required divesting ourselves of many cherished possessions—our red velvet sofa, my collection of men's dress clothes, my "museum of women's work" with the various items I had collected, a sizeable collection of books, and other things we'd accumulated over the years. I still miss many of the things I parted with and often think of them. I realized that I had worn my possessions as an extension of my identity, and I felt vulnerable without them. Still, Richard and I both adjusted to minimalist living, eventually giving away our car and many more possessions. We embraced this new simple life and told people quite proudly that the only real estate we owned was our burial plots, and these had been a Christmas gift from Richard's sister, the late Cherry Bushman Silver.

There is much to be said about living life unencumbered. We buy just what we want and need and throw out things with abandon. We try to live lean enough that we can open our apartment, drawers, and cupboards to anyone without apology or embarrassment. And it's not as if we have no space to put things. We still have too much stuff.

My daughter-in-law Diane gave me a copy of the wildly popular Frances Mayes book, *Under the Tuscan Sun*. Diane had been on a Latter-day Saint mission to Italy. She is the most enthusiastic of travelers, and Tuscany seems a close metaphor for heaven. I read the book with interest—such a pretty place, such a charming house, such an ambitious project, such a charmed life. I loved the way the author said how she had expected that her life would narrow as she grew older, but instead it had opened up, wider than she could ever have imagined. But, I thought, isn't it an extremely crazy thing to live in San Francisco and have a house in Italy? Even a Tuscan villa? That's a long way off. Any vacation house is just a "change of sink." A traveler should stay in a hotel.

Mayes was asked what the downside was of owning a house in Italy. She said there was no downside. Right, thought I, so long as you have very, very deep pockets—which of course her rapturous accounts of life in Tuscany had provided. Fine for her, thought I, but I had gotten used to living lean, with people to fix my plumbing, paint my walls, shovel my snow, take out my garbage, and kill my roaches. I don't miss a yard. I have all of Riverside Park across the street. I don't miss a garden. I have house plants, and cut flowers are cheap here. I miss fresh vegetables right out of the yard, but our local produce is still the best in the world.

So in a great surprise turnabout, we bought a house—a house at a great distance. Not in Tuscany, nor on the Irish coast, nor on the Windward Islands, nor in Sausalito or in any other fabled place, but in Provo, Utah. How could that be? It is true that we had spent our summers in Provo on various scholarly projects, but we had quite happily bunked down in minimally furnished student housing. When we entertained, we took friends out to dinner. When it got hot, we went to the library or to the movies. Instead of household cares, we could read and write.

I didn't want a house in Provo, but I did want this house, this little pink house in downtown Provo, at first north and fourth east to be specific. It was the first building on the block when it was part of a forty-acre farm off Center Street. The house has been there since the 1870s when it was built for or by my husband's great grandfather, Giles Bliss Holden. We think that Richard's grandmother may have been born there. This ancestral mansion came into the Bushman line when Richard's grandfather married into the Holden family. The family owned the house, even as they sold off bits of their forty acres every year to pay their taxes. They lost the house during the Great Depression, and it was out of the family for thirteen years before Richard's uncle Bob Bushman bought it back. Richard's father, Ted Bushman, spent some early years in the house while his father was on a Latter-day Saint mission in Great Britain. Many members of five or six generations of Holdens and Bushmans have lived there briefly or for long periods. People were born there. People died there.

Richard had visited family members in that house over the years. The house was most recently occupied by his Aunt Jessie, Uncle Bob's wife. Bob and Jessie raised their daughters, Gloria and Carolyn, there. After Bob's death, Jessie married a childhood sweetheart named Condor Smoot, and there is a brass plaque with their names on the front door, although they mostly lived elsewhere. Aunt Jessie, widowed again, moved back into the old place, and we visited her there. We let her know that if she ever

sold the house, we would be interested. When she died, her daughters, who lived some distance away, told us they would sell.

But having moved into our new simpler mode, we hesitated. Did we really want to take on a house again and at such a distance from our regular operations in New York City? Much soul searching ensued. Was it practical? What could we do with it? Was this a good idea? And we slowly backed into a positive decision. We wanted the house even if we did not know what we would do with it. I justified it to myself by saying that it was Richard's hobby, a better one than many other options. We decided to buy the house, arranged the finances, and went to the closing.

There, buyers and sellers had a rude shock. Creditors had slapped several liens on the title, unknown to anyone. And once the debts were paid off, the liens remained. The title company refused to allow the closing. The whole transaction was tossed into limbo. We moved into the house and lived there a month. At that point, we had nowhere else to go, and no one else was available to live there. We spent a happy month collecting furniture and oddments, getting to know the neighborhood, and listing the things we would change. In one fell swoop, Richard cut down fifty years of rampant greenery. Then we moved back to New York City.

The liens were gradually removed. Like Sleeping Beauty emerging from a century of overgrown plant life, the title was liberated from its impediments and was again free and clear. Soon after, when the new documents were all signed through the marvels of electronic communication, the little pink house became ours. We were thrilled.

Someone driving by might not notice this little house. It is less flamboyant than some other houses in Provo's flat central area. The front is stucco, the paint a subtle pink—really a pale salmon—with some worn white trim. This is a nice little house on a quiet street.

A quick look suggests that the house has been remodeled. An early photograph shows a standard transverse house, a living room/kitchen block; in the next photo, a two-bedroom wing has been added on the left, at a right angle. Another early picture shows a new front porch. In the next photo you can see that the front porch has been enclosed to make a larger living room. At the current house, Venetian blinds shade two many-paned front windows. Two huge old sycamores, seen as younger trees in the old photos, shade the front.

A visitor entering the front door faces a pleasant, large living room with very dark blue, textured wallpaper. The front windows face back to French doors opening onto a small patio and yard. The adobe walls are

plainly a foot thick. To the left are two bedrooms with a bath between them. To the right is a long kitchen. Behind the kitchen is a breezeway with a washer and dryer and stairs down to the small, dark, unfinished cellar. Behind the breezeway is a small, knotty-pine-paneled room that might be another bedroom or a den. Uncle Bob, who was also the proprietor of a pharmacy on Center Street in Provo, kept his hunting guns there. A separate garage with a driveway was to the right of the back wing. This is a U-shaped house, much of its small yard enclosed within the arms of the bedroom wing and the gun room, on the smallest lot on the block.

We felt that buying this house was a positive gesture saying that we own and value our relations, past and present. We have come to know Martin Isaac Bushman, Ruia Angeline Holden, Almira Tiffany, and others in new ways: we live in their space. We bought into Zion again and into Provo, with all that that means to life-long Mormons who did not grow up in Utah, who have spent their adult lives on the Eastern seaboard. In a theoretical return to our roots, we claimed some actual Utah soil when our hold on the Utah and Mormon past had been only virtual through books and historical records.

We moved into a less fashionable but more convenient area of town. While fashion steadily moves north and east, up the hills and into the canyons, we had an old place on the flatland, an area full of students and widows, young families starting out, and people facing eternity. Instead of sunsets over Utah Lake and multiple bedrooms and bathrooms for visiting children, we had a house just the right size for a pair of elderly scholars. Walking to BYU is possible, though seldom done; walking downtown is easy. While we had to manage gardens and repairs, we arranged to have someone mow the lawn and someone repair the roof, and we had a young carpenter who was happy to haul away cut-down greens, mend the gate, and fix the plumbing. Snow shoveling, when required, would at least be on flat land. We spent our spare time happily designing the new back wing to replace the breezeway.

And suddenly, I could buy things again. My powerful shopping genes, long repressed by our New York City limits, sprang to life. Between trips to the library, I visited home stores, choosing linens and china and plants and doormats and pictures. What a pleasure to have the need, and the funds, to purchase some nice things—always at a bargain, of course. Wouldn't that pot be pretty with an ivy plant? Wouldn't that cloth go well with the dishes? Couldn't I squeeze that little painted cupboard into the kitchen? And so it went. New possessions, a new place to put them, a new life.

The Little Pink House

We considered moving to Provo, but though retired, we decided to remain in New York, a good place for old people to live and to die. We had subways and buses that knelt down for arthritic knees. We had Uber cars and plentiful taxis. We had good restaurants and grocery stores that delivered. We had good theater and matinees. We had security and helpful doormen. We had a hospital within easy walking distance. But the people who come to New York City determined to stay, move away. They eventually go. We thought that we might end our days in Utah. Provo is convenient to our Salt Lake City burial plots.

We bought the house, unsure what we would do with it. We decided on a workable scheme: renting the house during the school year and living in it during the summer. Our renters, teachers or students at the university, were generally pleased to have a nine or ten month lease. We semi-furnished the place in one fell swoop, visiting the final sale of a retail outlet for retired hotel furniture. The place was down to its last weekend and, although much of the good stuff was gone, we bought a king-sized bed, three upholstered arm-chairs, two upholstered side chairs, five assorted tables and desks, half a dozen big mirrors, some framed pictures, and the pieces de resistance: two long, low, eight-drawered credenzas, great storage units that also had some flair. We put the off-white one in the kitchen and the dark wood one in the living room. We had two of Aunt Jessie's chairs; we added a chest of drawers, a kitchen table, and four wooden chairs. And that was that.

For five years we rented the house out during the school year and lived in it during the summer, each year adding a little furniture and repairing some flaws. We retiled the front hall, repainted the bedrooms, touched up the outside pink stucco, painted the unsightly side of the neighbor's garage abutting our driveway, replanted some garden beds, repaired and repainted the white picket fence, added a little rustic twig furniture, bought a new bed and bedding for the other bedroom, added to our store of blue and white china, and generally played house.

As 2004 hove into view, ambitions rose. Richard was increasingly offended by Uncle Bob's jerrybuilt frame addition behind the kitchen and wanted it replaced. I hung back because of the cost, but eventually got into the spirit as we made up plan after plan to reconfigure the small space. We needed laundry facilities, a bathroom, a study, and a loft. Countless were the times my brilliant husband seemed lost in high thought when he was really redesigning that little space. Our obliging architect, who taught drafting in high school, printed out plan after plan from the computer,

trying to make the best of the available footage. We requested permission, as this is an historic house, to extend the room six feet to the back, otherwise sternly keeping to the existing footprint.

With our finalized plan, we hoped to get building permits, begin construction in the spring of 2004, and spend the summer in the house. Of course, there were delays: permits, plans, and the availability of David Harrison who began doing repairs and turned out to be an expert builder. When we set out for Utah that next summer, construction had not begun. We were homeless. Several friends and relatives offered to take us in, but we set up housekeeping in a single guest room in a Brigham Young University dormitory. We soon had two desks, on the dresser, using the beds as chairs. We bought a supply of groceries for our tiny refrigerator, and lived there, occasionally having a meal out or going to a movie.

Meanwhile, a large dumpster moved into the driveway of our little pink house and was rapidly filled and refilled with chunks of the old frame construction. Concrete was poured for the six-foot addition. A new furnace and air conditioner were installed, replacing our aged swamp cooler, and work began on the new plumbing. Our enthusiastic young builder noted that if we were ever to redo the kitchen, the time was now. I had no plans to redo the kitchen that included such charming aspects as homemade wooden cabinets, a tile floor, and a triple sink. The kitchen was flawed by some awkward places and dark areas, but it had been redone within ten or twelve years. As I debated a kitchen rehab, I was shocked to find it torn out and tossed into the dumpster.

That was the first of many alarming revelations: the result of circumstances, our builder's advice and warnings, and our own preferences. I have to take responsibility for doubling the size of the back window which stretches up two stories for the study and the loft. This window had to be specially ordered, and it delayed proceedings for some weeks, but we look at that great big window now with satisfaction. Richard accepted his friend David Davidson's gift of enough Brazilian mahogany (left over from his mountain home in Wyoming) to cover our living room floor. The gorgeous floor, a great boon, meant that all floors in the house had to be replaced. We tiled the new kitchen and the entire new back addition. The builder issued many suggestions that we accepted.

The old bathroom was a case in point. It is true that the flush mechanism and the drainage were at best sluggish and the pipes had to be reamed out annually to discourage the roots growing into them. We had no plans to change that. But the pipes of the new bathroom some thirty feet away

had to empty out in the same direction. Alas, the old pipes were not up to the job. So the old bathroom underwent open heart surgery. The floor was removed and the plumbing dug up. The old pipes were replaced with larger and stronger ones, but the drainage was still bad. An alternate route across the backyard was dug, ending venerable plant life, the cement patio, the lawn, and the picket fence. The small backyard was a disaster area, requiring a new cement patio and walkway, sprinkler system, turf, and fence. And as long as we were redoing the back, the big front lawn needed a sprinkler system. And as the old bathroom needed a new floor, the china fixtures were replaced. The old kitchen appliances were still workable, but they didn't fit in the new spaces. Out they went.

For most of the summer we expected to move into the house. Each addition or change had to be exquisitely orchestrated to harmonize with others. My husband remained cheerful and optimistic during all this. I, on the other hand, felt doom coming daily. I couldn't bear to visit the disastrous hulk that had been our charming little house. Every day brought new revelations of things that must be done, which added costs.

Multiple decisions had to be made from endless options immediately. Tile. Light fixtures. Countertops. Stair style. We made quick runs to Home Depot and Lowe's to look over the stock. After agonizing over possibilities, finally settling on a choice, we were told why it would not work. I abdicated many decisions to my husband. I told him it might be better if I did not know about some of them, and particularly not about the costs.

When we returned to New York at the end of the summer, the house was still in construction. Richard was back and forth several times in the autumn; he made many decisions. So I have charming little frogs, birds, and lizards as pulls on my pantry cabinet. I love them. Richard forged onward. He remained enthusiastic and willing to spend.

Because we were under steady construction that year, we could not rent out our house. Then we priced ourselves out of the student market so that no one wanted it. But then, we did not want anyone else in our precious little house anyway.

By November, things were close to done. We decided to spend the Christmas holidays in Provo, inviting our western children and their families. Richard instructed the workmen to clean the house up so I would not be too shocked. He warned me to prepare for the worst.

Our plane from New York was delayed. Neighboring storms closed airports and delayed travel. Our stay in Cincinnati, long anyway, was doubled. When we finally reached Salt Lake City, our luggage was miss-

ing. The hour was late, the ground was covered with snow, the roads were slick. Much later, having gathered our possessions, we set off on the road to Provo. Hundreds of others spent the night in the Salt Lake airport, their connecting flights canceled. The perilous forty-mile drive stretched endless ahead. But by the time we reached the point of the mountain, the skies were lit with bright moonlight. The roads were clear and dry.

Giddy with lost sleep and an impending adventure, we reached our little house in Provo in high spirits. And found our dear little house more charming than ever. The stately trees rose above the house. The yard was neat, and verdant grass poked through the snow. The addition, with its extra story, seemed to belong, not dwarfing the original as we had feared it might. New steps led the way into the spacious rooms, now newly bedecked. The orange tile floor, for which the builder had disclaimed any responsibility, looked just perfect. The new pale maple cabinets were pinkish, not yellowish as I had feared. The blue counters were not too dark. The stove had jumped across the floor to a better location. The place was enchanting. The three bears should have had so charming a house.

We set to work. We made up the beds. We gradually filled drawers and cupboards, tried our existing furniture in various spaces, and listed the items we would need. The first and greatest need was a sofa. We bought a red velvet one to go with our red and blue oriental rug, our dark blue walls, and our mahogany floor. It was perfect. We added a paisley armchair and ottoman, filling the living room.

We planned to call local museums about donating a couple of Uncle Bob's very large oil paintings that had long languished in the cellar. They showed pharmacists, one contemporary, the other from the colonial era, and had probably hung in his old drugstore. They were historic items, painted fifty years before, by a close relative who had owned the house. Maybe they would fit in the study. We dusted off a decade of grime and brought them upstairs to find that the color was perfect and that we loved them in that space.

We furnished the children's carpeted loft space with sleeping bags and a stack of toys and games. There we could entertain our visiting families, the parents sleeping in the second bedroom, the children sleeping and playing in their own special place in the loft. We had some happy holidays.

The house adapts well to company, for while it is not a large house, all the spaces are generous. The living room includes the framed-in old front porch. The kitchen has plenty of eat-in space and is also well-suited to be set up for a buffet with people eating all around the house. The new study

seems larger than it is because it rises two stories and is overlooked by the loft. The enclosed backyard is generous enough if it is considered an additional room rather than ancestral acreage.

And while this is a small house, more diminutive than the dwellings of many of our friends, it is larger than our apartment in New York City. Our pink house's kitchen has better cupboards, floors, and appliances, all fresh and beautiful, than our New York place. The bathrooms are better, too, and the second bedroom in Utah is much larger than the second one in New York.

So, all in all, we were very happy with the transformation of our Little Pink House in the West. While things may not necessarily make logical or financial sense or be convenient, they can make spiritual, emotional, and other kinds of sense and bring great satisfaction. We bought the house not knowing what we would do with it, but we were certainly happy to have it. Just thinking of the place has brought us great pleasure, even as it brought added responsibility and expense. As my mother used to say, "A thing of beauty is a job forever."

We made improvements every summer. We eventually got the yard into shape with a new cement patio, a new fence, and some landscaping. Not perfect, but still very attractive. We were resting for the next big assault.

The little stand-alone garage, a wooden framed structure, was rickety. Old photos showed that earlier it had been located closer to the front of the driveway. In some renewing effort, the garage had been pushed back on the driveway to allow for more parking. Anyone who leaned on the garage could easily move it to a less-than-square state. We began to think that it might fall over on someone. Besides, Richard strongly disliked it. We began plans for a new attached garage. And then, because we were building anyway, we would add a small room on top of the garage.

We were dealing with very small spaces here. The buildings on this very small corner lot were immediately adjacent to the next-door properties on both sides. We had to make use of every inch, to maximize our own spaces. Our attached garage required new inside doors on two floors. Much of the side of the Little Pink House's recently completed addition had to be reconfigured; some nice inside walls were ripped out. We feared that the garage would seem too big for the little house, that the room over it might be intrusive. But both the garage and the room above had small windows that echoed the front windows, and they were far enough back that the addition never seemed to overpower the house.

Our Little Pink House, c. 2005.

We had no plans for the little room over the garage, even as it was being constructed, but the first time I ascended the steep stairs, I claimed it as my own. It was small, with great window views on one side up into the mountains and out to Utah Lake on the other. It soon had bookcases, my desk, my twig sofa, my armchair and footstool, and lots of pillows. It's where I invited my friends up for extended visits. I loved it. How I miss it.

We have had many memorable parties in the Little Pink House. It works well for a large buffet dinner event with serving tables set up in the kitchen and people moving into other nearby spaces. It works even better for a big open house gathering with assorted refreshments spotted around and people flowing out to the backyard. We've had big family reunions there. Kids can retreat to the big loft room upstairs to play games, leaving adults to serious conversation. The space is endlessly malleable.

Richard loved this house above all houses. During a sermon in church when the lesson was that we should not make idols of worldly things, he leaned over and whispered, "Maybe I'll have to sell the house." He may have cared too much about it.

In later years, we spent less time in the house. The place has been occupied by successive grandchildren attending BYU and their friends. The grandkids had begun to think that living in this house was part of their heritage; they lined up to stay there. And they wanted to stay on in the summer. We did manage to spend a happy month there in 2019,

surveying the inevitable damage and having it repaired. It was a wonderful month. But the house was less available after that.

In 2021, a major change occurred. During a celebration of Richard's ninetieth birthday in Provo, coinciding with a family reunion, we sold the Little Pink House. Our granddaughter Shelley Bushman, daughter of our son Serge and his wife Patty, had been living in the house for several years. She lived on there as she graduated from BYU and as succeeding roommates married and moved out. She, like previous residents, had become very fond of the place and wanted to stay on. Her father Serge had shown interest in the house over the years and made and renewed his offers. We had scarcely seen the house in several years and decided that this might be the time, grateful that family members valued it and wanted it to stay in the family.

On one warm autumn day, we met in a real estate office and signed many papers. Shelley has now married and lives in Salt Lake. Serge and his wife Patty, who had lived in Kansas City, have moved to Provo. They have bought another house to live in, but Serge runs his company Woodcache out of the Little Pink House. We brought the house up to date in many ways and gave it a lot of experiences, but it now serves a new group. We still see the house from time to time, but it has moved beyond our immediate sphere, to a new family and another generation. We realize that we were always caretakers rather than real owners.

–20–
The Claremont Idyll

In 2006, Richard had retired from Columbia and finished *Joseph Smith: Rough Stone Rolling*, a book that had been published in 2005 and was a big success. He was then involved in the very big project of gathering, explicating, and publishing the Joseph Smith Papers. Richard and I were on an extensive bus trip to visit the historic sites of The Church of Jesus Christ of Latter-day Saints. This trip was a gift to the people working on the Smith Papers by Larry H. Miller, the wealthy car dealer who had seen the value of an intensive, professional search for and publication of the materials produced during the early days of the Church and had sponsored the project. He had invited the staff and their wives to give them actual visual experience of the background of the documents they were gathering.

A large group of learned, important, and interesting people filled the bus. Many were old friends. Others we had only heard of. We had lots of good conversations as we shared meals, listened to lectures, and visited the sites. The people present were largely scholars of the Church, professors from Brigham Young University, employees of the Church history department, and successful professionals. It was a very enjoyable and instructive trip.

Richard and I sat together on the bus, often separating at break times. Sometimes, he and I talked with other couples. Sometimes we visited separately. After the latter visits, we would fill each other in on what we had just learned. After one break, he returned with big news. Joe Bentley, an attorney and Church leader in Los Angeles who was also a serious scholar working with the histories of the many legal cases that Joseph Smith had been involved in, had made a stunning proposal.

Bentley told Richard that Karen Torgeson, the enterprising dean of the School of Religion at Claremont Graduate University in Claremont, California, in an effort to enrich the school's offerings, had invited representatives of five religions to raise funds to endow ongoing scholarly chairs to provide continuing and advanced study of their groups. Representatives of The Church of Jesus Christ of Latter-day Saints were included. Claremont encouraged LDS church members to raise funds to support an academic

chair. A number of local Mormons, excited by the offer, were working to raise the necessary money.

Bentley had filled Richard in on the progress of the Mormon Studies chair—that is, the possibility that a position to fund a Mormon Studies program and a professor to administer it at Claremont Graduate University was moving along. He invited Richard to consider applying for the potentially endowed chair, which was a very exciting idea. Only one other Mormon Studies chair then existed: the Leonard Arrington chair at Utah State University in Logan, Utah, the long-time home of Leonard Arrington, the historian of the Church and the founder of the Mormon History Association. Bentley encouraged Richard to come to California to begin a Mormon Studies program. Richard was immediately interested and so was I.

Richard was then lecturing all over on his Joseph Smith book, and he was invited to give a public lecture at the Huntington Library in San Marino. We both loved doing research at the Huntington. I had had a month there some years before, and Richard and I had both been there for a year in 1992. The Huntington has an excellent collection of Mormon materials—one of its specialties—so it was reasonable that Roy Ritchie, the chairman of research, should invite Richard to give a public talk there. He had done so once before.

The Huntington has a nice multi-use auditorium for its guest speakers. Chairs had been set up, and we recognized friends and scholars from the Los Angeles area and students from nearby colleges. The crowd grew and grew. Soon Roy and others were setting up additional chairs. There was a "sellout crowd" to this free lecture. Richard, always an impressive speaker, gave an excellent talk. Roy asked Richard if he would be interested in coming to the Huntington for a year. So it was that although we were then thinking that we might go to Claremont to teach in 2009, arrangements there were somewhat delayed, and we were able to take the year-long Huntington offer in San Marino. We planned to go on to Claremont for the next three years while still living in Pasadena. It was one long, wonderful time. California, the sources, the schools, the classes, the people, it couldn't have been nicer.

All these opportunities have complex connections. The Huntington was always looking for large donations from well-off people and groups. The major local newspaper, the *Los Angeles Times,* had been a big supporter of the Huntington in the past. The publisher was just then retiring, and his job was offered to Mark Willes, a Latter-day Saint who had been chair-

man of the cereal giant General Mills. Roy Ritchie at the Huntington, who was certainly adept at getting clues and working angles, may well have thought that the new chairman at the *Los Angeles Times* might well be more interested in supporting the Huntington if a well-known LDS scholar like Richard Bushman was being supported there. Roy had lots of money to dispense; tie-ins like that were advantageous. So, we had a year at the Huntington Library with enough money to pay our expenses. I shared Richard's nice study for a while and then was even provided with one of my own.

We lived in a small, over-the-garage apartment belonging to the nice house of our landlords, just off Colorado Avenue, along which thoroughfare the sumptuous New Year's Day Rose Bowl Parade travels. We spent four years there, walking or driving to the Huntington and traveling the freeways to Claremont. We spent time at the Norton Simon and Getty Museums, dined in and out on fresh California produce purchased at the farmers' market, and enjoyed the culture of the Pasadena Playhouse and the Hollywood Bowl. We continued our Pasadena life even after beginning at Claremont, a half hour drive to the east, a trifle by Los Angeles standards.

The proposed chair of Mormon studies was the only one of the five proposed religious-based chairs that really gained traction. And the established faculty there was less than thrilled to have a Mormon in their midst. Richard began a program of visiting speakers for special events which became very popular with Mormons in greater Los Angeles. The large Claremont auditorium was repeatedly filled for lectures from visiting scholars. Other faculty people admired these programs, but they didn't want to be swamped by Mormons and told Richard to slow his programs down. They were more enthusiastic about the excellent LDS students who came to the program and took their classes. I remember one time when a couple of faculty members were wringing their hands about a big and complex upcoming event. The department secretary told them not to worry, that "the Mormons are in charge." The program offered excellent teaching, students, and student life in impressive amounts. Our students did well and went on to impressive careers.

Richard always taught two classes a semester, and I taught one on some aspect of LDS women's history. I would have done it for nothing, but I was paid at an adjunct rate. We had some women in our student group and an additional number of community women who were eager to take the course. I told these latter women that they could come and

audit the classes if they did all the reading and writing work as well as the regular students. But to get any credit for the class, they would have to pay the very high tuition. This plan worked well in that I always had a good group of students who felt an obligation to keep up. Even better, some of the most ardent listeners eventually paid all back and forward tuition and became regular degree-seeking students, resulting in graduation and masters' degrees. The range of age and experience made for excellent class discussion. We got on well, did lots of special projects, and became good friends.

Richard and I also made friends in our LDS community. There were several congregations within reach, and we were invited to speak and participate in many events. We also produced events of our own. One of mine was a musical event. I was assigned to "visit and teach" a young woman in our congregation. She was married to a graduate student and had several young children, but she was also an accomplished violinist who held a chair in the Los Angeles Philharmonic Orchestra, a position she had achieved right out of college. I decided that I would sponsor a recital for her. She was not particularly enthusiastic about it, but I persevered, asking several other women we both knew to work on it. One woman, with some newspaper experience, designed the program. Another oversaw refreshments. A third, a professional gardener, did the flowers. As the chairman, I arranged to have the event in our chapel and did publicity. I told our violinist that she should prepare her program, find an accompanist, and get a beautiful dress. We would take care of everything else.

It was an event to die for. I knew it would be first rate. Our violinist, young and beautiful with long yellow hair, was also a skilled performer. She wore a long, beige dress and played as her encore Claude Debussy's *La Fille aux Cheveux de Lin* (*The Girl with the Flaxen Hair*), which could well have been her musical theme.

I started the publicity early so that the people at the local newspaper knew well in advance. As we approached the date, the newspaper made the recital an "Event of the Week" with very nice newspaper coverage. The sisters at church made wonderful refreshments, and the program was very professional. And the flowers! Well, it was a supreme event.

I was not a regular professor at Claremont, but I did have good-sized classes. At a meeting of advisors and donors, I reported on some of our projects. A person there, whom I did not know and whose name I cannot recall, was impressed at something we had done and gave the woman's program at Claremont a donation of $10,000. What to do with that? I

am used to doing projects that are cheap and free. After some time and discussion, we decided to buy some electronic equipment and start an oral history program. We subsidized individual recorders and transcription machines for several students and bought some extra. We worked over a questionnaire. What did we want to know? How did we want to proceed? What would be the goal? We invited in several people and interviewed them in class as examples. We transcribed interviews and reported on them. We returned the transcriptions to people for correction and sent out final copies. We numbered the completed interviews and eventually submitted them, without names, to the Special Collections of the Claremont Library.

I interviewed my sisters (and myself) and sent out the four documents to each of my sisters for Christmas. We used the interviews to write class papers and eventually published a book about them. Several of the students continued to do oral histories of specialized groups and used them as sources for papers and theses. Several have adapted the program and the questionnaires to other languages and completed doctoral dissertations in other countries. All interviews were transcribed, edited, and added to the university collection. Oral history is now an ongoing project at Claremont. Faculty and students are experienced and productive. An additional copy of the original group of transcriptions is now also in the BYU Library Special Collections. We all got a lot of value out of that original $10,000.

While at Claremont I had a health adventure. On a doctor's visit I was asked about a strange, large, round, uneven patch on the top of my right wrist. I told the doctor that that was where I wore my watch. He took a sample of the flesh. Several days later, the doctor called, asking me to come in and to bring someone with me. That sounded ominous, so I brought Richard along. The doctor said that the suspicious spot looked and tested cancerous. He said that I might have it tested again, but that I should certainly go to the local and celebrated cancer hospital, The City of Hope, and have it removed. And so, I became a cancer patient.

The hospital surgeon looked it over and decided that it should definitely go. It was suspicious and dangerous, so I was scheduled for outpatient surgery. He cut out a large hunk of flesh, down to the tendons, and then trimmed out a large triangle of flesh from farther up the arm, still connected by a thread of flesh, and brought it down over the hole, bringing the upper edges of the flesh together and sewing a long seam. I now have a large Y-shaped scar closed at the top where the skin graft fills a hole

about two-and-a-half inches square, with another three inches of scar tailing up my arm. It's a very neat job. There has been no recurrence. People wonder if I have had a bike accident or something like that. I have come to doubt that I ever had cancer at all. If I ever did, I don't seem to have it now. It has been a long time since that incident.

On the day of the surgery, our women's group held an oral history event at the very beautiful home of the college president. She had offered us the use of a large living room space that overlooked a beautifully groomed back garden for our public program. We invited in other students, friends, family members, and subjects to hear our reports on the oral history project. I felt quite heroic with my large white bandage and throbbing forearm, and it was a lovely event with nice refreshments and students proud of their work.

We had feared that four years away might cause us to lose our Columbia apartment. Richard was retired and there was a modest but recurrent effort to snatch back the wonderful real estate that Columbia professors are able to rent from the university at inexpensive rates far below market value. Our daughter Clarissa, then teaching advanced economics at Stuyvesant High School in New York City, had been living there while we were in California. We had considered moving to Pasadena and looked hard at houses and apartments for sale and rent, but we did not find the right place to move to, and so we were very glad to be able to return to New York apartment on Riverside Drive, a place high above Riverside Park and the Hudson River. We have lived there ever since.

Claremont receded in our memories as an idyllic episode in a fairytale land where you wake each morning to "another day in Paradise." The graduate program still thrives, and the oral history project has provided the backbone of a number of dissertations. We still think of Pasadena as one of our homes.

–21–

Wellesley Revisited

As a young person, I thought eastern schools were all like the boarding schools we read about in novels: exotic, a different culture of all girls, a bit snooty. I thought that women's colleges in the eastern United States were still pretty much like that and very different from the western world I had grown up in. I certainly had no ambition to attend one. However, I was always willing to try something new when the opportunity arose. I have written earlier how a chance conversation with a guidance counselor had resulted in an application to one of the seven eastern women's colleges and how when it became possible to go, I went.

I was certainly influenced by the four years I spent beside Lake Waban at Wellesley College. For the better, I think. I know how to think about people when I hear where they have been educated. I recognize more of the influential cultural names that people throw around. I expect and recognize certain subtle learned behaviors. Going to school in the East made me less of a snob and more of an educated person. More, rather than less, tolerant. I became more appreciative of the Wellesley persona, if less impressed by the Wellesley individual. They're "jes folks," like the rest of us.

Going east to school meant that I traveled more. I had never been out of California except for one brief visit to Utah. Traversing the continent became common for me, and I doubt that I would have traveled so much since had I stayed in the West. I traveled by car, by train, and by airplane. I still don't consider myself a wide traveler and have never been to South America or China, or Antarctica like Richard, who has traveled more widely. Still, I've been to Lisbon, Istanbul, and Moscow. Not yet to Timbuktu.

I didn't exactly feel at home at Wellesley, though I was not homesick. I felt I was living in a novel. I aimed to live in that somewhat different culture, and I did, but not always successfully. I was recognized as a little less civilized than others because I was from California, the Wild West, but I was comfortable. For my senior year, I was a married commuter, and instead of regretting moving away from Wellesley culture, I lived happily in a little apartment in Cambridge with my husband. I was expecting a baby, born four months after my commencement. Instead of missing my campus college life, I was eager to get on with adulthood.

Wellesley Revisited

In my early married years, all the attempts by class officers to gather our graduated class members for visits and reunions fell on my deaf ears. I was done with college, and I mean *done*. And though I had loved Wellesley, I was just not that interested in the old college anymore. I was not active in regional Wellesley clubs, and I did not go to any early reunions. They were mostly held in distant places, requiring expensive trips. My life was domestic with young children and a husband in graduate school. I made perfunctory donations to the school when asked; I owed a lot to the college. But I was soon in graduate school myself, and with a young family, I was counting pennies.

I didn't feel I had many close friends in the class. I doubted that anyone would remember me. Nevertheless, I gradually began to go to reunions, and gradually I was asked to do things. I had put some books I had written into a display of post-college achievements, and at a couple of reunions, I led little classes on writing, urging keeping journals and writing memoirs. I sometimes led some singing. When someone I knew was class president, I took on the job of co-editing the five-year class yearbook. That was something I knew how to do, and my co-editor and I turned out a very nice class record. For a later five-year record book, we enlisted some classmates to work up an extensive questionnaire which we encouraged all classmates to fill out and submit. Someone did all the math to identify the trends, and I was asked to report on this study to our class. Having worked with the survey and having taught college students for some years, I had the confidence and skill to present our information. I was surprised when I got many positive comments for my brief report. And perhaps because of that I was asked to edit the class report for several more reunions. As the fifty-fifth reunion was not an important one, I simplified, shortened, and generally cut back the book in many ways, but added to its good characteristics in other ways, for which I surprisingly received many accolades. It has been with wonder and gratitude that I realize that I have begun to seem like a successful Wellesley girl, at least to my class. I am surprised at how grateful I am for that realization.

Building on the reunions and the yearbook, another Wellesley classmate named Sheila Owen Monks and I have been editing and publishing a modest but interesting literary quarterly, *Scarlet Letters*. We have worked on it for the past eight years. The title was my idea, though I was influenced by a friend in a Wellesley class two years ahead of me who was doing a similar thing. At Wellesley, all the classes have colors. Wellesley blue is for the whole student body, but the classes have individual colors, rotating

red, yellow, purple, and green. My friend was in a purple class, and she called her publication *Purple Prose*. Our class was a red one. I told myself that when I could come up with as good a title as the purple one, I would begin a class journal. I needed a classy, pretty name, but one with some additional meaning that would resonate with people in the know. Suddenly, I had it! *Scarlet Letters*! I asked Sheila, an established and accomplished poet, if she was interested in co-editing. She was, and the two of us have carried it on for eight years now. We never see each other. We very seldom talk on the phone. But we keep up a busy online correspondence, and we turn out issues of *Scarlet Letters*.

We often have difficulties gathering copy for our publication. Only a few people submit anything or produce ideas for articles. I sometimes fear that our class is just a tired bunch of little old ladies. Our ranks are thinning, and literary production is not easy or interesting for many of us. Our increasingly inactive classmates, those of us who are left, will all soon turn ninety. We increasingly publish obituaries and the stories of our deceased. When people leave the scene, they often leave their stories behind. Though I am frequently ready to quit, I carry on. Doing the layout, which Richard and I have been doing lately, is pretty hard for us, but we can almost do a reasonable job. Sheila and I may have to write the whole thing ourselves, but we think we should keep it going. It's only eight pages four times a year.

As a result, without meaning to, Sheila and I have become somewhat official in the class. The class president considers us class officers and includes us in official meetings. Any suggestions or requests we make are taken seriously. The bottom line on all this is that I now consider myself a good enough Wellesley girl. As an undergraduate, I often felt that I was substandard in various ways, a disappointing student somewhat lacking in any "Wellesley Girl Aura." I had been given a great chance to develop that, and given that chance, I thought that I might become somebody. I might succeed in a significant way, becoming a credit to someone. But instead of distinguishing myself as a student, a beauty, an athlete, a leader, or anything else, I was just an average person, a westerner, from a distant city and unknown high school, a disappointing student who seldom ascended above a C, a person who married after her junior year (although I did graduate with my class!), a girl who couldn't play tennis or sail. Despite not achieving much of anything in college, I think I have become a good citizen and an honorable member of my class. That means something to me.

Wellesley Revisited

Graduating from Wellesley made a real difference in my life, but it was also a big change in my family culture. I was the first member of my family to complete college. When my father was a boy, he lived on one poor farm or another, out of reach of most schooling. He went to school to the sixth grade and then had to be sent to another town to board with a family for high school. He was lonely. He thought of all the work back on the farm, and he left school and went back to help the family, ending his formal education. He was plenty smart, he read a lot, and he lived and worked with college-educated people all his life, but his formal education ended with the sixth grade. My mother attended high school and once even attended a brief college summer school program, but no more. Both of my parents were bright and had learned a lot on their own, moving with well-educated people through their adult lives, but, like many others of their time, they were not schooled.

I am always very grateful for the string of coincidences that led me to Wellesley. I don't necessarily think that my classes were all that much better than those at other institutions, though we had a very good set of professors and our classes were generally small with lots of class discussion. I am grateful for having the chance to get to know so much more of the United States than the California coast. I appreciate the college credentials I have that generally elevate me in the minds of people in the know. Though never a very good student, I think I learned a few things.

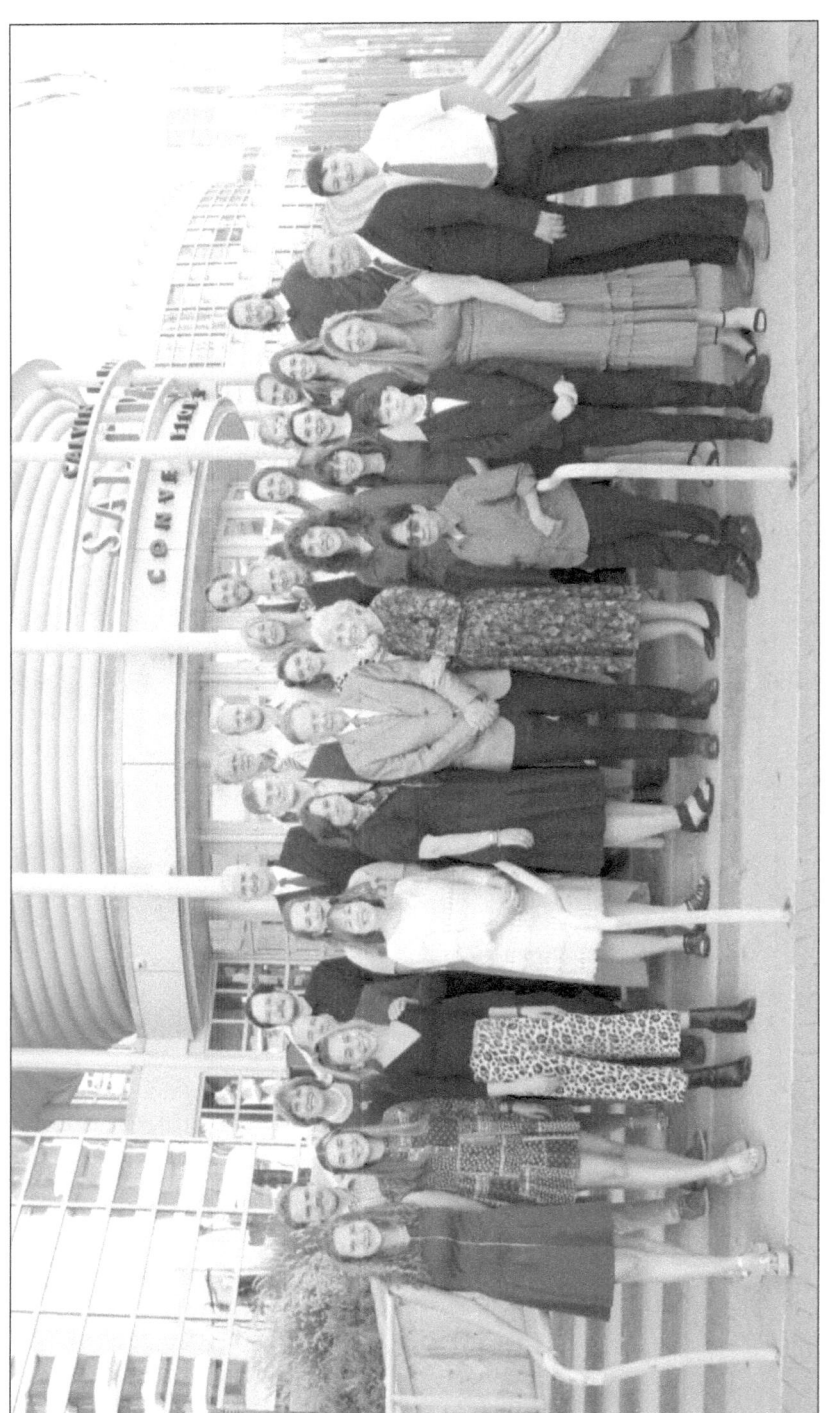

Family reunion, Salt Lake City, 2021.

–22–

Family

We celebrated our fiftieth wedding anniversary in 2005—twenty years ago. My mother did not live to celebrate hers. Richard's parents did not live to celebrate theirs. My sister Paulie's husband, Gib Hutchings, suffered an early stroke; he was not around to celebrate his and Paulie's grand event. My sister Georgia and her husband, Crawford, did celebrate theirs, so ours would be the second in the family. And my sister Bonnie and her husband, Glade, lived to their fiftieth, too. Richard and I scheduled our golden wedding anniversary event a week early on August 13, 2005, rather than our actual anniversary of August 19 so that all our children could be there. We rented the large lobby of the BYU Museum of Art and invited all our friends.

This was an important milestone. We had been married more than twice as long as we had been single. The longer we can stay alive and married, the less time one or the other of us will have to spend alone, trying to make a life from the remains of what we have shared. I know that either one of us would be more than lonesome. We have shared a lot of life in these fifty years, not always smoothly, but with increasing ease and satisfaction. We are used to each other. We enjoy each other's company. We have a lot to talk about. He is very good to me. I adore him.

Our companionship has borne fruit: six children, which is too many for modern tastes but entirely honorable in Mormondom. They are all notable in their own ways.

Clarissa

Clarissa was the brightest of golden girls. Always a beautiful and graceful child, she was born in the second year after we were married. She was the baby I carried at my Wellesley graduation. She was the beautiful blond child that you kept looking at. She always had pretty dresses and shoes—things I made myself, sometimes by hand. Clarissa was the first child in the family, the first Bushman grandchild.

Clarissa left high school a year early, enrolling at Radcliffe College, then the female Harvard. She took the next year to go to New York, studying and working as a dancer, which was her primary ambition. She returned to Harvard the next year, still dancing but somewhat disillusioned

by the realities of a dancing life. She married Charles Ortel, a Yale graduate who was a student at the Harvard Business School. On his encouragement, she also went to business school, and they both worked for New York brokerage firms. They purchased a huge house up the Hudson River at Salt Point.

Before their divorce, Clarissa and Charles had two children, Montana and William. As a young adult, William announced to us that he had come to realize she was a girl. Presenting herself as the feminine Sloane Veda brought great happiness into her life. She became a vegetarian and later created a mutual fund she called Investvegan, which has been doing well. She is currently living with Serge in the Little Pink House in Provo. Montana studied engineering at SUNY Binghamton in Binghamton, New York. She is now a practicing construction engineer in New York City, supervising portions of the rising of a New York apartment building. She recently announced her engagement to Andrew Kunesh; they plan to be married in Prague in 2025.

Richard

Our oldest son, Richard, Jr., generally called Brick by family members, lives in Kuwait. He was born in London's Muswell Hill, in the Alexandra Maternity Home because our London flat was not deemed up to standard for home deliveries. Brick always took his British identity seriously, wearing a little Cold Stream Guard uniform I had made for him to pre-school day after day. He was always musical as well, beginning school violin lessons in grammar school. He switched to the viola early on and played a great deal of chamber music with more musically accomplished friends in high school; he also played in youth orchestras.

He followed Clarissa to Harvard and the two made a handsome dancing pair at parties. They danced onstage in a student production of *Oklahoma*, and while attending a formal dance at Richard's twenty-fifth Harvard reunion, brought the Bushmans fame when they won first prizes for their dancing in both the ballroom and jazz competitions. Brick served a Latter-day Saint mission in Germany, and on his return to Harvard, he majored in French and German literature. He also organized his brothers as the long-lived doo wop quartet always called *Benny and the Pork Chops*. On his graduation, he was helped to a job as an investment banker by a then-current girlfriend, and managed to get a foreign assignment to London, recovering one of his early identities.

In London, he met and married a British girl who had joined The Church of Jesus Christ of Latter-day Saints and had just returned from a church mission in Italy. Her upper-crust family was not happy about her Mormon choices and certainly not about the possibility of her marrying a Yank. He persuaded them of his virtues by showing his familiarity with the songs of Gilbert and Sullivan, which he had often sung at home. His wife, Harriet, trained as a concert pianist, shares his broad musical interests.

Brick and Harriet spent ten years in Saudi Arabia where they organized many musical events for the ex-patriot community. Brick advised Saudi billionaire Prince Al-Waleed Bin Talal for a while. His best deal, however, was the purchase of a basement flat in the London suburb of Hampstead, increasingly valued for its Heath and high culture. The flat was fine for his bachelor existence, and later he was able to purchase the first floor, and eventually, the freehold of the property, including the land the house sits on. There are still two apartments in the house, on the two floors above the Bushman property, and the whole may never belong to one person again, but the space has provided a home when they're in London, rental income when they are not, and now has been remodeled (again!) as a home for their daughter Helena and her family.

After the Saudi stint, Brick and Harriet lived and worked in London for ten years before setting off on for a job in Kuwait. Still an investment banker, Brick inherited the chorus of an oil company, the Ahmadi Music Group. He decided that he needed an orchestra to go with it and organized a pick-up orchestra with all the professional musicians in the country, importing some when necessary. He began to produce concerts for his singers and Gilbert and Sullivan operettas. He produced, directed, choreographed, and conducted *The Desert Song* by Sigmund Romberg and Bizet's *The Pearl Fishers*, shows that echo the country's history. He began to teach children to play stringed instruments. He made connections, found sponsors, and became more ambitious. Leaving finance behind, he is now a full-time musical impresario: organizing events, staffing them, conducting concerts. He has guest-conducted the Bulgarian Symphony while his wife's opera, *The Revenge of Peter Rabbit*, based on the Beatrix Potter books and translated into Bulgarian, toured the country. She also continues to accompany, perform, and compose.

They have created a musical empire in Kuwait, but it is not one that can survive without constant management. They had always said that they would leave the Middle East if Harriet's widowed mother in Cornwall became ill or if their daughter Helena, living in the Hampstead House with

her husband, Jack, should become a mother. Harriet's mother has now moved on, and Helena is now the mother of Margaret Davina Clarissa Woodhouse, born on her great-grandmother Claudia Bushman's birthday, and James Richard Montague Woodhouse. Little James is slated to become a peer of the realm as the ninth Baron Terrington. His father, Jack, will be the eighth baron and Jack's father is the current seventh baron. Baron is the lowest of the hereditary English ranks, but imagine having a title at all. Brick and Harriet have not left the Middle East and may not do so.

Karl

Our next child, Karl, our medical doctor, lives in Pittsburgh with his wife and a large dog. Karl and Diane have the largest family of our children: five lively kids, close in age, who have already all left the household. Karl was the elfin, otherworldly one of our children. He and I share a great love of frogs and snakes. He is still very knowledgeable about such creatures.

Karl followed Clarissa and Brick to Harvard, majoring in literature. He interrupted his college years with a Latter-day Saint mission. Called to a Spanish-speaking Utah mission, he was called while in the Mission Training Center to give tours in French on Temple Square. He was later transferred to Ogden to teach in Spanish, but he also taught in English. He served a trilingual mission in Utah. After he graduated from college, he went on to Albert Einstein Medical School in The Bronx. Before medical school, he married Diane Spurgeon whom he had met at church. She was a medical technician, and they shared many interests. Karl decided to go into primary care and interned in Pittsburgh, a new place for our family. He joined a practice to his liking and settled there. He and Diane bought a house just up the street from his practice's suburban office in Mount Lebanon, a pleasant suburb with good schools and traditions.

Karl has been in the front ranks of the skirmishes over medical care, working longer hours to stay abreast of the new demanding record keeping, searching for new partners as his early colleagues retire, and selling the practice to the St. Clair Hospital in Mount Lebanon. He has now retired. He and his wife plan to serve a Mormon medical mission in Kenya.

Meanwhile, the children of Karl and Diane have grown and left home. Ted, the eldest, has the nickname of his paternal grandfather as his given name. He is not Theodore or Thaddeus. He is Ted: a singer, composer, playwright, writer, director, and now an equity actor with several shows and tours on his resume. The second of his own written shows, about Theodore Roosevelt, was designed to travel a National Parks' circuit across

the country. His Cyrano de Bergerac is very impressive. He has had a number of pretty good breaks and hopes to run into the really big one soon. He has now married Kristin Perkins, a graduate student in theater studies at Columbia.

Luke, the beautiful younger brother, went to BYU as Ted did and served an LDS mission in Brazil. He got a good job in Chicago where he could use his Portuguese, but deciding to own his gay identity, went to Seattle with his good friend Juan who was in medical school there. He used his Portuguese there too. The situation for gay couples in the Latter-day Saint Church is fraught, so the future is unclear. We all hope that there will be more comfortable accommodations for this community down the line.

Nadia, married to Ximmer Conkling, lives in South Jordan, a small town in Salt Lake Valley. She and Ximmer were married early and have been in various schools and employments. Ximmer has now finished college and has a job in healthcare. Nadia is also working in healthcare. She has become the mother of our second great-granddaughter, Hazel Autumn, who is an enchanting child. Hazel has been joined by a new little brother, Griffin.

Caroline is an artist, skillful in many media, painting murals and portraits. She is also a skillful interior decorator. She is married to Joey Wright, who will soon graduate from medical school and be commissioned as an officer in the army.

Suzy, the youngest of the children of Karl and Diane, has graduated from BYU in advertising and now works as a medical specialist.

At this point, Diane, having taken many courses in accounting, has prepared herself to be an accountant. She keeps track of funds for Serge and his company Woodcache. She also drives her own car for Uber. She loves to drive and is an excellent driver. She continues to do many other things, but when she has some free time and is in need of a few dollars, she takes to the road and picks up paying customers. Karl, meanwhile, somewhat weary of the fussy demands of today's medical practice, has retired. He has strong interests in music, literature, and particularly in gaming, the complicated practice of the new board games. His LDS congregation has a game night where young people gather, bringing their games and teaching them to others. Ted, his New York son, and Ted's friend Carson, travel to Pittsburgh sometimes to play games with Karl. Karl is our medical counselor of first resort and has been invaluable in that role as our ailments increase.

Margaret

Margaret and her husband, Michael LaBianca, made a very brave decision early in their married life. Margaret had had a painful time through school, sometimes taking off for longish periods. She had had several jobs with no future, working on a goat farm, coaching high school sports, reporting for a little upstate newspaper. Michael, whom she had met while running in the neighborhood, was managing a small company that removed asbestos from buildings. They decided to take a great leap to improve their possibilities for the future. Margaret applied to law school in various places and accepted an offer from the University of Arizona with financial benefits. They moved to that new place, and Michael took a job to support them. When Margaret graduated, she supported Michael through a master's degree in city planning. They planned for a future with two good jobs and wished for a baby, a house, and a dog. The first two were out of reach, but they did get a dog. Their daughter Claudia was born in time to be carried across the stage when Margaret received her law degree. Michael began school and was able to carry their second daughter, Frances, across the stage as an infant when he received his master's. They have continued to cooperate, working together on childcare and purchasing first one house, which they made comfortable and charming, and then renting out that house while they bought another larger house in a better neighborhood, which Michael has steadily improved. Margaret is now a Superior Court judge in Maricopa County. Michael manages city development projects for a large construction company.

Margaret and Michael LaBianca have three daughters, first Claudia, who graduated from the University of Arizona and from vet school at Washington State, prepared to operate on cows and lesser creatures. Frances, a graduate of the University of Arizona in journalism, is heading to law school. Libby, the third daughter, is attending Keene State University in New Hampshire from which her father graduated. Libby's big thing has been swimming and diving. She works as a lifeguard when she is not in school. She loves doing good for others, spending many hours working with a charity organization.

Serge

Back to our own children, Serge played the French horn in high school and marched in the Macy's Thanksgiving Day parade. After serving an LDS mission in Oakland, California—speaking Tongan—he graduated from Columbia University. He married Patricia Shelley, and they

Brick, Karl, Margaret, Serge, and Ben, 2021.

were soon off to Russia where he located investments on behalf of a US government fund to revive the Moscow economy. One of his successes was importing bananas to Moscow. He attended and graduated from the Harvard Business School where he organized and directed a singing group called Heard on the Street. He later took a job at Sprint in Kansas City and then other jobs in technology and marketing. He recently purchased the Little Pink House. Out of that house he runs a startup company called Woodcache. He aims to reduce the carbon dioxide in the air by burying dead trees and selling the carbon credits. He hires family members to work for Woodcache and to live in the Little Pink House. His wife, Patty, formerly a champion ice skater, wrote a book about a generation of ice skaters lost in a plane crash. She is an expert at compiling family stories and genealogies, gathering written accounts and pictures. From her many projects, she knows our family better than we do. After years in Kansas City, they have moved to Provo, Utah. Their daughter Shelley, who served an Alpine Mission for the Church, lived in the Little Pink House as a student and on until she married Rob Weatherford, a medical student at the University of Utah. She works as a historical interpreter. Her brother Peter attended the University of Vermont after creaming the college entrance exam. He studied Japanese language and culture and is seeking his destiny as a writer.

Ben

Ben, our youngest child, having just graduated from high school, drove north from Delaware to New York with us and began and completed his studies in engineering at Columbia University where he stroked the crew. He served an LDS mission in Japan, and on his return, he married a pretty redhead named Deborah Norton. They produced two children, Reeve and Gwyneth, before their divorce. Reeve is married to Aspen; Gwyneth attended the Oregon Art Institute and designs and dresses stage sets for a Portland theater. Ben lived in Fullerton, California, but has since moved to the Portland, Oregon, area. He later married Erica Hacking, an accomplished equestrian, and their two tall sons are Ayden, devoted to horses and engineering, and Asher, who hopes to fly airplanes.

Clarissa's Death

This parade of our children's lives was interrupted by the death of Clarissa, our eldest child, who died on December 15, 2018. She was sixty-two years old. Clarissa's death was a terrible shock to our family. Children should not die before their parents. That's not the proper order of things. Clarissa was a vibrant and accomplished woman. But her death was not a surprise. She had been ill for seven years.

She and her current boyfriend had been living in our New York apartment for the four years that we were away in California. She decided to stay with us while she had some minor surgery. She had an overgrown thyroid gland which made a lump in her throat. Others in our family, my mother and our other daughter Margaret had had such procedures.

Clarissa's children, Sloane and Montana, and Richard and I accompanied her to the hospital and whiled away the long hours of the day, waiting for a report. When the doctor finally appeared, she told us that Clarissa had advanced cancer, that her thyroid, her larynx, and her esophagus were widely compromised. The doctor had sewn up the preliminary wound and was waiting for the more experienced surgeon, Dr. Kraus, to do the necessary surgery. Soon after, Dr. Kraus removed her thyroid and repaired her esophagus, leaving an open hole, or stoma, in her neck. He cleaned out most of the cancer but did not touch her larynx. He said she had to consider the situation and make her own decision before he rendered her speechless. Within a day or so she made the decision, and she suffered her third serious operation in three days.

Clarissa said that it was the hardest thing of her life to lose her voice. She had been so good with sharp retorts and clever stories. She even had

Clarissa and Claudia, c. 2012.

a good singing voice. She signed up at the great cancer care hospital, Memorial Sloan Kettering, and was soon under the care of a notable oncologist. She began the long series of drugs and treatments familiar to cancer patients and their families. We all discovered that the medicines that attacked cancer have side effects. She had good luck with some which kept her cancer at bay for a long time, but along the way she suffered from many difficult side effects. She had chemo, x-ray treatments, and many tests. One x-ray revealed a growing tumor behind her right eye. Specially focused x-rays knocked out the tumor, but eventually destroyed the sight of that eye. She had shots and pills and patches, a wide range of medications several times daily that were frequently adjusted and changed.

She had thought that she would be able to return to teaching advanced economics at Stuyvesant High School. She was fitted with various technical aids, but they were not enough to overcome her difficulties and, in truth, the school did not think that she could continue. She retired early.

She continued to rise and dress most days, going to the theater and to visit with friends. She resumed her dancing classes and dressed up for many occasions. With her well-cut golden hair, her dancer's body, and her beautiful clothes, she was a striking and arresting presence. Men flirted

Clarissa, c. 2015.

with her at the theater. Her doctors treated her with more respect than they did their other patients.

She continued her life for six and a half years, even as her body deteriorated. She took ever increasing amounts of painkillers and was still in pain most of the time. Finally, she collapsed with a broken hip. She hadn't even fallen down. When her doctors told her that they no longer had any drugs that could help her, she was ushered into hospice. She had been on that regime just briefly when she fell in the bathroom and broke her other

leg. The hospice people thought that the leg should be stabilized rather than set. But she was still so much alive and so very much herself that her children and her parents thought she should go to the hospital to have the leg properly set. That was done. But problems developed. Clarissa couldn't get enough medication to ease her pain. She began to fight for breath. Sedating her enough to deal with that situation rendered her unresponsive. The doctors said that her disease had progressed to cause breathing problems. She was moved to a private room where her family could watch over her day and night. Her daughter Montana did not leave the hospital room until her mother's death a week later.

So, Clarissa moved on, leaving her family. People were very kind and generous to us. Her funeral services were well carried out by Richard and her children. Montana did an impressive slideshow from a lifetime of photos. The kids assembled a large, printed program with pictures and tributes. The funeral service—mostly with short talks by children, siblings, and friends—was excellent. The Church's Relief Society provided a nice lunch for a large group of attendees, relatives, students, friends, church people, and a group of old boyfriends. People from the many chapters of her life attended. It was a great event, soothing many past tensions.

I don't regret Clarissa's death. She had been sick for a long time. She suffered a great deal along the way and would have suffered more. She had said several times that she didn't want to live as she was doing any longer. She had come to a complete reconciliation with her children, and her children brought about a reconciliation with her ex-husband. She had been rebaptized into her family's church and chose to have her funeral there. She had lived a life of accomplishment, if not always of happiness and contentment. A continued life did not promise improvement.

Still, it is a terrible thing to lose a child, against the way things should go. We should be buried by our children, rather than burying them. We miss her. Years after the event we are still donating and distributing her many possessions. We have sent boxes and boxes to her nieces, her friends, and various charities. Her daughter Montana has moved many precious items to a storage unit in Connecticut to be dealt with later. I wear her colorful socks and one of her long white nightgowns. We have buried her ashes in our grave site in Salt Lake City. I don't want to lose any more children.

Richard and Claudia, 2023. Photo by Jon Moe.

–23–

The End of the Line

As a surprise to myself as well as everyone else, I find myself at eighty-nine years old, still alive and kicking. Of course, Richard is ninety-two, which gives me hope that I may be around for a few more years. But this is a good time to end this protracted portrait of myself. Before I actually disappear from the scene, I want to give a picture of my current life and state of mind.

I consider myself a very happy wife and mother in this changing world. I could not have asked for a better husband than Richard. We did not know each other very well when we were married, but all revelations since then have been positive, and we have been very happy together. I respect, admire, and thoroughly adore him. He is honest, ethical, and amusing. I would be very happy to spend eternity with him, and I hope that I get the chance. He has always been generous and encouraging. He works very hard at the things he does. We have now been married, at this writing, for nearly seventy years, longer than many people live. I would be very happy to be married to him for another decade—and more. We'll see what happens. The future is obscure.

And I am very grateful to have six wonderful children. It has been a great privilege to bear and get to know the six little people who came to our marriage. That was a good-sized family when they were born, and since then, families have shrunk. I'm grateful that I have so many children. I would be very sorry to have missed the chance to know my younger children. I need them all. They seem to like to visit with us and each other, and they have such wonderful children of their own. That's six children, twenty grandchildren, and at this writing, four great-grandchildren.

Where do we stand in the great society on earth at this time? We are fortunate to be Americans, Latter-day Saints, academics, New Yorkers, and many other things. A study in *The New York Times* analyzed class in the United States by ranking people in terms of their occupation, income, education, and financial worth. For a couple who watches their nickels, strictly limiting access to fancy restaurants, taxis, purchases, and travel, we came out very high. Our worth, which we do not want to spend, fits into the $1–5 million category, second from the very top group and high in the 90th percentile. Our education, two PhDs, again is very high. We

have more education than you can shake a stick at. We annually spend from our savings about $150,000 plus taxes and tithing, which is again high except for the few super rich. Only in occupation do we score lower. Compared to other professions, education comes out somewhere in the 80th percentiles. But even then, to be a full named professor and even an adjunct at an Ivy League university is honorific. Richard may be retired, and I may only have taught a couple of classes a year for a paltry sum, but we have gotten a lot of strokes out of Columbia and feel very grateful to be here. So as for class, we take back seat to nobody.

Then there are our living arrangements. When we moved to New York some thirty-four years ago, we were asked if we wanted a Columbia apartment. We did. We love our apartment ten stories above Riverside Drive with its view of the park, the Hudson River, and faraway New Jersey. We see an infinite variety of vessels, tiny and large, plying our waters. If we look upstream, we can see the George Washington Bridge. To my mind, we live on the best residential street in NYC. Park Avenue? Absolutely not! Too many big buildings and only a little landscaped strip in the center. Fifth Avenue? Okay, it has the park, but too much traffic and narrower sidewalks. Central Park West? Again, the park, and not too much traffic, so that's second best. But Riverside Drive, with its wonderful name, has a very good park of its own. We have the spacious gray or blue Hudson River, a wide and powerful river with New Jersey on the other side, out the windows of our bedroom and the living room. That's a real plus. We have dramatic storms and spectacular sunsets. We watch the construction on the New Jersey shore. We see the ships and boats go up and down.

The apartment does not have a real balcony or deck, just a couple of little walled ledges, the tiny "Juliet balconies" in real estate parlance, with their metal railings and small square footage. We have no fireplace. We do have a spacious enough living room for the kind of entertaining we do and a large enough dining room and front hall that we are able to have large groups over to meet and eat. We have two bedrooms and a maid's room, a kitchen with a washer/dryer, and two utilitarian bathrooms.

We have had our studies, one for each, in several rooms. At present, mine is our bedroom, and many days I feel as if I live in a studio apartment, tumbling from bed to the desk and back some hours later. Richard's study is currently the second bedroom where the generous space is piled with and surrounded by books, boxes, and papers. Our second bedroom has sometimes been my study and workshop, and more often we have had the company of one of our children. They have a fair amount of privacy,

The End of the Line

Living room of our Riverside Drive apartment, 2024.

if not much space. Ben lived there for some of his college years, plus after marriage for a while with Deborah. Margaret lived there while working on her master's at Columbia. We should have had Serge during his years at Columbia, but he lived nearby on Tiemann Street. Clarissa lived here after her divorce from Charles. The space has been a great help to various people during difficult years, and we have enjoyed having them around. The visiting grandchildren are around more often now. They are quite willing to sleep on couches or in groups and love the chance to visit the big city. We welcome guests, but we do not cook for them. They are welcome to eat whatever they find in the refrigerator and to wash their clothes in our machines. On occasion, I vacuum and empty wastebaskets.

This apartment is owned by Columbia which imposes a rent, somewhat subsidized and so lower than that of the market at large. I think we pay about $2,800 a month rent at the moment. The rent goes up about 3% a year. To buy this apartment would cost several million dollars. And with its amenities of location, convenience, view, it would be a good buy. But then there would be a monthly fee about the size of our rent for maintenance or whatever. So, we have had no incentive to enter the market, which continues to rise. The place is old, but Columbia fixes things up.

When a large chunk of cement and plaster ceiling, maybe five-foot square recently descended, the result of some obscure water leak, a crew was in for repairs within a few days.

I am grateful and happy to have been a member of The Church of Jesus Christ of Latter-day Saints which has had a tremendous influence on me over many long years. I was glad to be a little Mormon as I grew up, participating in many church activities. I am grateful to be an old one, still believing, still attending, still organizing church activities from time to time, still benefiting from the influence of the leaders and the community. I always say that everything I ever needed to know I learned at church. And I mean singing and dancing, speaking in public, and organizing big projects—as well as the gospel story.

My life has been a great gift to me. I have had wonderful opportunities and blessings, being born in the Church and active there all my life. To have been the daughter and wife of church leaders, to have been able and encouraged to create many events and activities on my own. The Church has been a wonderful arena for me to live in and to be able to play out some of my interests and abilities. Mormons are great workers and when asked to help with something, they say "yes!" The people are willing to help and work, and I've been involved in many, many a great event and project. That has given me the willingness and ability to work with larger groups outside the Church who are sometimes less willing than Mormons to say "yes." The Mormon model is my idea of good world management.

I was fortunate to grow up in San Francisco with her dark blue bays and foggy skies. I was lucky to be one of four sisters. I was fortunate to have been plucked from the West Coast to attend Wellesley College on the East Coast. That opened a whole new world for me, a new world of academic possibility, a place that was once a foreign country to me, a lifestyle that became familiar.

Of course, I was fortunate to marry Richard Bushman, fortunate to be in the small pool of his prospective mates. I was married after my junior year in college. I'm not so sure that we should have done that. We probably should have waited until my graduation. I lost my scholarship and had a very different senior year as a commuter than as a regular college person. I'm thankful to my generous parents who made my continuing education possible. And I am very grateful to have been able to graduate with my class, which I did in maternity clothes. Fortunately, graduation gowns hide many irregularities.

So, I am very grateful for my life. I am proud of my husband and my children. I am even proud of my books though most people have never heard of them.

1. *Mormon Sisters: Women in Early Utah* (Cambridge: Emmeline Press, 1976)

This was the first published book that had my name on it, as editor and contributor. It consisted of articles by the women of our early LDS study group. The writers were housewives who researched topics and presented lectures, then wrote them up. When we could not find a publisher who would take them on, we started Emmeline Press and published the book in 1976. It was later republished by Olympus Publishing Company in 1980 and 1984, and a new edition was published by Utah State University press in 1997. The book, an early example of women writing about women, has sold well over the years.

2. *"A Good Poor Man's Wife," Being the Chronicle of Harriet Hanson Robinson and her Family in Nineteenth-Century New England* (Hanover: The University Press of New England, 1981)

Studying the lives of ordinary women of the past at Boston University, I discovered the excellent run of diaries of Harriet Robinson and wrote my PhD dissertation about her life. Some people really liked it. Harriet and I lived together for many years. I share her every birthday refrain, "Fifty years old [or whatever year] and come to nothing yet."

3. *"So Laudable an Undertaking": The Wilmington Library, 1788 to 1988* (Wilmington: Heritage Press, 1989)

I began the press mentioned above when I worked for the Delaware Heritage Commission. We published significant books about local matters celebrating our state as part of our commemorations. Our designer at the time made this a very beautiful little book with a pearly pink cover and fold-out pictures.

4. *America Discovers Columbus: How an Italian Explorer Became an American Hero* (Hanover: University Press of New England, 1992)

I wrote this book on moving to New York. Working on it helped me to feel at home in the big city.

5. *In Old Virginia: Slavery, Farming, and Society in the Antebellum Journal of John Walker* (Baltimore: Johns Hopkins University Press, January 2002)

This is my distillation of the massive amount of information written by John Walker in his extensive journals. Almost everything I know about farming, I learned from John Walker.

6. *Contemporary Mormonism: Latter-day Saints in Modern America* (Westport: Praeger, 2006); (Rowman and Littlefield, January 2008)

This book was commissioned by Columbia University Press for a series they were doing on contemporary religion in the United States, but Columbia turned it down as not critical enough. The book was picked up by someone else.

7. *Our Journeys Through Life—and Literature: the Wellesley Class of '56 Fifty-five Years Later* (Dexter, Michigan: 2011)

This is one of the three extensive year books I have edited for my Wellesley class. I also co-edit a quarterly newsletter called *Scarlet Letters*.

8. *Pansy's History: The Autobiography of Margaret E. P. Gordon, 1866–1966*, #12 in Life Writings of Frontier Women (Logan: Utah State University Press, 2011)

This is the print version of the handwritten autobiography that I found in my grandmother's papers. None of us was aware that it existed. I edited it, added letters and notes, and published it.

9. *Mormon Women Have Their Say: Essays from the Claremont Oral History Collection,* edited with Caroline Kline (Salt Lake City: Greg Kofford Books, 2013)

This is some of the fruit of a $10,000 gift to the Mormon women's history class of the Latter-day Saint program at Claremont Graduate University. We used the funds to begin an ongoing oral history program.

10. *"Going to Boston," Harriet Robinson's 1870 Journey to New Womanhood* (Hanover: University Press of New England, 2017)

Here I revisited the life of Harriet Hanson Robinson, always a pleasure.

Claudia Bushman, the lady lecturer, c. 2023.

I am a person who likes neat guidelines, so I am going to finish with my rules for life. What have I learned? What ideas govern what I do? Ten rules seems like a good number.

1. I'll start with my old *If you keep up, you'll never get ahead*, which has helped me so much.
2. *A record shall/must be kept.* Even a bad record. Something must be created and preserved of the present for reference in the future.
3. *Every cosmopolitan needs a homeland.* Thank heaven for The Church of Jesus Christ of Latter-day Saints which I love and belong to. It also belongs to me.
4. *If I didn't quit, I could never go on.* Starting and stopping is the rhythm of life.
5. *Working together is better than working alone.* I am grateful for my life with Richard.
6. *Every event is improved by singing and dancing.* This has been proved over and over.
7. *It is possible to be happy even when you are miserable.*
8. *Finish your work.*
9. *A soft answer turneth away wrath.* Anger is not productive.
10. *Make order wherever you go.*

Is that enough? Looking back, I feel the need for additions. Given the chance, I may create a whole new life.

―Part Four―

Essays

–24–

How to Live a Life

I gave the following as a talk in Fullerton, California, on Sunday, January 18, 2009, to a group of Latter-day Saint teenagers and their teachers.

I appreciate this invitation and the chance to talk to you this evening. I am going to tell you how to live your life. I have had a lot of experience and can tell you things that will really help you. You may not believe me when I tell you what to do, and you will not remember much of what I say. But try to remember something. It will help you down the line. Guaranteed.

Life is hard. We all have to accept that fact. We will suffer. If we can accept that we will have problems, have to work hard, be required to do things that we don't want to do, and be disappointed in many ways, then we can face our problems, find much happiness along the way, and go on, despite the problems.

We will even find that if we truly strive to do our best, that we will find much compensation and satisfaction and happiness and find that if we earnestly strive to do things the Lord's way, that His yoke is easy, and His burden is light. Knowing that things are hard and that you will suffer, try to do hard things. As Shakespeare told us, assume a virtue if you have it not; that is, try to pretend to do the good, hard things, knowing that it will help you to do better.

Church is a great, great help to you in living your life and in doing all the hard things.

And I'm not even going to talk about the religious aspects which you know already, that you have direct access to your Father in heaven. When you need His help and comfort, you will receive answers to your prayers. You can have the still small voice of the Holy Ghost to be with you and guide you in your actions. I am not going to talk about those aspects. I am going to talk about the more mundane things of everyday life. Again, the Church can be a great, great help to you.

Everything in the world—that is, below the heavens—is personal relationships. No matter what, you have got to learn to talk to and to get along with people. You must learn to look them in the eye and speak

pleasantly. My mother used to drill us in this, and I must say that it has paid off handsomely during my long life.

At church people will compliment you on your talks or say how pretty you look. Smile, look them in the eye and say, "Thank you. That's very nice of you to say so." Try not to devalue any compliments that come your way. I know that it's a great temptation to say: "This old rag, I've had it for years." Or "My father wrote that talk." Or "I just copied it out of a magazine." Do not do that.

Do not look at your feet and mumble. You can blush if you want to, that's okay, but you must look up, look into their eyes, smile, and say thank you. If you can follow that up with a little comment, "I learned a lot reading a book about it," or "I was really scared," or "I'm glad it's over." That's even better. Learn to appreciate what people say to you and say a little more to move the conversation along.

What we have in the Church, in our wards, our congregations, our stakes, is a village. This is the village that it takes to raise a young person. That's you. You will never have, except in your own family, people who love you, are as interested in you, as willing to help you, who will go out of their way for you, as the people in your ward. They watch you. They are examples of the people you will grow up to be. They keep up with your achievements. They wish you well. They will give you advice. They teach your classes, run your scout troops, chaperone your dances. They listen to your talks and congratulate you on them. They may help you get summer jobs. They will wish you well on your mission. They may send you a check. They will come to your wedding reception and send you wedding presents. They will compliment you on your babies down the line. These people are a great, great resource to you.

Lesson I. Get Along with Them, Be Their Friend

Practice being warm and friendly to ward members. Congratulate them on their new dresses, their handsome ties. Offer to help them. "Let me carry that for you, Sister So and So." Practice your important human relations skills on them. Here's the drill. You need a little answer and something else.

They may say, "Hello, Johnny, how are you today?" You smile, look them in the eye, and say: "Very well, thank you, how are you?" Then listen when they tell you about their state. You do not offer to shake their hands; as a young person you wait for them to initiate that formality, but if someone offers you a hand, you take it with a firm grip.

Practice these things with the missionary elders. They have learned to be fearless.

Your older friends at church may say, "What a pretty dress you have on." You say, "Thank you," and something else: "Thank you, I got it for Christmas," or "My Mother made it. I always wanted a green dress."

Johnny, "you're looking very handsome today." "Thank you, I have a new tie, and I like yours too." Or "Thank you, I tied this tie myself." What you are doing, what you have to learn to do, is to grease the wheels of human interaction.

They may have something to offer. What you must learn is to keep up a civil conversation with someone you might not generally be comfortable with. But the conversation might lead to something. "Do you ever baby sit?" "Do you mow lawns?" "I have a green necklace that would look very good with that dress."

It takes a village, and you are part of the village. Lesson I is to talk to, get acquainted with, and be friends with the people in your village.

Lesson II. The Plan for Life

It is important, it is essential that you have a plan for your life and to be able to state it in two sentences. Keep it simple. Adults like to say, what are you going to do or be when you grow up. Actually, they're uncomfortable talking to you, too, but they will ask you what you plan to be.

Do not say, "I don't know," and kick the dirt. Do not say, "I have so many interests I can't decide." You need something short and specific. You can say something charming. My son Brick, when asked what he wanted to be, said "a dancing bear." That's pretty good. He was little. He meant it. Another time he said he wanted to be a scholar, like his father. That was good, too. Something specific, something ambitious. He became an investment banker, but to tell the truth, with the other musical things he does, he still is a sort of a dancing bear.

You can say two specific things, no more:

"Well, I want to be an astronaut, so I can fly in space, but I like to write poetry too."

"I'm going to be a veterinarian. I've always loved animals."

"I'm going to work for an airline so I can travel to lots of interesting places."

"I'm going to teach school so I can work with little children."

"I'm going to be a wife and mother, and when my youngest child is in high school, I'm going to go back to school, study law, and specialize in immigration problems."

Specific is always good. "I'm going to be a Broadway actor. That's why I am studying singing and dancing and act whenever I get the chance."

So you have to have a lifelong destination. You must have this direction at any point in your life. It's no fair to fly free. You have to have a direction. But feel free to change it at any point. You just have to change from one thing to another. "I used to want to be a neurosurgeon, but I have decided instead to be a flamenco dancer."

The thing is that you always need to have a direction and be heading there. If you have no destination, any path will take you there. That's nowhere. You need purpose. You need focus. You need direction. But you can change. Nothing you ever learned in the past is lost. If you have a purpose, you can do something every week toward your goal. Subscribe to a magazine, visit a place, look at a book, save clippings. Talk to someone who has reached the goal.

So Lesson II is that you need a plan for life.

Lesson III. Sense of Time

Related to that is that you need a sense of time—a different sense of time than the people you go to high school with. For many of them, high school days are the best and the only times of their lives. Many of those high school smarties do not look beyond those days. You have probably seen *Napoleon Dynamite* and remember that pathetic Uncle Rico who is still remembering the time the coach did not send him into the football game and how he did not become a hero. Not only did he not throw the touchdown pass, he was not even in the game. He can't look beyond those days of glory he didn't even have.

But we in the Church are very, very fortunate to have a different frame of reference. We live in a ward with people of all ages. We can know those people. We see their years of experience stretching well beyond high school. We can watch friends five or ten years older and see them making decisions. We also live in the dispensation of the fullness of times, in a huge universe where we progress forever. None of you will be has-beens at age 18. You will go on.

You know that there's a future beyond high school. You know that there's a future beyond mortality. That makes a difference about how you see your life and spend your time.

So Lesson III is: know what time it is and prepare for the long haul.

Lesson IV. Be a Good Mormon

Many years ago my mother told me a story about a man who was in a plane crash in frozen Iceland. The crash wasn't too serious, no one was injured, but they were off somewhere in the icy wastes, all freezing. The stewardesses managed to get something going and began to pass out cups of hot coffee. This man had a little difficulty with this coffee, because he was a Mormon, and he had standards, but it was very cold, he had come near to losing his life, he was freezing, and he considered this a special case. So he took his cup of coffee and began to drink it. The man who had been sitting next to him on the plane, to whom he had said something about his life, came up to him, holding his own cup of coffee, and saying, "You're not a very good Mormon, are you?" All his years of being a good example, and he was caught with the goods. He felt terrible.

Sad, but true—we are judged by different standards than others. That being the case, we really must abide by the Word of Wisdom, one of the most visible markers of Mormons. As long as we are Mormons or even have been Mormons, we will be judged as Mormons.

We have lots of good reasons to obey that church law. We'll be more healthy. We will be spared the significant financial costs of using any of the big four. We will be in the group that knows how silly and unattractive people who drink can be. We are less likely to be caught or killed while driving under the influence. We avoid the awful risk of becoming addicted to the substances involved.

There are lots of very good reasons not to smoke or drink. But to me, the most significant is that we compromise our claim to be good Mormons. We often do this in all innocence. We know that these are not really damaging substances in small amounts. People think: "No one knows that I'm a Mormon. People make so much of wine and coffee that I'd like to try it, etc."

But it is a major marker and really a pitiful rebellion. If you want to rebel against the Church, do it on doctrinal grounds or something major. Another one of my mother's related maxims was: "Don't be a thief for fifty cents." The gain is not worth the loss. So Lesson IV is: we're Mormons. Let's be good Mormons.

Lesson V. Learn to Speak

You will use the lessons you learn in Church the rest of your life. These are serious investments. They bring dividends. Speaking in public is one of the Church's great gifts to you. Years of practice giving little talks in

Primary and sacrament meeting, years of bearing your testimony, years of discussion in classes and seminary give you a terrific leg up in the world. You will do better in school if you can talk to people. You will do better at work. Speaking well can change your life.

An example of this is the high school experience of my husband. His family moved during his high school years. So he attended a second high school, even though he did not move out of the city. Some of you may have had that painful experience. He went from being somebody to being nobody. He was lonely and lost at his new school. He ate lunch alone. He did not play any sports. He was not in any clubs. He didn't know anyone.

But he did have friends at church, and one day one of them told him that he would have to run for student body president, at a new school, knowing no one. The friend said that LDS leadership was a tradition at the school and that it was his responsibility to take up that tradition. He was incredulous. He was astounded. He was terrified. But he decided that he would run. He would do it for the glory of God.

He had no posters, no campaign manager, nothing, but he could give a speech. He'd had a lot of good church experience with that. So he gathered a few jokes, made an outline, thought of a clever way to end the talk, and when the day came, he gave his speech.

Now all of us know that there are certain leaders in high school who expect to be voted in to office. They know who they are, they expect the honor, and they are generally elected. They expect leadership positions as entitlements. So they don't work very hard to prepare for the chores ahead. So while Richard prepared his talk, the other candidates did not prepare talks. They got up, mouthed a few platitudes, and kicked the dirt. Richard, on the other hand, got up and gave his funny, well-prepared, and entertaining talk. He won the election. Being a Mormon with all that built-in training helped him to a position that changed his life. We learn lots of skills at church.

Lesson V is to learn the skills that will help you and use then. They will help you in the greater world.

Lesson VI. Work a Little at a Time

We always know what we should do in general. But we may be overburdened with too many things to do. What we need are a number of little strategies to get things done. For example, I should tell you about my lists. They serve me and I serve them.

I always want to be a better person, but it's hard for us leopards to change our spots. I just can't seem to make myself better. But I can always do better, at least temporarily. That's a simpler job.

So on my lists I only put things to do. I may have lists where I put long-term goals, but unless it's a long-term goal I have to complete in this week, I don't put that on my list. Instead I put on things that can be accomplished in a much shorter time. Some are very simple, parts of a much bigger scheme, but I just want to get them done.

I can't put too many things on my list—no more than a page with some space left over to add a few other things. And I need space to write down a telephone number or do a little arithmetic, messing up the page. When I do something, I cross it out, and I can measure the success of my day by how much I can cross out.

Now, of course, there will be emergencies and things I remember I had to do, other things that I have to do although they are not on the list. That's okay. I write them on my list, maybe after I've done them, and then cross them out. Success. I also try to put several things on my list that I want to do: read, knit, call someone. Don't give up things you love to do; fit them in.

At the end of the day, I will have a messed-up, scribbled-on the list. So I write down on a clean page the things that didn't get done and add other things to do tomorrow. Once I get that thing onto one of my daily lists, it generally gets done. But I have other big things I have to do. I may hold them for a while before I actually put them on my daily list. I live by floating lists.

Calendars. Very low tech. See a month at a time. Go over it every day. Do you have deadlines? Use them. Much harder to do things after the deadline. I always tell my students that the simplest way to do well is to observe every deadline.

Once when I was a freshman in college, I had a little paper I had to write. I knew about this paper. I had done the reading and worried about it for some time. But I had nothing to say. I couldn't write it. I stayed up all night the night before it was due, waiting for inspiration to strike, trying to get myself to write that paper. I could not do it. That would be the last day of class before spring vacation. Things were closing in on me. I went to class and told the professor very shamefacedly that I did not have the paper, that I just could not write it. She was not shocked or surprised. She did not excuse me or comfort me. I don't know what I was expecting. She said, "When can you have it written?" In all hopelessness I answered,

"This afternoon. I'll turn it in today." And I went home and slogged out a terrible paper and turned it in. Actually it was about the same kind of paper I generally managed to write.

If you have a hard assignment coming up, sit down at your computer and spend half an hour writing out little germs of ideas. What do I want to talk about? Write a first sentence. Maybe some more. Save it. The next day, bring up the file, edit it, and add some more. Your mind will help you to have more to say each day. Get out the book you have to write about. What is interesting? Write that down. Spend a little time each day, gradually more. You will have a paper. Clean it up, print it out, hand it in.

All of us suffer from writers' block of one kind or another. We have nothing to say, can't write, and so on. Here is the rule for that. If you just cannot manage to write up to your standards when you have to write something, lower your standards. Write anyway.

Do you want to read your scriptures and never get around to it? My advice is to read in the bathtub. Get a cheap Book of Mormon, or something, tear off a few pages, read them in the bathtub, and when you have finished them, get out and throw them away.

I heard another idea along this line the other day. Maybe less sacrilegious than the tub idea. When you make your bed, put your scriptures on your pillow. As long as you have to move them to get into bed, you might as well read a chapter before turning off the light.

So that's Lesson VI. Work away at your work; develop strategies to get things done.

Lesson VII. Work Well Together

You learn things at church that will serve you well the rest of your life and into eternity. If God was once like us, wouldn't he have had to do lists when he was young? Wouldn't he have learned how to balance his time? Keep his room neat? Do his homework? Manage his money? Show up on time to fix the sacrament? Polish his shoes?

We have more opportunities to learn how to do things than others. The Church is a great school. Everything I ever had to learn, I learned at church. We learn from our earliest days to plan little class parties, to organize outings, to call people we don't really want to talk to. We learn skills that will stand us in good stead the rest of our lives. How to sing in choruses, how to give talks, how to dance the tango. And we learn that it is not the party that matters, it is learning how to run the party. It is not giving the speech that matters, it is learning how to construct and give a

speech. It is not planning the event but learning how to get along with the planning group. We learn to treat the people we work with well, and they learn how to treat us.

And one of the greatest opportunities we have for getting our lives in order is to serve a mission: a couple of years under strong discipline, having to get along with someone you might never even want to know under other circumstances, doing hard things every day, but finding true warmth and brother- and sisterhood. That will make an adult of you. You will grow up. You will get over high school for sure and focus on the future.

It is a great pleasure and privilege to be able to devote your life for more than a year on something of such importance, serving Heavenly Father and your fellow men, to focus on something outside yourself. To work very hard at a worthwhile chore. But as with all the other things I have been saying, the religious benefit is only one of the many that will come to you from this service. Take the opportunity seriously.

These are some of the lessons of life that I hope you will learn.

- Lesson I. Make Friends with the People in Your Village
- Lesson II. Have a Plan for Life
- Lesson III. Know What Time It Is, and Prepare for the Long Haul
- Lesson IV. Be a Good Mormon
- Lesson V. Learn to Speak
- Lesson VI. Do a Little Bit at a Time
- Lesson VII. Work Well Together

What an opportunity lies before you. Even in these bad days. Do well and you will get better. You will make mistakes. Try not to do it too often. You have a great and long future ahead. Make the most of it.

–25–

The Bushman Plates: A Tale of Lust and Material Culture

In my later years I have become a fanatical collector of plates and other dishes. Where did this fixation come from? What is there about china and porcelain that draws me?

My mother had worked at the May Company in Los Angeles as a young woman, and there she saw a few nice things and got a taste for them. She actually bought herself a few after she was married. She was touring the Oregon territory with my father, the traveling salesman, when her mother decided to spend a year in Salt Lake City studying genealogy and needed some financial help. Mother then took a small apartment in Portland and got a job at Meier and Frank in the china department. It was there that she accumulated a very few pretty dishes.

My mother had mostly serviceable dishes when I was growing up. And she continued to use serviceable dishes for most daily dining during her life. But I do remember the happy day in San Francisco after my father actually paid off the house he had bought for us several years before. Then we began to assemble some nice furniture for the house we had been living in. As the house became more than respectable, lovely and gracious, my mother decided that the family could afford some nice dishes and some silver flatware. I remember Mother's happiness as she shopped for a set of dishes with twelve of everything and some interesting matching serving pieces. She chose a formal floral style with lots of dark red and golden rims. Nice, but not the highest price. She made a similar compromise when she encountered the price of sterling silver and decided that the cost was just too great. She settled for a nice silver plate. Both silver and china are still in the family, being used to this day by her granddaughter, Kathie Kern, and stored in the buffet that Mother bought secondhand, along with chairs and a dining table to use them on. My mother, as creative and accomplished a homemaker as anyone could imagine, served elegant repasts without number in that dining room, on that table covered with snowy linen, on those chairs upholstered by her, with those warm red plates, with that gleaming silver flatware, with candles and chaste arrange-

The Bushman Plates

ments of flowers from the backyard. She was widely known as a supreme hostess and had created that world in her charming green dining room.

When I chose wedding dishes, I wanted simplicity, harmony, elegance. I chose what seemed to me perfect dishes: Franciscan's simple coup plates in a dusky blue with silver rims. These "Twilight" plates were simple, so I chose a heavy and elaborate sterling silver with a teardrop shape in the handle of each piece. Lunt Silversmiths made the set called Eloquence, rather suitable for my husband who did much writing and speaking. He was heavily involved in the selection of these dishes, and he wanted something suitable for when the governor came to dinner—a rather daunting possibility.

We registered for these dishes, saying that we hoped to get some as wedding gifts, at ZCMI in Salt Lake City, and received a dozen each of dinner plates, salad plates, and bread and butter plates. I saved them for the governor, but although we have known several governors, not one has yet graced our table. We received the Eloquence silver mostly in San Francisco where we had another wedding reception, and we began married life with ten place settings and many assorted extra pieces. We used that heavy, beautiful silver very often. Alas, it is gone. Our sterling silver, in its handsome rosewood box atop the dining room buffet, was stolen while we lived in Delaware. We did not replace it with the insurance money, instead using that for a year of college for our second daughter, Margaret. We make do with stainless steel and some modest silver plate ordered from Betty Crocker, paid for with coupons and small change.

Dishes began to accumulate in New York City. As we were entertaining large groups of people at buffet dinners, we needed a good number of matching dinner plates. I knew of a downtown outlet likely to have simple, unadorned dishes. Traveling down on the bus, I did a little math to figure out what I could afford. If the plates were $5 each, I could get a dozen for $60 and maybe even go for an additional six to $90. If any were as cheap as $3 each, I could get two dozen and feel very good about it. When I arrived at the store I found great stacks of simple white china plates, the exact kind I was looking for, pristine and seemingly perfect but with tiny imperfections. The price? $1 each. That is why I have thirty-six nice white plates. I wanted enough plates that an occasional broken plate would not break my heart. As it is, we haven't lost a single one of those white plates through more than twenty years of heavy use.

But I was not finished. While in Delaware I had begun a project with the Mottehedeh China company to create a set of dishes with versions of

the state seals of the thirteen original states that had been used on a handsome old etching of the Declaration of Independence. Long ago, some Staffordshire blue-and-white dishes had been created in England with a different state seal on each dish shape. Delaware was on a large platter. I had seen this handsome platter a number of times as it is on display in the dining room of the governor's mansion in Dover, Delaware. I deeply wanted to recreate that platter as a celebratory item. I had researched the dishes and bought a large copy of the Declaration. I called Mottehedeh with my idea and was invited to New York to discuss the potential project. Three of us talking there decided that we would like to see a set of thirteen dinner plates, one with each state seal on it, and maybe a bowl, a pitcher, and a platter. I hoped I could get Delaware on this last one. The only dinner plate in the original set had the New York seal on it, and there was one of those plates in the New York Historical Society. Was there a chance in the world that I could get that plate to copy? I had the job of borrowing the plate. Fortunately, I knew the director of the Society, and amazingly, he was willing to lend it and have it sent to England to be copied. Mottehedeh had a nice base plate like the original, the exchange rate was good then, and the English artisans copied the design and created a few of these New York plates, one of which I have. It was a bold, audacious, far-seeing, sort-of-expensive project—just the kind I like. We were in talks with the Smithsonian Institution which agreed to feature this grand set of plates on the cover of its Christmas catalog. It was a great project. But then I moved away and the project fell apart. I have three plates from the projected set, all that were ever made. How I wish that project had been completed! How I wish that I had them all! Maybe it's the lack of those other ten states that began my dish frenzy.

Later, during a family reunion near Rhinebeck, New York, I was wandering through an antiques store. I was more than a little interested to come upon another set of thirteen plates that were similar but different, this time a set of Wedgewood plates from 1936 depicting images of the buildings of Columbia University. I was at the time engaged in committee work to commemorate Columbia's 250th anniversary. I was working with the dean of the school of dentistry, who had a set of these Columbia plates in a special glass case in his office. I had admired and coveted these dishes, but I knew that they were far out of my reach. But here they were again! And the price was not impossible. Surely, we should have them. Back at the reunion I rehearsed all the Columbia degrees in the family. Ben and Serge both had BAs. Clarissa had an MBA. Margaret had an MA. Four

Columbia degrees! Who wanted the plates the most? To my surprised chagrin, none of the children wanted them at all! I tried to raise their enthusiasm, but to no avail. I told them they were missing a very good chance and they would later regret it and made many other such comments. No takers. When we left town, we left the plates in the antiques store.

Months later, at Christmastime, I received a very large box from my daughter-in-law Diane in Pittsburgh. I read the card saying that the gift was not just from her family but from all my children. What could it be? Yes! I have the blue-and-white Columbia plates. I love them! I am thrilled to have them! I love to know that they are stacked up there in my cupboard. I am often modestly proud when I use them for dinner parties and ladies' luncheons and tell my impressive little story. I am just hoping that some grandchild will go to Columbia so that I can pass them on.

Up through most of our time in New York we had a single small kitchen and a limited collection of dishes. That changed when we bought our Little Pink House in Provo, Utah. This was a family house, built by Richard's great-grandfather. Lost by the family for twelve years during the Great Depression, the house was bought back by Richard's Uncle Bob who lived there with his family. After Bob's death, his wife, Jessie, married again, living elsewhere for a while before she returned, a widow twice, to live in the house. She had also rented it out to others over its long years. When we got the house, we furnished it with old things, bits and pieces, and rented it out some more. When we were there for three months in the summertime, we bought things that we felt it needed. The house came to us with a utilitarian set of Pfaltzgraff Pottery for four. I added to this by frequent trips to the Deseret Industries Thrift Store. There I got miscellaneous dishes in dark blue and white, leftovers from other people's collections. When they broke, I replaced them with new dishes.

For entertaining, I tried the New York plate solution and found some plain white china plates to feed crowds. I already had thirty-six in New York, but I bought another eighteen to use in Provo. Then I was seduced anew by blue-and-white plates. They went so well in our little house with its dark blue living room wallpaper. I fell in love with Spode, a company that had been making china with blue-and-white designs since early in the nineteenth century. Theirs was the most familiar Willow design, dating from 1811. They did exotic florals, scenes of grand old cities, exotic animals in ancient zoo enclosures, pastoral scenes of milkmaids and their swains. Spode began to issue some of their old designs in sets of six plates, all named and dated on the backs and identified as coming from Spode's

Blue Room series. I found these so entrancing that I bought a set of six to use. Then they began to turn up as leftovers in some of the cheap stores I frequented, and I bought them. People sent me gifts.

I had about two dozen when I suffered the great plate disaster. Following a buffet dinner for which I had used the Spode plates, I stacked the cleaned plates on top of the refrigerator, ready to be put back into the high cupboard. I was slow in getting to that task, and every time I opened the refrigerator, the plates edged forward, until that awful moment when two dozen heavy blue-and-white china plates fell on my head, many of them shattering on the floor. What a catastrophe! I wept in pain, sorrow, and rage. My plates! My precious plates! I sank to the floor, sobbing bitterly, to survey the damage: many of these plates were beyond any repair, some with chips were still usable, a few were okay. It must have been at that moment that my mind snapped and it became essential to acquire more and more dishes. I sorrowfully threw out the broken pieces, put the good plates away, and went shopping.

Since then I have been insatiable. More everyday blue-and-white plates, more Blue Room plates—doubles of the ones I like—clear blue glass pieces to put in front of the window, interesting pots to grow plants in, a showcase full of decorative blue-and-white items for the living room cupboard, blue glasses in sets and singles. I don't even look at expensive plates. My searching is in the thrift stores, among the leftovers, the remainders, the sale items. But even with these limitations, I can almost always find something I like, decide I must have, and then purchase.

When we took on yet a third dwelling for a year in Pasadena, I had no difficulty assembling a very nice, coordinated set of mix-and-match blue-and-white dishes to take with us for general use. These were, of course, gathered from assorted sources and we left plenty for use in the Provo house. I was pleased that I had provided so well for this next place. We had a nice little dining room in our new apartment, we were told, but I was shocked—shocked—to discover that it was green, all green, and very green. I could not possibly use my blue dishes in that green room. I needed some new dishes.

And there are other excuses. I was in a new place, cut off from comforting surroundings and friends. My shopping genes which emerge in trying times began to shriek for attention. I was in a small place. After getting a few pieces of furniture, there really wasn't room for any more. The same could be said of clothes and other household fripperies. I did not need them. But one empty place remained: the dish cupboard in the

green dining room. That called for charming additions. I had a place, and I had a need.

So began a new search. I had to learn to see the green dishes that had previously been invisible to me. I had to find new sources to seek them in. I had to assemble enough individual units to make a dinner possible. I threw myself into the chore with a frenzy. I went out and bought. I started to assemble sets from the crumbs available to me. I made mistakes. I bought things I didn't really like. I started over. I had to find things that were valuable, not from being readily available, but because they went together and satisfied my aesthetic needs. Also, they had to be cheap. I would go back and start anew.

At first, I thought I could assemble an interesting set from disparate things. But the items were too different and did not satisfy. Then I settled on a set of large, heavy dishes made in China, as so many dishes seem to be today. They came in many colors and I decided on the green, but I could not find enough pieces of the green. So I matched those half and half with a rosy pinkish red, and then I had a wonderful set for Christmas and any other time. I got four each of green and red dinner plates and salad or dessert plates and nicely shaped soup bowls. These plates were all decorated with spiral designs, as if once painted with glaze, they were put back on the turntable and spun while a finger or some other item moved from the center to the edge. The designs, done by hand, were all slightly different. They had something I love: circular stripes. The plates were rolled or painted on the edges with a brownish red paint that gave them an attractive gravity. A few small brownish red dots were sprinkled on the edges. Enchanting! I also got a few green serving pieces and had a very satisfactory set of dishes that looked beautiful on my table, on a green or white tablecloth. I was very happy with them.

But I was not done. I found an intriguing green, luncheon-sized plate made in Portugal that had a rabbit molded in the center. Even better than that, it had a raised border of a carrot design: the rabbit was furnished with his own food. That's the kind of plate design that has real magic for me. I bought the plate thinking I could use it to feed a grandchild. Imagine my excitement to come across a similar plate with a pig on it, and this surrounded by an acorn design. What a pair! And before long I came upon a cow plate with a pumpkin border and a chicken plate with a corn border! I had a set of four! I kept hunting for more animals, but instead I once came upon a cache of four with a chicken, a cow, a rabbit, and a pig, all at once! Now I had a set of dishes for a party of eight. When I got the

chance to buy, on different occasions, a matching pitcher, bowl, tray, and teapot, I quickly snapped them up. The little green dish cupboard in my little green dining room was filling with pretty pieces.

And still, I could not stop. Once more an individual piece and design began to speak to me. I found a fish=shaped pottery plate. The fish was in profile, painted with fanciful colors and about the size of a salad plate. I loved it! Then I saw another with the same base painted in different colors. These would be charming for dessert or a fish course, I thought, so I began to look for them. These brilliant pieces, made in China, had Hispanic names: Talavera, Terra Bella, Madrid, Mexicano. Sometimes two colorways had the same name. When I saw some long fish, perfect for bread, I had to have two in different designs, and of course I could not resist some small matching fish where a person could put salt, bones, or olive pits. The dishes of this kind that I liked best were orange in color with a large yellow shield or device on each piece that held a stylized flower, as well as green leaves and borders and curliques in various colors. The warmth of the orange and the excitement of the varied bright colors and designs and the slapdash hand painting on them were very appealing. I began to buy a piece or two when I could find them.

I bought an orange pitcher and six tall orange flagons to drink from. I began to get a few cereal or dessert bowls when they would turn up. The plates seemed to be squares, both large dinner ones or smaller salads, so I got some of them. A few really spectacular serving pieces, a low casserole that was green with an orange center and design, a very nice covered tureen, a really commanding tray with divisions for relishes, appeared so I added them. But there would be long stretches when no Talavera piece appeared. Many times I feared that the pattern had been discontinued. I began to add similar pieces in different colorways from the same manufacturer to the collection. There was beige with blue, dark blue with pink, and green with orange (as opposed to orange with yellow.) When I saw a big beige Talavera green-and-orange bowl, a large Terra Bella pitcher, some charming oblong Talavera trays, I added them. I was fearful that I would miss out if I didn't. When I saw two orange cups, I bought them, even though I preferred the flagon shape. When I saw two orange sugar and creamer containers, fearful that I might never see them again, I bought them both. My treasures overflowed the china cupboard to the tops of the bookcases and are now even on the bookshelves themselves. When planning to leave the Little Pink House after a summer there, I asked my newly married granddaughter Nadia if she would like some of

The Bushman Plates

those dishes. She did. She and I often like the same things. I assembled a complete service for eight with lots of extra pieces and sent them her way. We still have a lot of Talavera.

Back in New York, I thought I was pretty much done with the dish craze. But one day in one of my cheap stores, I saw a small bowl of many bright colors, which was then embroidered with dots of colored glass in many other bright colors. The bottom said "Hand made in Turkey" in childish printing. I was drawn to it at once. A more determined search of the store yielded another three little cereal or dessert bowls, all in different colors and designs. I had to have them. When I told my husband I had bought some new dishes, he was genuinely sad but resigned. I showed off my new bowls to various people and received gifts of some matching pieces. I found more at another store. I now have more than a dozen bowls in five different sizes. They are not too comfortable to eat out of with all those glass lumps. It feels as if there is gravel in your bowl. But I do not care. I love them and will buy more wherever I see them. What I need now, however, is plates: salads and dinners. There must be some around. I'm always looking.

There are many more vices, even some possessed by me, much worse than buying plates.

Obituary

Claudia Marian Lauper Bushman died X in X of the general breaking up of old age. She was X years old. Always a domestic mother and housewife, she was also a productive scholar who measured out her life in projects of all kinds. She was born to Jean Vernon Gordon and Serge James Lauper on June 11,1934, in Oakland, California, the second of four daughters. Her sisters are Georgia Gates (deceased 2024), Paulie Hutchings, and Bonnie Goodliffe. She grew up in the Sunset District of San Francisco, California, the former sand dunes of the Pacific Ocean, frequently shrouded with fog and accompanied by foghorns. She attended San Francisco public schools: Lawton Grammar School for grades K–7; for grade 8, her class was bused across Golden Gate Park to the Richmond District to attend Presidio Junior High School, a circumstance reflecting the overcrowding of the schools during World War II. She attended Abraham Lincoln High School, "High on a hilltop, mid sand and sea," for grades 9–12. From that vantage point she could see the Pacific Ocean and San Francisco Bay, as well as the brilliant orange Golden Gate Bridge, when the absence of fog allowed.

She identified herself as a third-generation American and a fifth-generation Mormon, suggesting the reality of grandparents from four different countries: her father's parents Emma Wissing from Denmark and Emile Lauper from Switzerland and and her mother's parents James Frater Gordon (born after his parents emigrated from Scotland) and Margaret Elizabeth Schutt from England. Her grandparents, all involved in Mormon conversion, met and married in Utah, and later moved to California, where her parents met and married.

Claudia attended Wellesley College in Massachusetts from 1952 to 1956, the fortuitous and accidental result of the open society following World War II. She was an adventurous, if not brilliant student. She met her husband of x years, Richard Lyman Bushman while he was a student at Harvard College in the small Cambridge Mormon congregation. Married in 1955, they continued at school, Claudia as a Wellesley senior and Richard as a Harvard graduate student. Their six children are Clarissa (1956–2018), Richard Lyman, Jr. (1959) (m. Harriet Petherick), Karl Edward (1962) (m. Diane Spurgeon), Margaret Elizabeth Gordon (1965)

(m. Michael LaBianca), Serge James Lauper (1966) (m. Patricia Shelley) and Martin Benjamin (1971) (m. Erika Hacking). Claudia's twenty grandchildren are Helena, William (Sloane), Raffy, Ted, Max, Luke, Montana, Peter, Nadia, Shelley, Caroline, Reeve, Isabella (dec.), Claudia, Gwyneth, Suzanne, Frances, Libby, Ayden, and Benjamin Asher. Their great grandchildren are Margaret, Hazel, James, and Griffin. She is survived by . . .

Claudia had special interests in historical huswifery, birds, reptiles, the shows of Gilbert and Sullivan, songs and music of all sorts, nonsense poetry, and handwork. She sang in and conducted many choirs. She would break into song unexpectedly, and she often prefaced serious talks with the requirement that audiences sing or dance, activities which she believed improved most gatherings.

Claudia studied English literature at Wellesley College and lived a life of reading and writing as well as housekeeping and child-rearing. She graduated from college, the first in her family, in maternity clothes. She began work on her master's degree in American literature from Brigham Young University in Provo, Utah, with two children, and she finished with three. She began her work on a PhD degree in American studies from Boston University with five children; she finished with six. She studied women's work, switching from one life to another during her busy productive years. She taught at several universities, moving from Massachusetts to Utah, to Rhode Island, south to Delaware, and in 1989 to New York City as her husband, a distinguished American colonial historian, ascended academic ranks. He held named chairs at the University of Delaware, Claremont Graduate University, and Columbia University. An additional chair at the University of Virginia was named for him. Claudia regarded her husband as her greatest teacher, and they frequently discussed ideas, collaborated on projects, and read and edited each other's writing. In 2002, she was named the New York State Mother of the Year.

During the family's second long tenure in Massachusetts, from 1968 to 1977, Claudia was part of a Mormon feminist women's discussion group whose members became known for their activities, events, and publications. She edited their book, *Mormon Sisters: Women in Early Utah*, and was the founding editor of the Mormon feminist newspaper, *Exponent II* (1974–), named for *The Woman's Exponent* (1872–1914), which was published in early Utah.

After the family moved to Delaware in 1977, she taught at the University of Delaware and founded the Newark (DE) Historical Society. Her activism led to a position as the director of the Delaware Heritage

Commission, a state agency celebrating historical events. As the commemoration of the 200th anniversary of the United States Constitution, the ratification of which made Delaware "The First State," took place under her watch, the Commission oversaw a plethora of events: commemorations, reenactments, publications, concerts, dramas, wreath-layings, parades, and stamp introductions, as well as the Great Bicentennial Ladybug Launch, in which the state legislators and school children liberated more than a million specimens of the state insect.

During a four-year stay in Southern California when her husband was initiating a Mormon Studies program at Claremont Graduate University, she taught courses on women and began a large oral history project. She grew to think that documenting their lives was the most important thing people could do, creating primary sources for future use. She herself kept an almost daily journal for more than forty years and regretted not having begun sooner.

Her New York years were known for more academic and church projects. She produced church-themed shows at Carnegie Hall and Radio City Music Hall. Her list of published books grew. She wrote on women's work, Virginia farming, and attitudes toward Christopher Columbus. She spoke to many groups. She, her husband, and others sponsored The Center for Latter-day Saint Arts. She and Sheila Monks began a modest quarterly publication for her Wellesley class. The name *Scarlet Letters* indicates that red was the class color. She was grateful for things to do and the ability to do them. She moved along her many projects by focusing on their desired ends. As she said, "If you keep up, you'll never get ahead."

<div style="text-align: right;">Claudia Bushman</div>

Index

A–B

Arrington, Leonard, 138–39, 147, 259
Benny and the Pork Chops, 52, 189, 208, 226, 270
Bentley, Joe, 258–59
Brigham Young University, 66, 76, 83, 120, 135, 187, 250, 256, 262
Bushman, Ben, 136–37, 144, 159, 173, 225, 276
 education, 192
Bushman, Claudia (Lauper)
 Abraham Lincoln High School, 33–34, 59–65
 cancer, 262–63
 car accident, 115, 120
 childhood mischief, 13, 16, 34
 children, 103–5, 209–10
 dating life, 61–62, 74–75, 79–82, 86–87
 dissertation, 154–55, 163–64, 193, 213, 285
 engagement, 88–91, 93–95
 family pets, 13–14, 28, 158, 163
 further education, 109, 118, 120, 125–30, 144, 309
 "good enough", 57, 65, 77–78, 82–83, 95, 118, 193, 265–66
 grandchildren, 223–24, 270–76, 308–9
 heritage, 3–6, 9, 244, 308
 huswifery, 128–30
 labor and delivery, 106–7, 111–13, 117, 137
 ladybug launch, 200–201
 Lawton Grammar School, 33, 56–58
 left-handedness, 23, 53, 55, 64, 115, 219
 life lessons, 292–99
 mantras, 45–46, 288, 310
 mental health, 92, 217–18
 miscarriage, 123
 missionary work, 160–61
 music/choir, 50–51, 62–63, 77, 92–93, 101, 106, 179
 ocean voyage, 109–10
 oral history, 261–62
 parents of, 7–8
 patriotism, 58
 Presidio Junior High School, 58
 projects, 56–57, 133–34, 184–87, 200–201, 261, 301–2
 published works, 63, 199, 215, 285–86
 Record Year, The, 177, 187
 Scarlet Letters, 265–66, 310
 school reunions, 62–64, 265
 shopping/collecting, 250, 300–307
 speaking out, 175–76
 Sunday cultural expeditions, 171–74
 teaching, 120, 138, 177, 215–16, 260–61
Bushman, Karl 117, 119–20, 131, 174, 272–73
 band, 158–59
 career, 225
 education, 191
 herpetology, 143, 158
Bushman, Richard (Brick) Jr., 52, 112–16, 119, 131–32, 174, 270–72

career, 189, 225
education, 157, 188
orchestra, 124, 141–43
Bushman, Richard, 10, 162–63, 182
 Bancoft Prize, 121–22
 Brigham Young University, 117, 121–22, 139
 British Museum, 111–12, 114
 Brown University, 118–19
 ecclesiastical leader, 134–37, 150, 168–70, 174, 178, 187, 194
 Harvard, 125
 illness, 114–16
 Joseph Smith Papers, 258
 missionary work, 76, 85
 Mormon Studies chair, 259–60
 published books, 157, 182–83, 258–59
 reputation, 130, 183, 203, 211
 sabbatical, 213–20
 Sheldon Traveling Fellowship, 109
 support, 91–92, 101, 137, 146, 176, 281
Bushman, Serge, 120, 144, 173, 274–75
 band, 159, 192
 career, 225
 Woodcache, 257, 273, 275

C

Church of Jesus Christ of Latter-Day Saints, The
 education, 17, 19–22, 25, 73, 166, 168, 180, 284, 291, 295–99
 and feminism, 135, 169, 171, 176, 221–23
 gender roles, 39
 Word of Wisdom, 60–61, 295
Columbia University, 203, 209
 Harlem Campus, 239
 history of, 210–11, 216

student unrest, 122, 125, 127
Columbus, Christopher, 212–13

D

Delaware
 Delaware Heritage Commission, 198–203, 207, 212, 309–10
 Hagley Museum, 186
 history of, 181–82
 University of Delaware, 182, 185, 191, 195, 197
Dialogue: A Journal of Mormon Thought, 40, 139
 women's issue, 36–38
DuPont family, 181, 186

E–G

Edwards, LaVell, 245
Ellis, Doug, 227–28
Exponent II, 139, 147–53, 155–56, 163
feminism, 126, 309
 Pankhurst, Emmeline, 155
 Wells, Emmeline B., 155
Gates, Georgia (Lauper), 8, 10, 15, 21, 50, 53, 91, 103, 269
genealogy, 9, 52
Goodliffe, Bonnie (Lauper), 15, 21, 25, 50, 53, 269
Great Depression, 20

H–K

Hales, Robert C., 150–51
Harlem, 9
 Acosta, Ralph, 241–42
 Harlem Bridge Builders, 239–46
 Kittles, Dr. Rick, 9, 244
 squatter's rights, 240
Hinckley, Gordon B., 230, 235
Huntington Library, 259–60

Hutchings, Dixie Pauline (Lauper), 10, 15, 24, 45, 53, 56, 190, 269
Kimball, Spencer W., 175
Korean War, 85

L

LaBianca, Margaret (Bushman), 119–24, 131, 144, 159, 219, 274
 career, 225
 education, 191–92
Lauper, Jean Gordon, 44
 cultural leader, 18, 45–49, 166–67
 diary of, 53, 102–3, 152
 funeral of, 190–91
 music, 48–51
 projects, 194–95, 227
 seamstress, 13, 51–52, 56, 70
 stroke, 189–90
 poems, 11
Lauper, Serge
 anger, 15, 20–21, 48, 167
 bishop, 8, 14, 17, 165
 childhood, 3–4, 267
 church mission, 17–18
 funeral of, 217
 hard worker, 14–15, 20
 pride, 25, 69
 Remembrances, 40
Little Pink House
living nativity scene, 227–30
Low Library, 122, 211

M–N

Manhattan New York Temple Youth Jubilee, 230–35
Mutual Improvement Association, 38, 102, 133–34
New York
 apartment, 209, 282–84
 sightseeing, 70–72, 84, 210

Newark Historical Society, 194–97, 309

O–R

Ortel, Clarissa (Bushman), 105, 107–8, 116, 119, 157–58, 263, 269–70
 career, 188
 dancing, 123, 130, 140, 188, 225
 death of, 276–79
 education, 141, 188
Perry, L. Tom, 150, 233
Relief Society, 38, 133, 146, 155, 222, 240

S

San Francisco, 18, 70
Sheldon, Carrel, 146–47, 155
Smith, Emma, 185
Smith, Joseph
 church organization, 184
 statue of, 41, 235–39
Sunset Ward, 19, 95
 building a chapel, 20, 37–40
 remodeling, 40–43

U–W

University of California at Berkeley, 61–62, 66
Walker, John, 214–15, 220–21, 286
Wellesley
 acceptance, 69
 application, 66–67
 building a chapel, 83–84, 105–6
 Lake Waban, 88, 264
 senior year, 101
 Severance Hall, 72, 78
 social life, 77–79, 82
World War II, 29, 55–56, 59, 66
 USS San Francisco, 33

Also available from
GREG KOFFORD BOOKS

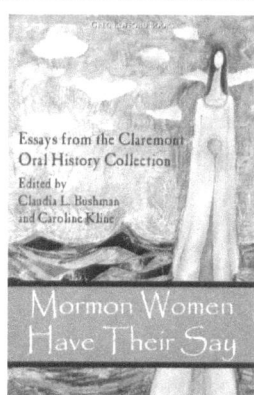

Mormon Women Have Their Say: Essays from the Claremont Oral History Collection

Edited by Claudia L. Bushman and Caroline Kline

Paperback, ISBN: 978-1-58958-494-5

The Claremont Women's Oral History Project has collected hundreds of interviews with Mormon women of various ages, experiences, and levels of activity. These interviews record the experiences of these women in their homes and family life, their church life, and their work life, in their roles as homemakers, students, missionaries, career women, single women, converts, and disaffected members. Their stories feed into and illuminate the broader narrative of LDS history and belief, filling in a large gap in Mormon history that has often neglected the lived experiences of women. This project preserves and perpetuates their voices and memories, allowing them to say share what has too often been left unspoken. The silent majority speaks in these records.

This volume is the first to explore the riches of the collection in print. A group of young scholars and others have used the interviews to better understand what Mormonism means to these women and what women mean for Mormonism. They explore those interviews through the lenses of history, doctrine, mythology, feminist theory, personal experience, and current events to help us understand what these women have to say about their own faith and lives.

Praise for *Mormon Women Have Their Say*:

"Using a variety of analytical techniques and their own savvy, the authors connect ordinary lives with enduring themes in Latter-day Saint faith and history." --Laurel Thatcher Ulrich, author of *Well-Behaved Women Seldom Make History*

"Essential. . . . In these pages, Mormon women will find *ourselves*." --Joanna Brooks, author of *The Book of Mormon Girl: A Memoir of an American Faith*

"The varieties of women's responses to the major issues in their lives will provide many surprises for the reader, who will be struck by how many different ways there are to be a thoughtful and faithful Latter-day Saint woman." --Armand Mauss, author of *All Abraham's Children: Changing Mormon Conceptions of Race and Lineage*

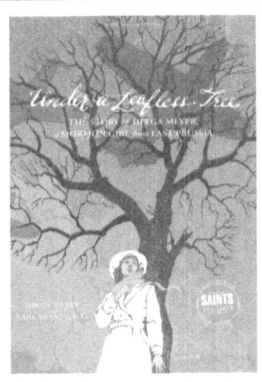

Under a Leafless Tree: The Story of Helga Meyer, a Mormon Girl from East Prussia

Helga Meyer and Lark Evans Galli

Paperback, ISBN: 978-1-58958-673-4

Imagine if the world you grew up in ceased to exist. In her own words, Helga Meyer tells of the disintegration of her hometown in Tilsit, East Prussia. From an idyllic childhood to persecutions for her curious, new faith, to the challenge of saluting Nazi troops while quietly befriending Jews, and suffering wounds in one of many, daily bombing raids, Helga reveals intimate details about coming of age in a world that is quickly falling apart.

Too soon, Helga's teenaged friends, brothers and cousin are facing death in the bitter fields of France and Russia. Amidst fellow refugees, Helga finds her natural optimism challenged by increasing and very personal heartbreak. Alone in a foreign land, Helga struggles to find refuge and braver still, a chance at romance. Led by a prophetic dream, she devises a means of escape in order to begin a new life in America.

Revealing previously unknown details of women's experiences during World War II and the lives of early Latter-day Saints in East Prussia and East Germany, this engaging account promises to be a valuable addition to the growing collection of World War II memoirs. A richly layered story, weaving together both personal and historically significant events, *Under a Leafless Tree* is an unforgettable, true story that stays with the reader.

Praise for *Under a Leafless Tree*:

"A wonderfully crafted and engaging narrative!" — Jill Mulvay Derr

"Simply amazing." — Association for Mormon Letters

"This is a remarkable book." — *The Exponent II*

"What an important, poignant story. I can hear Helga's voice as I read it." — Linda K. Newell

"Brings to life an important, but previously little known, part of our history." — Claudia L. Bushman

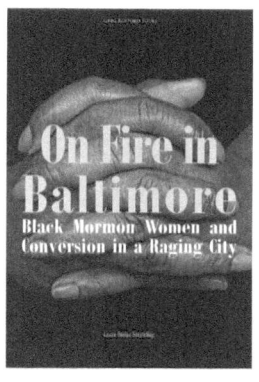

On Fire in Baltimore: Black Mormon Women and Conversion in a Raging City

Laura Rutter Strickling

Paperback, ISBN: 978-1-58958-716-8

On Fire in Baltimore is more than just the personal stories of Black women who converted to Mormonism. Against the background of a city known for its racial and economic inequality, these devout women of color tell stories of drug addiction and rape, of nights spent in jail and days looking for work, and of single motherhood and grief for lost children. Yet, their stories are also filled with visitations from heavenly beings, dreams of deceased mothers, protection from violence, and missionary messengers. They share how they reconcile their membership in a historically White church that once denied them full membership because of their race. Laura Rutter Strickling takes the reader on an intimate journey where Black and White racialized lives meet, where she is compelled to question how her own whiteness has impacted her perspective, and where an unquenchable spiritual fire burns bright in a raging city.

Praise for *On Fire in Baltimore*:

"A compelling book that encourages readers to consider the forgotten and the overlooked." — *BYU Studies Quarterly*

"Magnifies the universal human yearning for inclusion and redemption." — *Segullah*

"Latter-day Saint readers of diverse backgrounds will find themselves in deeply familiar territory as they listen to these Sisters faithfully implore an approachable, personal God. No matter what your geographic, religious, or social location is, many will find a warmth and connection to the stories of these women and the grace that they have welcomed into their deepest struggles." — *Dialogue: A Journal of Mormon Thought*

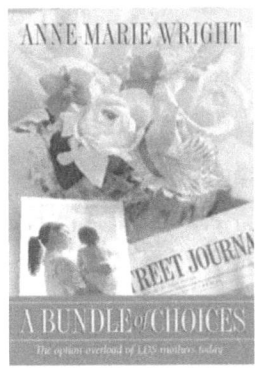

A Bundle of Choices: The Option Overload of LDS Mothers Today

Anne-Marie Wright Lampropoulos

Paperback, ISBN:978-1-58958-018-3

Children. Education. Work. Self-improvement. Church. Relaxation. Today, women enjoy more options and opportunities than ever before. Women can do anything and be anything they want. But all these choices seem overwhelming at times. What do women want to do, and in what priority, and when?

The option overload presented today demands that Latter-day Saint women perform a delicate balancing act, whether by choice or circumstance. With so many avenues available, prioritizing their lives and maintaining their sanity can be complicated. Women have the world advocating the benefits of working, the Church touting the joys of motherhood and the importance of education, and their own personalities and abilities weighing in as well. How do women reconcile these competing demands and enjoy their rewards?

Interviewing more than one hundred women throughout the country, Wright brings readers along on a personal journey toward self-discovery and an understanding of the acrobatic juggling required by Latter-day Saint women today.

Voices for Equality: Ordain Women and Resurgent Mormon Feminism

Edited by Gordon Shepherd, Lavina Fielding Anderson, and Gary Shepherd

Paperback, ISBN: 978-1-58958-758-8

Praise for *Voices for Equality*:

"Timely, incisive, important—this book teaches us that our sometimes very personal struggles with gender and equality in Mormonism have profound and far-reaching significance. In these pages, some of Mormonism's finest researchers and thinkers bring a richness of historical and scholarly perspective and a powerful new survey of tens of thousands of Mormon people to bear on headline-making issues like women's ordination, sister missionaries, church discipline, the internet and faith, and change in the LDS church. They offer us a rare and precious opportunity to grasp the full significance of this moment. This book is a much needed mirror for our time."
 — Joanna Brooks, co-editor of *Mormon Feminism: Essential Writings* and author of *The Book of Mormon Girl: A Memoir of an American Faith*

"*Voices for Equality: Ordain Women and Resurgent Mormon Feminism* is a very important contribution to the discussion of Mormon feminism and the struggle for the ordination of women to the priesthood in the LDS Church. Anyone interested in this subject, any library concerned to be up-to-date on these issues, needs to have this book."
 — Rosemary Radford Ruether, world-renowned feminist scholar and Catholic theologian, author of *Sexism and God-Talk: Toward a Feminist Theology* and *Women-Church: Theology* and *Practice of Feminist Liturgical Communities*

Mr. Mustard Plaster and Other Mormon Essays

Mary Lythgoe Bradford

ISBN: 978-1-58958-742-7

"Mary Bradford is the original literary 'Mormon Girl.' Long before anyone even imagined the bloggernacle, she believed that writing about everyday Mormon life—especially women's lives—could be beautiful and powerful. In her own essays, she brings unparalleled power of perception, generous humanity, and quiet humor to bear on even challenging Mormon subjects. This book is an incredible opportunity for a new generation of Mormon readers to get to know one of our faith's wise women elders. Don't miss it."
— Joanna Brooks, author of *The Book of Mormon Girl: A Memoir of an American Faith*

"Mary Bradford believes that the distinctive nature of the personal essay originates from what she calls the three "I's" ("I's," eyes, ayes)—the authors' first-person perspective, their clear and rich vision, and their honest and affirming testimonies of life. Mary's own essays are true to form: her essays are vibrant portraits of a kind and loving soul, a rich and unique perspective, and a life well-lived and deeply loved." — Boyd Jay Petersen, author of *Dead Wood and Rushing Water: Essays on Mormon Faith, Culture, and Family*

"Mary Lythgoe Bradford offers her autobiography in personal essay—revealing a lifetime that bridged generations and pioneered the power of essay in Mormon literature. Since the first issue of Dialogue in 1966, Mary's wisdom and presence as an editor, writer, poet and biographer have linked us together, reaching back to women like Virginia Sorensen and moving us forward into feminism. Today at 84, Mary is still helping 'Mormon women speak.'"
— Maxine Hanks, editor of *Women and Authority: Re-emerging Mormon Feminism*

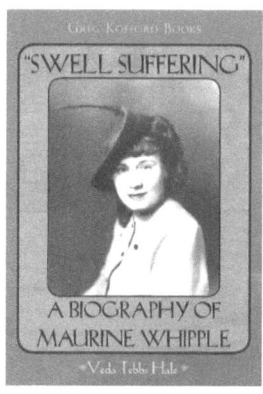

"Swell Suffering": A Biography of Maurine Whipple

Veda Tebbs Hale

Paperback, ISBN: 978-1-58958-124-1
Hardcover, ISBN: 978-1-58958-122-7

Maurine Whipple, author of what some critics consider Mormonism's greatest novel, *The Giant Joshua,* is an enigma. Her prize-winning novel has never been out of print, and its portrayal of the founding of St. George draws on her own family history to produce its unforgettable and candid portrait of plural marriage's challenges. Yet Maurine's life is full of contradictions and unanswered questions. Veda Tebbs Hale, a personal friend of the paradoxical novelist, answers these questions with sympathy and tact, nailing each insight down with thorough research in Whipple's vast but under-utilized collected papers.

Praise for *"Swell Suffering"*:

"Hale achieves an admirable balance of compassion and objectivity toward an author who seemed fated to offend those who offered to love or befriend her.... Readers of this biography will be reminded that Whipple was a full peer of such Utah writers as Virginia Sorensen, Fawn Brodie, and Juanita Brooks, all of whom achieved national fame for their literary and historical works during the mid-twentieth century"
—Levi S. Peterson, author of *The Backslider* and *Juanita Brooks: Mormon Historian*

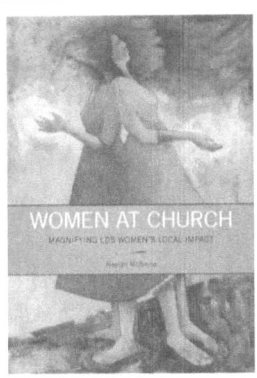

Women at Church: Magnifying LDS Women's Local Impact

Neylan McBaine

Paperback, ISBN: 978-1-58958-688-8

Women at Church is a practical and faithful guide to improving the way men and women work together at church. Looking at current administrative and cultural practices, the author explains why some women struggle with the gendered divisions of labor. She then examines ample real-life examples that are currently happening in local settings around the country that expand and reimagine gendered practices. Readers will understand how to evaluate possible pain points in current practices and propose solutions that continue to uphold all mandated church policies. Readers will be equipped with the tools they need to have respectful, empathetic and productive conversations about gendered practices in Church administration and culture.

Praise for *Women at Church*:

"Such a timely, faithful, and practical book! I suggest ordering this book in bulk to give to your bishopric, stake presidency, and all your local leadership to start a conversation on changing Church culture for women by letting our doctrine suggest creative local adaptations—Neylan McBaine shows the way!" — Valerie Hudson Cassler, author of *Women in Eternity, Women of Zion*

"A pivotal work replete with wisdom and insight. Neylan McBaine deftly outlines a workable programme for facilitating movement in the direction of the 'privileges and powers' promised the nascent Female Relief Society of Nauvoo." — Fiona Givens, co-author of *The God Who Weeps: How Mormonism Makes Sense of Life*

"In her timely and brilliant findings, Neylan McBaine issues a gracious invitation to rethink our assumptions about women's public Church service. Well researched, authentic, and respectful of the current Church administrative structure, McBaine shares exciting and practical ideas that address diverse needs and involve all members in the meaningful work of the Church." — Camille Fronk Olson, author of *Women of the Old Testament* and *Women of the New Testament*

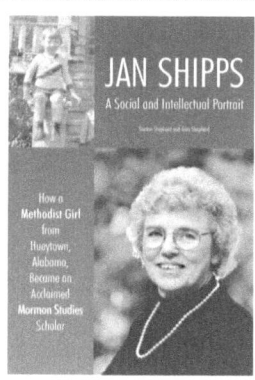

Jan Shipps: A Social and Intellectual Portrait: How a Methodist Girl from Hueytown, Alabama, Became an Acclaimed Mormon Studies Scholar

Gordon Shepherd and Gary Shepherd

Paperback, ISBN: 978-1-58958-767-0
Hardcover, ISBN: 978-1-58958-768-7

How did Jo Ann Barnett—a Methodist girl born and raised in Hueytown, Alabama, during the Great Depression and World War II—come to be Jan Shipps, a renowned non-Mormon historian and scholar of The Church of Jesus Christ of Latter-day Saints? In Jan Shipps: A Social and Intellectual Portrait, authors Gordon Shepherd and Gary Shepherd tell the story of how Shipps not only became an important and trusted authority in a field that was predominantly made up of Mormon men, but also the crucial role she played in legitimizing Mormon Studies as a credible academic field of study.

Praise for *Jan Shipps: A Social and Intellectual Portrait*:

"The person and work of Jan Shipps comprise one of the ten most important factors enabling Mormon Studies to eclipse its parochial past. Authors Gordon and Gary Shepherd have adroitly marshalled the tools of history and social science to lay bare how this unlikely event came to be. This is important reading for any who hope to understand Shipps or the emergence of the field in which she worked. Important also for any scholar feeling that the deck in a competitive academy is stacked against them." —Phil Barlow, Neal A. Maxwell Fellow at the Neal A. Maxwell Institute for Religious Scholarship at Brigham Young University.

"Jan Shipps deserves and the Shepherds are to be thanked for this celebration of her celebrated career. The authors rightly insist this is not a thorough treatment of Jan's life but rather an account of her role in the rise Mormon Studies in the late-twentieth century. It was a watershed time and Jan was a creator of and catalyst to much of the best scholarship which flowed from it. As such, there is much to learn here about Mormonism itself and those who studied it during this period." —Kathleen Flake, Richard Lyman Bushman Professor of Mormon Studies, University of Virginia

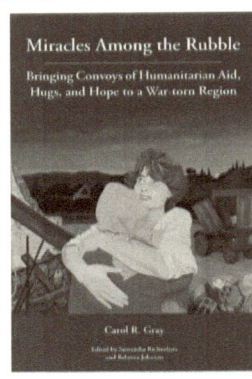

Miracles Among the Rubble: Bringing Convoys of Humanitarian Aid, Hugs, and Hope to a War-torn Region

Carol R. Gray

Paperback, ISBN: 978-1-58958-578-2

"All those years ago, feeling totally overwhelmed by what I saw of fear and destruction, I turned to the Lord with a yearning I could not understand. Still to this day I do not understand why a dear and loving Heavenly Father prepared the way for me, Carol Gray, an ordinary English wife and mother, to dare to believe that in my small and humble way I could possibly make the difference to a war-wearied country."

Carol Rosemary Gray was a British mother and homemaker of seven children who became a recognized humanitarian leader in Europe and Africa. After receiving the all clear from her first battle with cancer at age 29, she made a promise to her Heavenly Father that she would live every single day to the fullest. This promise was exemplified years later when she began by organizing and transporting relief aid for victims of the Balkan War during the early 1990s, returning more than 34 times in the following nine years. She then went on to found Hugs International TLC, which, through Carol's efforts, funded the construction and operating of homes, a school, dormitories, a medical center and a sports field in Ghana for the next 10 years. Carol passed away in 2010 at age 66.

This volume comprises a selection of heart-wrenching and inspiring experiences told in Carol's poetically unique style of expression. Her stories are a testament to the extraordinary achievements of an ordinary mother, who was able to do remarkable things with nothing more than unwavering faith, the help and guidance of the Holy Ghost, and her relationship with the Savior.

Praise for *Miracles Among the Rubble*:

"A beautiful testament to courage and compassion." — Neylan McBaine, author of *Women at Church: Magnifying LDS Women's Local Impact*

"A poignant and remarkable tale of an ordinary person who responded to the calling to do extraordinary things." — Association for Mormon Letters

www.ingramcontent.com/pod-product-compliance
Lightning Source LLC
Chambersburg PA
CBHW021900230426
43671CB00006B/463